ROBERT PLANT

A LIFE

BY PAUL REES

HARPER

HARPER

An imprint of HarperCollins*Publishers*
77–85 Fulham Palace Road,
Hammersmith, London W6 8JB

www.harpercollins.co.uk

First published by HarperCollins*Publishers* 2013
This edition 2014

1 3 5 7 9 10 8 6 4 2

A catalogue record of this book is
available from the British Library

PICTURE CREDITS

While every effort has been made to trace the owners of copyright material reproduced herein and
secure permissions, the publishers would like to apologise for any omissions and will be pleased to
incorporate missing acknowledgements in any future edition of this book.

Part-opener images: © Camera Press/Perou (part three); © News Ltd/Newspix/Rex Features (part two);
© Redferns (part one)

Plate-section images: © Sam Bagnall/AMA Photo Agency/Wolves FC p8 (top centre); © Camera Press/Perou
p8 (top left); Camera Press/© Randolph p3 (middle right and bottom left); © John Crutchley p1 (bottom right);
© Andy Earl p6 (third row, right); © Nigel Eaton p6 (bottom), p7 (top left); © James Fortune/Rex Features p4
(top left); © Getty Images p4 (middle left, middle right and bottom left), p8 (top right); © Ross Halfin p7
(third row, left and bottom), p8 (middle left); © Idols/Photoshot p4 (top centre); © King Edward VI Grammar
School for Boys p1 (top left, bottom left); © LFI/Photoshot p5 (middle left); © Mirrorpix p3 (top left), p4
(top right); © David Montgomery/Getty Images p6 (fourth row, left); © Bev Pegg p1 (middle), p7 (top right,
second row, left and second row right); © Redferns p2 (top left, top right, middle left, middle right, bottom left),
p3 (middle left), p5 (top left, top right, middle right and bottom left), p6 (second row, left); © Colin Roberts p1
(top right); © Pete Souza/dpa/Corbis p8 (bottom left); © Time & Life Pictures/Getty Images p3 (top right), p6
(top right); © Jezz Woodroffe p6 (top left); © David Yeats p1 (bottom centre)

PB ISBN 978-0-00-751489-2
EB ISBN 978-0-00-751490-8

Printed and bound in Great Britain by
Clays Ltd, St Ives plc

MIX
Paper from
responsible sources
FSC
www.fsc.org
FSC C007454

Find out more about HarperCollins and the environment at
www.harpercollins.co.uk/green

This one's for Denise, the love of my life, and the lights of it, Charlie and Tom.

CONTENTS

PART THREE: SOLO

ENCORE

*How can you ever tell how
it's going to go?*

For a moment he was alone. Back in his dressing room, where he had paced the floor little more than two hours before. Then, he had been in the grip of a terror at what was to come. The weight of history pressing down upon him; the burden of all the demons he had come here to put to rest at last.

He had felt fear gnawing away at him. The dread of how he might appear to all the thousands out there in the dark. Here he was, a man in his sixtieth year, desiring to roll back time and recapture all the wonders of youth. Did that, would that, make him seem a fool? In those long minutes with himself he had looked in the mirror and asked over and over if he really could be all that he had once been; if it were truly possible for him to take his voice back up to the peaks it had once scaled. He had so many questions but no answers.

There would be ghosts in the room, too. Those of his first-born son, of his best friend and of all the others he had lost along

the way. For each of them he wanted to be the Golden God this one last time …

It was going on midnight on 10 December 2007. Robert Plant was gathering himself in the immediate aftermath of Led Zeppelin's reunion concert at London's O2 Arena. The roar of the crowd, which had rolled over him like thunder, had faded. He could hear the chatter of many voices in the corridors backstage; the same corridors that had earlier been silent and still, pregnant with expectation before he and his band had walked tall once more.

Jimmy Page and John Paul Jones, the other surviving original members of Led Zeppelin, were off in their own corners thinking their own thoughts. Tonight they had come together but there would remain a distance between them. It was one that spoke of all they had built together and then seen turn to ruin; of shared victories and bitter recriminations; of relationships so complex and complicated they were all but impossible to unravel.

When at last Plant threw open his door, all of those who came to shake his hand and pound his back told him what he already knew. He, they, had been great. Better than anyone could ever have hoped they might be. His doubts had been stilled. His debt, such as it was, had been honoured.

Pat and Joan Bonham, wife and mother of John, the friend and colleague he had buried a lifetime or a heartbeat ago, were among the last he welcomed and he held them especially close. Jason, their son and grandson, had sat in his father's drum seat that night. He told them how proud John would have been of his only son. And then the ghosts came to him again.

He was supposed to go to some featureless hospitality room upstairs to meet with friends. There was a VIP party to attend

where he would be feted by Paul McCartney and Mick Jagger, Kate Moss and Naomi Campbell, Priscilla and Lisa-Marie Presley, and more and more. He instead took one last look around the scene of his triumph, then summoned a car and asked to be driven away from it. He wanted nothing more now than to get as far from everyone and everything as it was possible to be.

'The rarefied air backstage at the O2 was something you could only savour for moments,' he told me three years later.

On that cold, dark night he drove north, across the River Thames and through city streets aglow with Christmas lights. On to Chalk Farm, a corner of north London a mile from the bustle of Camden Town and a short walk from the more genteel Primrose Hill, where he had a house. The car dropped him off at the Marathon Bar, an inauspicious-looking Turkish restaurant on Chalk Farm Road.

Going inside, he walked past two spits of grey meat cooking in the window, past the stainless-steel counter and the garish display board advertising kebabs, burgers and fried chicken. He went into the small, windowless back room. There he sat at a wooden table, and ordered half a bottle of vodka and a plate of hummus. They knew him in this place and let him be. Here, at last, among the Marathon Bar's usual late-night crowd – the young bucks, the couples and the local gangsters – he felt at peace. Through an open archway he could look out over the restaurant's main room and onto the street beyond.

I first met Plant in 1998 when I was working for the British rock magazine *Kerrang!* At the time he and Page were about to release their second album together as Page and Plant, *Walking into Clarksdale*. I interviewed the pair of them in London. During the

course of our conversation Plant veered back and forth from being testy and disinterested to disarming and expansive, and I found him hard to read. I was fascinated by him because of this, drawn as much to his contradictions as to his obvious charisma. The quieter and more fragile-seeming Page left a much less enduring impression.

Our paths crossed a number of times during the years that followed. We shared a journey on a public ferry in Istanbul, and I bumped into him in the backstage corridors at assorted television and music-awards shows. Discovering I was both a fellow Midlander and a football fan, he appeared to warm to me – although the team I supported, West Bromwich Albion, were local rivals of Wolverhampton Wanderers, the one he had followed from boyhood. One summer he sent me a couple of emails proposing a bet on the outcome of a forthcoming game between the teams. I am still waiting for him to honour this wager – a meal in an Indian restaurant on London's Brick Lane.

I interviewed him again in 2010, this time for *Q* magazine and when he was basking in the afterglow of the success he had enjoyed with *Raising Sand*, the album he had recorded with the American bluegrass singer Alison Krauss. He was warmer and friendlier on this occasion, and also appeared more at ease. This was perhaps as a result of how well both *Raising Sand* and his work subsequent to it had been received, or just as likely because Page was absent. He reflected on his formative years in England's heartland, on the wild ride he had taken with Zeppelin and on his solo career, through which his fortunes had been as varied as the albums he had made.

Two things that struck me most about Plant were his passion for music – which burns as fiercely now as it did when he was captivated by the great American blues singers as a grammar-

school boy – and the uniqueness of his story. The best work of the vast majority of his peers is many years behind them but Plant continues to seek new challenges and adventures. This has kept his music fresh and vital, filling it with surprises and delights. Such was the spark for this book, fanned by the knowledge that no one had yet documented the entire span of his life.

There was also the challenge of forming a sense of what made Plant tick and drove him on. To the casual observer he might seem garrulous, but beyond this front he is guarded and private, careful never to reveal too much of himself. I wanted to reach the man behind the music, since gaining a better understanding of him would shed new light on the road he has travelled.

As he sat in the Marathon Bar collecting his thoughts that December night, the hours running to morning, did he reflect upon how far he had come and how long he had journeyed? Upon the years of struggle, the fights with his parents, when there was no money in his pocket and he had sensed the dream that had driven him slipping from reach. Upon the soaring heights to which Led Zeppelin had taken him, when he had basked in the adulation of millions and felt the heady rush of that band's power pumping through his veins. And on into the deep, black depths into which he had sunk, when there had been nothing to fill the empty spaces in his heart.

Through it all there had been music. It was, then and now, the thing that most lit him up. First it came crackling over the radio waves, then as something wild and primal from within. All the endless possibilities it promised had made his head spin. So often and so much he had been stirred by Elvis Presley and Robert Johnson, by sounds that rushed to him from the American West and the north of Africa. It had, all of it, carried him along. It had

given him more than he could have dared to ask for and he had taken every last drop of it. And as he did so it had exacted from him a heavy and terrible price.

And in looking back, did he also turn to contemplating his present and on then to what might lie over the horizon? *Raising Sand*, of which he was so proud, had awoken something new within him, but there was the question of what to do next, of where to roam and with whom. This relentless curiosity at all that could be was something he had never lost. Even on this night, when he had puffed out his chest and swaggered back into the past, what sustained him most was the sensation of forward motion, of new frontiers and the mysteries held within.

'You can never have a life plan if you're going to be addicted to music,' he told me when I had asked him about such things. 'At this age, when you find you're still getting goosebumps and a lump in the throat when you hear it, how can you tell how it's ever going to go?'

PART ONE

BEGINNINGS

There was no notion of where we were going, but no known cure either.

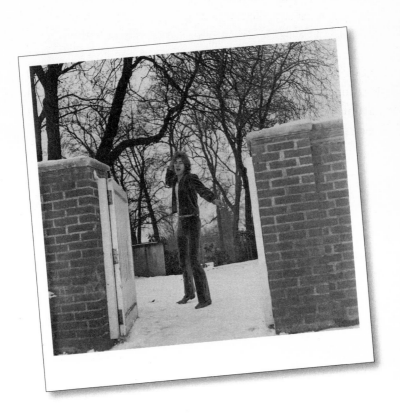

THE BLACK COUNTRY

Bloody hell, Rob did a fantastic Elvis impression.

Robert Anthony Plant was born on 20 August 1948 in West Bromwich, in the heart of England's industrial Midlands. His parents were among the first to benefit from the new National Health Service – the grand vision for a system of universal free health care set out by Clement Attlee's Labour government upon coming to power in 1945 that had been made a reality the month before their son's birth.

Plant's father was also named Robert, like his father before him. A qualified civil engineer, he had served in the Royal Air Force during the Second World War. Before the war he had been a keen violinist but the responsibilities of providing for his family took precedence over such things when he returned home. He retained, however, a love of classical music. His other great passion was cycling and he would often compete in local road races. He was by all accounts a decent, straightforward man, no more or less conservative in his outlook than other fathers of the time.

Father and son found a shared bond in football. Plant was five years old when his father first took him to see a local professional team, Wolverhampton Wanderers. Sitting on his dad's knee he watched as the players came out from the dressing rooms and onto the brilliant green pitch, those from Wolves in their gold and black strip, and felt euphoric as the noise of the thousands-strong crowd consumed him. His father told him that Billy Wright, the Wolves and England captain, had waved up to him as he emerged from the tunnel that day.

His mother was Annie, although people often called her by her middle name, Celia. Like most households then, it was she who ran the home and put food on the table. Plant would inherit his mother's laugh, a delighted chuckle. She called him 'my little scoundrel'. The Plants were Catholics and raised their son within the strictures of their religion. Later on they would have a second child – a daughter, Alison. But Robert was to be their only son, and as such it was he who was the receptacle of all their initial hopes and dreams.

From an early age, Plant can remember music being brought into the family home. His grandfather had founded a works brass band in West Bromwich and was accomplished on the trombone, fiddle and piano.

'My great-grandfather was a brass bandsman, too,' he told me. 'So everybody played. My dad could play, but never did. That whole idea of sitting around the hearth and playing together had gone by his generation. He went to war, lost his opportunities, and had to come home and dig deep to get them back, like so many men of the time.'

The town in which the young Plant spent his first years was two miles by road from the sprawling conurbation of Birmingham, England's second city. Locals called the regions to

the north and west of Birmingham the Black Country. This was on account of the choking smoke that had belched out from the thousands of factory chimneys that sprung up there during Britain's industrial revolution of the 19th century. Writing of these acrid emissions in *The Old Curiosity Shop*, Charles Dickens described how they 'poured out their plague of smoke, obscured the light and made foul the melancholy air'.

By 1830 the Black Country's 130 square miles had been transformed into an almost entirely industrial landscape of mines, foundries and factories, a consequence of sitting upon the thickest coal seam in the country. The rush to heavy industry brought not just bricks and mortar, but also the creation of new canal and rail networks, enabling the Black Country to export its mineral wealth to the far-flung corners of the British Empire.

They were still hewing coal out of the Black Country earth in the 1950s, although the glory days of the mines had passed. Iron and steel were worked intensively in local factories until the 1980s, glass to this day. The anchors and chains for the RMS *Titanic*'s first – and last – voyage of 1912 were forged in the Black Country town of Netherton, and the ship's glass and crystal stemware was fired and moulded in the glassworks of nearby Stourbridge.

In keeping with their austere beginnings the people of the Black Country pride themselves on being hard workers; tough and durable, they tend in general towards a stoical disposition and a droll sense of humour. Their particular dialect, which survives to this day, has its roots in the earliest examples of spoken English and is often impenetrable to outsiders. Habitually spoken in a singsong voice it conveys nothing so much as amusement and bemusement. There is an old saying around these parts: 'Black Country born, Black Country bred, strong in the arm

and thick in the head.' This was how they went out into the world.

Two of the most prolific gunfighters of the Wild West, Wes Hardin and 'Bad' Roy Hill, who between them killed seventy men, had their roots in the Black Country town of Lye, their families leaving from there for the promised land of America and their own subsequent infamy. The ancestors of Wyatt Earp, the Wild West's great lawman who wrote his name into history at the O.K. Corral in 1881, hailed from Walsall, less than four miles from where Plant took his first steps.

When the Second World War came the region was inextricably tied to it. Neville Chamberlain, the British prime minister at the time of its outbreak who had misguidedly attempted to appease Adolf Hitler, was born into one of Birmingham's great political dynasties. Although the war was eventually won, its after-effects lingered on into the following decade. The rationing of foodstuffs such as meat and dairy continued in Britain until 1954. At the time of Plant's childhood, West Bromwich and the Black Country, like so many of the country's towns and cities, still bore the scars from six years of conflict. As a centre for the manufacture of munitions the area had been a prime target for German bombs. Throughout Birmingham and the Black Country were the shells of buildings and houses blasted into ruin. It was an everyday occurrence to find the tail end of bombs or shards of shrapnel littering the streets.

'The whole area was still pretty much a bomb site in the early 1950s,' recalls Trevor Burton, who grew up in Aston to the north-east of Birmingham's city centre, and who would later cross paths with Plant on the local music scene of the 1960s. 'The bomb sites, these piles of rubble and blown-out houses, they were our playgrounds.'

The 1950s would bring great change to Britain. At the start of the decade few Britons owned a TV set; those who did had just one channel to watch – in black and white. The coronation of Queen Elizabeth II on 2 June 1953 led to an upsurge in TV ownership and by the end of the decade 75 per cent of British homes had a set. The '50s also witnessed the opening of Britain's first motorways – the M6 in 1958 and the M1 in 1959 – establishing faster, more direct road links between cities such as London, Birmingham, Liverpool and Manchester. Such progress brought the world closer to Britain, making it appear more accessible.

Yet at the same time Britain's role on the global stage was diminishing. The Suez Crisis of 1956, during which Britain tried and failed to seize back control of the Suez Canal from Egypt, hastened the end of Empire. The United States and the Soviet Union were the new superpowers, Britain being relegated to the role of junior partner to the Americans in the decades-long Cold War that was to unfold between those two nations.

The national mood in Britain, however, was one of relief at the end of the war in Europe and of hope for better times. This began to be realised from the middle of the decade, by which time the nation's economy was booming and wages for skilled labour were increasing. A rush by the British to be socially upwardly mobile left a void for unskilled workers that was filled by successive governments with immigrant labour from the Commonwealth. With these workers populating its steel mills and foundries – and now its car plants, too – Birmingham and the Black Country soon ranked among the country's most multi-cultural areas. To the already healthy Irish population in Birmingham there would be added vibrant communities drawn from the Caribbean, India and Pakistan.

In 1957, so pronounced was the collective sense of affluence and aspiration that Harold Macmillan, the Conservative prime minister, predicted an unprecedented age of prosperity for the country. 'Let us be frank about it,' he said, 'most of our people have never had it so good.' The British people agreed and elected Macmillan to a second term of office in October 1959.

The Plant family embodied the rise of the middle classes in Macmillan's Britain. As a skilled worker, Robert Plant Sr could soon afford to move his wife and son out from West Bromwich to the greener fringes of the Black Country. They came to leafy Hayley Green, a well-heeled suburban enclave located fifteen miles from the centre of Birmingham.

Their new home was at 64 Causey Farm Road, on a wide street of sturdy pre-war houses just off the main road between Birmingham and the satellite town of Kidderminster. It was a neighbourhood of traditional values and twitching net curtains, populated by white-collar workers. Unlike West Bromwich, it was surrounded by countryside. Farmland was abundant, the Wyre Forest close by and Hayley Green itself backed onto the Clent Hills.

Situated near the end of Causey Farm Road, number 64 was one of the more modest houses on the street. Built of red brick, it had a small drive and a garage, and from its neat back garden there was an uninterrupted view out to the rolling hills. For the young Plant there would have been many places to go off and explore: those hills, or the woods at the end of the road, or over the stiles and across the fields to the town of Stourbridge, with its bustling high street.

It was during this period that many of Plant's lifelong passions were first fired. The Clent Hills and their surrounding towns and villages were the inspiration for the landscape of J. R. R. Tolkien's

Middle Earth, the writer of *The Lord of the Rings* trilogy and *The Hobbit* having grown up in the area in the 1890s. Plant devoured Tolkien's books as a child, and time and again in later life would reference the author's fantastical world in his lyrics.

In the summer the Plants, like so many other Black Country families of the time, would drive west for their holidays, crossing the border into Wales. They would head for Snowdonia National Park, 823 square miles of rugged uplands in the far north-west of the country. It was an area rich in Celtic folklore and history, and this, together with the wildness of the terrain, captivated the young Plant.

He was entranced by such Welsh myths as those that swirled around the mountain Cadair Idris, a brooding edifice at the southern edge of Snowdonia near the small market town of Machynlleth, which the Plants would often visit. It was said that the mountain was both the seat of King Arthur's kingdom and that of the giant Idris, who used it as a place of rest from which he would sit and gaze up at the evening stars. According to legend anyone who sleeps the night on the slopes of Cadair Idris is destined to wake the next morning as either a poet or a madman.

At Machynlleth Plant learnt of the exploits of the man who would become his great folk hero, the Welsh king Owain Glyndŵr. It was in the town that Glyndŵr founded the first Welsh parliament in 1404, after leading an armed rebellion against the occupying English forces of King Henry IV. The uprising was crushed five years later, and Glyndŵr's wife and two of his daughters were sent to their deaths in the Tower of London. Glyndŵr himself escaped capture, fighting on until his death in 1416.

But for Plant there would be nothing to match the impact that rock 'n' roll was to have upon him as a child. Like every

other kid who grew up in post-war Britain he would have been aware of an almost suffocating sense of primness and propriety. Children were taught to respect their elders and betters. In both the way they dressed and were expected to behave they were moulded to be very much like smaller versions of their parents. Authority was not to be questioned and conformity was the norm.

The musical landscape of Britain in the '50s was similarly lacking in generational diversity. Variety shows, the big swing bands and communal dances were popular with old and young alike. As that decade rolled into the next, the country's clubs heaved to the sounds of trad jazz, making stars of such bandleaders as Chris Barber, Acker Bilk and Kenny Ball, who played music that was as cosy and unthreatening as the social mores of the time. In the United States, however, a cultural firestorm was brewing.

Elvis Presley, young and full of spunk, released his first recording on the Memphis label Sun Records in the summer of 1954. It was called 'That's All Right', and it gave birth to a new sound. A bastardisation of the traditional blues songs of black African-Americans and the country music of their white counterparts, rock 'n' roll was loud, brash and impossibly exciting – and it arrived like an earthquake, the tremors from which reverberated across the Atlantic. Behind Elvis came Jerry Lee Lewis, Little Richard, Eddie Cochran, Buddy Holly, Gene Vincent and others, all young men with fire in their bellies and, often as not, a mad, bad glint in their eyes.

In 1956 the mere act of Elvis swivelling his hips on TV's *Ed Sullivan Show* was enough to shock America's moral guardians. It was also instrumental in opening up the first real generational divide on either side of the Atlantic. Elvis's gyrations acted as a

rallying point for both British and American teenagers, and as an affront to their parents' sense of moral decency.

In the English Midlands rock 'n' roll first arrived in person in the form of Bill Haley. In 1954 Haley, who hailed from Michigan, released one of the first rock 'n' roll singles, 'Rock Around the Clock'. He followed it with an even bigger hit, 'Shake, Rattle and Roll'. When, on his first British tour, he arrived at Birmingham Odeon in February 1957 the city's teenagers queued all around the block for tickets. At the show itself they leapt out of their seats and danced wildly in the aisles. It mattered not one bit that, in the flesh, Haley had none of Elvis's youthful virility.

Laurie Hornsby, a music historian from Birmingham, recalls: 'The man who was responsible for going down to Southampton docks to meet Haley off the ship was Tony Hall, who was the promotions man for Decca Records in London. He told me that he stood there at the bottom of the ship's gangplank, and down came this old-age pensioner hanging onto his hair for grim death. Hall thought, "My God, I've got to sell this to the British teenager." But sell it he did.'

By the time Elvis burst onto the scene Plant was a primary-school boy. Tall for his age, he was blessed with good looks and a pile of wavy, blond hair. He might have been too young to grasp the precise nature of Elvis's raw sex appeal but he was immediately drawn in by the untamed edge to his voice and the jungle beat of his music. From the age of nine he would hide himself behind the sofa in the front room at 64 Causey Farm Road and mime to Elvis's records on the radio, a hairbrush taking the place of a microphone.

He soon progressed to the songs of Eddie Cochran and Gene Vincent. Each weekend he and his parents would gather

around the TV set to watch the variety show *Sunday Night at the London Palladium*, and it was on this, in the spring of 1958, that the ten-year-old Plant first saw Buddy Holly & the Crickets. That year Holly also came to the Midlands, playing at Wolverhampton's Gaumont Cinema on 7 March and, three days later, giving an early and later evening performance at Birmingham Town Hall.

By then Plant had begun to comb his hair into something that approximated Elvis's and Cochran's quiffs, much to the chagrin of his parents. He was also digesting the other sound then sweeping the UK, one that made the act of getting up and making music seem so much more attainable. Its roots lay in the African-American musical culture of the early 20th century – in jazz and blues. In the 1920s jug bands had sprung up in America's southern states, so called because of their use of jugs and other homemade instruments. This music was revived thirty years later in Britain and given the name 'skiffle'.

Britain's undisputed King of Skiffle was Lonnie Donegan, a Glaswegian by birth who had begun playing in trad jazz bands in the early '50s. Having taught himself to play banjo, Donegan formed a skiffle group that used cheap acoustic guitars, a washboard and a tea-chest bass. They performed American folk songs by the likes of Woody Guthrie and Leadbelly. Starting in 1955 with a speeded-up version of Leadbelly's 'Rock Island Line', Donegan would go on to have twenty-four consecutive Top 30 hits in the UK, an unbroken run that stretched into the early '60s.

Donegan's success, and the simplicity of his set-up, prompted scores of British kids to form their own skiffle groups. One of these, the Quarrymen, was brought together in Liverpool in the spring of 1957 by the sixteen-year-old John Lennon. For his

part, Plant was still too young and green to even contemplate forming a band. But in skiffle, as in rock 'n' roll, he had located a route back to black America's folk music, the blues. It was one he would soon follow with the tenacity of a pilgrim.

The thing that Plant thought about most on the morning of 10 September 1959, however, was not music but how little he liked his new school uniform. There he stood before his admiring mother dressed in short, grey trousers and long, grey socks, a white shirt, a red and green striped tie and green blazer, with a green cap flattening down his sculpted hair. At the age of eleven, and having passed his entrance exams, he was off to grammar school.

But not just to any grammar school. Plant had secured a place at King Edward VI Grammar School for Boys in Stourbridge, which had a reputation for being the best in the area. For his parents, his attending such an establishment would incur extra expense but would also impress the neighbours. The school had been founded in 1430 as the Chantry School of Holy Trinity and counted among its alumni the 18th-century writer Samuel Johnson. A boys-only school of 750 students, it was so steeped in tradition that first years were introduced in the school newspaper beneath the Latin heading *salvete*, the word used in ancient Rome to welcome a group of people.

On that first morning Plant and ninety or so other new arrivals were lined up outside the staff house in the school playground. Surrounding them were buildings of red brick, including the library with its vaulted ceilings and stained-glass windows. The masters in their black gowns and mortarboards came out and assigned each of them to one of three forms. Those boys who had excelled in their entrance exams and were considered

to be future university candidates were gathered together in 1C. Plant was placed in the middle form, 1B.

The school operated a strict disciplinary code, one that was presided over by the headmaster, Richard Chambers. A tall man who wore horn-rimmed glasses, Chambers had a hooked nose that led students to christen him 'The Beak'. Behind his back he was also mocked for a speech defect that prevented him from correctly pronouncing the letter 'r'. But Chambers mostly engendered both respect and fear.

'He was extremely strict, a sadist really,' recalls Michael Richards, a fellow student of Plant's. 'If you got into trouble, he would call your name out in assembly in front of the whole school. You would have to go and stand outside his office, and eventually would be called in. He would reprimand you for whatever you'd done and then whack you across the backside four times with a cane. Then he'd tell you to come back after school. So you'd have all day to think about it and then you'd get the same again.'

In many respects Plant was, to begin with at least, a typical grammar-school boy. He collected stamps and during the winter months played rugby. Although the school did not play his beloved football – indeed footballs were banned from the play-ground – he would join groups of other boys in kicking a tennis ball about at break times, using their blazers as makeshift goal-posts. In his second year he was nominated as 2B's form monitor by his tutor, a role that gave him the giddy responsibilities of cleaning the blackboard and trooping along to the staff room to notify the other masters if a tutor failed to arrive for a lesson.

What marked him apart was his love of music and the manner in which he carried himself. Going about the school he would typically have a set of vinyl records tucked under his arm – and

these, often as not, would be Elvis Presley records. He even took to imitating Elvis's pigeon-toed walk.

'Bloody hell, Rob did a fantastic Elvis impression,' says Gary Tolley, who sat next to Plant in their form. 'He was Elvis-crazy, but early Elvis, not the Elvis of *G.I. Blues*, when he'd started to go a bit showbiz. He was very into Eddie Cochran, too. He had the same quiff. When you see all those pictures of Cochran looking out from the side of his eyes at the camera, that was Robert.'

Plant and Tolley, who was learning to play the guitar, soon became part of a clique at school that was based around their shared interest in music. Their number included another class-mate, Paul Baggott, and John Dudley, a budding drummer. They prided themselves on being the first to know what the hot new records were and when the likes of Cochran or Gene Vincent would be coming to perform in the area.

'Not blowing our own trumpets, but we were all popular at school,' recalls Dudley. 'The other kids sort of looked up to us, because we knew a little bit that they didn't. Robert was a nice guy, but a bit full of himself. He was quite cocky. He's always been like that. The Teddy Boy era had died by then, but he made sure that he'd got the long drape coat and the lot. A lot of people thought he was arrogant because he'd got that sort of body language about him.'

'Rob was very good looking and he always seemed to be at the centre of whatever was going on,' adds Tolley. 'He had some-thing. Charisma, I suppose. In those days, the Catholics would have a separate morning service to everybody else and then come in to join us for assembly. Robert would walk into the main hall with his quiff and his collar turned up, and you could see all the masters and prefects glaring at him. He wore the

school uniform but somehow he never looked quite the same as everybody else.'

Plant and Tolley would become good friends. Outside of school they went to the local youth club to play table tennis or billiards, and Plant would bring along his Elvis and Eddie Cochran singles to put on the club's turntable. Plant had also picked up his father's love of cycling, and he and Tolley would go off riding around the Midlands on a couple of stripped-down racing bikes.

'Robert's dad knew someone at the local cycling club and I can remember going to a velodrome near Stourbridge with Rob, riding round and round it and thinking we were fantastic,' says Tolley. 'He'd come to my house a lot and always turn up at mealtimes. If we were going out cycling for the evening, he'd arrive forty-five minutes before we'd arranged. Inevitably, my mum would say, "There's a bit of tea spare, Robert. Would you like it?" "Oh, yes please, Mrs Tolley."'

'He'd be round our house for Sunday tea,' says John Dudley. 'He was always very polite. He'd ask my mum for jam sandwiches. If you're going to put people into a class, his mum and dad were a class above mine. My father worked on the railways. I believe Rob's father by then was an architect. They lived in a better house than we did. Rob was never from anywhere near an impoverished background.'

For as long as their son maintained his academic studies Plant's parents tolerated his love of rock 'n' roll, although his father, who mostly listened to Beethoven at home, professed to being mystified by it. In 1960 they bought him his first record player, a red and cream Dansette Conquest Auto. When he opened it he found on the turntable a single, 'Dreaming', by the American rockabilly singer Johnny Burnette. With his first record token he

bought the Miracles' effervescent soul standard 'Shop Around', which had given Berry Gordy's nascent Motown label their breakthrough hit in the US.

A future was beginning to open out for the eleven-year-old Plant. It was one now free from the spectre of being required to spend two years in the armed forces upon leaving school, Macmillan's government having abolished compulsory National Service that year. It did, nonetheless, still lie beyond his grasp, as was emphasised when his mother insisted he trim his quiff and he glumly complied.

2

THE DEVIL'S MUSIC

***There was us, academic whiz
kids in total freefall.***

By the time Plant entered his third year at grammar school in 1962 music had usurped his other interests. To begin with he was to be frustrated in his search to find something else that brought him the same sense of feral abandon he had felt upon first hearing Elvis. It was entirely absent from the TV light-entertainment shows of the time and his radio options were limited to one station, Radio Luxembourg. On that, at least, he came to hear Chris Kenner, a black R&B singer from New Orleans, and this nudged him further down his path.

'When I was a kid there was nothing to latch onto,' he told me. 'In the middle of everything, all these comets would occasionally come flying over the radio. But think about the difference between here and America. In America you just turned that dial five degrees on the circle and you were into black radio.

'We Brits, we're monosyllabic when it comes to music. When people say we took the blues back to America, it's such bollocks. Because John Hammond, Canned Heat, Bob Dylan, Mike

24

Bloomfield, Elvin Bishop ... all these people were already play-
ing it. Their vision and awareness of music is so much greater
than ours. All this stuff was going on, and being British I was
only exposed to tiny bits of it. There wasn't a great deal of atten-
tion being paid to the stuff that lit me up.'

Half a million black American servicemen were drafted over-
seas during the Second World War and it was they who first
brought blues records into Britain. In time these records found
their way into specialist shops and were picked up by collectors.
Old 45s and 78s, they were by men and women with such
evocative names as Muddy Waters, Howlin' Wolf, Memphis
Minnie and Blind Lemon Jefferson. Their songs documented the
entire span of the black American experience, from the chains of
slavery and grinding poverty to the pleasures of liquor and the
love of a good – or bad – woman.

This was folk music in its most raw and pure form, the ground
zero for the twelve-bar stomp of rock 'n' roll. For Plant, as for
countless other British kids at the time, it was all that he was
looking for. Ironically, it would be an Englishman who opened
up the floodgates for him. His interest sparked by rock 'n' roll
singles and odd nuggets captured from the radio, he picked up a
book titled *Blues Fell This Morning*, first published in 1960 and
written by Paul Oliver, a scholar from Nottingham. Oliver
related the history of black American blues in an entirely dry,
academic manner, but this did not deter Plant. He had an ordered
mind and began noting down each of the records Oliver refer-
enced in his book. He was to have a further Eureka moment
when he found out that a shop in Birmingham stocked these
records, and more besides.

The Diskery record shop, still going strong to this day, was
founded in 1952 by a jazz buff named Morris Hunting. By 1962

its home was on Hurst Street, a tucked-away side road a few minutes' walk from Birmingham's main railway station. Cramped and poky, the Diskery's floor-to-ceiling shelves were filled with rare and imported vinyl. It became a mecca for the area's aspirant musicians. One of the guys that worked there, a local black DJ known as Erskin T, specialised in turning these regulars on to the earliest blues, R&B and Tamla Motown sounds.

'There was a group of about twenty of us from school who were heavily into American artists, Robert no more so than the rest,' says Gary Tolley. 'But he was more interested in the original recordings. In that period before the Beatles came along there were lots of British artists doing pathetic covers of American songs. We'd all go up to Birmingham, but Rob, and also Paul Baggott, would go to great lengths to find the original versions.'

To fund these visits, Plant took on a paper round, heading out on his bike each morning before school. With the money he earned he picked up such records as John Lee Hooker's *Folk Blues* and Robert Johnson's *King of the Delta Blues Singers*. This last record had a profound effect on him.

Born in Mississippi in 1911, Robert Johnson, more than any other bluesman, is surrounded by myth and mystery. It was said that his mercurial talents as a guitarist, singer and songwriter came to him overnight. The legend grew that one night he had gone down to the crossroads on Highway 49 and 61, outside the town of Clarksdale, and there made a Faustian pact with the Devil. Johnson's early death at the age of 27 fuelled such speculation, although he was probably poisoned by the jealous husband of a woman he had been seeing.

Decades later Plant would tell the *Guardian* newspaper: 'When I first heard "Preaching Blues" and "Last Fair Deal Gone Down" by Robert Johnson, I went, "This is it!"'

He had, he would also add, never heard anything quite so seductive as Johnson's voice – a wounded howl that spoke of pain and lust all at the same time. Propelled deeper into the blues by Johnson, Plant began expanding his record collection as fast as the money he got from his paper round would allow.

Coming home from school he would go up to his room and play these records over and over again. He catalogued and carefully filed each of them, having first pored over the sleeve notes and recording credits. It had become an obsession, one that his parents found increasingly difficult to understand. Staunch Catholics, they began to refer to the songs blasting out from their son's room as 'the Devil's music'.

'My dad really didn't get much bluer than Johnny Mathis,' Plant suggested to the *Guardian*. 'I think he found Robert Johnson too dark.'

One evening, when Plant had played a Chris Kenner song, 'I Like It Like That', seventeen times in a row, his father came up to his room and cut the plug off his son's record player.

As Plant was embarking upon his journey through the blues a beat-group scene was bubbling up in and around Birmingham. By 1962 scores of suited-and-booted bands had begun playing the local pubs and clubs. Some of these had grown out of schoolboy skiffle groups but all were inspired more by the Shadows. Backing band for the British rocker Cliff Richard, a sort of virginal Eddie Cochran, the Shadows had struck out on their own in 1960 when their tremulous instrumental 'Apache' topped the British charts. Their bespectacled lead guitarist, Hank Marvin, was the Eric Clapton of his day, compelling fleets of callow boys to take up the guitar.

These were covers bands, their members scouring record shops in the city to find songs from the US they could learn to

play. Jimmy Powell was credited with the first recording to emerge from this scene, his cover of Buster Brown's R&B tune 'Sugar Babe' being released as a single on Decca that year. Later it was claimed that an eighteen-year-old named Jimmy Page had played guitar on this session, although in Birmingham it was also said by some that if bullshit were an Olympic sport Powell would have a home filled with gold medals.

As 1962 turned to 1963 Britain was in the grip of its coldest winter on record, snow blizzards and freezing temperatures bringing the country to a virtual standstill for two months. 1963 would be the year in which President Kennedy was gunned down in Dallas and a war in Vietnam began to escalate – it was also the year when the Beatles came to Birmingham in the middle of the big freeze. Like so many of the local bands, the Beatles had been born out of a skiffle group that had first been gripped by Elvis and Buddy Holly; they, too, cut their chops re-interpreting songs that had been flown across the Atlantic. The Beatles, however, had their own songs as well. Their second single, 'Please Please Me', was one of these and it was released in the UK on 11 January 1963, beginning a month-long run to the top of the British charts.

On 13 January the Beatles arrived at the ATV studios in Birmingham to perform 'Please Please Me' for that night's *Thank Your Lucky Stars* variety show. Police were forced to seal off the streets around the studios as thousands of kids turned out to catch a glimpse of them. Six days later the Beatles returned to play a gig at the Plaza in Old Hill, two miles from Plant's family home.

Promoting this show was Mary Reagan, who would come to play a significant role in Plant's early musical career. A formidable Irishwoman known to one and all as Ma Reagan, she and her

husband Joe, who stood less than five foot tall, had established a dancehall business in the Midlands in 1947. By 1963 the Reagans were running four ballroom-sized venues in the area, the Plaza at Old Hill being seen as the most prestigious on account of its revolving stage.

In the wake of the Beatles' visit the Midlands music scene took off. By the end of that year there would be an estimated 250 groups operating around the city. It was said that half of these still wanted to be the Shadows, the other half the Beatles. These bands were made up of kids in – or just out of – school. They were playing up to twenty shows a week in the hundreds of city pubs and clubs that nightly put on live music, earning more than their fathers did for going to work in the factories. Each of these bands aspired to get on the Reagan circuit, as it came to be known. The local acts that passed an audition for Ma Reagan could expect to perform regularly at all of her venues, often in a single night and for good money.

In July 1963 the Shadows' producer Norrie Paramor pitched up at Birmingham's Old Moat House Club to audition local bands for EMI, which was by then desperate to unearth another Fab Four, and he subsequently signed six Birmingham acts to the label. Although none came close to being the next Beatles, he did at least give the Midlands scene a name, christening it 'Brumbeat', a knowing adaptation of Liverpool's then reigning Merseybeat sound.

One band just then starting out on the Brumbeat scene was to have a direct influence on Plant. The Spencer Davis Group had debuted at a Birmingham University student dance in April 1963, performing a set of blues and R&B covers. The band was a tight one and the undisputed star was their singer, Stevie Winwood, a white schoolboy with the voice of a black soul man.

Like Plant, Winwood was then fourteen years old but he was moving faster.

In September 1963, at the start of the academic year, King Edward VI's students were gathered together for a school photograph. In this picture Plant can be seen standing towards the centre of the group, six rows back. He alone among the many hundred students looks as if he is posing for the camera – his curly hair is rustled up into its habitual quiff, a look of practised insouciance on his face. To his right stands Gary Tolley, appearing to be somehow much younger and less worldly-wise.

Yet it was Tolley, not Plant, who by then had formed a first band with two more of their friends, Paul Baggott and John Dudley. Tolley played lead guitar, Baggott was on bass and Dudley on drums. A further pair of boys from their school year completed the line-up: Derek Price on guitar and the singer Andy Long. This school group had begun playing in pubs and youth clubs, calling themselves Andy Long and the Jurymen. They performed contemporary pop and rock 'n' roll covers and dressed up in maroon suits with black velvet collars. Plant would often accompany them to these gigs.

'He sort of followed us around for a long time,' says Tolley. 'He'd come to see us play but he'd carry our gear as well. Derek Price's dad would drive our van and he lived just up the road from Robert. He'd pick Rob up first and then the rest of us.'

'It sounds daft but he was more of a hanger-on than anything at that stage,' adds Dudley. 'It only slowly dawned on us that what he wanted to do was sing.'

The Jurymen's nightly engagements soon brought them to the attention of Headmaster Chambers. He saw a piece on the fledgling band that ran in the local newspaper, the *Express & Star*,

one that made much of the fact that they were playing in places in which they were too young to drink.

'Because of the way things were for kids then, if you had hair an inch too long and were playing in a band, the figures in authority did look down on you,' says Dudley. 'Chambers had us all up before him. He pulled Robert in for that, too, because he knew that he would have been with us. He told us we were nothing more than a rabble – but because he couldn't pronounce his "r"s, it came out as a "wabble". That may have been the start of the masters disapproving of Robert.'

For Plant, however, the world was now expanding beyond the gates of his grammar school and 64 Causey Farm Road. Down the road in Stourbridge something was stirring. Blues, jazz and folk clubs had started to spring up around the town; so too coffee bars. The Swiss Café became the main meeting place for local teenagers. Later, a local singer named David Yeats opened the Groove record shop, catering for R&B enthusiasts like Plant.

In the pubs and clubs one could hear everything from Woody Guthrie songs to Dixieland jazz being performed. It was a movement largely driven by Stourbridge College, a technical and art institution that in the '60s had begun attracting students from all over the country and across Europe, and it was one into which Plant threw himself.

'It was a huge, amazing, subterranean moment,' he told me. 'There was poetry and jazz, there was unaccompanied Gallic singing. There were off-duty policemen standing up in folk clubs, holding their pints and singing "Santy Anna".

'There were hard drugs. There were registered junkies mixing with beautiful art students. And there was us lot at the grammar school down the road, academic whiz kids in total

freefall. I was just mincing about with my Dawes Double Blue bike, with my winklepicker shoes in the saddlebag, listening to all this stuff.'

Plant had by now also bought a cheap harmonica that he taught himself to play by blowing along to records on his repaired Dansette turntable. He began to take this harmonica with him wherever he went, delighting in pulling it out from his back pocket and blowing away, to entertain himself more than anyone else. On one occasion at school, Headmaster Chambers, fast becoming Plant's nemesis, spied him doing as much in the playground. Chambers loudly informed him that he would get nowhere in life messing around with such nonsense.

'Rob was so much into the kind of music that we weren't,' says Dudley. 'I mean, where on earth he got the knowledge that he had of the blues from I don't know. He was forever going on about people like Sonny Boy Williamson, and from that age. For God's sake, in those days you wouldn't hear anything like that on the radio.'

Plant got to see a physical manifestation of the blues for the first time on 10 October 1963 when his aunt and uncle took him along to the Gaumont cinema in Wolverhampton to see one of the new package tours that had begun travelling around the UK. This one featured the young Rolling Stones, the Everly Brothers, Little Richard, and a Mississippi bluesman, Bo Diddley. It was Diddley who transfixed him.

'I was sweating with excitement,' he told Q magazine in 1990, reflecting back on that night. 'Though the Stones were great, they were really crap in comparison with Diddley. All his rhythms were so sexual – just oozing, even in a twenty-minute slot. Now that's an evening.'

Before the year was out Plant had also stepped onto the stage himself. His opportunity came when Andy Long was struck down with appendicitis, which at the time required a six-week period of convalescence. Long's Jurymen were by now playing several nights a week and did not want to turn down the work, so who better to fill in for their singer than their friend Robert Plant, given that he already knew their set inside out?

Plant's début live performance came at the Bull's Head pub in Lye, a regular haunt of the Jurymen since it was run by John Dudley's grandfather. On this night one might imagine that he would have been stricken with nerves as he looked out from the small, low stage and into the eyes of an audience for the first time. That here, in this smoky bar, he would wilt before such judging looks and when standing next to his then more experienced schoolmates.

'When he first got up there, he was full of it – absolutely full of confidence,' says Dudley, laughing at the memory. 'He played more than half-decent harmonica even then and so he transformed our set into something a lot more bluesy. We had to busk it but we went down okay. I can't remember how many gigs we eventually did with Rob but people always reacted favourably. Even then he sang in this blues wail. He used to like to take it down to a low rumble and then build back up to a crescendo.'

His stint as the Jurymen's singer took Plant as far away as the East Midlands city of Leicester, a two-hour drive from home in the band's old van. It also brought what he wanted to do with his life into clear perspective. Before Andy Long returned Plant began to go to work on his fellow Jurymen, attempting to persuade them that he should now become their permanent singer. He was to be frustrated in his efforts, just as he would be many times during the next few years.

'We told him Andy was our singer and thanks very much,' says Tolley. 'We were all a bit mercenary. To be honest, we all had our stage uniforms and there wasn't anything that would fit Robert.'

3

KING MOD

He was a cocky little bleeder,
I'll tell you that much.

Plant entered his sixteenth year able both to follow the pull of music and all that it offered, and keep up his school work. In November 1963 he won a school prize for finishing top of his form in the end-of-year exams. Yet it was a precarious balance he had struck and one he was not destined to maintain.

The scales started to tip from academic achievement almost as soon as 1964 began. At 6.36 pm on New Year's Day the BBC launched *Top of the Pops*, a new weekly music TV show. Beaming the pop hits of the day into British households, it brought to the nation's teenagers the promise of something out there other than the drab and everyday. For his part Plant felt ambivalent about the British beat groups, but even he must have stirred at the sight of the fledgling Rolling Stones opening that first show – the young Mick Jagger pouting and preening through Lennon and McCartney's 'I Wanna Be Your Man' as if in celebration of his own beautiful youth.

On 28 February Plant hopped onto a bus to Birmingham, his parents allowing him to go off into the city on his own for the first time to see a gig. It was at the Town Hall, with Sonny Boy Williamson topping the bill. Plant snuck backstage afterwards and attempted to introduce himself to the venerable black American bluesman, happening across him in the urinal. Williamson, a bear of a man who stood six foot two, his head crowned by a bowler hat, turned and fixed the young interloper with a cold stare. 'Fuck off,' he snarled.

Beating a retreat, Plant stopped by Williamson's dressing room and pilfered a harmonica. This might have been a chastening experience but Plant had also fixated upon three younger acts that played that night. Each was part of the erupting British blues boom, and each sent out a message that all this could be his, too.

There were the Yardbirds, powered by the fresh-faced Eric Clapton's guitar; Long John Baldry and his Hoochie Coochie Men, featuring a cocksure twenty-year-old singer by the name of Rod Stewart (although he was advertised as being 'Rod Stuart'); and the Spencer Davis Group, with little Stevie Winwood on lead vocals and organ from a couple of miles up the road in Handsworth and in the same school year as Plant, a challenge to him to get a move on if ever there was one.

He was back at the Town Hall again the following month, taking his friend John Dudley along with him to see 'The Killer', Jerry Lee Lewis. As was the practice then, the show had finished by 9.30 pm, leaving an unsated Plant looking for further adventure. He dragged Dudley along to a city-centre pub, the Golden Eagle, telling him he knew of a crack new blues band playing there.

'We wangled our way in and went up the stairs to the second floor,' recalls Dudley. 'It was a typical dive, full of smoke, a low

ceiling. There were four young guys on stage. It was the Spencer Davis Group. The impression they made on us! I can still remember what they were playing: Ampeg amps, Hofner guitars, Premier drums. The whole band was superb but Stevie Winwood was something else. He was a real influence on Rob in those early days.'

Back home in Hayley Green, Plant had acquired a washboard and begun making his own kazoos, empowered by the inspiration of both skiffle and all he was now seeing. He took a keen interest in clothes and fashion, and had started to grow his hair out, having noted how mop-tops and Mick Jagger's modish mane made the girls scream. He had also found a venue of his own. A blues and folk club had opened at the Seven Stars pub in Stourbridge and Plant became a regular, taking along his washboard and Sonny Boy Williamson's harmonica.

The Seven Stars modelled itself on the great Chicago blues dens and a crowd of aficionados began gathering there to drink, smoke and play. Chief among them was Perry Foster, a local character who had hung out with the Yardbirds in London and chauffeured Sonny Boy Williamson around Birmingham. Foster, who always dressed in a blue suit with a porkpie hat perched on his head, played mean slide on a customised nine-string Hofner guitar. He had also recently put together a half-decent blues combo, the Delta Blues Band.

To Plant and his wide-eyed school friends Foster was a man to know, since to them he was a real musician. One night Plant approached him and asked if he could get up and sing with his band.

'He told me his name was Bob Plant and whipped out a washboard,' says Foster, remembering that first encounter. 'I'm nine years older than him but he was a cocky little bleeder, I'll

tell you that much. He had to be educated. Being older, I knew a lot more about the blues. I told him who was who and what was what, showed him how to do the twelve-bar. But then, when you'd told him once, you didn't need to again.'

With the Delta Blues Band, Plant began performing at the Seven Stars and other local venues. He, Foster and their rhythm guitarist, Peter Groom – soon christened 'Gobsy' on account of his unfeasibly large mouth – would also get up as a trio at folk nights such as the weekly one at Stourbridge Conservative Club. Their staple set featured such blues standards as Lightnin' Hopkins's 'Ain't Nothing Like Whiskey' and assorted Robert Johnson songs.

The band were earning £16 a night, split five ways between them and with a pound spare for petrol. Often as not, beery audiences greeted the fifteen-year-old grammar-school boy with shouts of 'Get your hair cut!' and worse, but these seemed not to ruffle him.

'Not everyone wanted the blues but he'd got what it took all right,' says Foster. 'I was always saying to people, "If that kid ain't a millionaire by the time he's twenty-five, my name's not Perry." I'd growl at the band if they weren't doing things right, and I was a bit of a tough nut at times, so as Robert would say I was a terrible man but I got on with him smashing.

'He was a great big, gawky teenager, all knees and elbows. We used to drive around in a little MG sports car and make him sit in the back. He said to us his father wanted him to be an accountant. Coming to the Seven Stars was seen as taboo – he always used to tell his parents he was going off somewhere else.'

For Plant this was another new world opened up to him. He was playing with older guys but treated as an equal, begging

cigarettes off them and drinking beer before he was legally allowed to do so. It did not sit well with his parents or his school-masters when he rolled in each morning, often late and usually bleary-eyed. But he could not – and would not – turn back. His path was set.

He began to hang out and jam with some of the other ambitious young musicians who had started turning up at the Seven Stars. There was twenty-year-old Chris Wood, quiet, withdrawn and greatly accomplished on multiple instruments, and a bassist named Andy Silvester. Both were in a band called Sounds of Blue, which was led by singer David Yeats and also featured a hotshot guitarist, Stan Webb, and pianist Christine Perfect. Sounds of Blue eventually mutated into blues rockers Chicken Shack, by which time Wood had hooked up with Stevie Winwood in Traffic. Later still, Christine Perfect married Fleetwood Mac's bassist John McVie and joined that band.

'It was at the Seven Stars that I met Robert for the first time,' says Stan Webb. 'He was with Perry Foster. He didn't say much but I remember he had a very mod haircut and was wearing a fur coat. From the word go he had that thing about him. I guess you'd call it arrogance or an ego.'

Yet the Delta Blues Band was not to last. With little money being made and no sign of progress beyond a handful of staple gigs their singer upped and left.

Says Foster: 'Robert just suddenly disappeared. Though he did leave me with his washboard.'

As 1964 progressed, so the music coming out of, and passing through, the Midlands began to evolve. A strong R&B movement had taken root in Birmingham, one fired by the release of the Rolling Stones' cover of Buddy Holly's 'Not

Fade Away' that February and with the Spencer Davis Group at its apex. It was this scene that gave rise to the Moody Blues in April 1964.

Mod truly arrived in the city at the end of the year. Taking their inspiration from the black American sounds of Stax and Tamla Motown, a glut of bands sprung up on the pub circuit, each as sharp-dressed as the next, practically every one of them having Martha and the Vandellas' 'Dancing in the Street' in their repertoire. Earlier in 1964 a compilation album titled *Brum Beat* had been released ('Birmingham's 14 greatest groups', it erroneously trumpeted), featuring a band called the Senators performing 'She's a Mod'. The sixteen-year-old drummer on that track was named John Bonham.

Plant was not impervious to such things. He had resolved to get himself onto the local ballroom circuit, albeit still playing his beloved blues. The names of the bands he would flit through during the next year or so spoke for themselves: New Memphis Bluesbreakers, Black Snake Moan, so called after a Blind Lemon Jefferson song, and after a John Lee Hooker track, the Crawling King Snakes. All but the latter were to be short-lived and soon forgotten.

'I went to see Black Snake Moan play in a pub near Stourbridge,' says school friend Gary Tolley. 'We all just thought the stuff he was doing would never catch on. We were very much still in the pop idiom while Robert was off doing something on his own.'

One song Plant had begun performing by now was Robert Johnson's 'Travelling Riverside Blues', more commonly referred to as 'The Lemon Song' on account of its suggestive lyrics – Johnson lasciviously leering, 'You can squeeze my lemon 'til the juice run down my leg.' Before the decade was out it would

become a calling card of Plant's, although there was no suggestion of that then.

'That was probably his favourite one to do,' says Tolley. 'I'm sure he used to sing it sometimes just to watch the reaction on people's faces when he got to the bit about squeezing his lemon. The rest of us hadn't got the nerve to do it, but he had. Because he was different, people in authority reacted quite strongly against him. One or two of the nastier pieces of work at school didn't like him either, because he never seemed to have any problem picking up girls.'

He was having other troubles at King Edward VI. His studies were coming a distant second in his priorities to rehearsals and gigs. He had often struggled to get to school on time in the morning, but now his late arrival, and a subsequent dressing-down from the prefects who manned the gates, were a daily occurrence.

'The prefects had their own little room,' says Tolley. 'If they didn't particularly like you, you'd have to go there and be made to stand on a table while they all sat around looking up at you. I suppose it was designed to humiliate and embarrass, but Robert just thought it was stupid. But for all of us who were playing in a band, our academic work suffered. We were rehearsing one night a week, and playing most Wednesdays and Thursdays, and certainly every Friday. You'd get home from school, have your tea and rush through your homework, then the van would pick you up.'

At the end of each term, students filed into the school library to be confronted by Headmaster Chambers, who would summon them up one at a time and pass comment on their grades. Chambers would have told the errant Plant to pull his socks up in no uncertain terms.

With external exams looming and the pressures of his father's expectations upon him Plant suffered a period of anxiety about his falling grades. But this passed and with it any chance he might catch up. Instead he spent the remainder of that school year skipping off the school premises and into Stourbridge town centre with his clique of budding musicians.

'We would bunk off school and go and sit in the railway station café,' remembers Tolley. 'Or there was a place called the Chicken Run, which was down a side street next to the town hall. We used to go in there for the bacon rolls, which you could eat down in the cellar and feel more grown up. Robert never seemed to have any money in those days. He was always cadging cigarettes. Four of us would take our school lunch money down to the station café and each get a cup of coffee and beans on toast, and we'd all have to share with Rob.'

That summer Plant and his friends sat their O-level exams. Of the Jurymen, Tolley, Dudley and Baggott scraped a handful of passes between them and left school, off to find jobs. Plant managed but a single pass, in history. His parents intended for him to remain at King Edward VI for another year and to re-sit his exams.

At least things had taken a turn for the better outside of the school. Plant was singing and blowing harmonica in the Crawling King Snakes, a band that had grown up in Kidderminster, the nearest town immediately south-west of Stourbridge. From messy beginnings at such places as the local YWCA they had gradually improved enough to get themselves on the Ma Reagan circuit, and were playing twenty-minute slots at her venues as a warm-up act.

'By the time I was capable of stepping in front of a micro-phone the Midlands scene was full of beat groups and I was a bit

late getting on the bandwagon,' Plant told me. 'But I'd gotten a really good schooling playing with people quite a bit older than me. I'd already been getting up in the blues clubs for more than a year before I even thought about going to places where women danced.'

In many respects 1965 was to be a pivotal year. The first rumblings of dark and crazy days ahead were felt in the US that summer as Los Angeles burnt during the Watts Riots. In October, with the number of troops being drafted to Vietnam doubling, anti-war protests swept through American cities. That same month in Britain, police in Manchester arrested Ian Brady and his girl-friend Myra Hindley, charging them with the murder of five children, three of whose bodies had been discovered on nearby Saddleworth Moor.

This was also to be the year that pop music came of age. The Beatles made *Rubber Soul*; Bob Dylan went electric and released his first masterpiece, 'Highway 61 Revisited'; the Byrds emerged on America's West Coast; and the Who crashed out of London shouting 'My Generation'. And as rock grew up out of pop, the notion that this was all to be a flash in the pan receded into the distance.

In Stourbridge, the town hall became a hub of activity, hosting weekly 'Big Beat Sessions' that brought both the Who and the Small Faces to town. Each found an especially enthusiastic supporter in sixteen-year-old Plant, by now a fully fledged mod. He got a taste of this action closer to home, too. Out of Wolverhampton came the N'Betweens, later to change their name to Slade and then cranking out fuzzbox-heavy Tamla Motown covers. There were also the Shakedown Sound, formed – like Crawling King Snakes – in Kidderminster, but steps ahead

of Plant's band, bagging opening spots with the likes of the Who and local heroes the Spencer Davis Group.

Plant was especially taken with the Shakedown Sound's singer, Jess Roden. A year older than him, Roden had, like Stevie Winwood, a freakishly soulful voice. His band were gigging most nights of the week on the Reagan circuit and beyond, performing powerful versions of blues staples such as 'Smokestack Lightning' and 'Hoochie Coochie Man'. The Crawling King Snakes and the Shakedown Sound became close, hanging out and copping songs off each other.

'I suppose Robert was King Mod,' says Kevyn Gammond, then guitarist in the Shakedown Sound. 'He had a good eye for fashion, so he'd always have the latest Ben Sherman shirt on and the right hairstyle. I think the N'Betweens and the Shakedowns had a big influence on him, because we were all little mods, and our band had played with the Who.

'Rob was really impressed by Jess. They'd both come round to my parents' house and ask me to work out all the chords to songs like "I Go Crazy" by James Brown. That's the way you learnt then, by putting the records on. I'd be left to sit there and get on with it while they went off to play pinball at the Flamingo Café down the road.'

It was in Kidderminster at this time that Plant first came across a gifted young guitarist named Robbie Blunt. The two would hook up after school, going round to each other's houses to listen to records and work out songs together.

None of this allowed for any appreciable improvement in Plant's relations with his parents, or with regard to his studies during what would be his final year at King Edward VI. He had grown to like his maths teacher, Mr Colton, but otherwise the state of things between him and the masters had, if anything, deteriorated.

Michael Richards, a contemporary of Plant's at the school, recalls him by then having a reputation as 'a bit of a hooligan', although he qualifies this by saying that 'he was mischievous more than anything'. He continues: 'The chemistry master was a guy named Featherstone, a nice old bloke who should have retired years ago. I remember that Robert played him up no end. But Robert was very popular, too. He hung around with a lot of people. Everybody wanted to be his friend.

'You'd hear lots of things about him, and I'm not sure a lot of them were true. There was one story that Robert's parents had gone off on holiday and left him to stay with someone else, and he'd broken back into his own house and thrown a party.'

In that last year Plant did join the school's jazz society and ended up sitting on its social committee. In this role he helped oversee three concerts in the school hall by King Edward VI's resident jazz band, the Cushion Foot Stompers. For a time he also joined a jazz-influenced group called the Banned with another schoolmate, Martin Lickert, who played bass. Lickert would go on to become Ringo Starr's chauffeur, appearing alongside his employer in Frank Zappa's surreal 1971 movie *200 Motels*.

The Banned got as far as opening the bill at the town halls in both Stourbridge and neighbouring Dudley in the spring of 1965, although Plant was forced to miss the latter engagement after having contracted glandular fever. The proprietor of the town's Groove record shop, David Yeats, who had sung in Sounds of Blue and seen Plant at the Seven Stars, replaced him for that one show. He went round to Plant's family home the night before the gig for a hastily convened rehearsal. Shown up to his small bedroom, he found Plant lying stricken in bed.

'He took me through this book of song lyrics he had got together,' says Yeats. 'I did the show, and I'd never heard anything

before that was that loud. I remember standing in the middle of this fantastic noise. The audience seemed happy enough, but what they must have thought I don't know, seeing this teenage sex god being replaced by a little bloke like me.'

Whenever things got especially strained at home, as was increasingly the case, Plant would sleep the night in the Banned's van. The vehicle made quite an impression, since they had used lipstick and nail varnish to graffiti it.

That summer, he re-sat his O-levels with a little more success. He gained passes in English, English literature, geography and maths. This was reported in the school's newspaper, the *Stourbridge Edwardian*, as was the fact that he would be leaving King Edward VI on 22 July to train in accountancy. Yet his departure appears to have taken place rather earlier than this, and was enforced.

'I heard that one day he was off playing truant in Birmingham, walking around with a mate of his and smoking, when he bumped into one of the masters who happened to be in town on his day off,' says Michael Richards. 'He was still wearing his school uniform so it was seen as a bit of a disgrace. I believe that was the culmination of a long series of problems and Robert was expelled. It did create a bit of a stir around the school. Most people thought he'd had it coming but there was also the sense that he'd had a bit of bad luck.'

There is some doubt about the veracity of this story. Gary Tolley dismisses it, although he had left King Edward VI the previous year, and no record of it happening is kept at the current school. But another of Plant's fellow pupils during his final year, Colin Roberts, who would later return to the school to teach, supports Richards's account.

'I don't know the circumstances of his being expelled,' Roberts tells me, 'but he must have done something bad because very few

people got thrown out. The story goes that Headmaster Chambers told him that he'd never make anything of himself. When I came back to the school in the early '70s, Chambers himself told me that Robert had later turned up at his house in a Rolls-Royce and asked the Headmaster if he remembered him.'

THE RUBBER MAN

*He would dance across the stage,
like he was floating.*

The summer of 1965 would be the last time Plant's parents were able to assert themselves when it came to his future prospects. At their behest he enrolled on a business studies course at Kidderminster College of Further Education, one supposed to equip him for a career in accountancy.

Before term started he took a temporary job as a stock boy at Stringers department store on Stourbridge High Street. He made the most of his time there, cracking jokes with the women on the shop floor. And with money in his pocket, the young mod could be seen zipping around town on a scooter, sporting a parka jacket with a Union Jack emblazoned on its back.

His second brush with academia, however, was no more diverting for him than the first. He wasn't at college long, but long enough for his fellow students to remember him. Recording her memories of the era on a local website, one of them later wrote: 'I was at Kidderminster College at the same time as Robert Plant. He used to strum a guitar in the common room,

but unfortunately he didn't impress most people and was often told to shut up.'

As had become the norm, it was in his other life that Plant was animated. Continuing to sing with the Crawling King Snakes, he had also ingratiated himself with local promoter Ma Reagan. She had him spinning records in between acts at her Old Hill Plaza. He would play Stax and Motown tunes, but also the Small Faces, the Rolling Stones and the Beatles. On occasion Ma Reagan would also ask him to take on the MC's duties at the ballroom.

'I became the apple of her eye,' Plant told me. 'When she made me Master of Ceremonies, I'd arrive at the Plaza on my Lambretta, go into the dressing room and put my suit on, and then go out and introduce people like Little Stevie Wonder. I remember he came out with his hand on his bandleader's shoulder, and he put him on the microphone. Then he started playing "Fingertips Part 2". This was in Old Hill in the Black Country!

'It was unreal to be able to hear such quality – to see that shit and still being at college. Being close to that kind of energy … Man, you can't ask for a better ticket than that. If that isn't going to turn your head and make you say, "Is there anything else I can do?"'

There were more mundane matters to attend to first. His father had packed him off to a job interview with a firm of accountants and they took him on. He went to work as a trainee chartered accountant in Stourport, a picturesque town on the banks of the River Severn, sixteen miles from Stourbridge. His wages were £2 a week, less than he could earn for one gig.

This didn't stop him going out most nights – to perform, to watch other bands or to dance in clubs. He dragged himself into the office for just two weeks before he was politely asked to clear

his desk. It was then he decided to turn pro with the Crawling King Snakes, although he had to take on additional work at a local carpet factory to supplement his income. In any event, this latest act of rebellion left his father despairing that his son was throwing his life away.

It was at this moment that Plant met John Bonham for the first time. Bonham, known to one and all as 'Bonzo', approached him after Crawling King Snakes had completed one of their twenty-minute slots at Old Hill Plaza. He told Plant his band was good but that the drummer was hopeless and he was better. Bonzo joined Crawling King Snakes soon after.

Born in the Midlands town of Redditch in the spring of 1948, Bonham was ten when his mother bought him his first set of drums. Her son had been gripped from the moment he saw the great jazz drummer Gene Krupa pummelling out the tribal rhythm of 'Sing Sing Sing' in the 1956 film *The Benny Goodman Story*. Bonham was drumming in bands from the age of fifteen, passing through the likes of the Blue Star Trio, the Senators, and Terry Webb and the Spiders.

Bonham was just three months older than Plant but was already married. He and his wife Pat were living in a caravan parked behind his family home. Not only worldlier than his new friend, in terms of ability Bonham was also ahead of anyone Plant had played with to that point. In the Black Country's pubs and clubs, he was already spoken of as a drummer of prodigious ability, a powerhouse.

'Bonzo had at one time been in a dance band,' Plant said to me. 'So he got all of his chops from being able to play those big band arrangements. I'd never seen anything like it.'

'John was a bit odd even in those days,' adds Tolley, Plant's school friend. 'Every time he walked into a room there was a

strange aroma – he was definitely smoking a lot of wacky baccy. But he was a great drummer and he had a better kit than anyone else.'

For a short spell the possibilities seemed boundless. With Bonham propelling them, the Crawling King Snakes opened up for the Spencer Davies Group, Gene Vincent, the Walker Brothers and others. Plant was brought closer than he had ever been to the magical centre of things, so close he could taste the glories that were being offered up.

He and Bonham stood at the side of the stage at Stourbridge Town Hall and watched the Walker Brothers, listening to teen-age girls scream at their singer Scott Walker as if he were a god. Even a band such as Liverpool's the Merseybeats, for whom fame was fleeting, could pull into town in their blue and white station wagon and appear to Plant as 'renegade guys who ran off with all our teen queens'.

'There was no notion of where we were going but no known cure either,' he told me. 'I mean to say, I didn't have any concept of fame as a seventeen-year-old kid. It was just the fact of being able to get away from the clerks desk as a chartered accountant. And then to go back to my parents, who only ever wanted the best for me, and proclaim that I had to go … and forever.'

Plant felt more now than just the pull of singing the blues. He had heard the screams, smelt the sex and sensed the power that could be bestowed upon the man with the microphone. And then, as was his custom in those days, Bonham walked out on the Crawling King Snakes. He had been lured back to his previous band, the Way of Life, by the promise of more money, and this he needed since his wife Pat was now pregnant.

With Bonham's departure the Crawling King Snakes dissolved. Yet Plant would not have to wait long for his next gig. While

DJ-ing at the Old Hill Plaza, he spotted a band called the Tennessee Teens. A three-piece, they played blues and Tamla Motown covers, and had recently returned from a resident club gig in the German city of Frankfurt. Plant introduced himself to their guitarist, John Crutchley.

'He asked me if he could sing with us,' Crutchley recalls. 'That's how it started. We were doing the Plaza three or four times a week; it would always be the last venue of two or three we'd do each night. When we got there, Robert began to get up and do a song with us; some blues stuff, some Chuck Berry, Solomon Burke's "Everybody Needs Somebody to Love". I can't remember who asked whom but we agreed to make it into a band.

'He stuck out, even then. He liked to wear bomber jackets and he'd got this big, blond, curly hair. We were working-class lads and he came from a completely different background to us. We used to have to go and pick him up on a Saturday night. I remember his mum was quite prim and his dad being an ex-sergeant major type. His dad seemed a nice chap but neither of them was at all supportive of what he was doing. They never came to see him play.'

Watching their son go off with yet another band, Plant's parents tried one last time to reason with him. The fall-out resulting from this encounter led to him leaving home at seventeen. He went off to live with his new bassist Roger Beamer, whose parents ran a bed and breakfast down the road in Walsall.

At the beginning of 1966 the Tennessee Teens changed their name to Listen. The band members had also thought up nicknames for each other, although it seems unlikely this overextended their imaginations. John Crutchley became 'Crutch', drummer Geoff Thompson's bulk led to him being christened

'Jumbo', while the rationale behind making Roger Beamer 'Chalky' and Plant becoming 'Plonky' is lost to time.

In a short press biography they put together at the same time Plant listed his hobbies as motoring and listening to soul records. 'Mod girls' and clothes were foremost among his likes, 'phonies' his biggest dislike. He soon revealed a flair for publicity, too.

Plant fed a story to John Ogden, the pop columnist at local newspaper the *Express & Star*. He told Ogden he had won a dance competition judged by Cathy McGowan, the alluring host of TV pop show *Ready Steady Go!* Plant claimed McGowan had accepted an invitation to come and see his new band, and had then asked them to perform on her show. Listen, said Plant, had declined as the proposed date clashed with a gig – 'And we don't break bookings like that,' he nobly added. It was enough to get them into the paper, Ogden's piece running on 3 March 1966, in the week the Rolling Stones topped the UK charts with '19th Nervous Breakdown'.

'They came into the office and we had a chat in the works canteen,' Ogden says. 'It wasn't at all surprising to me that Cathy McGowan would go for him – she wasn't alone. He looked great. There was something special about Robert, although not everyone saw it at the time.'

Listen's beginnings were otherwise decidedly small-scale. Fashioning themselves as a mod group, their first gigs were mostly in pubs such as the Ship and Rainbow and the Woolpack in Wolverhampton, alongside the now-traditional warm-up engagements on the Reagan circuit. Yet Plant had by this stage developed into an impressive performer. He had learnt to better control his voice, although it remained very much a strident blues roar. And he had gained enough confidence to unveil the dance moves he had honed strutting his stuff at mod clubs.

'Oh, he was great,' says Crutchley. 'We'd start off our set with "Hold On I'm Comin'" by Sam & Dave, and Robert would dance across the stage like he was floating. We rehearsed at my parents' house, which was an old corner shop. My dad would ask me, "Is the Rubber Man coming tonight?"

'Rob gave us all an extra confidence. He was ambitious, but not so as it was in your face. He was a bit more relaxed off the stage. But once he got on it he would go into a different mode. He had a great stage presence and the voice was very much there from the start. For sure, he was very popular with the ladies, too.'

Bill Bonham, no relation of John's, was then a fourteen-year-old schoolboy playing keyboards in a covers group called Prim and Proper. They shared a bill with Listen at one of these early shows. 'I remember going "Whoa" when they started the first song, and the next thing they'd finished and I breathed out again,' he says. 'To me, Robert was a star and I was mesmerised by him. He'd already got a big female following. We became friends but you couldn't trust him with your girlfriend for two seconds, that's for sure.'

That May, Bob Dylan and his new backing band, the Hawks, played the Birmingham Odeon. On this same tour a member of the audience at Manchester's Free Trade Hall shouted 'Judas!' at Dylan for the perceived crime of plugging in his guitar. Yet Dylan was instrumental in whipping up the storm clouds of cultural change that were billowing across the Atlantic. In all its speed-fuelled wonder, that year's *Blonde on Blonde*, a double album no less, cemented the idea of the rock album as an art form.

By the summer Dylan had crashed his motorbike in Woodstock and retired from view, but all that he had set in motion had begun to fly. The Beatles made *Revolver*; Brian Wilson went to

the edge and brought back *Pet Sounds* for the Beach Boys; and the Byrds soared through 'Eight Miles High'. It was this latter track, and the album upon which it featured, *Fifth Dimension*, that announced the arrival of the psychedelic movement. It was to be a fitting soundtrack to a decade of social and civil upheaval in the US, one filtered through the new perspective of the hallucinogenic drug LSD.

These sounds coming out of America would soon enough have a profound effect on Plant. It would be another year, however, before Britain basked in the Summer of Love. Yet the sands were shifting even in the Midlands, where people are traditionally cautious of such radicalism, as if wanting first to weigh up its substance. The boom in venues opening up to music continued unabated, the classifieds pages of the local newspapers filled each night with adverts for gigs in pubs, clubs and dancehalls.

In Birmingham, the Elbow Room and the Cedar Club were the places to be and to be seen. The latter club, it was said, attracted the drinkers, while the clientele at the former preferred to smoke dope and intellectualise about jazz. It was through such sessions at the Elbow Room that Stevie Winwood's Traffic would come together the following year. Out of the Cedar Club, in the first weeks of 1966, came the Move, who at a stroke raised the bar for the other local acts, Plant's Listen among them.

Bringing together the pick of Birmingham's musicians, the Move consisted of singer Carl Wayne, guitarists Trevor Burton and Roy Wood, bassist Ace 'The Face' Kefford and drummer Bev Bevan, each of whom had served a beat-group apprenticeship. To begin with they covered the same tunes as every other band in town but added songs by the Byrds and other blossoming West Coast acts to the mix. Their own songs came later, although from the start the Move's multi-part harmonies were one of two

things setting them apart. The other was their image. At the insistence of their manager, Tony Secunda, a former merchant seaman, the Move kitted themselves out in gangster-style suits. Securing his band a residency at London's Marquee Club, Secunda further compelled them to add an element of theatre to their presentation.

'Tony said to Carl one night, "Be a great idea if you smashed up a television on stage,"' recalls Trevor Burton. 'The next day Carl went out and got a TV and an axe. There was outrage. We let off a couple of smoke bombs, too. The third time we did it we had the fire brigade and the police hit the place. It made all the papers, which is what it was all about.'

The impression this made on Listen was instantaneous. The four of them went to a second-hand clothes shop in Aston, Birmingham, and bought double-breasted suits, co-opting the Move's gangster chic. Their idea for whipping up drama was more prosaic, amounting as it did to Plant and Crutchley staging a mock fight each night.

'Rob and I used to go at it for about two or three minutes,' says Crutchley. 'The bouncers would often intervene and stop us. We really should have mentioned beforehand that it was part of the act.'

Such mishaps seem to have been a common occurrence. Jim Lea, then the bassist with the N'Betweens, recalls frequently seeing Listen.

'The first time was at the Civic Hall in Wolverhampton,' he says. 'Plant had got that testosterone-filled thing about him. He had on plaid trousers and a shirt buttoned up to the neck, and he'd backcombed his hair. He was doing this really exaggerated kind of strut. At one point he got up on the bass cabinet, which was turned on its side. He was standing up there going "Ooh,

baby, baby" and got his mike stand trapped under the cabinet. He jumped down, went to strut off and was yanked backwards, almost off his feet.

'But the girls thought he was wonderful. They used to have these Monday-night dances at the swimming baths in Willenhall, down the road from Wolverhampton. I saw him there, dancing with a neck-coat on, showing off to all the birds.'

By then the N'Betweens had become the biggest band in Wolverhampton and were looking for a singer. Their new guitarist, Neville 'Noddy' Holder, had assumed the role but he recommended to Lea and the others that they hire Plant. Like the rest of Listen, Holder hailed from Walsall and had on occasion driven them to gigs in his dad's window-cleaning van.

Says Lea: 'Nod told us, "Plonk's a good singer, but all the birds like him – that's why he'll be good for us." At the time I didn't get what all the fuss was about. By then he'd got a reputation for getting up with all of the B-list bands in town. The thing is, once he was up you couldn't get him off the stage, so I was adamant we weren't letting him on with us.'

Lea's reasoning that retaining Holder as sole singer would mean more money for each of them swung the argument, and Plant was not asked to join the band. Had he been, it's doubtful he would have remained loyal to Listen. He had gone along to see the Who at Kidderminster Town Hall that May. Pete Townshend had sung lead vocals that night, Roger Daltrey having temporarily walked out following the first of many clashes. After the gig Plant waited outside the stage door for Townshend and offered him his services. If nothing else, he was sure of himself.

* * *

The English summer of 1966 was a wet one. There was a new Labour government in office and mounting anticipation of football's World Cup kicking off in the country that July. On a chill, damp night Plant met his future wife at a concert by British R&B singer Georgie Fame. Although she was born in West Bromwich, Maureen Wilson's family had come to the Black Country from Goa in India. Petite and pretty, she was a keen dancer, and the attraction between her and Plant was immediate.

Their relationship would have been frowned upon by many around the Midlands at that time. Less than two years earlier the General Election of October 1964 had exposed the nasty tensions simmering beneath the surface in the area. In a notorious vote in West Bromwich's neighbouring constituency of Smethwick the sitting Labour MP had been unseated by the Conservative candidate Peter Griffiths, who had fought a campaign protesting at the influx of Asian immigrants into the town.

Such was the vitriol stirred up by Griffiths that the victorious Labour prime minister, Harold Wilson, suggested he be met at Westminster as a 'parliamentary leper' when he took up his seat. Griffiths was ousted in the ensuing election of March 1966 but it would take many years for the raw wounds he had opened up to heal.

'Robert did everything against the rules then and it was quite brave of him to do so,' reflects Perry Foster, Plant's first mentor. 'Be it leaving his perfectly nice, middle-class home or stepping out with a girl from Goa. I will say this for him, he'd got more balls than I had.'

It was equally true that Maureen had a positive influence on Plant. He became a frequent guest at her family's home on

Trinity Road in West Bromwich, there acquiring a taste for Indian curries and spices, and also hearing new and exotic sounds.

'A lot of Asian families lived in that part of West Brom,' he said to me. 'Those amazing sounds of the Indian singers from the '50s … It was all around, coming from next door and up the alley from the terraced house where I was staying. I was intrigued by it.'

Says John Crutchley: 'Maureen was good for Robert, and he couldn't have wished for a better family because they took him under their wing. He stayed at Trinity Road quite a lot, among all the comings and goings there. I fancied Maureen's younger sister, Shirley, and the four of us used to go about together. It was a nice, cosy scene.'

Not that Plant's restless ambitions were stilled. He was mindful of the precedent being set by the Move, who had struck out beyond the Midlands, and he convinced the others that they needed to get off the local circuit, too. Listen's answer to Tony Secunda would be Mike Dolan, who ran a tailoring business in Birmingham. Dolan approached the band with a view to becoming their manager, telling them he had money to invest.

His money did not go far, but Dolan did get Listen taken on by two booking agencies, the London-based Malcolm Rose Agency and Astra in Wolverhampton. They began to get gigs in far-flung places such as the 400 Ballroom in Torquay on the English south coast, and up north at Newcastle's Club A'GoGo. On 30 July, the day that England won the World Cup at Wembley Stadium, Listen opened for the Troggs, of 'Wild Thing' fame, at the Boston Gliderdrome in Lincolnshire.

'We went all over the place in a van Mrs Reagan had given to us,' recalls Crutchley. 'It had belonged to another of her bands,

the Redcaps, but they'd split up. A friend of Robert's from Kidderminster, a lad named Edward, used to drive us. He was a total nutcase, this chubby little guy who used to take loads of substances.'

Carole Williams was then the receptionist at Astra. It was her job to hand out the wages to the agency's bands each week.

'The lads would all come and get their money on a Friday morning,' she says. 'Robert was living with Roger Beamer and neither of them was very good at getting up. One of my little jobs every Friday was to call them at 10 am to wake them. They were on £15 a night for two forty-five-minute slots, which was quite good in those days.

'Robert had an aura about him and stood out from the other guys in his band. He was drop-dead gorgeous, too. One time, a band I liked called the Roulettes were doing a show in Shrewsbury, a couple of hours away. Robert offered to take me. It was on a Friday night and he picked me up after work. He turned up in this really old, black car – a Ford Poplar, I think.

'We trundled along to Shrewsbury, saw the band and had a lovely night. We got home, and that's when he told me he didn't have a driving licence. To him that was a mere technicality. At least it was a straight road.'

For all this roaming, the highest-profile gig Listen played was back in the Black Country on 20 October. That night they and the N'Betweens opened up for Eric Clapton's heavyweight new blues-rock trio, Cream. It was to be an inauspicious occasion for them.

'At the end of their set Plant and John Crutchley started their fake fight, and Crutch ended up falling off the stage,' says Jim Lea. 'He broke his ankle, as I recall. Plant told me later that they

really were fighting. He said they argued a lot, so the fake thing was just an excuse to bash seven shades of shit out of each other.'

Listen's last roll of the dice was to record a three-track demo tape that Dolan shopped to various London labels. He secured a deal with CBS. Yet unbeknown to the others, the label's talent scout, Danny Kessler, had been taken in by Plant's voice, and it was the singer that CBS signed up and not his band.

As such, when the time came to record Listen's first single, a cover of a song called 'You Better Run' originally by the American pop-rock band the Rascals, it was Plant alone who was required to travel down to London for the day.

'CBS said they wanted to have session guys on it to make it more commercial,' says Crutchley. 'We were a little bit upset but it was one of those things. We were trying to get a hit record, so we were led.'

Even at this distance the power of Plant's voice on the track is striking but Kessler's own over-fussy production smothers it in strings, brass and backing singers, one of whom was future Elton John sidekick, Kiki Dee.

By unfortunate coincidence the N'Betweens had also chosen 'You Better Run' to be their first single, albeit in a more stripped-down form. Both versions were released on the same day in November 1966. To boost sales, Dolan directed his charges to go into every record shop in the area and order their own song. In the event it crept into the Top 50 for just one week and then vanished.

'At one point I had Robert on one phone line and Noddy Holder on the other, both of them asking me which version I liked best,' says Carole Williams. 'My loyalties were with the N'Betweens, but I told Robert a little white lie.'

'After that, things started to peter out for us,' says Crutchley. 'A lot of money had gone into publicising the record. We more or less sat down together and admitted it wasn't working out. We were really broke, too.'

With no band or money coming in, Plant moved in with his girlfriend and her parents. The couple were living off Maureen's wages from working as a shop assistant at Marks & Spencer, which were £7 a week. Plant, who had just turned eighteen, made her a promise: if he had not realised his dream by the time he was twenty he would give it up and get a proper job.

THE REAL
DESPERATION SCENE

I howled so much that I couldn't
do anything at all.

There remained something for Plant to hold on to: he was still signed to CBS Records. He was broke and had again been shoved back to the margins, but so long as he kept his foot in the door his dream would not die. He just had to find a way – any way – to kick that door open. If that meant abandoning himself to the whims of others then so be it.

As it happened, CBS did have a vision for their young singer. They had decided to mould him into a crooner. With that voice and those looks of his he could surely make the ladies' hearts flutter and soar. Their rivals Decca had done just the same with two of their own singers, and with great success. The first was a strapping bloke they had plucked from the Welsh valleys named Tom Jones. Then there was the still more unlikely Gerry Dorsey, an Indian-born club singer the label had re-christened Engelbert Humperdinck. As 1967 began, Humperdinck was enjoying a smash hit on both sides of the Atlantic with 'Release Me', a corny ballad Decca had found for him.

For their charge CBS had earmarked an Italian ballad, 'La Musica è Finita', which had been a Number One in its country of origin. For Plant the track was re-titled 'Our Song' and he was once more paired with CBS's in-house producer, Danny Kessler, to record it. Kessler was as unstinting in his use of strings and brass as he had been on Listen's ill-starred 'You Better Run', but such a backdrop was better suited to 'Our Song' since it was the most saccharine of confections. Not that the same could be said for Plant, who sang it as if straitjacketed. He told his friend Kevyn Gammond that it took him ninety takes to get a finished track, the process reducing him to tears.

Plant's first solo single was released in March 1967, the same month that Pink Floyd's 'Arnold Layne' and 'Purple Haze' by Jimi Hendrix came out. It was an abject failure, selling fewer than 800 copies. Even one of his first champions, the *Express & Star* newspaper's pop columnist John Ogden, dismissed it as 'a waste of a fine soul singer'.

'I got a phone call from Robert's mother soon after,' says Ogden. 'She wanted to know if I really thought her son was any good or not. I told her that while you could never guarantee anything, he stood as much of a chance as anyone of making it. She must have been terribly disappointed over the next year or so because it just didn't happen for him.'

Plant was not yet deterred from throwing himself into this radical transformation. Back in the Midlands, he crimped his hair into a bouffant, bought a dark suit and told anyone who asked that he was going to have a career in cabaret. He reasoned to himself that there was nothing not worth trying. He even had business cards printed up that unveiled a new identity, advertising 'Robert – The E Is Silent – Lee, now available for bookings'.

And he found an unexpected ally in his father. A local big-band leader, Tony Billingham, had hired Robert Plant Sr to design and build an extension to his home.

'Robert's father noticed the coming and going of musicians, and one day told me that all his son wanted to do was sing and asked if I could take him on,' recalls Billingham. 'I said that I would give him a go. We were called the Tony Billingham Band, and it was a traditional dance band.

'I couldn't say how many jobs Robert did with us but I remember one of them being at Kidderminster College. He sang some Beatles songs that night. We usually wore evening dress for functions in those days although we wouldn't have contemplated doing so for a college date. For that we'd have worn black shirts, something like that. Robert had got his long hair and his shirt open right down to the last button. Dance people didn't do that kind of thing.'

Five months after 'Our Song' had sunk, CBS tried again with a second single, 'Long Time Coming'. This was better tailored to fit Plant's voice, being R&B-based, but it was no less aimed at the middle of the road than its predecessor had been. It was also no more successful. But by then Plant had headed off in yet another direction, this one moving closer to the spirit of the time.

He had put together a new group, calling it Robert Plant and the Band of Joy. The guitarist, Vernon Pereira, was a relative of his girlfriend Maureen. Although the Band of Joy's line-up would be fluid for as long as it lasted, Plant's inspiration remained the same – the new American music he had by now picked up on.

The catalyst for this was John Peel, a twenty-seven-year-old DJ born into a well-to-do family in Liverpool and boarding-school educated. Peel's father was a cotton merchant who in 1961 had packed his son off to the US to work for one of his

suppliers. He remained in the country for six years, during which time he got his first job as a DJ – an unpaid stint at a radio station in Dallas – and also acquired a stack of records emanating from America's West Coast.

Returning home in 1967, Peel was taken on by the pirate station Radio London, creating for it a show called *The Perfumed Garden*. He filled this with the records he had bought back from the US, exposing the bands behind them to a British audience for the first time. Coming out of LA and San Francisco, they included the Doors, the Grateful Dead, Captain Beefheart and his Magic Band, and Quicksilver Messenger Service. These were rock groups born out of blues, folk, country and jazz traditions, but which pushed further out there through their consumption of the newly available psychedelic drugs and an uncontrolled urge to freak out.

'We'd never heard any of this music till John started playing it,' says Peel's fellow DJ Bob Harris. 'It changed my perception of things and I'm sure Robert was listening in the same way.'

Plant was indeed enraptured by it, digesting this American music with an appetite the equal of that he had first shown for its black blues. Of the bands then emerging from San Francisco's psychedelic scene the two that hit him hardest were Jefferson Airplane and Moby Grape. The Airplane's *Surrealistic Pillow* album of that year gave rise to a brace of acid-rock anthems, 'White Rabbit' and 'Somebody to Love', singer Grace Slick's spooked vocals haunting her band's lysergic drone. Released that summer, Moby Grape's eponymous début LP fused rock, blues, country and pop into a sound that oozed heady adventurism and a sense of unbridled joy.

From LA he embraced a further two bands in particular. Buffalo Springfield brought together two gifted songwriters,

Neil Young and Stephen Stills, whose woozy folk-rock was setting as much of a template for the era as the Byrds, the same tensions destined to pull both bands apart. Then there was Love and their ornate psych-pop symphonies conjured up by another singular talent, Arthur Lee. Love put out two albums in 1967, *Da Capo* and then *Forever Changes*, their masterpiece. Although neither of these records would make stars of Lee or his band, each served up a kaleidoscopic musical tableau for others to feast from.

'All that music from the West Coast just went "Bang!" – and there was nothing else there for me after that,' Plant told *Melody Maker*'s Richard Williams in 1970. 'Three years before I had been shuddering listening to Sonny Boy Williamson. Now I was sobbing to Arthur Lee.'

Soon John Peel brought this music to his front door. The DJ began hosting a regular Sunday evening session at Frank's Ballroom in Kidderminster, often appealing on air for a lift up to the Midlands.

'It was fantastic,' enthuses Kevyn Gammond, like Plant a champion of these shows. 'Peel would bring up people like Captain Beefheart and Ry Cooder, but also the first incarnation of T-Rex. There was a great story about Captain Beefheart's band being sat in the dressing room, rolling up these big joints, and Peel offering them cups of tea and cucumber sandwiches. Peel hipped us to this whole great scene and Rob especially got so into it.'

The first incarnation of the Band of Joy began to gig in the spring of 1967, playing both of Birmingham's hippest clubs, the Elbow Room and the Cedar Club, the latter as warm-up to former Moody Blues man Denny Laine's Electric String Band. It was still a covers band but one heading gingerly for the acid-rock frontiers.

Local music historian Laurie Hornsby recalls the group he was then playing guitar for doing a show with the Band of Joy at the city's Cofton Club on 25 April.

'The club was an old roller rink,' he says. 'I remember the place was packed. Drugs hadn't yet become a part of the scene. It was all about going out for a pint and to pull a bird. The mod look had gone by then – Robert and his band were all wearing Afghan coats, buckskins and things like that.

'Because they were far superior to us, we went on and did forty-five minutes and then they did an hour. I watched the Band of Joy's set but I only remember Robert. He sold himself so well, knew exactly how to make people watch him.'

'In the Midlands, there were two schools of thought about Robert at that time,' says John Ogden. 'People either liked him or hated him. All the women loved him. You could see them eyeing him up from the audience. Because of that the blokes most often didn't.'

This antipathy towards their singer extended to the band's de facto manager, 'Pop' Brown, father of their organist Chris Brown. Following a heated altercation between the two, Plant conspired to get himself fired from the Band of Joy.

'Robert had his own ideas and "Pop" Brown didn't like it,' suggests Ogden. 'Robert's always known his own mind and what he wanted, which was, basically, to be a star.'

That June the Beatles presented *Sgt. Pepper's Lonely Hearts Club Band* to the world and with it Britain was launched into its Summer of Love – one founded upon sounds, fashions and a predilection for mind-bending drugs that were all directly imported from California. The suggestion that this amounted to a sweeping cultural revolution has been exaggerated – the preposterous Humperdinck, Tom Jones and a crooner of even

greater vintage, Frankie Vaughan, fronted four of Britain's ten bestselling singles that year. Yet there could be no denying the extent of its impact.

This much was fast apparent to Plant. Within weeks of *Sgt. Pepper's* emergence both his beloved Small Faces and Stevie Winwood's new band Traffic scored hits with songs that mined the same seam of psychedelic whimsy, 'Itchycoo Park' and 'Hole in My Shoe'. The Traffic song would have jarred him most. Again he was confronted by the stark fact of how far his contemporary Winwood had travelled, and the distance he trailed behind.

By the time 'Hole in My Shoe' had risen to Number Two in the UK charts Plant was working as a labourer for the construction company Wimpey, laying Tarmac on West Bromwich High Street. Turning up for his first day on site, his new workmates took one look at his long, blond hair and began calling him 'The Pop Singer'.

It would not be long before Plant hauled himself up from this latest low ebb, since he was never lacking in resolve or self-assurance. He soon gathered about him another group of musicians, announcing them as Robert Plant and the Band of Joy. 'Pop' Brown howled in protest and for a time there were two Band of Joys hustling for gigs, but the others blinked first, changing their name to the Good Egg and drifting to obscurity. The following year Plant would marry into their guitarist Vernon Pereira's family – Pereira was Maureen's cousin – although the two of them never played together again. Pereira died in a car crash in 1976 at a time when Plant was consumed by other troubles.

To manage his latest band Plant called on an old contact, Mike Dolan, who had stewarded Listen. Dolan had an immediate

effect, although not perhaps a considered one. Plant had an impending court date to answer a motoring charge and Dolan convinced him this could be used to drum up publicity. Dolan hatched a plan to stage a 'Legalise Pot' march on the same day. He contacted the local press, suggesting that his singer was going to lead a crowd of young disciples to the courthouse steps, protesting their civil rights.

In the event Plant arrived at Wednesbury Court on the morning of 10 August 1967 accompanied by a supporting group that numbered just seven, one of whom was his girlfriend's younger sister Shirley. This ragged band carried placards daubed with slogans such as 'Happiness Is Pot Shaped' and 'Don't Plant It … Smoke It'.

A report in that evening's edition of the *Express & Star* described the scene: 'Police peered curiously from the windows of the police station and some even came out to photograph the strangely assorted bunch, which included two girls in miniskirts.' Dolan denied that the whole farrago had been stage-managed, telling the paper: 'It was a completely spontaneous act on the part of these youngsters, who regard Bob as a kind of leader.'

Although Plant was cleared of the charge of dangerous driving, a fellow protestor, a nurse named Dorette Thompson, was less fortunate, losing her job for her part in the march.

'That pantomime was Robert's scuffling side,' says John Ogden. 'He didn't need to do it, but he tried everything. He actually defended himself in court attired in the costume of an Indian bridegroom. Now, I'd been in court once to give a character reference and gotten cross-examined by this snotty lawyer. It's an intimidating experience. Yet he did that when he was still just eighteen.'

Plant's domestic arrangements at the time were no less haphazard than the march had been. He lived on and off with Maureen and her family in West Bromwich but crashed with friends, too. That summer he also moved in to a house at 1 Hill Road, Lye, close to his Stourbridge stomping grounds. One of his new housemates was Andrew Hewkin, an aspiring painter then in his final year at Stourbridge College.

'I can't imagine that house is still standing – it would be in need of serious renovation after what we did to it,' Hewkin tells me. 'People came and went all the time. It was hard to know who was living there and who wasn't because you'd bump into a different girl or guy every morning. We were all paying virtually nothing in rent.

'There were lots of rooms, each one with a different colour and smell, all sorts of music blaring out from them. I don't remember seeing much of Robert's room but then I don't recall seeing much of Robert either. The big dormitory up at the college was called West Hill; that's where all the action happened and where Robert was most of the time. He wasn't a student but he knew that all the best-looking birds hung out there.'

The house in Lye soon doubled up as a rehearsal space for the Band of Joy. The band set their gear up in the cellar, which was cramped, windowless and feverishly hot.

'It was seriously loud down there and Robert would drip with sweat,' says Hewkin. 'I saw them perform a lot, too. He was very much the same on stage then as he is now, the chest puffed out, but even more so. I think he probably learnt quite a bit off Mick Jagger because Robert strutted, too, though he was more of a cockerel.

'Otherwise, he was very down to earth, and charming, too, although he was heavily into his hobbits and underworlds. Sad,

isn't it? He bought a car, an old Morris Minor, and parked it in the garden of the house, which was completely overgrown. It never moved in all the time he was living there. I heard later that the police eventually came and took it away.'

This second incarnation of the Band of Joy was no more durable than the first. Their cause wasn't necessarily strengthened by the image they adopted – daubing their faces in war paint. In particular, this look did nothing for bassist Peter Bowen.

'It frightened everybody to death,' Plant told Richard Williams. 'This big, fat bass player would come running on, wearing a kaftan and bells, and dive straight off the stage and into the audience. I howled so much that I couldn't do anything at all.'

By the end of the year Bowen and the others had gone, leaving Plant to pick up the pieces once more. This he did with great zest, persuading both Bonham to join him again and Kevyn Gammond to walk out on reggae singer Jimmy Cliff's backing band. With typical chutzpah, he next turned to the Good Egg, bringing in their bassist Paul Lockey and organist Chris Brown, doubtless to the considerable ire of his father.

With this line-up, the Band of Joy gelled at last. Bonham's hulking drums giving them added weight, they were all heft and power, indulging themselves on sprawling instrumental workouts. This was a precursor to all that would soon enough change the lives of Plant and his hooligan drummer, although at the time neither could have known it. Yet it was all too much for the Midlands audiences of the time.

'I used to run a club at the Ship and Rainbow pub in Wolverhampton and booked them for a gig,' says John Ogden. 'It wasn't really a success because a lot of the audience were still blues freaks and Robert wasn't doing that then.

'I do remember him singing Jefferson Airplane's "White Rabbit" and it being bloody great. We had a chat afterwards and he was disappointed with the response. He was saying people ought to listen, that he couldn't keep doing the same thing. But back then if you were unusual, and especially if you were loud, you couldn't get gigs around here.'

Mike Dolan took the band outside of the area to the Middle Earth and Marquee clubs in London, and up north to Club A'GoGo in Newcastle. That March they did a handful of dates around the country with an expat American folk singer, Tim Rose. Such gigs were intermittent and paid less than the covers circuit they had each started out on but to begin with a shared purpose spurred them on.

'You couldn't call what we were doing freak rock but it had that spirit to it,' says Kevyn Gammond. 'It was exciting and it set us apart from all the twelve-bar stuff that we'd grown up with. A number could go on for ten, fifteen minutes – God help the poor audience. There was also a battle going on between John and Rob, because Bonzo was such a showman. He'd set up his drums in such a way that Rob and I could be pushed a bit to the side or behind him.'

Just as he had done with Listen, Dolan got the band to record a demo tape. It was done at Regent Sound Studios in London and featured versions of Buffalo Springfield's 'For What It's Worth' and the murder ballad 'Hey Joe', plus two self-penned songs, 'Memory Lane' and 'Adriatic Seaview'. Both covers suggest the potency of this Band of Joy, although little room was afforded for subtleties and even less for restraint. Plant embodied their full-on assault, his voice pitched lower than it would later be, attacking 'Hey Joe' as if by doing so he could rid himself of all his doubts and demons.

Yet each of the Band of Joy's own songs was as unremarkable as the next and the tape generated no great interest, Plant not even being able to rustle up enthusiasm at CBS, who retained his contract. Dolan managed to secure the band a residency at the Speakeasy Club in London but by then the game was up. Bonham accepted the princely sum of £40 a week to join Tim Rose's backing band and the Band of Joy crumbled.

It had become an all-too-familiar scenario to Plant, this act of coming so far and then falling short. He had other, more pressing matters on his mind now, too. Maureen was pregnant. And he was just a few months from turning twenty, the point at which he had promised her he would give all this up.

He went back to labouring and got engaged to Maureen. One can imagine the pressure exerted on them by their parents to do the right thing and uphold traditional values, however belatedly. He had come to appreciate the true worth of money, how help-less he was without it, how to treasure it and not to waste it. But still he would not quit. Still he kept on seeking that elusive break.

Meanwhile, the Move's guitarist, Trevor Burton, had passed on the Band of Joy's demo to his manager, Tony Secunda. Eventually, having listened to it, Secunda invited Plant down to London to audition for him and his business partner, Denny Cordell. Plant asked Kevyn Gammond to go with him.

'We had no money so we hitched down there,' Gammond remembers. 'They put us up in the shittiest, run-down hotel – the Madison. The next day, we went to Marquee Studios, just Robert and myself and those guys. They said, "OK, write us a song."We made something up, demoed it … I don't know what happened to it.

'On the way back we couldn't get a lift. We met this girl hitchhiker at the start of the M1. We asked her to pull her skirt up, and we ran and hid behind a hedge. A car pulled up, the door opened, and we leapt out of the hedge and jumped in as well. Got us back as far as Birmingham.'

During the Band of Joy's Speakeasy residency the blues musician Alexis Korner had popped his head round the dressing door to say hello. Then forty years old, Korner was the son of an Austrian-Jewish father and a half-Greek, half-Turkish mother, and had come to England via France, Switzerland and North Africa. Proficient on guitar and piano, he had joined Chris Barber's jazz band in the '50s, putting together his own blues collective in 1961. He named it Blues Incorporated and the band became a finishing school for a generation of young British blues players. At one time or other Charlie Watts, Ginger Baker and Jack Bruce passed through the Blues Incorporated ranks. And Mick Jagger, Keith Richards, Brian Jones, Rod Stewart and an angel-faced guitarist named Jimmy Page each got up to jam with Korner at his band's regular Marquee Club residencies.

Plant went along to see Korner perform at the Cannon Hill Arts Centre in Birmingham, re-introducing himself to Korner with his usual boldness. He told me: 'Alexis was up there playing away. He had this guy called Steve Miller on piano, a great player. I had a harmonica in my pocket and I started playing along, looking up at Alexis as he stood there on the stage. I just had that audacity, couldn't get enough of anything.

'He finished the song and looked down at me. I said, "Can I get up and play harp with you on one song?" He told me to come by the dressing room in the break. I ended up doing some eight-bar blues with him. He was a very charming and regal man.'

Korner asked Plant back down to London, putting him up in his flat in Queensway. He told his guest the sofa he was sleeping on was the same one Muddy Waters bunked down on whenever he was in town. Together with Steve Miller, Korner and Plant did a handful of club shows and began writing songs.

The trio cut two of these tunes – 'Operator' and 'Steal Away' – at a recording session. Both were solid but unspectacular blues numbers. Plant, however, sang each as if for his life, baying, howling and desperate sounding, here at last able to show he had the measure of Jagger, Rod Stewart and all the others ahead of him in the queue. The idea that the three of them might make an album was left hanging in the air.

Back in the Black Country he went to see his old friend Bill Bonham's new band and asked if he could join. They had the truly awful name of Obs-Tweedle but he would be able to earn some beer money and, since Bonham's parents ran a pub in Walsall called the Three Men and a Boat, have a place to lodge when he was not staying with Maureen's family.

Billed as Robert Plant plus Obs-Tweedle, the band did a bunch of local gigs during June and July of 1968. They were on at the Three Men and a Boat each Wednesday and most Saturday nights. There were dates at the Connaught Hotel and Woolpack pub in Wolverhampton, the sort of places Plant must have thought he had seen the back of. He taught them the same Buffalo Springfield and Moby Grape songs he had first done with the Band of Joy, although there was now no Bonham to make them sound murderous.

'I went along with anything he said, all of his ideas,' says Bill Bonham. 'He was great to be in a band with; hard-working, constructive in his criticism. People have often said to me that Robert is aloof or cold but I never experienced that from him.'

On 20 July Obs-Tweedle were booked to do a gig at the West Midlands College of Education in Walsall. It was a Saturday night and Bill Bonham recalls it being a typical student audience: 'They just stood there and watched, trying to be cool.'

There were three interested members of the small crowd that night, though. One was Jimmy Page, now guitarist in the Yardbirds, and a second was that band's bassist, Chris Dreja. The third was also the most conspicuous, their manager Peter Grant. A great, looming lump of a man, Grant had once worked as a bouncer – and as a wrestler, too – before breaking into the music business as minder to Gene Vincent and Little Richard. He shepherded the visiting American rockers around Britain, sucking it up and cracking skulls. The reason each of them found themselves in Walsall on this particular evening was Robert Plant.

The Yardbirds were then going through their death throes – wunderkind guitarists Eric Clapton and Jeff Beck were gone, the blues-boom hits long since dried up. On their most recent, wretched tour Page had confided in Grant his concept for a new band, one of all talents that could use the blues like heavy artillery and do much more besides. He would be its general, with Grant at his right hand.

Page had reached out first to the Who's drummer Keith Moon and their bassist John Entwistle but this had come to nothing. For a singer, he thought of Steve Marriott of the Small Faces, until their manager, the notorious Don Arden, asked him how he would like to play in a band with broken fingers. He next approached Terry Reid, an eighteen-year-old British blues singer then tipped to be the next big thing. Reid was working on his first solo album and declined but he tipped Page off to Plant, recalling a gig he had done earlier in the year with the Band of Joy.

So here, to Walsall, Page and the others had come, and there they stood watching Obs-Tweedle load their gear onto the stage. The initial omens were not good.

'They mistook me for a roadie,' Plant told me. 'Makes perfect sense – I'm a big guy. Terry Reid had told me that he'd mentioned me to Jimmy and I knew the Yardbirds had cut some great records – I'd seen them play with Eric. I didn't have anything to lose.'

Obs-Tweedle did nothing to impress Page that night. But their singer was something else. Page left the Midlands wondering how Plant had remained undiscovered, fearing it must be the result of some defect in his personality or a fault he had yet to spot. He decided to give the matter further thought.

Plant was left to carry on as before. That summer, a club opened up in an old ballroom in Birmingham. It was called Mothers and it fast became a magnet for the growing band of local 'heads' and hippies. Plant began to hold court there, a king still looking for his kingdom.

Recalling first seeing Plant at Mothers, the English folk singer Roy Harper says: 'I was twenty-six and he was nineteen. He was accompanied – or being followed, I don't know which – by four women. He automatically struck a light in my estimation. My clearest memory is seeing him waft away into the middle distance, surrounded by this coterie of chickpeas, and thinking, "That guy's got something very attractive going on."'

Returning to his lodgings at the Three Men and a Boat one night, Plant found a telegram from Grant waiting for him. It read: 'Priority – Robert Plant. Tried phoning you several times. Please call if you are interested in joining the Yardbirds.'

A month shy of his twentieth birthday, Plant's moment had come at last. Not that it seemed this way to him at first. He had,

after all, grown used to having his hopes raised and then dashed. And anyway, the Yardbirds were no longer anyone's idea of a sure thing.

'I ran into him one night at the Queen Mary Ballroom in Dudley and he told me that he'd had this offer to join the Yardbirds,' says Jim Lea of the N'Betweens. 'He'd got Maureen with him and he said he wasn't sure about it, didn't know if it'd work out. He told me he'd rather be playing the blues with Alexis Korner.

'We were doing quite well at the time and I'd bought myself a sports car, an MG Midget. Planty had this green Ford Prefect. I was just getting into my car and he shouted over, "Nice car – I guess I'll have to start playing pop!"'

Plant went and picked up the phone to Grant. What else was he going to do? Speaking a year later to Mark Williams of the *International Times* he said, 'It was the real desperation scene, man. I had nowhere else to go.'

PART TWO

AIRBORNE

*We were really good and
we didn't fuck about.*

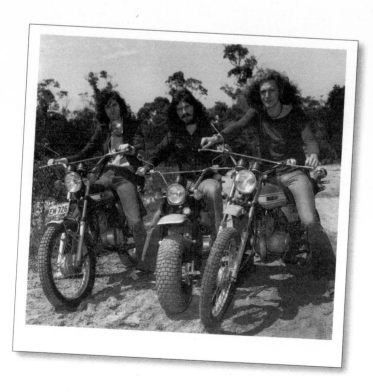

BOOM! BOOM! BOOM!

Do what this man says,
or fuck off.

Peter Grant passed on an invitation to Plant to meet with Jimmy Page at his home in Pangbourne on the banks of the River Thames so that they could test the waters and get the measure of each other. Stepping off the train from Birmingham, Plant found himself being set upon by an old woman. She began slapping his face and shrieking about the length of his hair. This would soon seem in keeping with everything that happened to him. He would feel as though he were walking in an alien land, the terrain littered with the unfamiliar and unexpected.

The village of Pangbourne was a rural retreat for well-off Londoners to escape to and Page had found himself a charming boathouse on the river. A new Bentley was parked in the driveway. Out back a flight of steps led down to a mooring and the water. Inside the house Page had installed a large aquarium and filled the place with antiques he had picked up on his travels.

This had all been paid for with the money he had earned from the Yardbirds and years of session work before that. For

Plant it was a vision of what success looked like. Yet it also made clear to him that, here and now, he and Page would not be meeting as equals.

'I was taken aback when Jimmy asked me to his house,' Plant told me. 'I mean, the Yardbirds had cut some serious shapes at one point and obviously they were working in America. Then I met Jimmy and he was so charismatic. His contacts were phenomenal.'

Four years older than Plant, Page was born in the London suburb of Heston, five months before the end of the war in Europe. An only child, he had been a keen athlete at school, a promising hurdler, but nothing else mattered to him once he heard Elvis on the radio. He got his first guitar, a Spanish acoustic, at the age of twelve, teaching himself to play by copping licks off James Burton, Elvis's guitarist.

In his teens Page joined his first band, Neil Christian and the Crusaders, doing one-night stands around the country, bashing out rock 'n' roll covers. Upon leaving school he enrolled at an art college in Surrey. Most nights he headed into London's West End with his guitar and began getting up with the house bands at clubs such as the Marquee and Crawdaddy. This led him on to the session circuit, where he flourished, since he was a fast learner and versatile, too, as proficient with ornate acoustic melodies as stinging electric leads.

The session jobs came thick and fast. He played on the Who's 'I Can't Explain' and the Kinks' 'You Really Got Me' singles, but also with Burt Bacharach and on advertising jingles. In 1965 the Rolling Stones' manager Andrew Loog Oldham hired him as staff producer at his new record label, Immediate, for which the Small Faces and Fleetwood Mac recorded. He joined the Yardbirds as bassist the following year, switching to guitar when

Jeff Beck, whom Page had known since school, upped and left. He toured the US, storing up knowledge and being shaped by all he heard.

Kim Fowley, the veteran American producer and hustler, recalls Page running into him in Los Angeles on one of these first visits. 'I was having breakfast one morning at the Hyatt House Hotel on Sunset Strip when in he comes, Mister boyish, dressed in crushed velvet. He spotted me, and came and sat down. He told me he'd just had the most insane, disturbing experience.

'A well-known singer-songwriter of the time, a pretty blonde, had asked him over to her house. When he got there, she'd detained him. He said she'd used restraints. I asked if he meant handcuffs and he said yes, but also whips – for three days and nights. He said it was scary but also fun. They say there's always an incident that triggers later behaviour. I contend that this was it for Jimmy Page. Because being in control – that became his deal.'

Plant stayed at Page's house for a week. The time was spent sizing each other up and rifling through Page's record collection to find shared touchstones. An immediate chord was struck when Plant alighted on Joan Baez's version of 'Babe I'm Gonna Leave You', written by Anne Bredon in the '50s. A delighted Page told him that he had marked the song out for his new band, something they could electrify.

Yet in most other respects the two of them were very different. Page was reserved and withdrawn, Plant outgoing and cocksure. Plant had left home at seventeen and been scuffling on the fringes of the music business ever since. Page lived with his parents till he was twenty-four, and had them nurture and encourage his passion. For as long as Plant had scrapped, Page had been at the heart of the action.

Before Plant left he played Page his old Band of Joy demos. Page had not yet found a drummer and Plant suggested he check out John Bonham. On the evening of 31 July 1968 Page and Grant trooped along to a club in Hampstead, north London, to see Bonham drum with Tim Rose. Bonham's playing was ridiculously loud but also fast and dextrous, so one might miss the great skill behind the thunder. Page, however, had a keen ear and was sold.

Bonham was less taken with the idea of throwing in his lot with Page. He and his wife Pat were still living in a caravan behind his parents' house. The couple now had a two-year-old son, Jason, and Bonham was indebted to his father. He was getting a steady income from Rose, not to mention the fact that Pat was of a mind that anything involving her husband's big, daft mate Robert Plant was bound to end in financial ruin.

Plant was nonetheless dispatched to work on his friend, although Bonham was finally swung by a visit from Page and Grant, and their offer of more money than Rose was paying. Plant now had a familiar face along for the ride, someone to hold on to should the going get rough. He opened a bank account, depositing £35, his first rewards from this latest band.

A week before his twentieth birthday he and Bonham returned to London for rehearsals. That summer there were portents in the air for them. Both of the other mercurial guitarists who had been Yardbirds, Eric Clapton and Jeff Beck, had put out new records. Clapton's Cream released *Wheels of Fire*, their third, a sprawling double album that was shot through with fiery blues but also burdened by excess and over-indulgence. Beck debuted his Jeff Beck Group on *Truth*, with Rod Stewart on vocals, coming up with a sound that was also steeped in the blues, but heavy and portentous. Yet Cream

would not survive the year and Beck's group were no more built to last. As a result there would be a clear run for what Page had in mind.

Arriving at a poky rehearsal room beneath a record shop on Gerard Street in London's Soho, Plant and Bonham met their other new band mate. Like Page, John Paul Jones was an only child. Born in 1946 into a musical family in Sidcup, Kent, he was also in a touring band by the time he was a teenager, playing bass guitar for the ex-Shadows duo, Jet Harris and Tony Meehan. He, too, had gone on to do sessions, which is where he and Page had first crossed paths.

Jones was accomplished on both bass and keyboards but gifted as an arranger as well. He had scored the Rolling Stones' 'She's a Rainbow' single and 'Sunshine Superman' for the Scottish folk singer Donovan, a US Number One in 1966. Again like Page, Jones was an introvert, although there was something still more enigmatic about him, as though he kept a part of himself locked away at all times.

This, then, was the band. Two diffident southern Englanders with experience beyond their years, two garrulous lads from the Midlands as green as they were driven. To begin with, Page called them the New Yardbirds, since it afforded them both instant recognition and the opportunity to take on some bookings left over from his old group.

The reaction in Britain to them was lukewarm at best. The weekly music paper *NME* named their singer 'Bob Plante', and in Plant's own neck of the woods John Ogden at the *Express & Star* newspaper was even less engaged.

'I don't think I even wrote about it,' he says. 'I thought the Yardbirds were old hat. It seemed to me like another bloody lost cause for him.'

The four of them knew differently. This much had been clear from that initial rehearsal. They had thrown themselves into 'Train Kept A-Rollin'', a staple of the Yardbirds' live sets, and the force of their collective sound had shocked them. It became more apparent still during the first gigs they did together that September. These were club dates in Denmark and Sweden, 40-minute sets a night, the songs hand-picked by Page: blues covers, tracks he had done with the Yardbirds, and an ominous-sounding dirge called 'Dazed and Confused' he had begun messing around with during the end days of that band.

Each of them understood, no words needing to be spoken, that this was a band apart. It was as if they had captured lightning in a bottle.

'Straight away, we could see the power of it,' Page told me, years later. 'It was a very intense thing. Was it extreme for the time? Good God, yes. The use and employment of electric and acoustic guitars – that hadn't been done by anyone – or the shaping of the songs. There was something alchemical between the four of us that was totally unique.'

Plant nodded, adding his own rejoinder: 'We were really good and we didn't fuck about.'

Still buzzing from their short Scandinavian excursion and having been together for just a few weeks, the band trooped into London's Olympic Studios on 27 September to record their début album. Based in Barnes, on the south-west edge of the capital, Olympic was a small, eight-track studio housed in an old music hall. The Rolling Stones had used it that same summer to record *Beggars Banquet*.

As he would do on all their albums Page was producing the sessions, assisted by the in-house engineer Glyn Johns. Plant's studio experience, like Bonham's, was limited, so much so that

he had to be told to use headphones. Despite this he gave off his usual aura of self-confidence.

Phill Brown was then a teenage apprentice at Olympic. 'Glyn Johns was using down-time at the studio for them,' he recalls. 'He'd bring them in at weekends, when no one else was using the place, and that's how they made the record. I met Robert and Jimmy. Robert was very striking. He seemed sort of god-like. As a band they definitely had a vibe to them. They were very focused and full-on. Arrogant isn't the word but they were self-contained and sure of themselves.'

Page, however, was the band's undisputed leader. Since there was no record deal at this point he was funding the sessions out of his own pocket and kept a forensic eye on costs. Plant moaned to Kevyn Gammond, his friend back home, about Page charging him for a plate of beans on toast he had ordered for lunch one day.

Page did not ease up on this control in the studio, where he took the major role in creating and moulding the songs, although he often tapped into Jones's arranging skills (Plant, still under contract to CBS, was not permitted writing credits). In his soft-spoken manner Page directed the others, Plant and Bonham in particular. The pair were both then on wages, no more than hired hands. The singer seemed carefree but he feared being replaced at any moment and so was compliant. Bonham was more bullish. It was left to Grant to step in and set the drummer right. 'Do what this man says,' he instructed him, 'or fuck off,' as Charles Cross reports in *Led Zeppelin: Shadows Taller than Our Souls*.

'I wanted artistic control in a vice-like grip,' Page told the writer Brad Tolinski, 'because I knew exactly what I wanted to do with the band. That first record sounded so good because I

had gotten so much experience in the recording studio. I knew precisely what I was after and how to get it.'

Such was Page's attention to detail and the work ethic he instilled, recording was completed in just thirty hours' studio time. The sessions had cost a mere £1,782, the shrewdest investment Page would make. Long before the album came out the band that made it had become Led Zeppelin. This dated back to when Page first proposed forming a group to the Who's rhythm section, Keith Moon telling him it would go down like a 'lead balloon'.

For the record's cover Page chose a screenprint of a burning airship. The stark, explosive nature of the image was fitting. *Led Zeppelin* was a trailblazing album. Perfect it was not – the material was too much of a mess for it to be that, and not all of it flew. Yet when it took to the air its power seemed almost elemental, Page's guitar strafing the grunge of 'Dazed and Confused', Bonham filling pockets of space on 'Good Times, Bad Times' with dazzling flourishes, the revved-up rush of 'Communication Breakdown' and the rousing 'Your Time Is Gonna Come'. In moments such as these, Zeppelin soared.

Plant shone on 'Babe I'm Gonna Leave You', the song that first bonded him to Page. Here it embodied the sense of light and shade that Page intended to be at the band's core – winsome acoustic passages giving way to full-bore rock, Plant riding the currents of both. Less convincing were two Willie Dixon covers, 'You Shook Me' and 'I Can't Quit You Baby', Plant as overwrought in his reading of the old bluesman as the band were leaden. He was otherwise somewhat constrained, suggesting little of the wild abandon he had shown with Alexis Korner just months earlier.

Grant began shopping the album to record labels in the UK. The offices of Island Records were on a floor below his own on

London's Oxford Street, and he pressed a copy upon the label's founder, Chris Blackwell. Birmingham-born drummer Mike Kellie was then a member of blues-rockers Spooky Tooth and signed to Island.

'We went in to see Chris one day and he handed me this record, telling me there were a couple of guys on it that I knew,' Kellie recalls. 'I had no idea who they might be but I took it with me. Those were the days of getting it together in the country and we were living on a farm out in Berkshire. We went back there and put the record straight on.

'Our singer, Mike Harrison, and I had the same reaction to it. We wanted to be in that band. It was the best of everything we'd heard and all we aspired to be. It was only later that I found out it was Robert and Bonzo. To me, Robert sounded just like Steve Marriott on that first record, when Marriott was at his very best.'

The general reaction to the band continued to be more muted. Grant could not negotiate a deal for them in the UK, and they often met with unresponsive audiences during their first gigs around the country that October and November. If this put Page's nose out of joint, it was nothing Plant was unused to.

'When I opened up shows for Gene Vincent and the Walker Brothers in the town halls, I was playing to thirty-five people,' he told me. 'And that was the zenith of all opportunity. Bonzo and I couldn't even get in to some of the first gigs we did because we didn't have a tie on. The fact that we kicked up a gear and got bigger audiences, that was just an act of God.'

More specifically, it was the act of Grant turning his attentions towards the US that did it for Zeppelin. The Yardbirds still had enough currency there to open doors for him, and when he flew out to New York he was also blessed with good fortune and opportune timing.

Atlantic Records was at this time being run by Ahmet Ertegun and Jerry Wexler, a pair of passionate music fans who between them had signed Aretha Franklin, Ray Charles and Wilson Pickett to the label. The Turkish-born Ertegun was then the more ascendant of the two, having picked up both Cream and an American rock band, Iron Butterfly, each of which had taken off.

Although Wexler was more of a soul man and had little interest in rock music, he nonetheless had a point to prove and took the meeting with Grant. When it concluded, and despite leaving Zeppelin to Ertegun thereafter, Wexler handed Grant a $200,000 deal for his band. It was an unprecedented sum for a new act and one that soon enough led to accusations of their being over-hyped.

On his return Grant handed the salaried Plant and Bonham each a cheque for £3,000, more money than either had ever seen. They went out and bought matching cars, gold S-Type Jaguars. Back home in the Midlands, Plant paraded his first flush of success, rolling up at Stringers, the department store on Stourbridge High Street where he had been a stock boy, showing off his flash new motor to the girls on the shop floor.

He had, however, the promise of an even greater prize. Zeppelin's first US tour was scheduled to begin that Christmas. He was headed west, to the source of all the music that had lifted and then propelled him out of his parents' home and on through two-bit bands and dead-end jobs. The anticipation of it kept him awake at night, but so did a cold, hard fact. Going there, he would come face to face with an audience that had seen it all before. Looking into the whites of their eyes he would know whether he had what it took or not.

On 9 November, the month before he left, Plant married Maureen at a church in West Bromwich. She was eight months' pregnant at the time, their daughter Carmen arriving less than two weeks later. After the wedding the couple hosted a reception for friends and family at Queen Mary's Ballroom on the site of Dudley Zoo. Zeppelin had a gig at the Roundhouse in London that night and the groom had to duck out early, taking Bonham with him.

As their families gathered for Christmas, three-quarters of Led Zeppelin flew out to Los Angeles. Jones, their man apart, went instead to New York with his wife to visit friends. He would make his own way to Denver for the band's first show on American soil. Grant had also absented himself, choosing to spend the holiday at home with his wife and two children.

Landing in LA, Plant, Page and Bonham were met by their new road manager, Richard Cole, a twenty-two-year-old who'd paid his dues with Grant on the last Yardbirds tour. Cole drove his charges to the Chateau Marmont Hotel, where Bonham cooked them a Christmas dinner. The mood was quiet, reflective.

'Robert and Bonzo seemed nervous,' says Cole. 'Jimmy had played big places with the Yardbirds and Jonesy did theatres during his time with Jet Harris, but those two hadn't experienced anything like this. They were apprehensive about everything.

'You have to remember, going to America then wasn't like it is today. Everywhere you go in the world now is Americanised. The first time I went there in 1967 I couldn't wait to get out. I was petrified – the way things were done was on a different scale.'

In 1968 the US was divided along social, political and racial lines. The resulting collisions were ugly and brutal. That year Martin Luther King was gunned down in Memphis and Senator Robert Kennedy shot dead in Los Angeles, wiped out in his prime, like his elder brother Jack before him. The wave of hope the Kennedys had ushered in was extinguished the month before Zeppelin's arrival. Richard Nixon, the Republican candidate, had won the presidential election of that November, driving the fractures further apart, rushing the '60s to a violent and venal conclusion.

This tour of the States was like no other Zeppelin would do. They were ferried around in rental cars, flew commercial airlines and crashed out in budget-price hotels. And for the first – and last – time they were often as not the warm-up act, beginning with the opening night at Denver's Auditorium Arena on 26 December, at which they did the honours for American rockers Vanilla Fudge.

The impression Zeppelin made was instant, indelible. American audiences of the time had been fed a staple diet of stoned-sounding bands but there was nothing mellow or rolling about Zeppelin's groove. They hit hard and loud, and in doing so seemed new and impossibly exciting.

By the time they made it out to California at the beginning of 1969 they had got into their stride. They were there for three shows with Alice Cooper at the Whisky a Go Go in Los Angeles and a four-night stand at the Fillmore in San Francisco. Out West they laid foundations and made connections that would endure to the end.

One such connection was with Bill Graham, a thirty-eight-year-old impresario born Wolodia Grajonca in Berlin in 1931, the son of Jewish émigrés from Russia. Both his parents and

elder sister had died during the war and he had fled Nazi Germany, first to France and then New York, where he was adopted by an American family and changed his name to William Graham. In the early '60s he moved to San Francisco, working first as a theatrical manager and coming to preside over the Fillmore, the venue that provided a launch pad for bands such as the Grateful Dead and Jefferson Airplane.

Straight-talking and obdurate, Graham was instrumental in revolutionising the rock-concert business in the US, bringing to it high-quality PA and lighting systems, and later establishing the practice of building large-scale events around superstar acts. For the next eight years, right up to its sordid and senseless end in Oakland in 1977, he and Zeppelin enjoyed a mutually beneficial relationship.

Yet if there was a centre of the empire Zeppelin created it would be Los Angeles, specifically Sunset Strip, a neon-lit, two-mile stretch of Sunset Boulevard that runs through West Hollywood. Since the 1940s the Strip had been the city's nocturnal playground – a subterranean world of jazz clubs and opium dens, where movie stars and starlets rubbed shoulders with gangsters. Glamour and glitz on its surfaces – and decadence just underneath.

Once the '60s got going, sparked by the Beatles and the British Invasion bands trailing them, the Strip gave itself over to new sounds and a different kind of hedonism, the Byrds emerging at the head of this coming aristocracy. When drugs and egos took the Byrds down, the Doors occupied their throne. Not that Jim Morrison and his cronies were any longer able to breathe such rarefied air, so by the time Led Zeppelin came to town the Strip was waiting to be taken once more.

Soon enough Zeppelin would conquer it, setting up court beneath the shadow of the Hollywood sign and gorging

themselves on the fruits and flesh on offer. That, however, was to come. On this initial sortie Zeppelin had it all to prove – not least their singer, for whom California was the land of promise.

'I started hanging out with Janis Joplin and Jefferson Airplane, people like that,' he told me. 'They were crazy days. You couldn't say that any of us had any idea of continuity. But all the time I was meeting these little starbursts and around me galaxies were going Boom! Boom! Boom! I absorbed it all, like moondust.'

The Flower Power children were rather less prepared for Led Zeppelin. During those eight shows on the West Coast the band did not so much entertain as attack.

'They were so fucking blasé on the West Coast,' says Cole. 'Not just the musicians but the audiences, too. Because they'd been spoilt rotten, having all these fantastic bands out there. They were so much more laid back than everywhere else in the States. When Zeppelin got there it was like a rocket going up their fucking arses.

'Once the band fired up they were off. They were incredible, they really were. After the second show in San Francisco I was driving back to the hotel with Peter and I told him I didn't want to work with any of his other bands. I said, "Just give me this one – they're going to be good for you."'

Looking out into dumbstruck faces night after night, Plant got his answer – he was where he was meant to be. Once more, he strutted. Or, as he put it to Q magazine in 1988, 'I must have been pretty insecure to want to run around, pushing my chest out, pursing my lips and throwing my hair back like some West Midlands giraffe.'

'Robert was then starting to find his feet,' says Cole. 'But there are always two different sides to musicians – off-stage and on-stage. Off-stage he and I had our ups and downs. Stupid little

niggles. I remember being in Miami on that tour, sitting out by the pool at the hotel. Robert said he was going off to the shops and, joking, I told him to bring me back a sandwich. If Peter had been going I'd have said the same to him but I don't think Robert ever forgave me for it.'

The band's début album was released in the US on the day of their last show at the Fillmore. Critics treated it with suspicion if not outright disdain. Writing in *Rolling Stone*, John Mendelsohn dismissed it as 'an album of weak, unimaginative songs', suggesting the band's singer was 'nowhere near as exciting as Rod Stewart'.

It also gave rise to the first of many plagiarism allegations that would dog the band. A young American singer-songwriter, Jake Holmes, claimed 'Dazed and Confused' as his own, insisting Page had heard him perform an acoustic version of the song in New York in 1967. Page and the band brushed aside both Holmes and the critics. On the road they were winning over American audiences one stop at a time. The album took up residency on the US charts and would remain there deep into the following year.

The tour concluded on the East Coast. On the last of four nights at Boston's Tea Party club a baying crowd refused to let them go and Zeppelin ended up playing a four-hour show, filling it out with Beatles covers. In New York Grant pulled a favour off Bill Graham at his Fillmore East, having his band switched from being the first on to the middle act of a three-band bill. It was a showman's gambit, putting Zeppelin in direct competition with headliners Iron Butterfly, whose pedestrian set they pulverised.

For Plant, even his wildest expectations had been exceeded, and all too fast for him to take it in. Eight months beforehand

he had been penniless and starting a job as a labourer; now he had the US at his feet. It was enough to mess with anyone's head.

'As the guy from the Black Country I felt very much out of place to begin with,' he told me. 'To go from laying Tarmac in West Bromwich to playing the Fillmore in San Francisco ... it was really disorientating. I had been twenty when Zeppelin started touring. I was marooned many times. I had to be saved here and there, and got lost, too.'

In the middle of it all, the strangest experiences must have been the most compelling, since it was through these that he was best able to gauge just how far he had come.

In Chicago, towards the end of the tour, Plant took a call at his hotel from a couple of the Plaster Casters, a group of girls who had taken it upon themselves to make casts of the erect penises of young buck rock stars. In the event he did not acquiesce.

'These two girls came into the room with a wooden case, suitably inscribed and all very ceremonious,' he told Mark Williams of the *International Times*. 'All of a sudden one of them starts to take her clothes off. She's rather large, no doubt about it, and there she is, standing naked as the day she's born.

'Then she covered herself with soap, cream doughnuts and whiskey, all rubbed in together, head to toe, and she's this moving mountain of soapy flesh. At first, she dug it. But her friend, who'd come along for the ride, began trying to disappear under the bed. Eventually, she got into the shower, grabbed her clothes and split.'

Back in the UK all that was familiar to the band was the antipathy with which British critics received their début album when it was finally released there in March. At home they were

returned to the club circuit and Plant found himself playing Wolverhampton's Club Lafayette and Mothers in Birmingham, not so far from where he had begun.

A typical date was on 8 April, when Zeppelin performed at the Cherry Tree pub in Welwyn Garden City, a satellite town of London. Dave Pegg, who had played with Bonham in the Way of Life and would later join folk-rockers Fairport Convention, accepted an invitation from the drummer to the gig.

'Bonzo picked me up in what must have been his mum's car, a Ford Anglia Estate, and we tore off to the show,' Pegg remembers. 'It was a fabulous gig, but it was in a pub.

'The next time I saw him we went down to London in his gold S-Type Jag. Robert was with him. The two of them had got the same car and all they did was compare noises. "You've got a funny rattle there, mate," that kind of thing. On the way back, we stopped off at the Watford Gap services on the M1. There was a bit of an altercation involving Robert, because Maureen was in there. She'd gone off to see another band called Trapeze and she was with them.'

At the end of that month Plant could again put such everyday realities behind him, Zeppelin going back to the US for a co-headlining tour with Vanilla Fudge. They would cross the States twice more before the year was out, the shows getting bigger, the furore around them swelling.

That summer, Zeppelin rolled through North America as Neil Armstrong stepped on to the moon and members of the Manson family broke into the actress Sharon Tate's Los Angeles home and sent her to her doom. In August Grant turned down an offer for the band to join the last hurrah of the peace and love generation at the Woodstock Festival, most likely balking at the size of the proposed fee, although he was reported to have said

that he declined because Zeppelin would have been just another band on the bill. Whatever his reasoning, Zeppelin were not shackled to the era now passing.

Arriving in LA that April, they had begun work on their second album at A&M Studios. Recording would continue, on and off, for the next eight months, the band using nine different studios in the US, Canada and the UK. However piecemeal this approach, *Led Zeppelin II* proved to be a tighter, more coherent record than its predecessor, the months of touring having sharpened the band into a precision-drilled unit.

The music was honed to Zeppelin's base elements: the relentless chop and chug of Page's electric riffs and his acoustic shadings; the elasticity of Jones's booming bass lines; Bonham's deafening cannon fire. Then there was Plant, his range now fully opened up, his libido seemingly unchecked.

It was an album of great songs, too, with such swaggering beasts as 'Whole Lotta Love' and 'Heartbreaker', the panoramic sweep of 'What Is and What Should Never Be' and the honeyed jangle of 'Thank You'. Even accounting for 'The Lemon Song''s tiresome plod or the needless indulgence of 'Moby Dick', it conveyed a singular vision and sense of purpose.

Plant was credited as co-writer on each of the nine tracks, although with mixed results. He saddled 'Ramble On' with ham-fisted *Lord of the Rings* references. On 'Thank You' he articulated a more dignified declaration to his wife. Yet it was 'What Is and What Should Never Be' that would continue to prompt conjecture. There was a popular strand of gossip within the Zeppelin camp that claimed Plant had been at one time fixated on his wife's younger sister, Shirley. This, it was said, was the 'should never be' referred to in the song's title. Subsequent events did nothing to dampen this speculation, although such rumours

were unsubstantiated at the time and Plant has never commented on them.

As with their first album, *Led Zeppelin II* was scorned by the critics and became the butt of plagiarism claims, on this occasion regarding its abundant – and originally unaccredited – references to old blues songs. None of which halted its relentless momentum when it was released in October. It sped to Number One in the US, knocking the Beatles' *Abbey Road* off the top spot, and also reached the top of the charts in the UK, selling five million copies worldwide within six months.

By then the '60s were over, although the spirit of the times had died at Altamont Raceway on 6 December 1969. It was there, at a free concert given by the Rolling Stones, that a Hells Angel had stabbed the black teenager Meredith Hunter to death.

As the hippy idyll went up in flames, what better soundtrack to the conflagration than Robert Plant's banshee wail and the squall of Jimmy Page's guitar?

VALHALLA

***If I'd been in Zeppelin, I'm sure
I wouldn't be alive now.***

The money from *Led Zeppelin II* had not yet begun to pour in, but even still Plant was flush enough to buy a first home for his new family. He had found a rambling farmhouse a few miles up the road from his parental home but further into the countryside.

Set within acres of open fields and looking out on to the same Clent Hills he had walked as a boy, Jennings Farm was a pastoral sanctuary far removed from the world he inhabited in Led Zeppelin. This was where he could escape from that to normality, however briefly, as soon as the farm gates clanged shut behind him. It would also keep him bolted to his roots. Here he would be held fast to old friends and familiar haunts.

'I was incredibly fortunate to have the decompression chamber of that and my family,' he told me. 'Because whatever was happening to me out there with Zeppelin, I couldn't explain it when I got back. It wouldn't have been right for anybody and I'd have lost all connection with where I came from. I had to keep quiet about everything.'

He paid £6,000 for the place but it would be months before he could move his family in since it was almost derelict. While this great ruined shell was being renovated, Plant, Maureen and their daughter Carmen continued to lodge with his wife's family.

John Crutchley, guitarist in Plant's old band Listen, recalls catching up with him during this lull. 'We went off to Mothers in Birmingham in Robert's Jag. He'd dressed up in a suit, with a shirt and tie. Because we were with him we didn't have to queue to get in. The club was packed and after about half an hour Robert said he was getting hot. Being Robert, he drove five miles home to West Bromwich just to change into jeans and a T-shirt, and then drove back.

'We went out to Jennings Farm, too. It seemed massive to me. It was dark, run-down. There was a big duck pond, but no electricity. We spent a few candlelit nights out there. Then it all went crazy for him and we lost contact.'

This first year of a new decade claimed some of the best and brightest stars of the '60s, rendering several to ashes and dust. The Beatles would announce their break-up in April, and before winter had bitten, both Jimi Hendrix and Janis Joplin were dead, twenty-seven years old the pair of them, he choking on his own vomit and she overdosed on heroin. The '70s were harsher and less innocent times than the preceding decade, and Led Zeppelin were made for them.

They were up and running again in the first week of 1970, beginning a two-month-long tour of the UK and Europe at Birmingham Town Hall – the very place from which the sixteen-year-old Plant had pilfered Sonny Boy Williamson's harmonica. He was well practised in stealing from the old blues masters.

Two nights later, on 9 January, they headlined London's Royal Albert Hall. A grand old Victorian building crowned by a glazed,

wrought-iron dome, the Albert Hall conferred a sense of recognition upon all those who played it. Emphatically, their being there meant that Zeppelin had arrived in their homeland.

Their Albert Hall set is preserved on film and even now is astonishing for its raw power. As at most of their shows during the first half of that year they kicked off with a titanic reading of soul man Ben E. King's 'We're Gonna Groove', not so much covering the song as rolling over it like a juggernaut. Page, bearded and slight, summoned up one juddering riff after the next, the skipping gait of the original re-purposed by Jones and Bonham into a mighty crunch.

Yet for all the musical fireworks, watching the show today one's attention is drawn most to Plant as he pouts, preens and prances, basking in the spotlight. The West Midlands giraffe had gone into a cocoon and emerged as the blueprint rock god. He and Zeppelin stomped and rumbled on for more than two hours that night, and when they were done the Albert Hall stood and roared.

When compared with the theatres and city halls the band had filled in the UK, the North American tour that began on 21 March took place on an epic scale. It comprised twenty-six shows in large sports arenas, commencing in front of a 19,000-strong crowd at the Pacific Coliseum in Vancouver. Billing the tour 'An Evening with Led Zeppelin', Grant dispensed with the need for an opening act. His band upped their game accordingly.

There was a well-practised ebb and flow to Zeppelin's set. It began with a barrage, 'We're Gonna Groove', 'Dazed and Confused' and 'Heartbreaker' rushing into each other, before easing down, first into Page's showpiece 'White Summer/Black Mountainside' and then 'Thank You'. After this they cranked the tension up again, releasing it like a tight-coiled spring on the last

climactic surge, 'Communication Breakdown' snapping at the heels of 'Whole Lotta Love'.

Page had long since used a violin bow to scrape unholy sounds from his guitar during 'Dazed and Confused', and the song now became a piece of theatre as he wielded his bow like an impish ringmaster, milking the moment. Yet on this tour it was Plant who was most enhanced. No longer uncertain of his place in the scheme of things, with no trace of awkwardness left, he paraded front and centre, becoming at last the band's focal point. Offstage the atmosphere had also changed and become more charged. Limousines glided the band about and they took over entire floors of plush hotels. Booze and cannabis had sustained Zeppelin on their first trips through the US but by the time of their going back in 1970 cocaine had become the touring rock musician's drug of choice. The post-show carousing no longer had a warm, fuzzy afterglow to it, but a sharp-edged rush, heightened and inflamed. Bonham, who needed little encouragement where such things were concerned, gave himself up most to whatever mayhem ensued.

'Sadly, as we got more famous, the whole precocious aspect of Zeppelin became more of an issue for the media,' Plant told me. 'People backed off, not wanting to be associated with this supposed enormous quantity of hedonism. But that's what happens. You lose people along the way.'

Arriving in Los Angeles in late March, the band took over an upper floor of the Continental Hyatt House – right on the pulse of Sunset Strip. The lobby of the hotel began to crowd with groupies and hangers-on. This was nothing new, but the numbers were growing and with it the sense of rapaciousness.

'The first white girl groupie arrived in Hollywood in 1964,' recalls Kim Fowley, an old hand on the scene. 'Her name was

Liz, she had red hair and looked like a miniature version of Maureen O'Hara. She showed up at the Hyatt House and demanded I take her to see Manfred Mann, because she wanted to have sex with their singer. I'd never before seen an American girl who'd gone along expressly to fuck a member of a British group.'

Writing in her memoir *I'm with the Band*, Pamela Des Barres, who as Miss Pamela was perhaps the most famous of the LA groupies, described the frenzy stirred by Zeppelin's coming to town. 'The groupie section went into the highest gear imaginable,' she stated. 'You could hear garter belts sliding up young thighs all over Hollywood. Led Zeppelin was a formidable bunch. Robert Plant … tossing his gorgeous lion's mane into the faces of enslaved sycophants. He walked like royalty, his shoulders thrown back, declaring his mighty status.'

Page was among the rock stars bedded by Des Barres. He would normally dispatch a minion to do his bidding, having them escort his chosen girl, the younger the better, up to his hotel room, where the blinds were drawn and a state of permanent night existed. Plant, it was said among the crew, preferred to romance his tour girlfriends with flowers and poetry. He was twenty-one years old, and within the suspended reality Zeppelin occupied home and all that went with it might as well have been on another planet.

'It would have changed anyone, all of that,' says Cole. 'Because of all the money and success and everything else, you develop another way of living. The whole package is changing. But did they become a bunch of egomaniacs? Not from what I saw, no.

'After the shows, the band all went out together, all the time. They'd pretty much go to the clubs. All the things that were said about our behaviour … Of course, a lot of it is true but some of

it's not. Basically, it was the same four blokes, having the same in-jokes.'

The heat of the tour, however, took its toll. Constant travel, lack of sleep, too many highs both natural and artificial – all these exhausted the band. Battling a fever, one day blurring into the next, Plant struggled on. His voice finally gave out during the penultimate gig in Phoenix on 18 April. The last scheduled date in Las Vegas was cancelled and Zeppelin flew home.

The comedown from the tour lasted no more than a couple of months but this was a pivotal point for the band. For it was now that the seeds were sown not just for their next album, but also the three that followed – and these were their zenith. With Plant emerging alongside Page at the head of Zeppelin's creative power base, their inspirations were located in the rich musical stew then swirling around both men.

Specifically, this was music of a kind rooted in the past, but otherworldly, too. It was informed and brought about through escape and a sense of glorious isolation, both figurative and literal. In the US, Dylan's old backing group, the Hawks, took themselves off to a rural retreat at Woodstock in upstate New York. There, as the Band, they made a brace of wonderfully evocative albums, *Music from Big Pink* and *The Band*, bathing each in a sepia-tinted aspect of Americana.

The splintering of the Byrds and Buffalo Springfield gave rise to Crosby, Stills and Nash, their imperious harmonies captivating Plant in particular. The latter band also cut loose Neil Young, who mixed a more potent folk-rock brew on *Everybody Knows This Is Nowhere*. Plant and Page were both as taken with Joni Mitchell who, like Stills and Young, was Canadian by birth and had taken the same route out West. Mitchell's songs were hushed

and haunting, unfolding across two spectral records, *Clouds* and *Ladies of the Canyon*.

Closer to home, a pugnacious Irishman, Van Morrison, had served up a pair of entrancing albums of his own, *Astral Weeks* and *Moondance*, their bucolic landscapes peppered with folk, jazz and blues textures. With regard to Zeppelin, there were two significant native folk bands, too. The Incredible String Band was the brainchild of a couple of itinerant eccentrics, Robin Williamson and Mike Heron. Williamson had travelled through North Africa and brought back with him exotic-sounding instruments, adding these to his band's whimsical folk songs and stirring a singularly esoteric cocktail.

Fairport Convention had formed in London and, like Plant, been captivated by the sounds coming from America's West Coast. They had found their feet on the same club circuit as the Band of Joy but by 1969 had cast their net further back, to traditional English and Celtic folk songs. Decamping to a 17th-century house in rural Hampshire, they there assembled *Liege & Lief*, the album that set the benchmark for British folk-rock.

Plant also had a mind to get away from it all. He remembered an old stone cottage in North Wales his parents had taken him to one summer. It was named Bron-Yr-Aur, Welsh for 'golden hill'. Close by was the mountain Cadair Idris, legendary seat of King Arthur's kingdom, and also Valle Crucis Abbey, where the Holy Grail was reputed to have been hidden. Folklore and remoteness – if ever there was a place to light Plant's creative fires, this was it.

He sold Page on the idea, too. The first warmth of spring was in the air when they set off, Plant bringing along his family and dog, Page his new girlfriend, a French model named Charlotte Martin. To take care of their domestic needs, a couple of

Zeppelin's roadies, Clive Coulson and Sandy Macgregor, were commandeered for the trip.

To get to Bron-Yr-Aur, one must first head out from the town of Machynlleth on the road to Pennal village. A mile down and just off this road a steep track winds up the hillside. Walking along it, the only sounds to be heard are those of birdsong and the babble of a brook. Soon the track levels out, following the line of the brook through an avenue of trees, fields and moor to each side, the crest of Snowdonia's peaks on the horizon. At its furthest point is the cottage, quaint but hardy, set in the 'V' between two looming hills and with the broad sweep of the Dyfi Valley ahead of it.

Then, as now, the cottage had no running water. For warmth there were a couple of gas heaters and a wood fire. There was a chemical toilet but the luxury of a bath required a trek down to a pub in the town. Plant, Page and their small band holed up here for a month. A restorative but also a productive spell, it was at Bron-Yr-Aur that the two principals first began to write together, the songs pouring from them as they roamed the hills or pulled up around the fire each night.

Plant hit upon the chords to a trippy ballad, 'That's the Way', one afternoon as the pair of them sat out by the brook with their acoustic guitars. Recalling a series of scales he had picked up in India during his days in the Yardbirds, Page used them as the basis for another new song, a mystic-sounding drone called 'Friends'. Both these songs would appear on the next record. Others originating from this time, such as 'Down by the Seaside' and 'Over the Hills and Far Away', would be stored up and find their way onto later albums.

Reflecting on this sojourn, Plant told me: 'It created such a dynamic, coming off tour and going up to Wales. It was this

thing about trading excess for nothingness, having these great pastoral moments.'

Leaving their idyllic retreat, he and Page gathered up the others and followed in the footsteps of Fairport Convention, making for the Hampshire countryside and a crumbling old mansion house, Headley Grange. Built in 1795, it had once served as a workhouse and shelter for the local poor and destitute before falling into disrepair. The band hired the Rolling Stones' mobile studio, parked it on the overgrown lawn out front and set to work on their third album.

'It was a horrible place – cold and freezing,' says Cole of Headley Grange. 'That first time, they were all staying there, though later on it'd just be Jimmy and some of the crew that kept rooms. It was too miserable for the rest of us.

'They'd all wander downstairs at different times. Jimmy would be messing around with something. Jonesy would listen in and add a little bit to it. Robert would sit there writing his lyrics. It was as informal as that.'

The record that came out of these laid-back sessions, *Led Zeppelin III*, remains their most undervalued. There is an intimacy to it lacking on the first two albums, the sense of a moment having been captured, one in which the band were playing for themselves and no one else. The span of material is greater still than on their début but there is none of that record's desperate urgency. Here Zeppelin sound assured, stretching themselves and enjoying the act of doing so.

The work begun by Plant and Page at Bron-Yr-Aur, and completed at Headley Grange, opened the band's frontiers. Not just to blues and rock 'n' roll now, but to sounds that ranged far and wide, from the heat-haze of California and the east of India, on down through the roots of the British folk tradition.

Half these new songs were acoustic. There was a second ballad, 'Tangerine', and a skiffle shuffle misspelt as 'Bron-Y-Aur Stomp' (later corrected for the instrumental 'Bron-Yr-Aur' on *Physical Graffiti*); this last was Plant's tribute to his dog, a collie named Strider, with Bonham on castanets and spoons. 'Gallows Pole', an old English folk song, was stoked by the band into a heady whirl.

Of the electric tracks, 'Celebration Day' and 'Out on the Tiles' have the feel of songs coming together on the spot, one as carefree as the other. Best of all, the stately 'Since I've Been Loving You', debuted towards the end of the last North American tour was their first great blues, Page's fluid, weeping guitar offsetting Plant's bruised howls.

The song that launched the album, 'Immigrant Song', came together at the end of the sessions, Plant inspired to write the lyrics upon returning from a gig in Iceland that June. To the gallop of guitar and drums, he sent out Zeppelin's battle cry: 'The hammer of the gods will drive our ships to new lands, to fight the horde, singing and crying, Valhalla, I am coming!'

On 28 June Zeppelin made their second appearance at the Bath Festival in England's West Country. Like the Albert Hall show, this would be a further symbolic gig for them in the UK. That weekend, a hot one, 150,000 people crowded the Shepton Mallet Showgrounds, Zeppelin headlining the closing night. This offered them the perfect platform on which to seal their victory at home.

They went on directly after Jefferson Airplane and just as the sun fell behind the stage. Such a dramatic backdrop was no accident. Aware of the significance of this one gig, Grant had checked the precise time of sunset and determined his band would go on

to meet it. When a group called the Flock began to overrun their set earlier in the evening, threatening his master plan, Grant had them hauled off. Nothing and no one would be allowed to stand in the way of his boys.

Roy Williams, then running a popular Black Country rock club, Dudley JB's, travelled down to the festival.

'I'd seen some of the very early Zeppelin gigs and couldn't make top nor tail of them,' he says. 'It was loud, but I just didn't get it. That weekend, a group of us had rented a van to drive to the gig. We did all head off with this attitude of, "Aw, Planty, let's see what you can do." By the third number we were up on our feet like everybody else.

'It was a revelation for all of us. They were magnificent. Robert had become more aware of how to handle an audience, more confident. We went home with a degree of pride. You know the crap that comes out: "Good old Planty."'

'It was astounding, because I'd never heard anything like that before and I don't think the audience had either,' adds the folk singer Roy Harper, also on the bill that weekend. 'After the initial shock had passed, I realised who the singer was – the guy with the girls on his arm I'd met in Birmingham just eighteen months before. There he stood, with a freak of a voice, conducting this great force.

'More and more people stood up. I became aware of the fact that tears were streaming down most of the women's faces. It was a moment of ecstasy. By the time they'd finished it was obvious that the world was at their feet.'

For Zeppelin the respect was mutual. Watching Harper's set that afternoon gave them the missing title for the discordant blues track intended to close their forthcoming album. It became 'Hats Off to (Roy) Harper'.

On they rolled. Into the US, then descending deeper into the abyss, National Guardsmen shooting dead four students at an anti-war protest at Kent State University on 4 May. Not that much would now be allowed to permeate through to Zeppelin, since Grant and his emissary Cole had begun to throw a protective shield around the band, sealing them off and allowing them to run wild.

Those late summer months Zeppelin tore through the country, the shows getting looser and rowdier. They were back in LA at the start of September, the Continental Hyatt House now re-christened the Riot House such was the carnage Zeppelin had begun to trail about them. After an incendiary show at the Forum on 4 September, the band headed out to blow off steam. Their friends Fairport Convention were in town and playing the Troubadour club. By now an order had been established: Bonham would blow harder than anyone else.

'It was incredible what went on,' says Dave Pegg, bassist with Fairport Convention. 'If I'd been in Zeppelin I'm sure I wouldn't be alive now. I don't know how anyone can have gone through what they did and still be sane.

'We drank all night. I opened my eyes and it was 10 am the next morning, the sun shining through the window of the club. The place was deserted but for Bonzo and me. He said, "Come on, I'll drop you off, the limo driver will be waiting." Sure enough, there he was – he had sat outside all night.

'Bonzo was supposed to be on a plane to Hawaii that evening. He never made it. I was with him and Janis Joplin at Barney's Beanery, a well-known drinking establishment. We went back to my hotel and bumped into two over-excited ladies from Texas, who'd got a big bag of grass that we started smoking. John ended up running around the pool in just his

Y-fronts. He phoned me the next day to ask me if I knew where his clothes were. We had to lend him some clobber and buy him an airline ticket.'

For now these were still high jinks. They were entitled to celebrate, after all. The tour ended with an afternoon and evening show at New York's Madison Square Garden, their gross from this single engagement running to $200,000. Back home they were crowned 'Most Popular Group' in the music paper *Melody Maker*'s annual poll, the first time in eight years an act other than the Beatles had won the award.

Plant retreated to the Midlands. He looked up his old schoolmate, John Dudley, for whose band he had first sung just seven years back but a lifetime ago.

'Robert came into my granddad's pub, the Bull's Head, where we'd done our first gig together,' recalls Dudley. 'Of course, he was famous now, so everyone was staring and pointing at him. My band was up there playing when he walked in, so we immediately started up the riff to 'Whole Lotta Love'. He smiled and said, "You bastards".'

He and Maureen took up residence at Jennings Farm. He had restored the barn, turning it into a music room with a drum kit and guitars, and bought himself an old Jeep in which to charge about the property. The couple threw open the doors, entertaining friends old and new.

Mike Kellie, drummer with Spooky Tooth, was one visitor. 'Robert was very generous with his friendship, though I was always quite intimidated by him. I didn't have the self-confidence he had. I remember walking around the fields with him – he'd got some goats and some of them had escaped. I didn't get to know Maureen well but she liked to party. Our wives had a lot to put up with.'

'I ran into Robert in a gun shop in Dudley and he was giving me all this blather about him becoming a gentleman farmer,' recalls Perry Foster, who had taken the teenage Plant on as singer for his Delta Blues Band. 'He was a bit patronising. He affected this posh voice: "You must come down to the farm and we'll do a tape for posterity."

'Now, I'd never had anything to do with drugs, but around this time he'd got certain people around him. One of them he'd named his estate manager. I told him if he got rid of all the scum hanging about I'd be happy to see him. He didn't like being spoken to like that.'

Released that October, *Led Zeppelin III* came wrapped in an expensive spinning-wheel cover modelled on an old crop-rotation chart. Etched onto the inner vinyl groove of the record were two quotations: 'Do what thou wilt shall be the whole of the law' and 'So mote be it.' Both were attributed to Aleister Crowley, an occultist and conman born in the British spa town of Leamington in 1875 who was once dubbed 'the wickedest man in the world'. Such was Page's growing fascination with Crowley he had just then bought his old home, Boleskine House, a gothic pile on the banks of Loch Ness in Scotland. For now, the reference to Crowley passed unnoticed. Soon enough it would be blamed for all the ills that beset the band.

The album repeated the path of its immediate predecessor, going to Number One in both the US and UK. Good as it was, however, this was a less immediate and obvious record, and its success would not be as enduring. It soon slipped out of the charts, having sold five times less than *Led Zeppelin II* had done.

For Zeppelin this was a first bump in the road. Grant's response to it was immediate, sending them off to make another record. They already had a stockpile of material, much of it dating from

Plant and Page's stay at Bron-Yr-Aur. In particular, Page was struck by the bare bones of a song he had begun working up while they were there. Although it was just a guitar melody at this point, he sensed in it something special. Such were the beginnings of 'Stairway to Heaven'.

BLOND ELVIS

***He was this preening
peacock.***

A flood of great music gushed out in 1971. Running through the best of it was a seam of pure, naked inspiration that was white hot and crackling with magic. It was as though the survivors of the '60s had gathered themselves to launch one last, heroic upsurge, their fires not yet dimmed and the drugs still then working. Once done, few of them ever aspired – or reached – as high again.

The Rolling Stones, at the pinnacle of their decadent pomp, came up with *Sticky Fingers*; the Who, never better, made *Who's Next*; Jim Morrison roused himself to a powerful valediction on the Doors' *L.A. Woman*. From the debris of the Beatles, John Lennon continued to touch at greatness with his second solo record, *Imagine*, although it would be the last time he would do so.

Still it poured out, into the delicate beauty of Joni Mitchell's *Blue* and through the pulsating funk and narcoleptic jazz of Isaac Hayes's *Shaft* soundtrack; or, as other, very different songwriters

flexed their muscles – Leonard Cohen, David Bowie, Elton John and Roy Harper, whose beguiling *Stormcock* included a guest appearance from Page. Then, too, a contrasting pair of visionary soul albums: Marvin Gaye's bittersweet song cycle, *What's Going On*, and in brilliant answer to that, Sly Stone's nightmarish state of the nation address, *There's a Riot Goin' On*.

As a creative statement Zeppelin's fourth album sat shoulder to shoulder with the best the year gave up. It was timeless and boundless, and the sum of all their parts. It housed some of their hardest rock and mightiest blues but also songs that are among their most pastoral – these again stretching back through the ages of Britain's folk tradition. Soon enough it would stand unopposed as a commercial behemoth, a looming colossus that was bigger and more enduring than all the rest.

Not that it was begun in splendour. At the start of 1971 Zeppelin went back to Headley Grange. There had been no improvement in conditions at the old house, it being still damp and frigid, and the winter nights were deathly cold. In the background the band's record label, Atlantic, was panicked by the relative failure of their last album. Yet that record had freed Zeppelin and they were now arriving at the peak they would sustain for the next four years.

The Rolling Stones' mobile studio was again parked out on the lawn and the laid-back vibe of the previous summer also returned. The prevailing sound among the band was of laughter. Bonham, a habitual late riser, often as not came down to find his drums had been hidden, the day's work developing to his ranting and raving about the place. This playful mood filtered through to the sessions. There was an instinctive spontaneity to them – the best of things happening on the hoof and seized from out of the ether.

This was the case with 'Black Dog' and 'Rock and Roll', the songs that would open the album with such a gleeful flurry. These morphed out of impromptu studio jams, the jumping-off point for both being a couple of Little Richard tunes the band kicked around to let off steam, 'Good Golly Miss Molly' and 'Keep A-Knockin''. Each of these informed Page's propulsive riffs, the latter song giving up the drumbeat with which Bonham cracked open 'Rock and Roll'. Ian Stewart, the Stones' road manager and sometime pianist, sat in as that song unfolded, his boogie-woogie piano winding through the track like a vein. Plant scat the lyrics to 'Black Dog' on the spot, leering and lecherous and unapologetic for it.

One night Bonham arrived back at the Grange from a jaunt into London worse for wear and of a mind to set about his drums. He did so armed with a pair of sticks in each hand, summoning up both the dense rhythmic grumble upon which 'Four Sticks' was built and the song's title. It was Bonham again who was the key ingredient of 'When the Levee Breaks'. Written by Memphis Minnie to document the Mississippi River flood of 1927 that left 600,000 people destitute, the original song was a sparse acoustic lament. Zeppelin transformed it into a thrilling, monstrous surge. It was swung into being by Bonham's resounding volleys, Page recording his cavernous drum track in the Grange's high-ceilinged entrance hall.

On this song, and elsewhere on the record, Plant sang with as much assurance and conviction as he ever would with Zeppelin. The escape to Bron-Yr-Aur with Page had energised him and now he was further emboldened by the newly rich variety of the band's palette. For the first time there was as much evidence of him in the material as there was of the guitarist. He fed into the record his hippy ideals and passions for ancient history and

mythology. 'Going to California' was shaped by his appreciation for the gentler musings of Neil Young, Crosby, Stills and Nash, and, most pointedly, Joni Mitchell – the 'girl with the flower in her hair' in Plant's love letter to both the sunshine state and a state of mind. To the band's rolling gait on 'Misty Mountain Hop' he recounted the tale of London police busting up a love-in, burnishing it with the sense of a mystic quest.

Drawing the inspiration for 'The Battle of Evermore' from a book he had been reading about border wars between the armies of Albion and the ancient Celts, Plant peppered the narrative with references to Tolkien's *The Lord of the Rings* – from here came the song's 'Dark Lord', Sauron, and its Ringwraiths riding in black. Just as they had done so often at Bron-Yr-Aur, he and Page sketched out the song one night while sitting in front of an open fire, Page picking at a mandolin that Jones had left lying about, the first time he had played the instrument. For all their differences as people, at times such as these the two of them were joined at the hip.

'I think Jimmy and Robert now are far more opposite to each other than they ever were back then,' considers Cole, an observer of these sessions. 'They've gone in such different directions. You wouldn't have thought of them as that if you'd seen them in Zeppelin, at least not when it came to the music. They were a unit when they were working.'

To sing the song's ethereal counter-melody they brought in Sandy Denny, who had known Page since his art-school days and had not long left Fairport Convention. Set against the keening of Plant, Denny's enchantments evoked an arcane atmosphere alive with mystery and wonder – one that suggested tendrils of mist snaking around towering battlements at morning's first light.

120

Later that year Denny would produce a solo record almost as evocative, *The North Star Grassman and the Ravens*. It was to be her artistic swansong. Soon, a ruined marriage and the ravages of alcoholism would consume her, and she died on 21 April 1978, aged thirty-one, from injuries sustained in a fall.

Yet it was the song that came to define Zeppelin's fourth album, and to a great extent the band itself, that most conflicted Plant. Filling in the outline he had first set down at Bron-Yr-Aur, Page determined that 'Stairway to Heaven' would be an epic, the ultimate welding of Zeppelin's acoustic–electric dynamic. From the lilting melody Page had hit upon in North Wales, it rose up through a series of escalating movements, concluding with a roaring finale. As Page worked through the arrangement with Jones and Bonham, Plant began to improvise the lyrics.

'We were channelling a lot of energy,' Page told the writer Brad Tolinski. 'My sharpest memory of "Stairway" is of Robert writing the lyrics while we were hammering away. It was really intense. By the time we had the fanfare at the end and could play it all the way through, Robert had 80 per cent of the words down.

'I'd contributed to the lyrics on the first three albums but I was always hoping that Robert would take care of that aspect of the band. By the fourth album he was coming up with fantastic stuff. I remember asking him about the phrase "bustle in your hedgerow" and him saying, "Well, that'll get people thinking."'

'Bonzo and Jonesy had gone off to the Speakeasy Club in London – to relax, I think that's a good term for it,' Plant told *Rolling Stone* writer David Fricke. 'Jimmy and I stayed in, and we got the theme and the thread of it there and then. It was some cynical aside about a woman getting everything she wanted all

the time without giving back any thought or consideration. And then it softened up. I think it was the Moroccan dope. It's a nice, pleasant, well-meaning and naïve little song, very English.'

As proud as Page was of their new creation, Plant was ambivalent about it. Later, when he came to crave distance from Zeppelin and also critical approbation, his attitude towards the song hardened. Its overwhelming presence made it his millstone. He was self-conscious about its hippy-dippy lyrics and made to flinch as it spawned one portentous rock ballad after the next.

Yet for all that it has been over-exposed, 'Stairway to Heaven' has retained its power. Neither Zeppelin's finest song nor perhaps even the best on their fourth album, it is a great one nonetheless.

However good the feeling within the camp at Headley Grange, little of it translated to outsiders once Zeppelin moved on. Finishing off 'Stairway to Heaven' was foremost in Page's mind, since he had still to cut his guitar solo. For a couple of weeks he and the band retired to the Island Records studios on London's Basing Street, intending to complete the final mixes of both it and 'Four Sticks'.

It was a cramped, windowless room, oppressive enough before Zeppelin, Grant and a couple of their crew crowded into it. Engineering the session was Phill Brown, who had first encountered the band at Olympic Studios during the making of their début album. From then to now Brown sensed about them something darker and more menacing, and this emanating from Page and Grant.

'It was really rough,' Brown says. 'Peter Grant was there pretty much all the time. He used to sit either with me at the mixing desk or on this big settee behind. He unnerved me. He was like

an East End hood. He was about 350 pounds then – big, sweaty and aggressive. Having him sat there with a couple of 220-pound minders, it wasn't the usual way we did things at Island.

'At that point Jimmy Page seemed really messed up. There were obviously a lot of drugs around but he was also into this Aleister Crowley thing. It just put an edge to the session. There was something unpleasant about the whole thing.

'The rest of the band was OK. Robert seemed very polite. He'd make the odd comment but more to Page than anyone else. John Paul Jones was a bit of a sweetheart, very clever musically. Bonham could be full-on and aggressive, though I didn't see him that much because he wasn't needed.'

Unlike at the Grange the pace of work was slow and laborious. Time and again Page took a pass at his 'Stairway to Heaven' solo.

'The track was still in something of a skeletal state,' recalls Brown. 'We did take after take with Page and for days on end. Robert later told me that Jimmy does a lot of experimenting, and out of all the best bits he moulds a solo. Nothing was explained to me at the time, though. I was just left to wonder what the hell was going on.

'Page was all over the shop, too. Out of tune a lot of the time. He didn't communicate with me at all. A lot of it was done in the control room, through an amp in the studio and with him sat right next to me. He would just go: "Again … Again … Again". It was all very aggressive. He seemed a dark character, that's the only way I can explain it.'

To test out the new material the band undertook a series of low-key dates around the UK that March. Dubbed 'Back to the Clubs', the tour found Zeppelin as energised as at any time since their first charge through the US, performing stripped-down

and hellishly loud sets, often up to three hours in length. They previewed 'Black Dog', 'Going to California' and also 'Stairway to Heaven'. On the opening night at Belfast's Ulster Hall on 5 March Plant introduced their new epic as 'A thing off the fourth album – I hope you like it.' He later claimed that people had nodded off the first few times it was played.

On 1 April they recorded a session for the DJ John Peel's BBC radio show in front of 400 people at the Paris Theatre in London. Peel, who had been instrumental in introducing Plant to America's psychedelic music and was then one of the few representatives of the British media to champion the band, broadcast their set to the nation three nights later.

'The atmosphere at the Paris Theatre was quite formal, very austere,' recalls Bob Harris, a colleague of Peel's. 'Everyone was sitting down. It wasn't a show where you'd got a band whipping the audience to a wild frenzy, quite the opposite. Yet the music was sensational and Robert had become the definitive cock-rock god.

'By that time Peter Grant had got this idea of trying to make Zeppelin untouchable, of removing them from access so that a mystique began to build up around the band. I think his template was Tom Parker with Elvis, but it meant there began to be this fist of iron thing in terms of the environment in which they operated.'

Life went on outside of the Zeppelin bubble. That March Page had become a father for the first time, Charlotte Martin having born him a daughter, Scarlet. There was, though, never much time afforded for such things. Come the summer, Zeppelin were back on the road, first in the US, where the lack of a new album did not stop them from selling out twenty-one arena shows, and on then to Japan for the first time.

It was a relentless schedule and one through which cracks were beginning to show. Bonham's drinking was getting heavier, and with it his behaviour became more erratic and unpredictable. Yet it also let Plant satisfy the wanderlust that had grown inside him since childhood, when his parents had first whisked him off to the Welsh mountains. Its pull was as great as that of his family. Rather than head home direct from Tokyo, he and Page wound their way back via Thailand and India, accompanied by Cole. They visited the great Buddhist temples in Bangkok and stayed at the Taj Mahal Hotel in Bombay, shopping for trinkets and antiques.

'They took me along because they needed someone to look after them and pay for everything,' Cole says. 'We had a fantastic time. I managed to get a couple of good local drivers who took us everywhere we wanted to go and even to places we didn't know about. We didn't want to go to the same spots as everyone else. In those days that mostly involved heading out to shops where you could buy old artefacts.

'Robert loves travelling. He likes eating different foods, meeting different people, and hearing all kinds of music. How would I describe being with him? Um … It depends on the mood I was in. He was quite sweet, actually. He's harmless, certainly not malicious.

'You worked in a field where anything could happen. I mean, Bonzo … Sometimes you'd go to his house and he'd be dressed up as a country squire, then he'd come on tour and be decked out in a white suit. He was a real chameleon, always changing. Robert basically stayed the same. He was always a hippy. A golden god.'

Plant and Page continued to explore, absorbing the music they heard on their travels and filtering it back into Zeppelin.

Early the next year they returned to Bombay. Here, through a contact of Page's, they set up a recording date with the city's symphony orchestra. At this, they re-worked 'Four Sticks' and 'Friends' with the local musicians, setting a precedent that Plant, in particular, would follow time and again.

A second trip the pair took together in 1972 left an even more marked impression on Plant. This was to Morocco, sitting on the north-west tip of Africa, just across the sea from Europe but a world away. In Marrakech, a centuries-old city of low, red-brick buildings to the south of the country, Plant first heard the music of the indigenous peoples, the Berber and the Gnaoua – these were enticing and trance-like drones, rhythmic and hypnotic.

He and Page took a tape recorder and drove up into the Atlas Mountains, the great range that runs east to west across the country for 1,600 miles, recording this music in villages and farmers' markets. Back in Marrakech and wandering its teeming network of souks, Plant also came across Oum Kalsoum, an Egyptian by birth and then the greatest living Arab singer. Her remarkable, soaring voice haunted the city's radios, an instrument in itself.

'I think my thing with North Africa actually began in North Wales,' he told me. 'That whole thing about the mountains and remoteness was a great alternative to my days as a grammar-school kid. I went to Morocco in 1972 looking for clues and they were all around me.

'Marrakech then was a far different place to what it is now. We stayed in a hotel that was surrounded by barbed wire and these guys with Royal Enfield rifles – they looked as if they were guarding us from an impending attack. But basically, it was another world. I remember going into town the next day. It was almost as if I'd just got over a huge loss in my life and found

everything again. Yet I'd never been there before. I could speak enough French to get by but up until the last ten years or so I was always a tourist there.

'Above all the sounds I heard this voice – Oum Kalsoum singing. Her voice was everywhere, coming out of one doorway after another, shimmering through all the fuss and the chaos, the car horns and the braying donkeys. I just went, "Wow! How do you take that into what I do?" And I bought into the whole thing.'

The fourth Led Zeppelin album did not emerge until November 1971. The record had been delayed by a battle Page fought with Atlantic Records over the sleeve artwork. He had grown sensitive to the critical attacks on his band and especially to the persistent charges that their label had hyped them. In response he intended the new album's sleeve to have no information on it: neither the band's name nor a title. The stand-off between him and Atlantic lasted months, but Page won.

In the end all that graced the front cover was a framed picture of an old hermit – this Plant had picked up in a junk shop. The photograph on the back of the gatefold encapsulated the conflicting moods of the album itself: a withered tree in the foreground, a background of ruined terraced houses and a block of flats – a pastoral idyll encroached upon by looming hulks.

Page also had the idea that each member of the band should choose his own symbol. Pictured on the inner sleeve, these gave the record one of its default titles – *Four Symbols*, the other being *Led Zeppelin IV*. Page's Zoso emblem has long been presumed to possess occult connotations, although he has refused to be drawn on its derivation. Jones and Bonham each picked something out of a book, neither giving the matter much regard.

Plant, however, had his symbol designed for him, a circle around a feather. He explained that the feather represented courage to Native American tribes and the circle was meant to depict the truth. 'Though you might also say it's about a French maid tickling someone's bum,' Page quipped to the writer Mick Wall.

Whatever ground Zeppelin had lost with their third record, the fourth reclaimed it and then kept on going. It went to Number One in the UK and, although it was held off the top spot in the US by Carole King's mellow blockbuster *Tapestry*, it would remain on the charts there for three years, selling twenty-five million copies.

That November they headlined two nights at London's vast Empire Pool, billing the shows 'Electric Magic' and populating the arena with jugglers, acrobats and – but of course – pigs dressed with ruffs. Still there was no pause. The following year began with dates in Japan and Australia. And then the band started work on their next record, moving houses in Hampshire from Headley Grange to Mick Jagger's country home, Stargroves.

There was no let-up either in the torrent of material coming out from them. Page and Plant especially were filled with all the music they had taken in on their travels during the past year. At Stargroves the songs seemed to drip from their fingertips, so much so that they would spend the next months obsessing over which ones to use.

'The band was in great shape,' Eddie Kramer, engineer on the sessions, told the writer Barney Hoskyns. 'They were focused, they were together and the music was incredible. They were fun to work with – and they wound me up something horrible. I'd brought this chick over from the US and Robert banged her right away.'

Plant took a break from the ribald atmosphere of the Stargroves sessions towards the end of April, as he and Maureen celebrated the birth of their second child, a son they christened Karac Pendragon Plant. Pendragon was his father's choice, it being the name of one of King Arthur's uncles and also Welsh for 'head dragon'. Just as he did with Carmen, Plant doted on the boy. At home, at least, he was the picture of a proud family man.

Yet he was gone again two months later. In the summer of 1972 Zeppelin took off on a sixteen-date rampage through North America. However much success they had had at home, it was in the States that they still reigned supreme. The Rolling Stones were heading out to America at the very same time but Zeppelin would outsell the self-styled 'world's greatest rock band' by a ratio of two to one. Before the trek began, Grant had used the full force of their power to demand for the band – and receive from the promoters – an unprecedented 90 per cent of the tour's profits.

They arrived in the States as news was emerging of a break-in at the Democratic Party headquarters in the Watergate building in Washington, DC. Eventually, this act would engulf President Richard Nixon in scandal and bring him down. Yet for now he appeared able to act with impunity. It would be as good a parallel as any for the route Zeppelin were embarked upon and to where it would lead them.

On this tour they seemed unstoppable but also untouchable. Out in LA, Page was widely reported to be consorting with a petite, dark-haired groupie named Lori Maddox, who bore a striking resemblance to him. Whatever went on, and whatever it took, Grant and Cole were there to clean up the mess and keep the rest of the world at a strong-arm's length.

The band flew in to New York during the second week of June. They had booked a session at Electric Lady Studios to continue work on the new record. Mike Kellie, Plant and Bonham's friend from back home, was also in town for a recording date of his own and joined the Zeppelin entourage for a couple of days.

'There were always limos parked outside the hotel for them; that's the way they operated,' he recalls. 'The entourage – Peter Grant, Richard Cole, the band – they'd all go out together. With the exception of John Paul Jones. He never joined us. Jonesy was a lovely, sweet guy and he'd fly his wife in whenever they had a day off. He suffered a lot of abuse from Bonzo, and some from Robert, too, for not being a party animal, but he was the real glue in the band.

'You didn't mess with Richard Cole. He took the punches and gave them out. Him and Peter Grant – they were definitely intimidating. Of course, all that went too far but they made me hugely welcome. They showed me a different side of the world, however dark, through the parties and the debauchery that went on.'

One afternoon in the city Zeppelin trooped along to Madison Square Garden to see Elvis Presley give a matinée performance. Elvis was then on his first tour of America's arenas, encouraged to do so by the example of bands like Zeppelin.

'Bonzo put on his Teddy Boy suit and slicked his hair back to go,' says Kellie. 'I'll remember one moment till the day I die. It showed off all Robert's confidence and how he was this preening peacock.

'We were coming out of the show. I thought it had been wonderful but Robert wasn't impressed – he thought Elvis had died when he went into the army. As we were walking to the

limo a couple of girls walked by in the afternoon sunshine. Robert shouted to them: "Don't worry, girls – Elvis is alive and he's got long, blond hair!'"

SODOM AND GOMORRAH

***That's the kind of world they inhabited
and Robert detested it.***

Zeppelin closed 1972 and began the next year touring the UK. There was a visceral, almost manic intensity to these twenty-five shows, the band cranked up into top gear. London aside, the venues were modest, theatre-sized, seeming not quite big enough to contain them. When they were like this, locked into each other and the moment, it was as though they were an untamed force of nature.

Each night would open with an explosion of drums, Bonham hunched behind his kit, arms flailing. And then, to a blaze of white light, Page stepped forward to fire up the headlong charge of 'Rock and Roll'. Next, they would go into a song destined to appear on their fifth record, 'Over the Hills and Far Away', light on its feet and effortless, before bringing the hammer down again on 'Black Dog'.

His chest bared and head flung back, Plant puffed himself up and paraded through this spectacle like a great lion. No one, him least of all, doubted for a second who everyone was looking at.

And he was now more than just a singer. He would send his voice shrieking to the heavens – using it like an instrument, just as he had heard the great Arab singers do in the markets and mountains of North Africa.

The sets were long, nearly three hours, but full of peaks and valleys – 'Whole Lotta Love' stretching out into a melody of old blues and rock 'n' roll songs, each night rounded off by a shuddering 'Heartbreaker'. Yet it was 'Stairway to Heaven' that emerged as the centrepiece of the show, hushing audiences as it unfolded, sending the place wild when it swept to an end. These were the best of times for the band in their homeland. Just then, it would have been impossible to believe that this was to be the last time they would tour the country.

Two London shows rounded off the first leg of the tour, both at Alexandra Palace, an elegant Victorian building set on a hill to the north of the city and once the site of the BBC television studios. The last of these took place on 23 December, snow falling on a freezing night, and after it Plant handed the band's crew a Christmas present. It was a single bottle of Scotch whisky to be shared between them. By now they had grown used to Plant being cautious with his money and had given him a suitable nickname. Among each other and his band mates he was called Percy – the man who never got his purse out.

When the band was not working Plant saw very little of Page and Jones. He would retreat to Jennings Farm, spending his time off messing around in his music room or, on a Sunday morning, playing football for the local pub team. Bonham had also bought his own farm, a fifteen-acre spread a couple of miles down the road from Plant's, and the two men often met up for a beer, although Plant steered clear of Bonham whenever he went off raging.

'When John was really having a drink, I think he scared Robert and he didn't want to be around him,' says Stan Webb, guitarist with Chicken Shack and one of Bonham's regular drinking buddies. 'I can remember a lot of the big nights I spent with Bonzo, and Robert wasn't present at any of them.'

'Page, and Bonham to a degree, were different to me,' Plant told the writer Cliff Jones. 'I reasoned that I could sing about misty mountains and then chip a football into the back of the net on my days off. That felt like the good life to me back then. It wasn't all-consuming for me in the way it was for the others.

'Don't forget that we had no choice but to get caught up in all that hotel room and drug binge kind of thing, because it was part of the experience, almost expected. But I always knew there was a time-out when I'd get off the bus and come home.'

Plant bought a second property, a working sheep farm at Dolgoch on the southern edge of Snowdonia National Park in Wales. Dividing his time between there and Jennings Farm he settled back into life with his wife, daughter and newborn son at the end of the UK tour. He had converted the old stables at Jennings Farm and went riding in the surrounding fields or hiked up into the hills.

By now he had also wrapped around him a close-knit gang of mates, most of whom he had known from his first bands or the local club circuit. Although people came and went, the central core of this group has remained to this day. To a man they're fiercely loyal to Plant, so much so that in the Zeppelin camp they were referred to as his 'Midlands mafia'. Among these friends, and with his family, he seemed less imposing, more relaxed, although no less sure of himself.

Bev Pegg, a local folk musician, first met Plant that year. 'He was converting his barn into a recording studio and he'd got

these old Revox tape machines lying around that he didn't know how to use,' he recalls. 'I gave him some tips on how to multi-track with them. He'd got a beautiful old jukebox in there, too.

'He took me around the house. The living rooms and the bedrooms all had a very Indian-style décor. There were several cars parked out the front, a late-'50s Buick and a maroon Aston Martin, which he said he'd bought from Donovan. He seemed very down to earth, though. He could be a bit abrupt sometimes, but I found it difficult to understand all these reports about hotel rooms being smashed up. It didn't sound like the same bloke I knew. He always gave me the impression of being someone who'd be in control.'

'Robert had kept in touch with me and he'd come by when Zeppelin weren't doing anything,' remembers Bill Bonham, keyboard player in Obs-Tweedle, Plant's immediate pre-Zeppelin group. 'The last time I saw him was at Jennings Farm in '73. He wanted to know if I still had a pair of trousers that he'd left at my parents' pub five years ago.

'We went out to his village pub and he was telling me about all the money he was making. Back then he was still saving the money-off coupons from his cigarette packets. Then he said he'd left his wallet at home and I had to pay for the drinks.'

Soon enough Zeppelin stirred again. For the next tour Plant wanted to have a sound engineer to enhance his on-stage vocals. He was recommended Benji LeFevre, a twenty-three-year-old Londoner who had been working with the prog-rock band Soft Machine and at a jazz club, Ronnie Scott's.

'He rang me and suggested we meet near his home – at this pub in Kidderminster called the Market Tavern,' recounts LeFevre. 'He told me they had a great stripper on. So I took the

train up from London, met him, watched the stripper and had a few pints. Then he asked me back to his place.

'We got in his E-Type Jag and he scared the living daylights out of me with his driving. Anyway, I didn't appear fazed so I guess I passed the audition. I thought he was arrogant, full of himself and very confident. He was also articulate and I thought perhaps I could have a laugh with him.'

The band went back out on the road at the start of March, touring Europe. This was a prelude to the serious business. Released at the end of that month, the new album paved the way for their biggest and most ambitious assault yet on North America.

It had taken months of wrangling, but the band had pruned the excess of material they had cut at Stargroves the previous spring down to eight songs. The rest they put to one side. One of these leftover tracks gave the album its title, *Houses of the Holy*, the first time they had bothered with such a thing.

If Zeppelin had felt pressured at having to follow the staggering success of their fourth record it did not show. Most of all, *Houses of the Holy* sounded like the work of a band that felt they could do whatever they liked. At best, this sense of abandon resulted in some of their most enduring songs, such as 'The Song Remains the Same' and 'The Ocean', full-bore rockers both, Plant's urging vocals cutting a swathe through Page's driving, densely layered guitar parts. Or the gently meandering 'The Rain Song', Page's response to ex-Beatle George Harrison, who had told Bonham his band could not do ballads. Or 'No Quarter', an imposing and doom-laden epic that Jones had brought to the table.

This sense of ease also allowed for slighter, airier fare, like 'Dancing Days' and 'D'yer Mak'er', the latter's title coming from

an unfunny joke about Jamaica, the song itself more palatable than Led Zeppelin doing cod-reggae should have been. Far less appealing was 'The Crunge', a horrible homage to Otis Redding that failed gracelessly to locate a loose-limbed funk groove.

The record was given a lavish cover, designer Aubrey Powell being dispatched to the north coast of Northern Ireland to photograph cherubic infants scaling the Giant's Causeway, a vast natural rock formation. According to the writer Mick Wall, when Powell informed Grant such a shoot would be expensive, Zeppelin's manager fired back: 'Money? We don't care about money. Just fucking do it.'

Houses of the Holy, as expected, raced to Number One in the US and the UK. Yet good as it was, it was not the all-conquering monster their fourth record had been and it fell off the charts before the end of the summer. In this regard Zeppelin's thunder was stolen that year by another British rock band, Pink Floyd, their grandiose concept album *The Dark Side of the Moon* appearing the same month.

The reviews were also poisonous. Writing in *Rolling Stone*, Gordon Fletcher described *Houses of the Holy* as 'one of the dullest and most confusing records that I've heard this year'. In response, Grant appointed the band a US PR, twenty-two-year-old Danny Goldberg, a teetotal vegetarian. Goldberg worked for an upmarket New York agency, Solters, Roskin & Sabinson, which also handled the affairs of Frank Sinatra and *Playboy* magazine, and was briefed to improve the band's standing among American commentators.

His first route to doing so was to emphasise the scale of their achievements. He sent out a press release describing the band's forthcoming tour as 'the biggest and most profitable in the history of the United States'. He found an instant ally in Plant,

even now wanting to impress his success upon his father, still then convinced his son ought to get a 'proper job'.

When it began that May the sheer size of the tour was self-evident. The opening night at Atlanta Stadium drew a crowd of 40,000, earning $246,000 in ticket sales. At the next show at Tampa Stadium Zeppelin set a new attendance record of 56,800. The production itself was grander – the band utilising louder PA systems, mirror balls and a battery of lasers. And Grant had forked out $30,000 to charter them a private plane, a Boeing 720, stocked with a bar, a bedroom and an organ for Jones to entertain them on. It was christened 'the Starship'.

'Oh God, that tour was the biggest I've done,' says Cole. 'It was intoxicating. I mean the band was enormous. The plane? Well, it was very luxurious but it was still about going to work. The band would get on it and have a few drinks. Coming back, they'd discuss the gig. Then they'd get off and get in the waiting cars and decide where they were going for the evening.'

Or, as Page told the writer Brad Tolinski, 'Richard Cole ran into one of the air hostesses recently and she said to him, "You know, I made a lot of money off you guys." When people on the plane used to sniff cocaine, they'd roll up $100 bills to use as straws. Then, after they were high or passed out, they'd forget about the money. That might've been true, but I'll tell you one thing: they never got any of my money.'

Presiding over the whole enterprise was Grant. He had made it his job both to seal the band off in their own bubble and to get them every penny they were owed. The bigger they got, the more forceful he became in enforcing each aspect.

'Everybody was shit-scared of "G",' says Benji LeFevre. 'But it must have been a very difficult period. Peter's whole philosophy was to change the music industry from the promoters making all

the money to the artists doing so – and then paying the promoters a fair share. All these guys were Mafiosi. There was only Bill Graham striking out on his own and going, "This is for the people, man!" Peter must have encountered incredible resistance and probably violence.

'Plus when you work for someone who used to be a wrestler you've got to understand that physical intimidation is one of the responses in your arsenal. Especially in a country where people are allowed to carry guns. It's a different order of watching your back, even though the band had security guards who were all off-duty FBI guys.

'Richard Cole was there to be Peter's assistant and to make sure that nobody touched anybody. And a lot of dodgy things happened. But Richard had no capacity to make any decisions – that was Peter. And probably Peter and Jimmy, and then the rest of them, in that order.'

The shows themselves were electric. As a band they were riding high on the crest of a wave, on-stage revelling in their own glory. Audience reactions were wild, hysterical. I once asked Plant and Page how it felt, right then, to be in command of all that power.

'It was a question of communication between band and audience,' Page replied. 'You sent it out and they sent so much back, and it just kept building. That's how you made it into an event.'

'We needed a physical thing – a catalyst between the band and the audience,' Plant added. 'A sense of power? We didn't have it. It was just up there somewhere,' he said, waving his arms above his head.

The band invited their friend Roy Harper along to open the shows. Harper found himself attempting to quieten baying hordes with his lone voice and an acoustic guitar.

'It was like walking into the lion's den,' he says. 'I was in front of 50,000 people by myself. I remember being on stage at the Kezar Stadium in San Francisco. At the back, it was almost Falstaffian, debauched. At the front, there was a man who was completely stark bollock naked, except for the fact he was painted green and his pubes were scarlet. There's no way of communicating with that many people, who were that out of it, in one place.'

For all the triumph of their shows, something rotten had begun to fester at the band's core. The buccaneering spirit with which they had first caroused around America had turned meaner and more avaricious. Most often this change was embodied in Bonham, to whose roistering and acts of destruction there was now, often as not, a savage intensity.

The journalist Nick Kent recalled being in a club one night and seeing Bonham and Cole beat a guy to a pulp. There was no apparent reason for this and as they left the two of them tossed handfuls of dollars onto their prone victim.

'It makes me feel sick when I hear Robert Plant talking about what a great geezer Bonzo was,' Kent wrote. 'Because the guy was a schizophrenic animal, he was like something out of *Straw Dogs*.'

Page, too, had started to withdraw into his own twilit world. Long before tragedy stained the band for him, it was this turn of events that sowed the seeds of discontent in Plant.

In *Hammer of the Gods*, his notorious biography of the band, the American music writer Stephen Davis purported to have lifted the lid on the crazed world Zeppelin inhabited on the road. Published in 1985, the book portrayed each of the band members as indulging in a non-stop orgy of excess and violence, with no fear of reprisal or thought for the consequences. Plant,

Page and Jones were each at pains to distance themselves from Davis's book as soon as it emerged, claiming it was wildly inaccurate and that the writer had known nothing about the band. Plant in particular was dismissive of it, suggesting Cole had been the source of most of the more outlandish stories in the book and that he had greatly exaggerated them.

'He [Cole] had a problem which could easily have been solved if he had been given something intelligent to do rather than checking into hotels, and I think it embittered him greatly,' Plant told Mat Snow of the *NME* in 1985. 'A lot of the time he wasn't completely well, and his view of things was permanently distorted one way or another.'

Plant maintained that many of Zeppelin's extracurricular activities amounted to nothing more than youthful high jinks. This might have been true of their earlier tours, but there is no doubting the destructive turn things took the more omnipotent-seeming they became. Bonham was usually the central figure in this, with Cole and assorted hangers-on joining in or egging him on to carnage. Yet whereas Jones vanished himself at such times, Plant was frequently present, although more so as a voyeur than a participant, disapproving of the most extreme goings-on but remaining on the scene.

Revelling in his role as Zeppelin's frontman he was hardly a shrinking violent, and he certainly did not abstain from the sex and drugs part of the rock 'n' roll equation. But Plant also held to a set of values that were those of a peace-and-love-abiding hippy, and he grew increasingly weary of the darker forces that rose up in and around the band. These had very much taken root by the time of the American tour of 1973.

'That tour was crazy, absolutely crazy,' says Roy Harper. 'Episodes going on backstage that weren't always that kosher.

The under-the-surface tensions, shall we say. I'm not going to tell any kind of story but it was actually deathly. It probably happens with a lot of bands, though not on that scale.

'Bonzo, though he was a friend of Robert's, his high jinks were extreme. Although he wasn't actually that violent a person, he was capable of being a rough boy. There were times when there was gay abandon in circumstances that others would have thought were close to the edge. More than once, Richard Cole gave me his watch and said, "Hold that for a minute." That's the kind of world they inhabited and Robert detested it, I know he did. I think that's one of the reasons why, after the fact, he never wanted to be involved with Zeppelin.

'Yet Robert would be in the middle of it, hating it, whereas John Paul Jones wouldn't be seen at all. John Paul slept on a different floor to the rest of them at the hotels and so did Peter Grant. The others were all culpable because they were party to what was going on. In those days Robert was a peacemaker. He would make the way he was feeling obvious. You'd only have to look at his face to know it wasn't what he wanted for himself, the band or the humanity surrounding them. There is an innate good person in him.'

Which is not to say that Plant did not have his own particular weakness. His was being an inveterate womaniser. Later on Danny Goldberg suggested he had never met anyone who relished being a rock star quite as much as Plant did.

'Where Robert used to come undone a lot was in his dalliances with the opposite sex,' says Harper. 'It was kind of taking what you could. Though the thing is, he had so much opportunity and he didn't take as often as he might have done. He was reluctant to let himself down in any capacity – even the one he

was drawn to the most. He expressed guilt, yes. He was brought up a Roman Catholic.'

Benji LeFevre takes a rather different view: 'Internally, I think Robert's a very gentle, loyal and caring person, but he has that form of rock-star schizophrenia,' he says. 'At Jennings Farm there was definitely a feeling of, "Come into my home, this is my family and I am a family man." Then, as soon as he'd closed the gate behind him and driven off, it was Robert Plant the rock star.

'Why not? Flying first class, having motorcycle cops as outriders and a string of young women after his knob.'

As ever it was Los Angeles that was the seat of Zeppelin's operations. The band arrived in the city at the end of May to play two shows at the Forum and took over the upper floors of the Riot House. Their visit coincided with Bonham's twenty-fifth birthday. The band's present to their drummer was a Harley-Davidson bike.

'There were outlandish high jinks going on,' recalls Roy Harper. 'Things being thrown out of windows. Bonzo, among other people, was riding a motorbike down the hotel corridors.

'At one point I said to Robert, "Do you think that I should throw this TV out of the window?" He said, "No. Do you see that car down there?" I leant out the window and there was a big old American convertible below us. He said, "It belongs to Elvis."'

'A number of the US crew had served in Vietnam,' says LeFevre. 'The Riot House was probably a bit like that for them.'

The atmosphere on Sunset Strip had also changed, however. The girls that flocked to it had got younger, more desperate, the drugs harder. Good times going bad. The centre of the band's

nightly activities had moved to a new club on the Strip, Rodney Bingenheimer's English Disco. An unprepossessing twenty-five-year-old with a high-pitched voice, Bingenheimer was a confirmed Anglophile and had discovered glam rock on a trip to London the previous summer. He opened up the club on his return.

'That place was a public toilet with a dancehall in it,' says Kim Fowley, Bingenheimer's fellow scenester. 'There were only a couple of bathrooms and the toilets overflowed all the time. It smelt so foul you thought you were going to die just sitting there.

'Zeppelin hung out there. The regular crowd would dance to exclusively British pop music. The guys were all trying to look like David Bowie. There were lots of mirrors hung around the place and all these thirteen-, fourteen- and fifteen-year-old girls would dance around them. Of course, all of them had shaved cunts and no underwear on.'

The tour ended with a three-night stand at Madison Square Garden in New York that July. Grant had hired a young film director, Joe Massot, who had filmed the band's set at the Bath Festival in 1970. Given barely enough time to assemble a crew, Massot was flown in from England to shoot the first two shows at the Garden and also backstage footage. So began the saga of Zeppelin's ill-starred movie.

Back home the rhythm of life continued being set by the band. Benji LeFevre found out he was now expected to run errands for Plant – 'Driving up and down the fucking motorway all the time,' he bemoans. Grant kept Plant and Bonham out of one drama of that time. Returning from the tour, Jones told his manager he would leave the band if things did not change. He

was tired of being away from home for such long periods, and with short notice. Grant assuaged him and things rolled on.

By now it had been decided the film would be more than just a concert movie. Joe Massot was dispatched to film fantasy sequences with each of the band members and also Grant, no one thinking it necessary to provide him with a script. Plant's self-aggrandising segment was shot at Raglan Castle in Wales, the singer casting himself in the role of a bold knight rescuing a damsel in distress.

'I mean, talk about self-indulgent bollocks,' says LeFevre, laughing. 'Robert, the director and I went up into the hills and … it was just completely mad. If you're going to do a film, then someone's got to be in charge and have the end result in mind. Not, "Well, I think my bit will be like this," and, "OK, I'm going to do this then."'

Massot showed the band a rough cut of the film at the beginning of 1974. It seemed to them an incoherent mess and Page ordered him fired. An Australian filmmaker, Peter Clifton, was parachuted in. Since most of the original concert footage was unusable, Clifton had to persuade Grant and Zeppelin to re-shoot it. This was finally done on a sound stage at Shepperton Studios in Surrey, with the band miming to the Madison Square Garden soundtrack.

'Being a cynical bastard, the thing I love about the film is that you can spot Bonzo being twenty pounds heavier in some shots,' says LeFevre. 'Because we did the takes at Shepperton almost two years later and he was the size of a house by then.'

This débâcle did not dampen their hubris. Zeppelin's deal with Atlantic Records was due for renewal, and Grant and Page were now set upon establishing the band's own boutique label as part of any future agreement. The multi-million dollar contract

they subsequently signed with Ahmet Ertegun duly included the provision for Zeppelin to form Swan Song.

The Beatles and the Rolling Stones had set a precedent for superstar acts having their own vanity labels, with varying degrees of failure. The Beatles' Apple had proved to be a hopeless basket case, while Rolling Stones Records would have just three acts: the reggae musician Peter Tosh, a Cuban band called Kracker, which only managed one single, and the Stones themselves. Swan Song, Grant and Page insisted, would be different.

To begin with, at least, things looked promising. Three acts were soon signed, all managed by Grant. These were Bad Company, formed from the ashes of Free by singer Paul Rodgers and drummer Simon Kirke, a Scottish singer named Maggie Bell, and the Pretty Things, a London band that had been knocking around since the early '60s. Within months Bad Company's début album topped the charts in the US.

Swan Song opened a plush suite of offices in Manhattan, Grant installing Danny Goldberg as its manager. At the beginning of May Grant and the band flew to America to attend two launch parties for their label, one in New York and the other in LA. The night after the LA bash, on 11 May, they went to see Elvis Presley at the Forum.

Zeppelin and Elvis were now sharing a promoter in the US, Jerry Weintraub. He set up a meeting between the two parties, which took place after the Forum show in Elvis's penthouse hotel suite.

'Robert was the one who'd mimed to all his records but it was Bonham who engaged with Elvis more than anyone,' says Cole. 'He was talking about cars with him. And Peter sat on Elvis's dad by mistake. He didn't see his father on a chair and he flopped down on top of him.

'Elvis was lovely, very gracious. It was like meeting God. When he stood up, everyone in the room stood up. He walked us out to the elevator and Robert started singing with him: "Treat me like a fool, treat me mean and cruel." When you're listening to him as a fourteen-year-old, the last thing you'd ever think is that you'd be in Elvis's hotel room and getting pissed with him.'

It was the Swan Song office in London that better suggested what lay in store. Sited on the King's Road and opposite a pub, it was decked out with second-hand furniture and was as grubby looking as the building that housed it. Abe Hoch, who had worked at both Atlantic and Motown, was brought in from America to run it. This was easier said than done, given the disorder and chaos that soon reigned there.

Page had already absented himself. The guitarist had bought a new London home – a gothic edifice called the Tower House, built in the 1870s in Holland Park. There he shut himself off to embark on a doomed project of his own, a proposed soundtrack for the American filmmaker Kenneth Anger's next experimental project, *Lucifer Rising*. Page worked sporadically. Rumours were circulating around the Zeppelin camp that he had begun using heroin, although Page has never publically commented on this and the rumours were never substantiated.

'I think the idea of a having a label really appealed to Robert,' says LeFevre. 'Because he's somewhat of a musical historian – I mean his knowledge is absolutely incredible. And it could have been brilliant. Abe Hoch was a super-intelligent guy and he knew his business. But 484 King's Road was not as much of a place for business as it should have been. I was there all the time and someone would always say, "Oh, let's just go to the pub."

'My impression is that all the band liked the idea but when it came down to it they couldn't be fucked. They tried to put

people in place to orchestrate the running of it but didn't give them any authority, so no decisions were ever made. Of course, I suspect around this period certain people also started to experiment with certain substances, so there was never any cohesive movement.'

It would be October before the band got around to officially launching Swan Song at home. Fittingly enough, the party took place on Halloween in a series of underground tunnels called Chislehurst Caves to the south-east of London. A sense of all that had happened to Led Zeppelin in the last year – and all that was still to come – seemed to be encapsulated in that one night.

'The whole thing was madness,' recalls the DJ Bob Harris, a party guest. 'I remember the jazz singer George Melly did a set and there were rows of coffins in front of the stage. Once he started doing his act, the coffins opened and naked girls appeared from out of them, covered in jelly and writhing to the music. One looked around thinking, "What was that thing about Sodom and Gomorrah?" It was ridiculous. Ridiculous – and very, very crazy.'

10

CRASH

I was lying there in some pain,
trying to get cockroaches off the bed.

Neither the setting up of Swan Song nor the chaotic production of their film distracted Led Zeppelin from the business of making their next record. In the spring of 1974 they retired for a third time to Headley Grange. Page retained a room in the freezing house but the others chose to be sequestered nearby at a plush country hotel. Not coincidentally, the mobile studio parked on the lawn on this occasion belonged to Ronnie Lane of the Faces – a cheaper alternative to the Rolling Stones' studio they had previously used.

During the creative boom of the last four years enough songs for two records had been stockpiled and they elected to use them all. Since the band were now filled with a sense of their own importance, this much was inevitable. The double album was then perceived as being a defining artistic statement, one that had already been made by the Beatles' *White Album*, the Rolling Stones' *Exile on Main St.*, Bob Dylan's *Blonde on Blonde* and, just the previous year, the Who on

Quadrophenia. Of course, Zeppelin would have to join this pantheon.

They worked fast, cutting the majority of the songs in one or two takes. Fifteen tracks in all, eight dating as far back as the spring of 1970 and the rest written in recent months. Sound engineer Benji LeFevre was present throughout the sessions. 'There were moments of musical genius,' he says. 'As a unit it was like … Phew! There was the most amazing bond, certainly when I began working with them.

'Yet there were also times when it all stuttered to a halt. We took farm animals up to the first floor and let off flares. Complete madness. Everything stopped for several weeks when one of the roadies, Peppy, drove Bonzo's new car – a BMW 3.0 CSL – into a wall. Bonzo was so upset about his pride and joy that he wanted to kill Peppy, who hid in a wardrobe for thirty-six hours.

'It was just young blokes having a laugh. The band had this belief about them then that they were untouchable – as we all do. It was all to do with testosterone and, believe me, Robert had more of it than anybody I've ever known.'

Still, at the edges, the fraying continued. One morning Bonham arrived at the Grange with a bag containing 1,500 pills of the sedative Mandrax, intending to conceal them from the rest of the band by taping them to the inside of his drum heads. A member of the crew spotted the flaw in this plan, pointing out to Bonham that he had a Perspex kit.

'Like most drummers, Bonzo tended to exceed the limit more than most people would,' says LeFevre. 'Sometimes he was particularly cruel to Mick Hinton – his roadie. Bonzo would punch him in the face for no reason at all.

'With Robert and Bonzo, they were so tight you couldn't slip a piece of toilet paper between them. But Robert wasn't afraid

to go out into the world and be himself. He'd buy a few people a drink in the pub. Whereas Bonzo would go into a pub and announce that he was going to buy everybody drinks all afternoon. Why? Insecurity probably.

'As with any group of friends, the dynamic between each of them ebbed and flowed. The relationships changed depending on the circumstances, of which there were some heavy ones. And also, I imagine, with the amount of mind-altering substances being consumed. Because then paranoia starts to evolve.'

For now, however, none of these external forces diminished the music. The completed album, *Physical Graffiti*, was the second – and last – stone-cold classic Zeppelin would make. Its fifteen tracks ran to more than eighty minutes and sprawled out across four sides of vinyl, but none of this expanse was wasted. Rather, it allowed for the setting loose of Zeppelin's most intricate and varied collection of songs, plunging through rumbling rockers like 'Custard Pie' and 'Night Flight' and into gradually unwinding epics such as 'Ten Years Gone' and 'In the Light', the latter's spiralling drone stolen from the baked streets of Marrakech. Something as decorative as 'Bron-Yr-Aur' or reflective as 'Down by the Seaside' was set alongside the primitive crunch of 'The Wanton Song'.

Appropriately, it sounded enormous. Conducting the orchestra through all its tremors and earthquakes, Page reached his apogee as a producer. He mixed the songs into a great rhythmic soup, basing it on Bonham's reverberations – his drums again recorded in the Grange's vast entrance hall – and layered multiple guitar tracks on top of these.

There was a manic zeal to the whole enterprise, though. 'Trampled Underfoot' cut a thrilling dash, Jones taking the inspiration for his bubbling clavinet line from Stevie Wonder. 'In My

Time of Dying' was unrecognisable from the original blues song from which it was appropriated, Blind Willie Johnson's 'Jesus, Make Up My Dying Bed' from 1927. Huge and unbending, the Zeppelin track powered along for more than eleven minutes, Page's bottleneck guitar ricocheting off Bonham's tumultuous fills.

Then there was the song that is perhaps their grandest achievement, 'Kashmir'. Page's majestic, circling riff cast it out across a cool desert night and into Jones and Bonham's driving rhythm, and on through all the mysteries and wonders of Plant's incantations. It did not matter that Kashmir itself is, in fact, a wet, mountainous region or that neither Plant nor Page had ever been there – it was the song that best captured the spirit of their wanderings.

On 'Sick Again' Plant looked back with a jaded eye at the tawdry scene he had last encountered on Sunset Strip, perhaps referring to Lori Maddox, Page's teenage consort, in the line, 'One day soon you're gonna reach sixteen.' Yet 'Black Country Woman' gave rise to more lasting examination, as Plant, in the best blues tradition, beseeched his woman not to treat him mean, before concluding, 'That's alright, I know your sisters, too.' Here was further fertile ground upon which to grow speculation about the state of relations between Plant and his wife's younger sister, although if this was at the song's root it suggested that Maureen Plant never listened to her husband's records.

Physical Graffiti was released on 24 February 1975 in a die-cut sleeve that pictured a New York City brownstone tenement block, through the windows of which one could pick out Elizabeth Taylor, Lee Harvey Oswald and the band themselves dressed in drag. There were other big, ambitious records that year, Bob Dylan's *Blood on the Tracks*, Bruce Springsteen's *Born to*

Run and *Fleetwood Mac* among them, but this, the artwork alone seemed to insist, was the greatest and most imposing of all. So it proved, shipping more than a million copies and becoming the fastest-selling record in history. For now, at least, there was still no stopping them.

By the time *Physical Graffiti* came out Zeppelin were touring North America. This was also a vainglorious endeavour, taking in thirty-five dates. It began with three consecutive shows at Chicago Stadium, and included as many nights again at both New York's Madison Square Garden and the Forum in Los Angeles. The band and their closest retinue once more piled aboard the Starship, basing themselves in two or three key cities for weeks on end, flying out to each gig from these and then back again.

The production was even bigger than it had been on their last haul around the US almost two years before – louder, flashier and with more of everything. On-stage, Page was often resplendent in a black velvet suit, a pair of flaming dragons snaking down its sides. Bonham dressed in the garb of a *Clockwork Orange* droog – a white boiler suit and a bowler hat – as did his hapless Sancho Panza, Mick Hinton.

When they were firing on all cylinders, as remained the case on the best of nights, Zeppelin seemed immense and invincible, both larger than life and also a step removed from it. Their sets, longer than ever, never quite buckled under the weight of so many gargantuan songs: 'In My Time of Dying' and 'No Quarter', 'Kashmir' and 'Stairway to Heaven'.

Dennis Sheehan, now U2's tour manager and then one of Grant's staffers, joined the entourage for the first time on this tour. 'A lot of what's written about Zeppelin is how raucous they

were, and how sex and drugs dominated – everything but the music, which always seems to be a secondary thing. You can't be as good as they were and have everything else be dominant over the music,' he insists. 'Yes, there were bad things that happened on that tour. But for every bad thing, there were a thousand great moments.

'When you saw them on-stage and looked out at the faces of the audience … it was an amazing experience. As a band, they loved performing. And Robert, in particular, loved the adoration.'

Says Michael Des Barres, singer with the band Detective, soon to be signed to Swan Song: 'The mythology that grew up around Zeppelin was created out of a universal and almost spiritual need in kids that had no band to ally themselves with, other than the decadence of the Stones or the cuteness of the Beatles – or the diluted versions of those bands, which was everyone else. Then, suddenly, you had Valhalla in the parking lot of stadiums and people just flocked to it.

'There was something magical about the whole thing. What the critics didn't grasp was the potency of the band. Being around it, one did. They were the greatest live rock 'n' roll band I've ever seen – and I've seen them all.'

For all this, the influences that would bring Zeppelin to their ruin had become more prominent and corrosive. Their road manager, Richard Cole, claimed that this was the first tour on which heroin was freely circulated, but only some partook. A cocaine dealer was attached to the flotsam that tagged along with them, attired at all times as a cowboy.

Both the drugs and also a sense of unchecked self-indulgence began to haunt the shows. Bonham's drum solo expanded to fifteen, twenty minutes in length. 'Dazed and Confused', replete

with Page's guitar-mangling act, could run to twice as long. The writer Stephen Davis, assigned to the tour, recorded how Plant regularly returned to the stage after such overblown interludes and would jokingly announce, 'What a wonderful blowjob in the dressing room.'

On the road the soul of the band had started to seep away. Grant was by now nursing his own cocaine habit. This ratcheted up the levels of paranoia surrounding Zeppelin and the propensity for violence to flare. Bonham had slipped the last of the moorings keeping him in check. His appetite for destruction had grown to such an extent that the Plaza Hotel in New York demanded a $10,000 deposit before allowing him to stay there.

'In my view, this was the point at which the boisterous, fun-loving, couple of pints after a show properly developed into something more serious,' says LeFevre. 'There was this fucking game they were playing, being late on stage at every show. Three hours late going on at Madison Square Garden. I wonder why! Maybe the subtle blend of the cocktail certain parties were imbibing wasn't right on that night.

'Of course, the American kids just loved it when they came on two, three hours late. The whole audience was off their heads anyway. Instead of losing the buzz, everyone just got higher and higher.'

'Richard Cole had a beady eye,' recalls Dennis Sheehan. 'He was quite a character, and he was doing anything and everything that one could do. If you look at the demeanour of the people around the band it would almost seem as if their way of sorting out every problem was with an iron bar or a baseball bat. Forget about sitting down to discuss things. I can laugh about it now but it certainly wasn't amusing at the time.'

Offstage, and among the principals, the most complex of the various psychodramas being played out was between Plant and Page. Having begun as the apprentice, there for Page to mould and shape, Plant had long since grown into the twin roles of being his creative partner and the band's lightning rod. It was him that all the girls leered at.

Page had helped and coaxed him this far, no doubt, but while Plant continued to bask in the limelight he was withdrawing to the shadows. And there into the embrace of whatever it was he used to see him through the long, dark nights. Petty jealousies festered and were picked at, and after that deeper cuts began to open up.

'Between ourselves there was a lot of unspoken rivalry,' Plant later told *Rolling Stone*'s David Fricke. 'Jimmy employed a very democratic approach to the whole thing. He encouraged me a lot. Then, suddenly, we were side by side, and he didn't quite like that.

'Occasionally, I could sense it. If the shoulders were close, you could feel the flinch a little bit. Especially when we were both sitting in the same bar, and a woman walked by and we both liked her. Then it was, "Oh no, here we go."'

'Jim has this division within him,' maintains LeFevre. 'He can be absolutely delightful. But as soon as you say "L", he becomes Jimmy Page of Led Zeppelin and it's his baby. He's always considered it to be that and it's all he's ever done. And as soon as he's the other Jimmy Page, he's fucking ruthless.'

But then the glare of Zeppelin's extraordinary success had exposed each member of the band. For seven years now it had been unstinting and become harsher, shaping and changing them and, at its sharpest point, damaging them, too.

'Being an acolyte of Zeppelin's you saw the flaws,' suggests Michael Des Barres. 'The humanity and the vulnerabilities that

were most illustrative of what was happening. They were four individuals, all with very different ways of dealing with things. Jimmy hid, Bonzo anaesthetised himself and John Paul Jones could give a shit.

'Definitely "cock" is a word one could use to describe Robert. The thing about him was he knew what was going on. All that posturing was for him, I think, absolutely fun. I don't think he ever walked into a room not knowing for one second that everyone would turn and look at him. A lot of people don't want to embrace that, but he did. I made a movie with Mick Jagger a couple of years ago and he disdained that sort of thing; he'd go from A to B as fast as he could. Robert, by contrast, strutted through many a young girl's fantasy.

'Jimmy is a very complex man. He's very erudite, very well read and a curious fellow. But you know, cocaine is a spectacular and treacherous drug.'

The band set up camp in Los Angeles through March. A clear division opened up between them: Plant and Jones each fled Sunset Strip and rented houses on the beach; Page and Bonham remained holed up on the upper floors of the Riot House.

As ever was the case, it was in LA that the band's dark heart beat hardest. Porn actress Linda Lovelace, star of *Deep Throat*, introduced them on-stage for the last show at the Forum on 27 March. The scene at the Riot House was more bacchanalian. The elevators teemed with teenage girls, greedy and desperate, cruising from floor to floor in the hope of spotting a band member. On the floors occupied by Page and Bonham, security guards were stationed at the elevator doors – there to 'take care' of any undesirables.

Since they barely went out during the day, Page and Bonham found other ways of amusing themselves. Page hired a Harley-

Davidson bike and drove it up and down the sixth floor corridors. Bonham held a party in his ninth-floor room, the noise from this being loud enough to be heard on the ground floors.

'When the band got into town, I think Richard Cole used to break off to go and see the local authorities, just to make sure they could party without implication,' says the DJ Bob Harris, a guest at the hotel at the same time. 'They had power in spades.

'The lobby of the hotel was so packed with people at 2 am, you couldn't get across it to the elevators. There was a frightening edge around the fringe of the band. If anyone was trying to get at them it wasn't unusual to see them being physically restrained. Their security was heavy. You really didn't want to mess with Richard Cole.

'I spent a night in Jimmy's room and Robert was there. I remember at 1 am Robert got a call from David Bowie, who was somewhere else in town. David had some kind of problem and he'd called Robert to help him out. Robert put the phone down and the whole tone of the moment changed completely. He said, "I've got to go and do stuff now." I left him to it, but God knows what problem David had got.

'I got the feeling around that time, particularly about Jimmy, that there was this black-magic aspect that was beginning to come into the mix. I wonder if karma applies, that notion of what you put out you also get back. As Zeppelin began to drift to the darker side, so things began to happen to them that were really distressing. I don't know – how do you explain all of those things?'

There was little time for Plant to gather himself at home. The previous year, the incumbent Labour government had raised the top rate of income tax on Britain's wealthiest individuals to a

prohibitive 83 per cent. To get around this, Grant planned for the band to spend a year out of the country in tax exile. This was due to begin after the last five shows of the tour, all of them being held at London's 17,000-capacity Earl's Court in May.

The *Financial Times*, Britain's most august business paper, reported that Zeppelin's earnings for 1975 would top $40 million. Plant took great pride in presenting this article to his father.

'Robert's dad hated the lifestyle he'd chosen,' says John Ogden, a journalist at the *Express & Star* newspaper in the Midlands. 'It is true he read that piece in the *Financial Times* and it was only then that he said, "Perhaps you're right after all."'

Ogden ran into Plant again at this time. He had been working with a local rock band called Little Acre, whom Plant began to take an interest in. Plant recommended the band to some of his record-label contacts but without success. Later, he appointed the band's guitarist, John Bryant, as his farm manager. Bryant was married to Shirley Wilson, Plant's wife Maureen's younger sister, and the couple moved on to the Jennings Farm estate.

At Earl's Court, Zeppelin peaked. Using their full US production, the stage flanked by a pair of giant video screens that magnified them still further, there was something regal about them – with Plant, never more full of himself, their crown prince. On the last night, a Sunday, they played for four hours, concluding just after midnight with a scorching 'Communication Breakdown'. It was the last time the four of them together would have it this good.

After the show Plant held court backstage, perching himself on the bonnet of his limousine, looking resplendent. Dave Lewis, now the editor of the Zeppelin fanzine *Tight But Loose*, met the singer for the first time that night. 'For a fan, it was literally like

coming face to face with God,' he says. 'He had Maureen with him and all his jewellery on. I remember asking him where he'd got one of his rings from and him telling me about finding it in the back streets of Bombay.

'They had an all-night party afterwards. Jeff Beck and Chris Squire of Yes were there, and Dr Feelgood did the live music. A few of us waited outside. When Robert came out, he sang the first line of "Kashmir" to us. Jimmy was nice, too, but he was quite out of it.'

Two days later, Plant, Maureen and their two children left the UK for Morocco. They holidayed in Agadir on the country's south-west coast, travelling from there to meet Page, Charlotte Martin and their daughter Scarlet in Marrakech. Hiring cars, the two families wound their way down through the country and into the Western Sahara, which was then the centre of escalating tensions between Moroccan forces and those of the autonomous Sahrawi.

'I was idly researching the possibility of recording various ethnic groups of different tribes in Morocco,' Plant told *Creem's* Chris Charlesworth. 'In one city we had lunch with a local police chief and received his blessing before carrying on. We showed him an old map of where we wanted to go. He called round one of his friends, a tourist guide. This guide told Jimmy and me that he had been on that route once in his life, but wouldn't go again because he was a married man.

'We still went. Into a land of nice, honest people who found a Range Rover with Bob Marley music very strange.'

They broke off to travel to Montreux in Switzerland for a band meeting with Grant, staying on for the city's jazz festival, Cole having rented them a couple of houses in the city. By the end of July, they were off again, this time to the Greek island of

Rhodes, where Maureen's sister Shirley and her husband joined them.

On 3 August Page left for Sicily, intending to buy Aleister Crowley's old home on the island – the Abbey of Thelema. The next day the others set out on a drive across Rhodes. Maureen was driving a rented Austin Mini sedan, Plant beside her in the passenger seat, Carmen, Karac and Scarlet Page in the rear. John Bryant, Shirley Wilson and Charlotte Martin were in a following car.

At a certain point on the drive Maureen lost control of the car, spun off the road and crashed into a tree. She broke her skull, pelvis and leg. Plant broke bones in his right leg and ankle, and in his wrist. Karac suffered a broken leg, Carmen a fractured wrist, and Scarlet Page cuts and bruises. The others flagged down a passing fruit truck. Loading the stricken Maureen, Plant and the children onto the flatbed of his vehicle, the driver took them to hospital.

Speaking about the accident to Chris Charlesworth the following year, Plant said: 'The memory is very vivid, but it's like spilt milk and there's no time to cry over it. I had the normal instant reaction of anybody and that was for my family who were in the car with me.

'[In hospital on Rhodes] I had to share a room with a drunken soldier who had fallen over and banged his head. As he was coming round, he kept focusing on me, uttering my name. I was lying there in some pain, trying to get cockroaches off the bed, and he started to sing "The Ocean".'

'I can't recall whether I was in the office or the pub when one of the secretaries came and found me,' says Cole. 'She told me Charlotte wanted to speak to me and that there'd been an accident on Rhodes. The communication was that Maureen was

going to die if someone didn't get down there. Being an Anglo-Indian she didn't have a common blood type. Fortunately, what saved her life was that her sister was with her.

'One of our roadies, Clive Coulson, knew of a Harley Street doctor, John Baretta, who was fluent in Greek. I called him, told him the situation and he said we'd also have to take an orthopaedic surgeon with us.'

John Baretta recommended Mike Lawrence, a prominent orthopaedic surgeon. Baretta was also personal physician to the construction magnate Sir Robert McAlpine and from him secured the services of a private plane equipped with medical facilities.

'We flew into Rhodes,' continues Cole. 'It was tricky, because you can only land and take off there when it's light. We went to the hospital and our doctors looked at all the X-rays. They were very complimentary to the Greek physicians but as soon as they were out of earshot they told me the bones weren't setting correctly. Maureen's pelvis was offset, so if she got pregnant in the future you wouldn't have been able to pull the baby's head through it.

'They told me we had to get them all out of there. Basically, we smuggled them out from the hospital. We had to work it out so that we got them to the airport and could take off right away.

'There were ambulances waiting on the tarmac at Luton airport. They were all taken to hospital in London. The children's bones were mended and they took care of what they could with Robert. Maureen was in a bad way for a long time.'

Maureen spent several weeks in hospital. In the aftermath of the crash her heart had stopped beating for a brief, terrible moment.

His right leg encased in plaster, Plant was initially confined to a wheelchair. He was told it would be months before he would

be able to walk without the aid of a stick. To this day he is unable to fully extend his damaged arm.

Days after being flown back to London Plant was gone again, leaving to continue his tax exile. The godfather of Cole's insurance broker was a wealthy businessman named Dick Christian who was based on Jersey, an island in the English Channel. Christian offered Plant the use of his guesthouse on the island. For the flight out to Jersey the British Airways crew removed a row of seats in the first-class cabin so Plant could stretch his leg out.

'I sorted Robert out in Jersey and then the other lot flew in,' says Cole. 'Afterwards, they all went to Los Angeles. John Bonham wasn't a tax exile then. He wouldn't go because his wife was having a baby. He said he didn't care about the money to begin with – but he started it later that year. It was a terrible year that one.'

'I saw Robert a very few days after he'd been flown back from Rhodes,' recalls Benji LeFevre. 'The question was, "Is Robert going to stay next to Maureen and are they going to get better together, or is he going to be persuaded to carry on with the scheme?" He decided to carry on with the scheme. He said to me, "You're going to have to come with me, man."

'Within a week, he was in Jersey. Why did he go? I really don't know. It's a very interesting question. For a time there, Maureen had died. It was exactly the opposite of the Robert who was a stable, family-loving gentleman.

'Presumably, when one has that sort of trauma one doesn't think especially clearly. Maybe, because of the tax situation at that point, they had to do it as an ensemble. All I know is I spent the next nine months pushing him around in a wheelchair.'

11

DARKNESS, DARKNESS

**Robert was sitting on the bed with
his head in his hands.**

The extent of Plant's injuries forced Zeppelin to cancel a
two-month-long North American tour planned for the summer
of 1975, and after that a series of shows in Europe and the
Far East. Not that the band intended to remain idle. At the
end of September the four of them, together with Grant, flew
out to Los Angeles, where work was due to begin on a new
album.

Each of them rented a large beach house in the chic Malibu
Beach colony, an hour's drive from the city. Since he was still
immobile Plant took Benji LeFevre with him as his nursemaid.
As part of his recuperation he had been instructed by doctors to
attend daily physiotherapy sessions, although to begin with he
slipped more readily into the established routine of being on the
road with Zeppelin.

'I don't think he was aware of the potential permanence of his
injuries, of certain parts of his body not recuperating properly,'
says LeFevre. 'We'd drive into Hollywood and do his

physiotherapy, and then I'd also been given some exercises to do with him back at the house. On several occasions I said to him, "I think we should stop doing so much drugs – it's not helping you. Why don't we have a big old fucking line once we've done the exercises instead of before?"

'It was like being his fucking wife. We had our laughs but it was tough for sure. We certainly got to know each other. He couldn't do anything. I had to push him, carry him and lift him. I had to put him in the bath and wash his willy.'

It was an impermanent, dislocated existence, the same as that of being on tour but without the anchor of having a show to do each night. Just as it did whenever he left home for the band, being in this self-absorbed state allowed Plant to separate his life into two distinct boxes. He was a rock star in one, a family man in the other, neither intersecting. Even now, so soon after the car crash.

'Yes, I think that's true. And the more you do that, then the more natural it becomes,' says LeFevre. 'In other words: "Yes, I'll call you every day, darling, and I do love you." Then, as soon as you're out the door, it's like, "Yeah!" He really didn't talk very much about Maureen. It was strange.'

The mere fact of their being in Los Angeles added to the general air of anything goes, and they remained a magnet for all that was wild and unhinged about the city. Hollywood scenester Kim Fowley remembers driving out to a party at Plant's Malibu pad during that long, hot summer.

'I was living with all kinds of lesbians and nymphomaniacs at the time,' he tells me. 'This one girl I lived with, Denise, she and I had both fucked this astoundingly beautiful blonde bitch, Linda. I have these two girls in the car with me and another wildcat named Robyn.

'We got to Robert's house, a giant place on the beach, and he's in there with fifty or sixty women. You know that picture of Jimi Hendrix with all the naked women? Imagine that in someone's living room. Robert was just sat there having a Napoleon Brandy. He was the sex object – not the girls. They were just waiting to be selected.

'I walked in and announced, "Tonight, for your pleasure, we will have a three-way. My bitches will eat each other's cunts and fist-fuck each other." All these girls applauded and my girls did just that thing. Robert said to me, "I've seen this before, come outside for a moment." He told me he had $25,000 set aside to buy this one particularly rare record and did I know of anyone who had a copy? Then he said, "Are you in love with the blonde? No? Sure? OK …"

'He was fundamentally a very exceptional human being. He's smarter in a different way to Jimmy Page, who doesn't have all his cards out on the table. Robert brings his intelligence right out there with the haircut, the smile and the bravado. Like Errol Flynn or Douglas Fairbanks, all those swashbucklers.'

'One night, Robert and I came back to the house and the lights were on,' recalls LeFevre. 'I went inside to check and there were these two Charlie Manson chicks sitting there – shaved heads, Tarot cards laid out on the floor. At that point I thought, "I get it." That's why there was such apprehension about people who came to be around the band.'

Against this backdrop progress on the record was slow and halting. There was no longer a backlog of material to draw from since the band had exhausted that on *Physical Graffiti*. For the first time in years Plant and Page had to write an entire collection of new songs together. Problem was, even though they were

living in such close proximity, the two men were barely seeing each other.

Page had vanished into his rented mansion, the curtains of which were permanently drawn to block all traces of light, sealing him inside.

'We occasionally went up to Jimmy's house but there was no work done there to my knowledge,' says LeFevre. 'The master plan had been interrupted by the accident but it couldn't be put on hold. That wasn't on the agenda. Yet things had changed within the band.

'Listen, man, if something has happened to you physically or mentally then that impinges on your relationships with other people. There's no doubt Robert had lost that sense of invulnerability. Subject A, Robert, was reacting thus: getting his head round it and trying to get his body working again. Subject B, Jimmy, is affected in a different way … and maybe finds solace in other areas.'

On the odd occasions that Page did venture out it was into Hollywood and then by night. He went to see Michael Des Barres's band Detective, signing them almost on the spot to Swan Song, although he was otherwise disengaged from the business of the record label he had founded.

'It was a pain in the ass, eventually,' admits Des Barres. 'Jimmy was going to produce us and we had to wait a year for him in LA. You give me a million dollars and put me in Los Angeles for that length of time – big trouble, obviously. I got strung out on everything.

'None of the Zeppelin guys was hands on with Swan Song, though. They were too involved in their own lives. At that time they were going through unbelievable pressures – continuing substance abuse and the question of where it is you go from the

very top. It was a hard place for them to be. I don't resent them for it.'

Bonham was also cut adrift on Sunset Strip. One night he was involved in an altercation with Kim Fowley's assistant, Michelle Myer, at the Rainbow Bar & Grill when Bonham took exception to the way Myer had smiled at him. Later it was reported that he had punched Myer to the floor, although Fowley maintains the fracas was more of a wrestling match. 'And believe me,' he adds, 'Michelle could handle herself, especially against a guy that wasted.'

Somehow seven new songs materialised, all bar one of them credited solely to Page and Plant. The band regrouped at SIR Studios in Hollywood to knock these into shape. Bonham and Jones added their input to the shortest track, 'Royal Orleans', which ultimately sounded like a studio jam that had not found a point to coalesce around. Such was the tone of the whole record.

At the end of October they exchanged the West Coast heat for the bitter bite of winter in Germany. They were booked into Musicland Studios in Munich, although for just eighteen days, all the time they could squeeze before the Rolling Stones took over the complex to make their *Black and Blue* album. Arriving in the city, Plant balked at the hotel Cole had booked for them, stating the rooms were not big enough and promptly moving himself to the local Hilton.

Page did not leave the studio. In the event he succeeded in begging an extra three days off Mick Jagger, but even still, he and his engineer Keith Harwood had to work around the clock and without sleep. Nerves were frayed. Because he had to sit down to sing, Plant struggled to take in enough air to sustain the longest and highest notes. He was not alone in being handicapped.

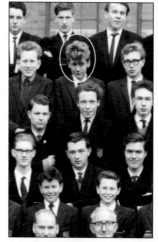

TOP LEFT: The school newspaper of the King Edward VI Grammar School for Boys announces Plant as a form monitor.

TOP RIGHT: Plant, circled, in his 1963 school photo, with Gary Tolley, guitarist in his first band, to his right.

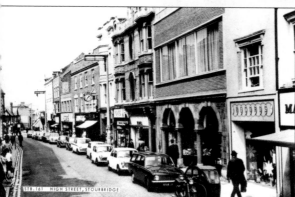

MIDDLE: Stourbridge High Street, c. 1963.

BOTTOM LEFT: The school newspaper records Plant's stint on the committee of the Jazz Society.

BOTTOM CENTRE: Dave 'Rowdy' Yeats of the Groove Record Shop, Stourbridge.

BOTTOM RIGHT: Plant, top left, with Listen in 1966.

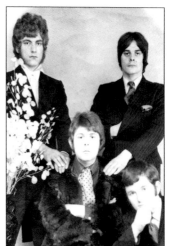

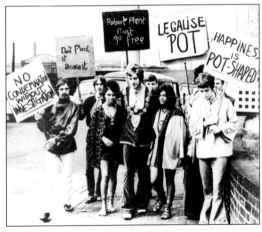

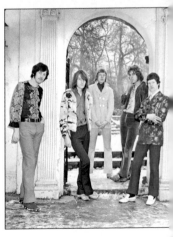

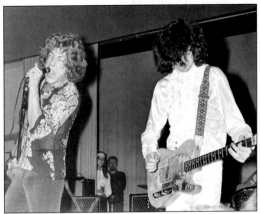

TOP LEFT: Plant's ill-starred march in 1967, with Shirley Wilson to his left.

TOP RIGHT: Plant and Bonham (far left) with the Band of Joy, c. 1968.

MIDDLE LEFT: Plant and Jimmy Page at the New Yardbirds' first gig in Denmark, 1968.

MIDDLE RIGHT: Plant in 1968.

BOTTOM LEFT: Led Zeppelin in London, 1968.

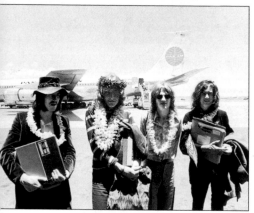

TOP LEFT: On stage at London's Royal Albert Hall, 29 June 1969.

TOP RIGHT: Plant somewhere in America, 1969.

MIDDLE LEFT: Zeppelin in Hawaii in 1969 with the *Led Zeppelin II* master tapes.

MIDDLE RIGHT: Plant, his wife Maureen and their daughter Carmen, 1969.

BOTTOM LEFT: Plant and friend at his sanctuary, Jennings Farm.

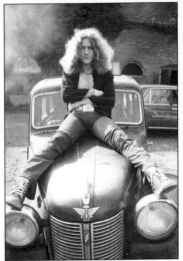

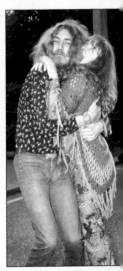

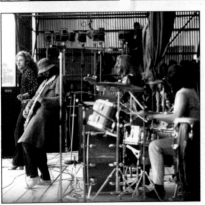

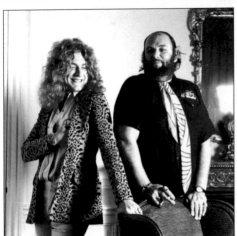

TOP LEFT: The proverbial hippy and his bird, San Francisco, 1973.

TOP CENTRE: Plant at Headley Grange.

TOP RIGHT: With the late Sandy Denny his co-vocalist on 'The Battle of Evermore', 1971.

MIDDLE LEFT: Zeppelin on stage at the Bath Festival, 1969.

MIDDLE RIGHT: Zeppelin hold court on Hollywood's Sunset Strip.

BOTTOM LEFT: Plant with Zeppelin's formidable manager Peter Grant.

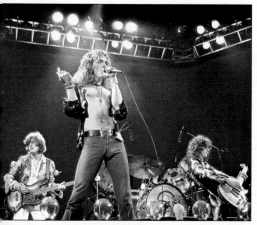

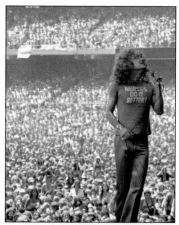

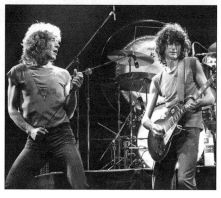

TOP LEFT: Zeppelin's crowning moment, on stage at London's Earl's Court, May 1975.

TOP RIGHT: The last US Zeppelin show, Oakland, 24 July 1977.

MIDDLE LEFT: Plant and Page en route to the stage at Knebworth, 1979.

MIDDLE RIGHT: The Tour Over Europe, 1980.

BOTTOM LEFT: Plant, the solo artist, 1982.

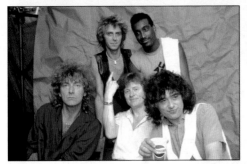

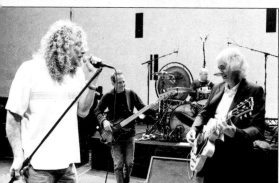

TOP LEFT: With hurdy-gurdy player Nigel Eaton in Arizona, May 1995.

TOP RIGHT: Plant with Najma Akthar at a Black Country wedding.

ABOVE LEFT: Plant at his local tennis club with Bev Pegg (in pink shirt).

ABOVE RIGHT: At his 60th birthday party with Black Country comic Tommy Mundon, 2008.

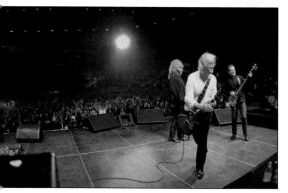

BOTTOM LEFT AND ONE ABOVE: Zeppelin rehearsing for and performing at their O2 reunion, December 2007.

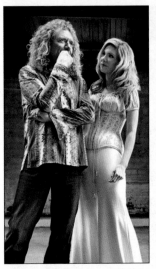

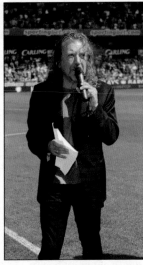

TOP LEFT: Plant and Alison Krauss raise sand, 2008.

TOP CENTRE: Plant at Molineux, home of Wolverhampton Wanderers.

TOP RIGHT: With Patty Griffin, his collaborator and partner.

LEFT: Plant, Page and Jones, together again in New York, 2012.

BOTTOM LEFT: . . . And receiving the Kennedy Center Honors from President Barack Obama.

None of them could run from the hard truth that the band was sounding like a shadow of its former self.

Years later Page insisted that *Presence* was his favourite Zeppelin album. He was doubtless swayed by the fact that so much of the music on it had come from him, seeing it as a personal triumph against the odds. For his part, and at the time of its release, Plant said it was a record shaped by circumstance, a howl of pain. Most of all *Presence* amounted to a yardstick, one measuring just how much had drained from Zeppelin in the preceding two years.

It was not the work of a functioning band, at least not in the way their previous records had been. The landscape it covered was flat and unchanging. Ideas had formed but few were seen through into fully realised songs. The ten-minute 'Achilles Last Stand', 'For Your Life' and 'Candy Store Rock' – each of these was a rampaging Page riff looking for a tune to fasten on to. Each followed a straight, narrow line without ever taking the twists, turns and unexpected detours that inhabited Zeppelin's greatest moments.

Sonically, it was pitched high and full of treble, hard at the edges and with a surface as cold as the point of a needle. Page left no space unfilled in the final mix, compressing everything to such a degree that it sounded wired and jittery. At the forefront he placed his own guitar, its tone sharp and grating.

Through this, occasional moments of power and clarity none-theless emerged, such as 'Nobody's Fault but Mine', another bruising blues epic, or 'Hots On for Nowhere', a frenetic boogie, Jones's bass and Bonham's drums dancing a fast-footed shuffle. The album, however, was summed up by its closing track, a second weighty blues titled 'Tea for One'. On this, Page's playing

had the consistency of liquid and there was tangible conviction to Plant's vocal, but its mood was morose and it extended for more than nine minutes, so that one was left wishing for it to end.

Throughout, Plant's singing betrayed his physical state, his voice drawn in and limited. Yet his lyrics shone a light into the band's darkest recesses. On 'Hots On for Nowhere', he reflected: 'I've got friends who will give me their shoulder, event I should happen to fall/I've got friends who will give me fuck all.' While 'For Your Life' found him pointing an accusatory finger as he sang of 'cocaine-cocaine-cocaine in the city of the damned', going on to sketch out a bleak and hopeless scene: 'Down in the pits you go … The next stop's underground.' It requires no stretch to imagine Plant working up these words in the hothouse atmosphere of Malibu Beach, his intended subject shuttered behind the walls of the house up the road.

The cover artwork proved to be entirely fitting. *Presence* was contained in an expanse of grey, at the centre of which a family of four was pictured looking at a mysterious black object, their expressions fixed and inscrutable. Like the record inside, it was a curiously passionless affair. The album was released on 31 March 1976, to begin with selling faster even than *Physical Graffiti* but stalling just as abruptly.

A month after it came out, another four-piece band, this one from New York and an insouciant-looking bunch, released their eponymous début. *Ramones* also sounded as if it were jacked up, but on amphetamines rather than cocaine – cheaper, edgier and more urgent. Rushing by in an anxious blur, not one of its fourteen tracks lasted longer than three minutes. There was nothing dextrous about this and it sold the tiniest fraction of what *Presence* did, but soon enough it would power

a challenge to the old order, the one that Zeppelin headed and epitomised.

With Plant still in recovery from his injuries, the band was returned to a suspended state and things continued to unravel. Page went back to his long-gestating *Lucifer Rising* soundtrack, for which he had managed to pull together less than half an hour of music, and this unsettling and incoherent. Grant also now had troubles of his own. His marriage had ended and he was slipping further into cocaine addiction. As he did, his grip on the band's affairs was seriously loosened.

Dave Lewis, editor of the Zeppelin fanzine *Tight But Loose*, began working out of the Swan Song office on London's King's Road during this period. 'I saw some amazing goings on,' he recalls. 'For a young and impressionable teenager it was an eye-opener. There were a lot of hard drugs going around. I remember one afternoon Richard Cole coming running up the stairs with an axe stuffed down his trousers. I don't know why he had it but he wasn't happy.'

There seemed no escaping the aura of menace that had engulfed the band. That summer Plant went to see Bob Marley and the Wailers at Cardiff City football stadium. He first made himself as conspicuous as possible, sweeping on to the pitch in the afternoon sunshine and being surrounded by people, and then retired to the hospitality lounge.

'I was having a chat with Robert when this guy named John Lodge came over to join us,' says Bob Harris, who was compering the show. 'John was bass guitarist in a band called Junior's Eyes. Everyone knew him as 'Honk'. He was six foot eight and had a massive nose.

'I don't know whether Honk was out of it but he was being kind of annoying. I had to excuse myself because I was due on

stage. Five minutes after I left, and as I was walking down the steps to the stage, I heard a cry from behind me. It was Honk and he had blood pouring from his nose. Someone from Robert's security had taken him to one side and asked him to cool it. Since Honk didn't really listen this guy had head-butted him.

'I'm not at all sure Robert even knew this had happened. But it was an indication that the ice was very thin around the edges.'

The year ended on a low note for the entire band. In the US that October – and in the UK the following month – Zeppelin finally premiered their film *The Song Remains the Same*. Critics drubbed it and also the accompanying soundtrack album, the one vanishing from cinemas as quickly as the other exited the charts.

Had Grant or Page still been on their game it is doubtful that either film or album would have ever seen the light of day. The film was a confusing shambles, almost grotesque in its self-indulgence, the record a document of Zeppelin's worst on-stage excesses. Both made it seem as if the band had lost its last shred of self-awareness, that the four of them were now as remote from reality as they were becoming from each other. On screen and record, when Page brandished his violin bow during a tortuous 'Dazed and Confused', it might appear as though he were fiddling while all around him burnt.

In the UK 1977 gave rise to two very different happenings: Queen Elizabeth II's Silver Jubilee celebrations and the breaking out of punk rock, one rising up as if in direct competition to the pomp and ceremony of the other. The Sex Pistols and the Clash opened Britain's punk floodgates, setting loose scores of snotty, abrasive bands in their wake. The most popular narrative following on from this point is that punk levelled the cultural landscape

at a stroke, the lumbering beasts of '70s rock being swept aside and music democratised to such a degree that virtuoso guitar solos and stadium-rock extravaganzas were instantly rendered passé.

In this context Keith Richards's arrest for possession of heroin in Toronto that February and the death of Elvis six months later can be seen as the last flailing of a bloated corpse. It is a dramatic account – but also a fiction. For no matter how hard punk impacted, and however much its influence has endured, it was no Year Zero. Even then, at the epicentre of the storm, the records that most engaged the mass audience had a familiar bombastic ring to them: Pink Floyd's *Animals*, Fleetwood Mac's *Rumours*, Queen's *News of the World* and ELO's *Out of the Blue*.

The biggest cultural phenomenon on both sides of the Atlantic that year was not *Never Mind the Bollocks* but *Saturday Night Fever*, in which white-suited John Travolta danced his nights away as Tony Manero to the Bee Gees' euphoric disco soundtrack. True, the Sex Pistols did stir up controversy with their 'God Save the Queen' single but this tilt at the windmills of tradition was still overshadowed by the Jubilee, millions gathering for street parties across the country on 7 June.

Zeppelin were foremost among the 'dinosaur' bands the punks took aim at. John Lydon of the Sex Pistols, then calling himself Johnny Rotten, scorned Plant for turning up to see the Damned with an entourage of minders, and Paul Simonon of the Clash claimed he felt sick just by looking at Zeppelin's album covers. Plant was particularly sensitive to these charges. Yet no one was architect of Zeppelin's downfall so much as the band themselves.

The end was begun with the announcement of a scheduled 51-date tour of North America set to start that February. From

the start it was too much to ask of them. For although Plant's physical injuries had healed, the band's health was ailing and they were in no fit state for such an undertaking.

In the event the dates had to be pushed back a month when Plant contracted laryngitis but his illness was the least of the problems that were soon to beset Zeppelin. When the tour did begin it seemed mired in darkness from the start. At one of the early gigs at the Riverfront Coliseum in Cincinnati sixty people were injured and more than seventy arrested when fans tried to gatecrash the arena.

Around the band's camp the mood also seemed blacker, its shifts more difficult to predict. The crew had swollen to include personal assistants for each member and for Grant, and also a greater security presence. To this Grant added John Bindon, a thirty-four-year-old Londoner who had first latched on to Cole.

A volatile character, Bindon was a professional bodyguard and part-time actor. On screen he had appeared in a pair of classic British gangster films: 1970's *Performance* alongside Mick Jagger and as a crime boss in the following year's *Get Carter*. The character he played in *Performance* was aptly named Moody, since Bindon had a hair-trigger temper and a reputation as a hard man.

'Bindon was just nasty, absolutely nasty,' says Dennis Sheehan, then working as Plant's assistant. 'He was well-built but good looking, and he could turn on the charm when he wanted. But a lot of the time you didn't see that. If you looked into his eyes you'd see something very devious and … unacceptable. Not the sort of person to have on the road.

'Richard Cole went completely off the deep end, too. I would rescue him. I hate to put myself into that role, but there were times when he was about to do the Superman act out of the

seventh-floor window of his hotel room. That's where his head was at and what drugs were doing to him.

'Peter wasn't tremendously well, either. He was suffering with a weight problem and from a bit of depression, too, I think, probably due to the amount of drugs he was taking. There were many occasions that I'd answer the phone in my room and he'd ask me to pop up to see him. What he wanted was for me to sit down and talk with him. He'd chat for hours about his wife, Gloria. It was quite sad. She was a lovely woman, but his drug-taking and other things had pushed the love away from their marriage.'

There had been no weakening in Zeppelin's pulling power, more than a million tickets having been sold for the tour. They were playing six nights at both Madison Square Garden and the Forum in LA. Business had never been better. Yet even though they could still lift themselves to great performances, it was getting harder for them to do so. And outside of the sound and fury of the shows, the fact was they weren't the same band. Nor would they ever be again.

Page appeared frail and drawn, Bonham bloated. Page had never been seen to eat much of anything but now he actually looked starved. In Chicago, the third night of the tour, he came on stage in full Nazi regalia, wearing an SS officer's peaked cap and black leather jackboots. It was as though he were attempting to be a physical manifestation of the cancer eating away at his band's spirit.

'For me, that was just another element of rock 'n' roll,' says Sheehan. 'And he did end up with some incredibly good-looking and curvaceous women in leather leotards. I think you have to look at a more rounded picture of that tour. In reality, there wasn't that much going wrong.

'Though the magic had gone at that point. There were moments when Jimmy wasn't quite there. He'd be playing one thing and the rest of the band another. There were some occasions, dare I say it, when I found myself falling asleep.

'There were also a couple of people within the organisation that had no need to be there. One was a pharmacist. His sole job was to make sure whatever drugs were bought were OK. Robert detested the fact that these people were around, especially the John Bindon situation. It brought out the worst – or even worse – in Peter and Richard Cole.'

'Sometimes it made me cry that Jimmy played so well,' says Benji LeFevre. 'Other times it made me cry that he was so fucked up and just couldn't play. Therein lay a problem for him and ultimately for Robert. Because when they started it was Page and Plant. They were so close. And that had changed.

'There was a certain inevitability about that tour. At the centre of it, you'd got four characters, plus Peter and Richard, who didn't have the same control over things they were used to having. It was all very different to the other tours I'd done with them and no longer as Zeppelin had been envisaged. It seemed to me that the camp was divided into Jim and Bonzo, and Jonesy and Robert. The first two,' he mimes nodding out, 'and the other two,' he mimes looking at his watch and waiting around.

At least outwardly, Plant remained very much as the band's former PR, Danny Goldberg, had once described him – Zeppelin's 'happy warrior'. According to Sheehan, he kept to a relaxed, carefree schedule. After a show he would head out to a club or bar, still enjoying being the centre of attention.

'He'd order a brandy or a cognac and take it easy,' Sheehan says. 'I'd last about an hour and then leave him to it. When he got

back to the hotel, he'd usually drop a note under my door asking to be woken at 11 or 12 the next morning.

'On days off he would spend time with friends if he had them in the area. On the odd occasion that would be with a girlfriend. I don't think he ever got into relationships that were intended to be anything other than mere flippancies – that wasn't part of what he did in life. The problem was he liked people – and women more so than men.'

Still, trouble stalked the tour. On 3 June at Tampa Stadium a torrential downpour forced the band off stage after just two songs. The storm raged on and the show was cancelled, sparking a riot that led to nineteen arrests and dozens more injuries.

'It had been the loveliest evening,' recalls Sheehan. 'All the families were there. Bonzo and Jimmy had been staying in Miami with their group. Robert and John Paul Jones were at the Disney resort in Orlando. The plane came and picked us all up, and it seemed the ideal situation.'

'There was an air of absolute disappointment, turning to hysteria,' Plant told me of that gig. 'They sent a US Air Force plane up to gauge how long the storm was going to last. It radioed back to security in the stadium so an announcement could be made. By the time that happened, kids were over the stage and going apeshit.

'We realised then that what they wanted was far more than we had. In real terms, what we had created in terms of expectation was something no amount of hype could ever hope to do.'

The first leg of the tour concluded later that month in Los Angeles. Here, the wounded beast steeled itself for one last, mighty roar. Across those six nights at the Forum, the last shows they would ever play in the city, Zeppelin summoned up the

ghost of all they had once been. It was a magnificent spectacle, the more powerful for being so close to ruin.

'The adoration of those crowds, night after night, it was of biblical proportions,' says Michael Des Barres. 'I was very privileged to be close to the inner sanctum but it was hard to be a part of it. For six nights, nobody slept. It was like being in an altered state.

'To be that near to them, it was shockingly fabulous and also dangerous. Peter Grant, Richard Cole and John Bindon – these guys were extremely aggressive and incredibly protective. Jimmy required that because he was – shall we say – compromised and needed to be protected. He was also shy and reclusive. And Peter was unquestionably in love with him.

'Robert was never a part of that extreme side of the band. He was a voyeur, perhaps, but not a participant. Robert, being a force of nature, brought the sun.'

After a three-week lay-off the tour resumed on 17 July in front of 65,000 people at the Kingdome in Seattle. Firecrackers rained down from the upper tiers of the enormous venue that night – another audience verging on the hysterical. Yet the band themselves seemed tired, sluggish. There was no lightening in the atmosphere offstage, either. To some of those closest to the band the air inside the bubble seemed heavy and ominous.

'The last section of that tour, everything about it felt strange,' insists Cole. 'There were so many bodyguards around. Peter had his children with him and even they had bodyguards. There was loads of coke about. There may have been a bit of smack here and there, too, but I don't think it had much to do with drugs. It was just this funny feeling.

'There was the odd fight. Not between the band members. It's very easy for people to be judgemental but they don't know what you have to fend off. You've got fucking lunatics banging on your door night and day. You know you're vulnerable to things so you just have to take whatever measures you can.'

'We were staying at the Edgewater Hotel in Seattle, right on Elliott Bay,' says Dennis Sheehan. 'As I was settling up the bill, the guy at reception told me that they were going to have to redecorate Mr Bonham's room because he'd completely destroyed it. He began to go through a list of everything that had been broken.

'As he was doing so I looked out at the water and I could see a fridge floating away. Those were the days when hotel rooms didn't have fridges and I'd rented some to put in each of their suites. Jimmy had decided that his never worked from the time he got there, so therefore it wasn't worth shit and out it went.'

The following week Zeppelin descended upon California for two outdoor shows at the Coliseum in Oakland, both promoted by Bill Graham. At the first of these the brittle threads holding the tour together finally snapped. The catalyst for this was an incident that occurred backstage, the precise details of which have been disputed ever since.

This much is clear: one of Graham's security staff, Jim Matzorkis, stopped Grant's eleven-year-old son, Warren, from removing a wooden plaque posted outside Zeppelin's dressing room. Doing so, Matzorkis, who probably had no idea who Warren Grant was, knocked the boy to the floor. This news was fast conveyed to Peter Grant, who was told his son had been struck. Together with Cole, John Bindon and Bonham, Grant headed out in search of Matzorkis. Finding him, the four of them hauled him into a portacabin and administered their own

form of retribution. Testifying in court later, Matzorkis claimed he was savagely beaten.

'I was stood less than forty yards from the portacabin and I saw it happen,' says Sheehan. 'I saw the security guard push over Peter's son. I don't think he meant it. He put his arm out to one side – Warren was a little off balance and fell. Then I saw the guy being taken to – or running to – Bill Graham's portacabin.

'Again, that name John Bindon. There's one thing about Peter going in there … He could be quite abrasive but I don't think Peter could have managed that on his own. He would have been very vocal but eventually it would have petered out. The guy had said sorry and would continue to apologise. Having Bindon there made it a thousand times worse.

'Regarding what happened to the guy. There are stories saying that he was carried out on a stretcher and they broke his face. I was stood there when he walked out. Yes, he had a bloody nose and he was being helped by a couple of people, but he was walking on his own. He went to an ambulance that was parked up backstage and he was seen to. It was a sad business. It ruined two great shows and the band's relationships in San Francisco.'

The next night the show itself passed without incident, but by the time the band returned to their hotel Graham had called in the police. Grant, Cole, Bindon and Bonham were arrested, charged and bailed. 'Once we got let out of jail,' says Cole, 'we had our pilots on standby and got the fuck out of there to another state.'

They flew to New Orleans, where the band's next gig was due to take place on 30 July. Touching down in the early hours of Tuesday 26 July, the entourage was met by a fleet of limos and ferried to the city's French Quarter. They checked in to the Maison Dupuy Hotel at 6 am. At the front desk Plant took a call

from his wife Maureen back home. Their seven-year-old son, Karac, had been taken ill with a viral infection.

'After that, I went up with Robert to his room and asked if there was anything he wanted,' recalls Sheehan. 'He used to use Flex shampoo – I remember he wanted to wash his hair. We'd known that Karac wasn't very well. I asked him how he was doing and he said, "He seems to be alright."

'Within half an hour I got back and went up to the room. Robert was sitting on the bed with his head in his hands. He'd just had the news that Karac had died.'

THE OUT DOOR

*Bonzo saved me. And while he was
saving me, he was losing himself.*

For the rest of that day, 26 July, time seemed to stand still. A numbing sense of shock reverberated through the camp. For Grant and his chief lieutenants there was the distraction of needing to get Plant home to his family as quickly as possible. Complicating this was the fact that they could not use the band's private plane, the pilots being grounded on account of having flown in to New Orleans from San Francisco just that morning.

It took hours to make alternative arrangements and book commercial flights. Plant seemed on the verge of breaking apart. He asked that Bonham, Cole, Dennis Sheehan and Benji LeFevre accompany him. It was late afternoon before this party was able to leave New Orleans. They flew first to Newark in New Jersey and transferred to New York's JFK International Airport, going on from there to London. Bonham sat next to Plant on the flight home. He kept his hand on Plant's arm, few words passing between them.

'The feeling was one of absolute despair,' says Sheehan. 'There are no words that can express what must have been going through Robert's mind at the time. There wouldn't be anything else that could be worse in your life.

'It was a very, very difficult journey. It was hard to have a conversation, to know what to say. As much as Robert was being comforted in the best way he could be, I don't think his mind was on anything that was being said to him.'

'There was nothing you could say to him. Nothing at all,' adds Cole. 'I thought it best to leave him be.'

In London a car was waiting to speed Plant and Bonham up to the Midlands. There, at Jennings Farm, Plant, Maureen and their eight-year-old daughter, Carmen, were left to mourn Karac.

Through the long days, weeks and months that followed, something else began to press down upon Plant. This was an awful, suffocating sense of guilt. It was stirred by the knowledge that he had been absent from his family when they had needed him most. He agonised over whether things might have been different had he been there. More bruising still was his understanding of what he had given himself up to: the state of the band during the time he was gone. When he reflected on everything that had surrounded that last tour – the decadence and violence, the arrogance and carelessness – it all seemed utterly pointless.

'Those were very dark times,' says Roy Harper, a friend of Plant's. 'He actually blamed Zeppelin for that. Not a particular person, just Zeppelin as an entity. For his being away at the time his son died and for not being there. I think he probably came to an end with the band long before the others did.'

'To be honest, I don't believe that Robert ultimately has ever got over that feeling of guilt,' says LeFevre. 'Karac's death cut him

and Maureen to the very bone. And after they'd only very recently been physically cut to the bone.

'I think he had all these thoughts within him. "What the fuck am I doing here with these people that used to be my mates and who can hardly function? I knew it was going to be like this and so why did I do it? I could have been there and saved my son." If he's being honest, he's probably still having them.'

The four men that travelled back with Plant from New Orleans also attended Karac's funeral. The others remained in America. Jones was out of contact, having taken off with his family after the Oakland débâcle, not intending to return until the scheduled gig in New Orleans. Page also disappeared off the radar and Grant flew with his children to New York, each man as dazed as the other.

'I was in Oregon and I called in to New Orleans,' Jones told the writer Mick Wall. 'Anyway, Robert had gone home with Bonzo and I went on to Seattle. It was a very strange time. We just knew we had to give him time.'

'The way I see it, some people can handle these things and others can't,' reflects Sheehan. 'Maybe the others were at a loss. I truly believe that they felt the same as he did but it was their inability to express it. Sometimes people don't know how to say, "Look, I just couldn't handle it," regardless of how close they are to you.

'At least I'd like to think there was no reason other than them not being able to deal with it. Because you'd hate to have to hold that against anybody.'

'I don't know or I can't remember if Robert wanted them at the funeral,' says LeFevre. 'My interpretation of it was that he wouldn't have had Jimmy there for anything. I think that he felt something inexplicable in that way. I don't know whether

he could articulate that at the time but he just didn't want any of that atmosphere being around him and Maureen in their grief.'

After burying his son Plant retreated to grieving, and through that the long process of healing himself and his family. He doubted he would be able to go back into his rock-star box and questioned whether he even wanted to. He went so far as swearing off drugs and applying for a post at a teacher-training college in Sussex – the Rudolf Steiner Centre. An Austrian, Steiner was a social reformer who had pioneered an alternative learning system at the turn of the century based upon encouraging artistic and creative development. In 1934 a Steiner school was established in Stourbridge, the town in which Plant had grown up. His application was accepted, although by then he had decided not to pursue it.

Benji LeFevre, at that time going through a divorce, moved in to the guesthouse at Jennings Farm. 'For whatever reason, Robert and Maureen welcomed me in to their home,' he says. 'I spent the next few months with Robert drinking an inordinate amount of the local beer, Banks' Bitter, every day and night. I put on four stone.

'I experienced all the sadness and grief that he and Maureen went through. I think Robert found himself expecting to be able to get over Karac's death in some sort of way, but emotionally not quite making it. He seemed to me to do his best to recover as quickly as he could. Though one can't imagine how he felt.'

'I used to have a little 8mm camera that took three-minute spools of film,' recalls Sheehan. 'When I went through all of these after Karac had died I realised that I had seven or eight films of the whole family. Things that I'd taken when they were with us,

bits and pieces. So I packaged them up and sent them to Robert. They were for him, not me.'

It would be more than a year before Plant even thought of removing himself from his family and returning to the band. The world he had departed from kept turning through 1978. The Rolling Stones and Bob Dylan both hit the road again. The Sex Pistols ran their short course, imploding at a gig in San Francisco in January. Eleven months after the band broke up, the Pistols' bassist, Sid Vicious, strung out and hopeless, was arrested in New York on suspicion of the murder of his girlfriend Nancy Spungen. Keith Moon checked out that September, an overdose claiming the Who's drummer at thirty-two.

For Plant there was a more a terrible echo closer to home. Carl Bridgewater, a thirteen-year-old schoolboy, was murdered at Yew Tree Farm, three miles from Stourbridge, on the morning of 19 September. He was on his regular paper round when he disturbed burglars at the property. They shot him dead. If one were searching for a meaning to things, this offered none, save for the certainty that life was fragile, senseless and sometimes cruel.

Gradually, Plant stepped out. He and LeFevre produced a single for a local punk band, Dansette Damage. Their keyboard player, Eddie Blower, also worked as a photographer and had done some family portraits for Plant. The session took place over an afternoon at the Old Smithy, a new studio that had opened in Worcester, down the road from Jennings Farm.

Titled 'NME', after the music paper, the song was a basic two-chord stomp. The cover of the single featured a black and white photo of the seven-piece band and a suggestion to 'Play Loud'. Plant was billed as the Wolverhampton Wanderer.

'Robert said he couldn't have his name associated with the record,' says Mike Davies, a local journalist who was at the session. 'He seemed to be really into it but he didn't want it getting out that he'd been involved with a punk thing.

'None of Dansette could actually play. Robert was trying to get the singer, Colin Hall, to sing in tune and he joined in as well. You can hear him at the end of the track – they were all stood around one microphone. He was very affable, the sort of guy you'd go and have a beer with. Before he arrived Eddie had told us not to mention anything about his son.'

At Jennings Farm the wounds had begun to mend, although deep scars would remain. Maureen became pregnant again that spring.

'I went to see Robert a couple of times during that period,' says Sheehan. 'Part of his life had been destroyed and he was trying to build it back up again. Maureen getting pregnant helped that process. It wasn't a replacement for Karac, it certainly wasn't, but it re-established the fact that life has to go on, it can't be all about living in the past. Robert realised that.'

In October Page and Bonham convinced him to attend a band meeting at Clearwell Castle, an 18th-century mansion house in the Forest of Dean near the border between England and Wales. He was reluctant to go and, once there, soon regretted it. Although they tried playing together the band were still in a mess and so was their manager, none of the demons having been laid to rest. The meeting broke up and Zeppelin's exile went on.

It would be many months before Plant saw Page, Jones or Grant again – but then, even at the best of times, he had had little contact with them when the band was not working. Bonham, however, was a constant presence at Jennings Farm. Most often he would come round with his wife Pat and a bottle of some-

thing, determined to pick his friend up and cajole him back to life. Not that Bonham was better able to look after himself. That September he had crashed his car driving home from the pub. This he had bounced back from, but he was also nursing a ruinous heroin habit.

'When I lost my boy it was Bonzo that came and fished me back out again,' Plant told me. 'He lived nearby and we were much more, if you like, related than the others. There was nothing fey about the pair of us. We had our feet on the ground but at the same time we were also spaced out.

'In all the wildness of Zeppelin … you saw all these things. And when big things happen, you cave in and collapse. You think, "It's all my fault, I should never have gone away." Bonzo saved me. And while he was saving me he was losing himself.'

'Bonzo used to do a lot of fucking drugs and mix up a lot of things, too,' says Trevor Burton, whose band Bonham took to jamming with on Birmingham's pub circuit until he turned up at a show drunk and belligerent, and they had to throw him off stage. 'Put it this way, he was a lot like Keith Moon. He thought he was invincible.'

Plant took a low-key route back to performing, putting together a knockabout band with a group of musicians who drank in his village pub, the Queen's Head. Calling themselves the Turd Burglars, they began doing intermittent pub gigs playing rock 'n' roll covers. Plant's co-vocalist in this band was Melvin Gittus, a local character reputed to have the biggest penis in the West Midlands.

'Melvin had been a sergeant major in the army and was then a double-glazing salesman,' recalls LeFevre, who became the band's soundman. 'He fancied himself as a singer and he did have the biggest dick you've ever seen.

'It was an incarnation of a local pick-up band having fun. After eight pints of beer one night we said, "What would happen if we called it the Turd Burglars?" We all used to play for the Queen's Head's football team – I was the goalie. We did annual road trips. We'd arrange games with these social clubs in places like Penrith, up north, or down south in Weymouth. The stipulation was that we needed somewhere to pitch Robert's tent, which slept thirty-two people foot to pole. Robert and the band would give a performance in the club the night before the game.'

The Turd Burglars also went into the Old Smithy and cut a couple of tracks, both American rock 'n' roll tunes dating from the '50s – Huelyn Duvall's 'Three Months to Kill' and 'Buzz Buzz A-Diddle-It', originally recorded by Freddy Cannon. It was an altogether different world from that which Plant inhabited with Led Zeppelin but one he would return to time and again. Here, surrounding himself with friends and playing for the hell of it, he was able to recapture the pure, untainted spirit that had first fired him.

Finally, in the winter of 1978 he regrouped with Zeppelin. Initially, they began rehearsing together in London, although the health of the band remained precarious. In the time off Page had not come up with any new music, and the split between him and Bonham, and Plant and Jones, was more marked than ever. Still, they ploughed on with making an album.

In November they moved base to the Swedish capital of Stockholm, where they booked in to local pop superstars ABBA's Polar Studios. Mindful of Plant not wanting to be away from home for long stretches, and with relations in the band being fractious enough as it was, it was decided that they would commute between the UK and Sweden. For the next two

months they flew out to Stockholm from London on a Monday morning, returning each Thursday evening.

'It was fucking mad out there,' remembers LeFevre. 'We were staying at the Sheraton Hotel, on the fourth floor. The principals all had suites, one at each corner of the building. Since they all wanted their own sound systems, and packets of M&Ms with the brown ones removed, and this, that and the other, these rooms were kept for the whole period, even though they weren't occupied half the time.

'Another crew guy, Rex King, and I were charged with looking after these suites and we had a blast. We'd go down to the local Atlantic Records office whenever we needed more money and they'd hand over wads of bills. Limousines were parked outside the studio and the hotel, twenty-four hours a day. They'd be sent off to McDonalds to get a Big Mac and a chocolate milkshake. It was total excess.'

Even though Page was subsequently credited as producer, he was often as not a spectral presence. As much out of necessity as design it was Plant and Jones who took the lead roles in shaping the record that became *In Through the Out Door*.

Jones had written a bunch of songs, although not originally intending them for Zeppelin, and had begun experimenting with the latest synthesisers. He and Plant had always maintained a distant relationship but, having been restricted to writing lyrics in isolation on the last album, Plant was grateful for having a creative partner. It was also a long time since he had been backward in coming forward.

'Robert, Jonesy and I would get up each morning and go for a jolly good walk,' says LeFevre. 'We'd end up in the pub and get to the studio later in the afternoon. Maybe Jimmy and Bonzo would be there, maybe they wouldn't. It was a fantastic studio.

The control room was in the middle of a semi-circle of glass with all the separation rooms around it, so everybody could see each other.

'The engineer had warned us that sometimes the fire alarm would go off for no reason. The first room on the left from the control room was where Bonzo sat. One night he was in there, nodding off but still keeping the groove. The fire alarm went off and all these firemen came bursting in with extinguishers. Bonzo just looked up and carried on playing.'

Plant had his own particular memory of the period. He told *Uncut* magazine in 2007: 'I was saying to myself, "If I go tomorrow, is this where I want to find myself: in a sex club in Stockholm, being silly with Benny and Björn from ABBA, while Agnetha and Frida are driving around trying to find which den of iniquity Led Zeppelin had taken their husbands to? And this guy lying on the circular mattress, how big is his dong? …"'

Maureen gave birth to a son in January 1979. The couple christened him Logan Romero and once more Plant retired to family life. The months rolled by. Britain got a new government, Margaret Thatcher coming to power that May, the country's first female prime minister. The world's first Islamist republic was established in Iran, Ayatollah Khomeini overthrowing the ruling Shah and sending him into exile in the West.

Zeppelin's new album was due that summer. As its release loomed, Plant resisted overtures from Grant to commit to an American tour or even to consider going on the road for an extended period. Eventually, he agreed to just two shows in the UK. These would be staged over consecutive weekends in August in the grounds of Knebworth House, a stately pile in Hertfordshire

on the outskirts of London. The band would be paid £1 million for doing them, with more than 100,000 people expected to attend each day.

In the event there was a dispute about the exact size of the crowds. Grant claimed the total figure far exceeded the projected amount, an opinion backed up by many of those who were there. The promoter Freddy Bannister insisted that less than half the tickets had been sold for the second show, losing him a considerable amount of money, although if he intended using this as a tactic for recovering some of Zeppelin's huge fee from Grant, he failed.

There were also different interpretations regarding the well-being of the band itself. Certainly, Zeppelin appeared changed. Plant and Page had trimmed their hair, and in publicity photos for the shows both of them wore a jacket, shirt and a skinny tie, although Plant still bared his chest on-stage. Bonham looked heavy, Page skeletal.

'They didn't look as harrowed as they had on the '77 tour,' insists Sheehan. 'When I saw all four of them together at Knebworth I was amazed. They seemed happy and healthy, Robert extremely so. They appeared absolutely refreshed. That period had been good for them.'

'I was in a bad way, I make no denial of that,' says Cole. 'Were the others? I don't know. Not Robert and Jonesy, that's for sure. I couldn't honestly tell you whether either of them had ever used heroin, but they were very much against it by then. It had caused a split in the band, because those two were on a different wavelength.'

'I think we determined there was a point earlier that things changed,' concludes LeFevre. 'There was nothing to be added to that at Knebworth, that's all I can say.'

Yet just as they had on the best of nights two years earlier, when they had to perform Zeppelin could still soar. On both nights at Knebworth they hit the heights – majestic on 'Kashmir', roaring on 'Rock and Roll', revived on a towering new song, 'In the Evening'. Whatever the trials of recent years they seemed unbeaten. Even the punks turned out to acknowledge them, Mick Jones of the Clash and Steve Jones, the former Sex Pistols guitarist, both appearing backstage. But the jibes the punks had made at Zeppelin still rankled with Plant. On-stage, he made caustic comments about 'doing dinosaur rock'.

'The fact that we were so bloody popular made them hate us,' he told me. 'We should only have been judged on what we did on record and we hadn't done anything for a while then. So when 1978 and '79 came around we were pretty remote. And we had a lot more money than Sid Vicious.

'The thing is, all those guys that are still around, they became careerists. You had John Lydon decrying Zeppelin in the Pistols. Then, when he was in Public Image Ltd, I got a call saying that he wanted to get hold of the lyrics to "Kashmir".'

The reality was that punk had barely scratched Zeppelin. Had things turned out differently they might have faced a second, more sustained challenge from another quarter, at least in their homeland. As the new decade began bands like Iron Maiden and Def Leppard emerged from the UK's regional club circuit. Although they saw themselves as being far closer in spirit to Zeppelin than the punks had been, these bands were also younger, hungrier and more accessible to a new generation of rock fans. This movement, saddled with the cumbersome title of the New Wave of British Heavy Metal, rose up just as Zeppelin started their descent from view.

Critics in Britain generally dismissed *In Through the Out Door* when it came out a week after the second Knebworth date. It topped the charts, but was knocked from its perch after a couple of weeks by the electro-pop of Gary Numan's *The Pleasure Principle*.

If this suggested a changing of the guard in the UK, it was a different story in America. At a time when US record sales were slow, *In Through the Out Door* shifted four million copies in just three months, singlehandedly bringing the market back to life. In doing so, it allowed Grant to prove a point. Copies of the album – for which there were six different covers, each one a variation on the same bar scene – were slipped inside a brown paper bag with the title and the band's name stamped on it. Grant had maintained that Zeppelin records could be sold in paper bags.

It was not as though *In Through the Out Door* was a great Zeppelin album, either. The pall that settled over its predecessor had been lifted, but it was still disjointed and lopsided. It sagged badly in the middle – on the Elvis tribute 'Hot Dog', as wretched a pastiche as 'The Crunge' on *Houses of the Holy*, and on the tiresome 'Carouselambra'. Page and Bonham were largely muted, Jones's clunking keyboards dominant. By contrast Plant sang with assurance but also restraint.

There were just enough good moments to sustain it. Both 'South Bound Suarez' and 'Fool in the Rain' had a lively kick to them. Yet it flew only when Page came to life. This he did on the opening 'In the Evening' and the grand closing track 'I'm Gonna Crawl', shrugging off the fog he was in and playing beautifully.

As with *Presence*, Plant's lyrics offered an insight that was more interesting than much of the music. 'All My Love' was a tender tribute to his son Karac, his words and vocal too heartfelt for

such a so-so song. While on 'Carouselambra', two lines, aimed at Page, stood out from the gloom: 'Where was your word, where did you go?/Where was your helping, where was your bow?'

Plant also continued to look outside of Zeppelin for stimulation. At the end of that year he performed with Dave Edmunds, who had been signed to Swan Song, joining his band Rockpile at a Concert for Kampuchea gig at London's Hammersmith Odeon, although if he was being arch in choosing the song he sang with them, he never said. It was an old Elvis tune, 'Little Sister'.

He also considered forming his own record label, planning for it to release vintage rockabilly and rock 'n' roll songs. 'I was going to call it Palomino Records,' he told me. 'I contacted Mo Ostin, who ran Reprise in America, and he agreed to give me some of his stuff on licence – there were things like Ral Donner, an Elvis impersonator.'

This came to nothing. Instead, almost a year on from Knebworth, he agreed to tour again with Zeppelin. It was a short commitment, three weeks in Europe, beginning in Dortmund, Germany on 17 June 1980. The venues were modest-sized arenas, the shows shorter and stripped-down, shorn of Bonham's drum solo and such extended pieces as 'No Quarter' and 'Dazed and Confused'.

'Having found out that he wasn't invulnerable, I think Robert was possibly trying to believe that at least this thing – the band – would be,' reflects LeFevre, 'even though it proved very difficult for him and all the guilt things he'd begun feeling as a result of Karac's death were ever-present. I think it was an attempt to shake things off.'

The performances were erratic, Bonham often flagging. Missing from the touring party was long-serving road manager

Richard Cole, dispatched by Grant to get himself off heroin. 'From people I know that were there, that tour sounded more of a shambles than they like to make out,' he told me.

'It was a very different Zeppelin. There wasn't the same cock-sureness about them,' says Dave Lewis, who followed the tour as a fan. 'Robert was on really good form and he was trying to be the rock star again, but Jimmy was obviously not in the best of health.'

However trying the tour, Plant had seen enough to suggest that the band had a future. As they touched down in London at the end of it he turned to Grant and told him he was prepared to go back to America once again.

The condition Plant set when submitting to a tour of America was that he would not be away from home for longer than a month. The first batch of dates the band announced were scheduled to run from 17 October to 15 November, beginning in Montreal and ending with four shows at Chicago's basketball arena. This initial itinerary followed the pattern of the recent European trek, keeping to indoor venues. It was as if, in scaling back the excesses of their production, it was hoped the band might also be able to cleanse itself.

'I don't think everybody was over the moon about the prospect of that tour,' says LeFevre. 'It was almost like, "Let's try it once more and see if it works." Though certainly, everyone else didn't bring Robert kicking and screaming to it – he'd agreed to do it.'

Rehearsals began during the fourth week of September. The band set up camp in Bray, a large village on the banks of the Thames, four miles from Page's new house in Windsor. Again, they divided in two. Plant and Jones based themselves in London

at Blakes Hotel, while Bonham was to bunk up with Page. There was no encouragement to be drawn from the first rehearsal on 24 September. Bonham turned up drunk, too incapacitated to play, and the session was abandoned.

Driving back up to Bray from London the following day, Plant, Jones and LeFevre decided to call in at Page's house and rouse the other two. When they arrived Page had surfaced but there was no sign of Bonham. LeFevre went upstairs to wake him, Jones following. Opening the bedroom door, the fetid smell was enough to tell LeFevre that Bonham had gone.

'I remember coming back down the stairs and saying to Jimmy and Robert, "Don't go up – it's all over." That's all I said,' he recalls. 'I immediately phoned Peter. Then, the first concern was to get to Pat Bonham before she heard about it through any other source. So Robert and I got in the car and drove at a million miles an hour up to the Midlands.'

At the inquest into his death the coroner revealed that Bonham had consumed an estimated forty measures of vodka and had choked on his own vomit while asleep. He was thirty-two, the same age as Keith Moon had been when he died.

John Bonham was buried on 10 October at Rushock Parish Church near his home in Worcestershire, 300 mourners attending the funeral service, his shell-shocked band mates and Grant among them. For Plant it was almost too much to bear, these last years, all the tragedy he had suffered and been witness to, all the questions without answers, and all of it emanating from the band.

'When we lost John, I thought, "Fuck this – I don't need this shit." There had to be another way of doing it,' he told me. 'Because actually, there is some joy in this thing.

'I knew I'd got to go and make it on my own, and not just bathe in this … kind of false economy of success, if you like. You know, get another drummer and just keep on going with the band. That was the end of all naïvety. It was very evident that my last connection had been severed.'

After the funeral Plant, Page, Jones and Zeppelin's crew flew to Jersey for a long weekend. 'Just to be together,' says Benji LeFevre. 'I never thought that it was anything else but the end.'

Back in London the remaining band members and Grant met at the Savoy Hotel. The short statement they agreed upon was released on 4 December and read: 'We wish it to be known that the loss of our dear friend and the deep respect we have for his family, together with the deep sense of undivided harmony felt by ourselves and our manager, have led us to decide that we could not continue as we were.'

'There was no way with the loss of John Bonham that the thing between us could ever be re-created,' Page told me. 'But Robert had a voice, which is easier to project out than a guitar. It took me a while to recover from the shock of it. When I say recover, I mean to at least get standing up again.'

'I was a young man when Zeppelin finished,' Plant said to me. 'I was 32 and I didn't know what the rules were. "No more singing, maybe I should write a book." I thought I was all washed up.'

PART THREE

SOLO

Hey presto!
I was born again.

13

EXORCISM

It was almost like a spiritual quest ... like
we were all walking five feet off the ground.

In the immediate aftermath of Bonham's death, vultures were
soon circling. Plant and Page were each approached through Peter
Grant to form a new 'supergroup' with bassist Chris Squire and
drummer Alan White from the prog-rock band Yes. This proposed
group was to have been called XYZ, which signified ex-members
of Yes and Led Zeppelin. Page met Squire and White, and even
went as far as sitting in with them. Plant ignored the offer.

As he'd done after his son Karac had died, Plant instead
collected himself at Jennings Farm. Once again, the route he
charted back to music started from far off the beaten track. He
was sparked into it by Benji LeFevre, who was still living on the
farm and had assigned himself the job of clearing out one of the
barns, as much as for having something to do.

That job done, LeFevre next occupied his time in setting up
a small four-track studio in the barn. At LeFevre's urging, Plant
began using this new resource, inviting local friends round to
jam with him, setting these sessions down on tape for the sheer

fun of it. First to drop by were Andy Silvester and Robbie Blunt. Both men hailed from down the road in Kidderminster and had known Plant since he was a grammar-school boy.

An unassuming character, Silvester had met Plant at the Seven Stars blues club in Stourbridge in the early '60s. He played bass and guitar, both equally well, although others had a higher opinion of his abilities than he himself did. The teenage Robbie Blunt was a frequent visitor to Plant's family home at 64 Causey Farm Road. There, the pair of them had sat up in Plant's bedroom listening to blues records. Even then, Blunt was a gifted guitarist. He'd gone on to play with a couple more of Plant's old Kidderminster posse, Jess Roden and Kevyn Gammond, in a band called Bronco, and also with Michael Des Barres in Silverhead.

These get-togethers at Jennings Farm were relaxed affairs and a regular group of musicians formed around them. Joining Blunt and Silvester were Jim Hickman on bass, Kevin O'Neil on drums, Ricky Cool on harmonica and a saxophonist, Keith Evans. Belting out old R&B and rock'n'roll standards with this collective, Plant seemed happier than he'd been in years, his love of music rekindled.

'He found a freedom again to do what he wanted, rather than what was expected of him,' says LeFevre. 'Underneath it all, I think that was how he experienced the last few years of Zeppelin. He had all these confused thought patterns – this feeling of responsibility to the other members and their families. This was something that he could enjoy doing. It was just about playing music and it wasn't to do with self-indulgent, 30-minute guitar solos.'

'I was living in the West Country at the time, and I went up to see Robert quite often when he'd decided to get his life

together again,' recalls Dennis Sheehan. 'He knew he'd never again have financial worries, and he had his family and a new son, but it's not as if you fall into a band as momentous as Zeppelin by accident. He needed to fill his life with something else, too.

'I remember in Zeppelin, he often told me about this American rock'n'roll singer from the '50s, Ral Donner. Robert thought he was the greatest. I can't help but think he was trying to model himself on Donner when he went into his own career.'

Plant gave this makeshift covers group a name – the Honeydrippers. His inspiration was an old American blues pianist, Roosevelt Sykes, who went by the nickname of the Honeydripper. Early in 1981, he called in a local promoter, Roy Williams, and asked him to book some low-key gigs for the band. He had two stipulations: that none of the venues could advertise his name, and he wouldn't play south of Watford, the satellite town that is a gateway to London.

The Honeydrippers played their first show at Keele University in the East Midlands on 3 March. During the next four months, pub and club gigs followed in such Midlands cities as Wolverhampton, Derby and Nottingham, and further north in Manchester, Middlesbrough and Sheffield. The band travelled in a transit van driven either by Roy Williams or Plant's mate, 'Big' Dave Hodgetts, with LeFevre following behind in the three-tonne truck that carried their PA system.

'It was great fun,' enthuses Williams. 'The band were doing R&B stuff, the shows were hot and sweaty. Robert was trying to get over the fact he'd lost his mate and this was one way of doing it. Of course, people would find out he was playing because of the network of fans that Zeppelin had got. We took 90 per cent of the door, the same deal Peter Grant had done with promoters.

'We hadn't used to bother booking hotels; we'd just get to a town and ask people if there was a good place to stay. I remember we couldn't find anywhere in Sheffield and ended up driving around the city. Eventually, Robert spotted another Transit van parked outside of a pub and said, "I bet there's a band in there, let's go and ask them." He went up the staircase at the back of the pub and, sure enough, there's a group of kids rehearsing. They were open-mouthed – the Golden God had walked in on them. His opening line was: "Excuse me, lads, do you know where I can find a cheap bed and breakfast?"'

Dave Lewis, founder of the Zeppelin fanzine *Tight But Loose*, travelled with Plant and the band to some of these shows. 'Robert was used to being ferried around in limousines and here we were, driving around the Midlands in an old van,' he says. 'It was a brave thing for him to do.

'People would be asking him where Jimmy was and shouting out for "Stairway to Heaven", and he was up there doing rockabilly tunes. They'd turn up with Zeppelin album covers, wanting him to sign them, and he wouldn't do it.'

In all, The Honeydrippers did fifteen shows, the last of them on 15 June at a pub called the Golden Eagle in Birmingham. By then the band had served its purpose, getting Plant back on his feet. Establishing the pattern he would follow from then on, he put them to one side and moved on.

All told, 1981 was a particularly bleak year in Britain. With the economy in the doldrums, riots flared through that spring and summer in two of the UK's most deprived inner-city areas, Brixton in London and Liverpool's Toxteth. The musical movement that blew up in the country that year offered the promise, however vicarious, of an escape from such grim realities.

Although they had formed in Birmingham, Duran Duran seemed to have come from another world altogether, one more glamorous and hedonistic, as fabulous as it was ridiculous. As much as the music itself, it was this sense of artifice that held the appeal of the New Romantic scene that Duran Duran fronted. A blitz of flamboyant fashion and outrageous characters, it had an unabashed gaudiness to it that stood in brilliant contrast to the stark, grey mood of the day.

Robert Plant turned 33 that summer. By the youthful terms of pop he belonged to an older generation, one far removed from the pulse of the time. Yet Plant was curious enough to see if he could use what was then happening in music to signpost his next move. Since the prevailing sound was electro-pop, coming from the New Romantics and acts such as Depeche Mode and Soft Cell, he bought a Roland drum machine. By the end of the year he had begun using it to work up ideas with Robbie Blunt, the one member of the Honeydrippers he had retained.

'It was uncomfortable to begin with and I wasn't sure I could handle it,' he told Tom Hibbert of Q magazine in 1988. 'Page and I had known each other back to front in that area. It had been a bit twitchy at times, because of all the drugs, but basically comfortable. And so to start again with anyone else was a very, very odd feeling.'

Gradually, though, he settled into a new routine, he and Blunt and LeFevre gathering in the makeshift studio out at Jennings Farm. As things progressed, Plant brought in Jezz Woodroffe to write and play keyboards with them. Woodroffe had recorded and toured with Black Sabbath, and also ran a popular music shop in Birmingham. Plant came by the store one afternoon in the spring of 1982, ostensibly to buy a Moog synthesiser.

'I vividly remember Robert walking in that day,' Woodroffe says. 'He looked really well. He was sun-tanned and wearing a Hawaiian shirt. As much as anything, I think he was checking me out to make sure I wasn't some kind of nutcase.

'I went out to the farm and Robbie Blunt was there with him. Robert had just bought him a guitar amp for a thousand quid. Robbie was struggling at the time, he hadn't got any money and he was living in a council house.

'We worked out in the barn. Robert christened it Palomino Studios. His daughter, Carmen, had a Palomino horse in the stables next door. Benji and Robert were very close, like brothers. It was a very up, family-oriented vibe. Robert's son Logan used to come running into the studio as we were playing. Maureen was around a lot, too.'

Soon, the communal mood was further enhanced by the presence of John Bonham's fifteen-year-old son, Jason. Plant had asked him along to help out on drums.

'Jason used to arrive from school on the back of his friend's scooter,' says Woodroffe. 'A lot of the numbers on that first album were worked out with him. He was a natural, sounded just like his dad.'

'The whole thing was like a big experiment,' says LeFevre. 'I had set Robert up in the home studio so he could overdub his vocals without anyone being there, because he is technically hopeless. He talks as if he knows everything, but really he has very little clue about that side of things.

'During that time, he also asked me to manage him. He said, "I don't want to be involved with all that big bollocks in London." I told him not to be so silly. But I did love the music.'

The first song they completed was a spare, syncopated track titled 'Fat Lip', rooted in the blues, but with a light feel to

it that suggested the weight of Zeppelin falling from Plant's shoulders. It sounded like nothing so much as an exhaling of breath.

'I wrote that as a tribute to Bonzo,' Plant told me. 'He had gone and I had the drum machine, so what better thing to do than fall in love with automated rhythm? It was so far away from that kind of fantastic force that Bonzo was. After that, I was off. And every time I moved another step, I got freer.'

Plant continued to work off the grid, both Grant, his nominal manager, and his record label, Atlantic, being left in the dark about his new project. In the summer of '82, he moved base to Monmouth in rural South Wales, there hiring out Rockfield Studios, a residential facility set within miles of open countryside.

Different musicians came and went. Andy Silvester returned on bass, until his confidence failed him and Paul Martinez, a seasoned session man, stepped in. Bad Company's Simon Kirke tried out on drums, but didn't click. Two tracks were recorded with Cozy Powell, who'd drummed with the Jeff Beck Group and most recently in ex-Deep Purple guitarist Ritchie Blackmore's band, Rainbow. The rest were done with Phil Collins of Genesis, who completed his parts in just three days.

'To begin with there was no idea of doing a record or putting a band together,' insists LeFevre. 'Robert was just interested in pushing this thing further to see where it went and what it felt like.

'Eventually, it turned into the making of the first album and then it became a real fucking gas. It felt like a socialist situation, where everyone was equal. Of course, everyone was aware that Robert was funding it, but that wasn't the point. It genuinely felt as if it was all about the music.'

'Certainly to start with, Robert kind of let us get on with things,' says Jezz Woodroffe. 'The main structure for most of the songs came from Robbie Blunt and me. When we'd got a basic arrangement, Robert would develop it from there. Though I never heard the finished vocals – he'd always sing them when the rest of us were off down the pub.'

The finished record, *Pictures at Eleven*, did sound like a fresh start, one divested of Zeppelin's heaviness, both musically and in terms of the emotional baggage that had been carried through the band's last two albums. If anything, it was too well mannered. It now sounds very much of its time, clean and neat but with no hidden depths.

Plant's singing was assured and unburdened, although he cut loose just the once, on 'Slow Dancer'. The album's best track, this was also the one that most echoed Zeppelin. An intense, exotic swirl, its driving guitar line was lifted from an Arab song, 'Leylet Hob' ('Night of Love'). This had been most notably sung by the famed Egyptian vocalist Oum Kalsoum, a tape of which Plant had picked up in Morocco in 1972 and carried around with him ever since.

Once the record was finished, Plant at last reached out to Peter Grant and Phil Carson, who ran Atlantic Records in the UK. He invited the two men up to Rockfield to hear *Pictures at Eleven*. It was a tense occasion, with neither man showing much enthusiasm for the music or the musicians that Plant had surrounded himself with.

'Phil Carson wasn't particularly happy about Robert's new direction,' recalls Woodroffe. 'He was always telling us to go back to that Zeppelin sound, because he knew the kind of money that it generated. He was a supermarket manager before he went to

Atlantic. I remember him telling me that if he could sell beans, he could shift records.'

'I think that Peter said something to the effect of, "You'd better just pay these guys off, because you've got a career here,"' says LeFevre. 'He wanted Robert to be in a supergroup situation and not playing with unknowns, because then they'd all make lots of money.

'Robert's reaction to that was two-fold: "I take your point," and, "No, this is my thing." I think it's true to say that Robert's respect for Peter had diminished during the previous five-year period, and for obvious reasons. The camp had been split and Peter had come down on one side more than the other. It had always been, "Jimmy's done this, and Robert's sung on it and written the lyrics." Robert didn't want to go back to that, because he'd tasted a bit of freedom and intellectual satisfaction outside of the machine.'

Grant and Carson were reluctant for the record to come out and there was a stand-off. Carson contacted Ahmet Ertegun in New York, asking him to intervene on their behalf. Plant told me years later that he felt as if Grant were trying to sabotage his solo career before it was begun. He turned to Phil Collins for advice and was urged to stand his ground.

'I had a meeting with Ahmet, Peter and Phil Carson,' he told me. 'I went into the room and said, "I'm going to do this on my own now and if anybody here doesn't take me seriously, then all we've known between us is over." The doors had been flung open and I wasn't going to hang about.'

In reality, the resolution wasn't that clear-cut. When Plant returned to Rockfield, it was evident things had changed. Beforehand, he had contemplated calling the project the Band, or something similar, to suggest that this was a meeting of equals.

That was now forgotten and *Pictures at Eleven* would be released as a solo record under his own name.

Robbie Blunt and Jezz Woodroffe had also been led to believe that there would be an even split in the publishing monies for songwriting, a potentially lucrative arrangement. This, too, was no longer the case.

'Up until that point it had been, "This is a co-operative and we're going to share everything,"' recounts LeFevre. 'Then all of a sudden it wasn't. Everybody went, "Uh? That's not what we were talking about last week." Yes, he was funding it, and he was the star and without him none of it would have happened for them. But it put a sour taste in everyone's mouth.'

It also brought an end to Plant's professional dealings with Grant. Yet he remained fiercely proud of the record itself. He took a tape of it to play to Page at his house in Windsor. It was an emotional meeting and one pregnant with meaning, the last cutting of the ties – and in the very place that Zeppelin had come to such a dreadful stop.

Page had been working on a soundtrack to the sequel to the dismal vigilante movie, *Death Wish*. He was otherwise living in a land of shadows. As much as Plant had been emboldened, Zeppelin's passing had left him bereft. Plant also sent a copy of *Pictures at Eleven* to Jones.

'He said, "Well, ah, I thought you could have done something a little bit better than that, old chap,"' Plant told Steven Rosen of *Guitar World*. 'So I said, "Well, thank you." And yet again, I was just the singer of the songs.'

Plant floated the idea of taking his new band out on tour but was talked out of it. He didn't have anything like enough new material and he was unwilling to fall back on Zeppelin's songs. He instead decided to get on with a second album.

Before doing so, he took off with Maureen and the children for a holiday in Morocco in the spring of 1982. It was a bittersweet time for the couple, the last trip they'd share as man and wife. They had clung to each other through the hardest of years, but doing so had exhausted their relationship and the wreckage resulting from Karac's death was still between them.

Pictures at Eleven was released on 28 June 1982 and charted at Number 5 in the States and went three places higher in the UK. It was also positively reviewed, Plant later claiming that he had framed the most glowing notices and hung them up around Jennings Farm.

'I'd cut off my hair and hadn't played or listened to a Zeppelin record for two years,' he told Tom Hibbert of Q. 'It would have been longer, but my daughter's boyfriend, who was in a band, started telling me that part of "Black Dog" was a mistake, because there was a bar of 5/4 in the middle of some 4/4. Well, my dander was up at that, so I pulled the record out and plonked it on. I said, "Listen, you little runt, that's no mistake."'

Work began on Plant's second album in Hereford, a picturesque English city 16 miles from the border with Wales. There, Plant rented his friend Roy Harper's rambling 15th-century house. The only new addition to the ranks was Barriemore Barlow, who had previously been a member of prog-rockers Jethro Tull and was sharing drumming duties with Phil Collins.

From Hereford the party moved on to the Mediterranean island of Ibiza in the summer of 1982. Phil Carson had a home on the island and hooked them up with the Australian owner of a luxury hotel, Pikes. The whole place was let out to them, the band setting up their gear around the hotel swimming pool.

'I put a tarpaulin up over the yard, the weather was beautiful and we had as much fun as making the first record, if not more,' says LeFevre. 'We were playing music outdoors and going out to bars at night. The juices were flowing. It was a fantastic period, a rebirth in a lot of ways.'

There was, though, a marked shift in Plant's demeanour. He took a tighter grip on the reins, leaving no one in any doubt as to who was calling the shots. It was as though he had suddenly realised he could run things as Page had done in Zeppelin. He proved to be just as demanding as his former band mate, and no born diplomat.

'He can be incredibly intense and very, very controlling,' says LeFevre. 'He winds people up the wrong way. He knows what he wants but he doesn't know how to put it across to other people terribly well sometimes. Same with that great historical knowledge of music he has – he uses that in some fairly inappropriate ways, too.

'There was one particular guitar solo that Robbie Blunt was trying to do. Robert made him play it over and over again. In the end Robbie was exhausted and totally bemused. Robert said to him, "Don't you think you should use a Gibson Les Paul?" – which is what Jimmy played. Robbie played a Fender. I had to intervene and tell Robert that we'd already got more than enough down on tape.'

'I'm only dominant when I don't like what's going on,' Plant insisted to John Hutchinson of *Record* magazine, after the album's release. 'If Jimmy and I had disagreements, we would curse each other to everyone else but be very polite to one another. With these new people, it's extremely difficult. Because my track record is a little daunting for anyone that is going to step into that situation with me.'

None of these tensions were betrayed on the finished record. *The Principle of Moments* was a further step removed from the tumult of Zeppelin, being more refined and sedate than its predecessor, even if its slick production has aged no better.

'Robert had this thing about trying to be modern, which we all used to take the piss out of him for,' says LeFevre. 'I was forever saying to him, "Why don't you sing some blues-based rock songs, man?" "No, no, I don't want to!"'

One song did stand out. Written at Roy Harper's house on a Sunday afternoon, 'Big Log' was built around a simple, nagging guitar figure, closer in feel to the Police than Led Zeppelin. It would give Plant his first hit single and helped propel *The Principle of Moments* into the Top 10 on both sides of the Atlantic in the summer of 1983, repeating the success of *Pictures at Eleven*. Atlantic put the album out on Plant's new vanity label, Es Paranza, there being no suggestion now that this was anything but a vehicle for its star.

It was against this backdrop that Plant's marriage to Maureen came to an end. He did not join the family on holiday that year, asking his former assistant, Dennis Sheehan, to take care of things in his place.

'We went to the island of Madeira,' recalls Sheehan. 'I took Maureen, Carmen, a friend of Carmen's from school, and Logan. I didn't get into any kind of conversation with Maureen, but I realised that they were in the middle of splitting up and that this was the defining break. We didn't do very much. I hired a car, but it's not the most exciting place.

'I suppose I was there to be a father to the kids and to make sure Maureen was OK. I guess Robert felt that as I was a family man myself and having children, I'd be responsible enough to look after them and also be discreet.'

The divorce was finalised that August, the same month that Plant began his first solo tour. He wasn't alone in that respect. Both Jezz Woodroffe and Robbie Blunt were also going through divorces.

'All of us were on a different planet to the one we were on when the band started,' says Woodroffe. 'I had a home and a family, and in one year I was only there for two weeks out of fifty-two. How could anyone have a normal relationship in those circumstances? Did we help each other? Not really. Because we all had our own set of things going wrong.'

Going on tour was a relief, a welcome distraction. They started out in North America, selling out twenty-three arena shows, including dates at Zeppelin's old stomping grounds, New York's Madison Square Garden and the Forum in Los Angeles. Plant and his band, with Phil Collins on drums, travelled on an old Viscount turboprop plane. A sense of bonhomie pervaded, and the shows were tight and rapturously received, with Plant confident enough in his own songs to shun Zeppelin's.

'It was almost like a spiritual quest,' recalls Woodroffe. 'It felt like we were all walking five feet off the ground. The plane went about 60 mph – it was like being on a bumblebee. We had one near miss on it. Flames flashed out of one of the motors just as we were taking off. No one noticed but Robert. He didn't say anything to the rest of us, he just ran for the exit door.'

This drama was short-lived and the plane took off a few minutes later. But then, the tour as a whole seemed to be blessed.

'I saw the very best of him on that tour,' says Woodroffe. 'He was all that he'd been before but in a different way. He had this amazing vocal talent but also the brains to know how to apply it.'

'It felt like Robert had shrugged off the mantle of being a rock god,' says LeFevre. 'It made him seem more down to earth and also he became re-engaged with his talent. I think he'd been disengaged from it in the latter years of Zeppelin. Nothing was as intense as it had been. He was happier.'

For all that, on the road, and especially in the States, Plant found he couldn't shake off the spectre of Zeppelin. It was always there, still resonating, still exerting a deep and primal power.

'Page came to see the show at Madison Square Garden and Robert asked him to get up and do the last number with us,' says Woodroffe. 'He walked on and the place just blew apart. He hadn't done a thing – just stood there with Robert. What we'd done for the preceding two hours was completely and utterly forgotten.'

'I immediately found out that I missed a partner,' Plant later told David Fricke of *Rolling Stone*. 'Robbie [Blunt] had the toughest job of all. He is a great guitarist and he didn't want to have to step into Page's shoes. As much as I was proud of the fact that he had his own style, I missed the volatile showmanship that was second nature to Jimmy. Page's performance was stunning. Suddenly, I was holding the whole thing together on my own.'

The tour climaxed in the UK that winter, John Paul Jones getting up with them at Bristol's Colston Hall, Page appearing again on the second of their two-night stand at London's Hammersmith Odeon. There was a triumphal air to these shows, putting the seal on a memorable couple of years for Plant.

Had he been a less complex man he might then have rested easy, but he was never stilled. Although outwardly he most often seemed calm, almost beatific, something churned inside that drove him on.

'Robert's birth date puts him perilously close to being a Virgo,' reflects LeFevre. 'It makes for a very interesting cross between an extrovert Leo who wants to be taken at face value, and a more private man who has to keep everything organised for the sake of his own sanity.

'He is very generous but also unbelievably tight. At the end of that tour, he wanted to buy me a gift as a thank you for everything. Rex King, who was with us on the crew, told him he knew exactly what to get, and went out and bought this Rolex watch for three grand. Robert almost choked when he found out how much it was going to cost him. He still gave it to me, though, and I've worn it every day since.'

'He can be a really nice guy,' adds the rock photographer Ross Halfin. 'I shot him on that tour for a music paper and I remember being in awe of him, but to begin with he was charming. Then we came to do the pictures. He's a big guy and he got right in my face. He said, "Do you know how to take a Robert Plant picture?" I said no. He prodded me in the chest and said, "Quickly." It really threw me, because he turned so quickly.'

Soon enough, the forces that warred within Plant would destroy the peace that this new band had brought him.

SEA OF LOVE

*He's the kind of person that likes to get on
with life ... and with the babysitter.*

Plant and his band finished their first tour together in Japan in February of 1984. In the period between them coming off the road and starting work on his next record, Plant began a relationship with his ex-wife Maureen's younger sister, Shirley. She and Maureen were very much alike, both of them striking looking and vivacious.

As if these waters weren't muddied enough already, at that time Shirley was married to Plant's farm manager, John Bryant, and the couple had been living on the Jennings Farm property. Bryant also played guitar in a local band, Little Acre. Plant had first taken an interest in them in the mid-'70s and tried then to help them get a record deal, but without success. In more recent times he had once again become a familiar face at their gigs.

'A nicer bloke than John you couldn't wish to meet,' says John Ogden, a local journalist and sometime member of Little Acre. 'They were a really nice couple, he and Shirley, and I was shocked

when I heard they'd split up. She was a smashing girl and a great-looking one, too, no doubt about it.

'Robert had known John for a long time. He was Robert's sort of gopher, the guy that looked after the farm side of things, what little bit of farm there was. Robert never really did any farm work, not like Bonham. They were all living on the same premises. Shirley was there all the time and Maureen had moved out after the divorce.

'When Shirley left him for Robert, I'm not even sure that John quit his job straight away. I don't know that he and Robert had a huge bust-up, or that it was more of a slow, crumbling affair. The fact of the matter is, Robert likes women and he never had any trouble getting them. If he saw a woman that he wanted, it was job done.'

Led Zeppelin insiders had been gossiping about Plant and the Wilson sisters for years. Pleading anonymity, one of the band's former roadies insisted to me that it was no surprise when Plant took up with Shirley after his divorce. 'In any case, when you've seen Robert shagging his way through 16,000 women, there's nothing very shocking about another, whoever it is,' he concluded.

'That situation had been in the background from when I first met Robert, three years beforehand,' says Jezz Woodroffe, then keyboardist in Plant's band. 'All of us knew it was going to happen – we were watching it develop. How did we react? It was just something else that was going on, like lots of other things. Shirley was lovely. I saw a lot of her, of course. She was around all the time for the next couple of years.'

In the long run, the relationship did not shatter Plant's family. Maureen would eventually move back into Jennings Farm and raise the kids there. Plant bought another property just up the

road from them. They remained a close-knit group. When asked about this, Plant would simply observe that Christmas get-togethers at his house were always interesting affairs.

'There you go!' says Benji LeFevre, laughing. 'Fucking hell – what can I say? Despite everything, I think Robert has a great sense of family. His weakness, though, is women – and his dick. I once saw a cartoon that reminded me of him. It was a picture of a guy with an erection. There was a speech bubble coming out of his dick that said: "I love you."

'Then again, it might not be his weakness. It may be that the rest of us haven't got as much courage as he has. He's the kind of person that likes to get on with life … and with the babysitter.'

It was in the middle of this convoluted atmosphere that Plant began work on his third record. Having now found his feet as a solo artist he was of a mind to do something different again, pushing himself further from his comfort zone. He had contin-ued to take an interest in the electronic music of the time and was taken in particular with Depeche Mode, the synth-pop band from Basildon in Essex.

To work alongside LeFevre on the record he bought in a new engineer, Tim Palmer. Then twenty-two years old, Palmer had no experience with recording rock bands, having cut his teeth with such electro-pop acts of the period as Dead or Alive and Kajagoogoo.

'I hadn't even engineered many drum kits at that point,' he says. 'But Robert told me he was more interested in modern keyboard sounds and that he thought I could help him in that regard.'

The sessions started early that spring at Marcus Studios in Bayswater, West London. There were two new recruits to the

original band – a nineteen-year-old backing singer named Toni Halliday and a drummer, Richie Hayward.

LeFevre had sought out Hayward and flown him in from the States as a surprise for Plant. A virtuoso, Hayward had been the engine-room of Little Feat, once hailed by Jimmy Page as his favourite group and one of the great bands to come out of California in the late '60s. Their music was a tantalising gumbo of rock and soul, blues and funk, gospel and boogie. Pretty much everything, in fact, but electronic pop.

'Richie was a brilliant drummer,' says Woodroffe, 'but he hated technology. Robert bought him an electronic kit and every time he hit it, he'd laugh. We had loads of arguments about it.'

That summer, Plant and the band moved back to Rockfield Studios in South Wales. The rift that had opened up between them continued to widen, Plant pushing his bold agenda harder, finding allies in Woodroffe and Tim Palmer, but with the others continuing to resist it.

'Aside from me, most of the people that played on that record hated it,' Plant told me. 'I just wanted to get the past behind me. I didn't care about glory. I wanted to have another bash at singing songs and coming from a different angle. Yet despite the fact I did some decent stuff I don't think I ever really achieved what I was looking for.'

'We started to rehearse at a little hotel just down the road from the studio,' recalls Woodroffe. 'It had a gym that had all these weights and stuff in it, and I set up my keyboards in there. At that time I got hold of every new electronic gizmo that came out. I was encouraging everybody to get involved in that, and so was Robert. But Paul Martinez wasn't interested and Robbie Blunt hated it. It turned into mine and Robert's album, with the others playing on it.'

There was still the occasional moment of light relief. The band would troop off to the village pub each night, and there Plant proved to be more amenable to having his past exploited.

'One night, we came across these Led Zeppelin fans in the bar,' says Tim Palmer. 'There was one particular girl who kept going on about wanting to listen to what we were doing. In the end she came back with us to the studio. When we politely asked her to leave she didn't want to go. So I gave her some headphones, and she stood up on a flight case and danced as we cut the backing tracks. To top it off she took all her clothes off.'

The album was finished, though, with a sour mood hanging over the band. Blunt, in particular, had taken against the new direction.

'Robbie just wasn't into it,' says Woodroffe. 'He'd rather go and sit in his car and listen to the cricket on the radio. It destroyed the band in the end. Robbie didn't want to play on the stuff, and he and Robert were arguing all the time.'

'Robert had this bee in his bonnet about needing to feel that he was being contemporary,' adds LeFevre. 'Plus, everything was emotionally confused – it was going on at the same time that he was taking up with Shirley.

'He was beginning to grow away from the idea of the band being "us". The last time he'd invested in that, it had gone disastrously wrong. I think he was deciding that he was never going to let that happen again. That it would be all about him from now on and that he was going to stay in control.'

When they were in Japan in February of that year, Atlantic Records' boss, Ahmet Ertegun, had pitched Plant the idea of doing a record of American songs from the '50s. The following month Plant flew out to New York to make it, breaking off from

pre-production work on his own album. Although he told none of his current band, Robbie Blunt included, he intended reviving the Honeydrippers name for this project. As a further stab to Blunt, an original Honeydripper, he had also asked Page to play on the record.

'I knew that he was going to New York, but not what for,' says LeFevre. 'I hadn't previously experienced anything like that with Robert. I guess that, in the wanderings of his mind, things might then have already been changing.'

'It was done kind of as a promise to Ahmet, because he always said I knew too much about American music to leave it at that,' Plant told me. 'I could sing, I could croon. It was a deal made in a bathhouse in Tokyo one night for a laugh. I wouldn't want to hang my hat on it and say that it was an important move. It was a bit of a hoot, that's all.'

The record was cut in a single day at Atlantic's studios in New York. Joining Page on guitar was his fellow Yardbird, Jeff Beck, and also Nile Rodgers from Chic, the line-up being completed by a band of top session musicians.

Five songs were recorded. Among these was Ray Charles's 'I Got a Woman' and 'Young Boy Blues', written by Phil Spector and blues singer Doc Pomus and originally performed by Ben E. King. DJs in the US began playing another track, the more soothing 'Sea of Love', a US Number One for the crooner Phil Phillips in 1959 and chosen by Plant because it was one of his mum's favourite records. Plant's version also became a Top 5 hit in the US, helping to turn its parent record into an unlikely smash.

Jokingly titled *Volume One*, since Plant had no intention of making a second instalment, the Honeydrippers' EP was released at the budget price of $5.98 in November 1984. It fast went on

to sell more than two million copies in America, not bad going for such a lightweight confection.

Plant's next album, *Shaken 'n' Stirred*, was an altogether different beast. Where the Honeydrippers' record had been as familiar as a pair of old slippers, this was harsh and alien, as bold as it was challenging. Its sound was jagged, with each track rising up through a throb of synthesisers and punctuated by Blunt's jabbing guitar and the clatter of Richie Hayward's drums. Through the static, the odd Plant lyric did come into sharp focus, and these seemed to pick at his emotional scabs. The reference to grieving on 'Little by Little' suggested his son Karac or Bonham, or both. 'Pink and Black' begged to be read in the context of his tangled love life: 'I know I used to run around, now I'm sure I'll settle down,' he confessed. Yet it was the record as a whole that perhaps best reflected Plant's state of mind at the time – made up as it was of many fractured pieces, some fitting together, others jarring and unsettled.

At this time Jimmy Page had formed a new band with ex-Free and Bad Company singer Paul Rodgers, calling it the Firm. Their self-titled début album emerged at the start of 1985 and ploughed a familiar blues-rock furrow, although it never sniffed at magic. The album was a modest success and Page went on the road to support it. He made a second record with the Firm the next year, *Mean Business*, but by then Page appeared to have flagged and it failed to spark. At the time of that first record Plant offered Page and his new band the faintest of praise, and expressed surprise at how traditional both sounded.

'Jimmy is primarily a musician,' he told Mat Snow of *NME*. 'I motivate and point my finger and create a fuss amongst people. Pagey liked the idea of being considered a man of mystery. He got some kind of enjoyment out of people having the wrong

impression of him. It's not up to me to start saying that the guy plays cricket.'

'I spent that ten years with Zeppelin just developing a guitar style,' Page pleaded to me. 'Let's face it, when Zeppelin was no more, that was my thing. I never wanted to change the way I played – I felt comfortable. That trademark is always going to be there.'

But if there was an element of gloating on Plant's part it was soon stopped. When it came out in May 1985, *Shaken 'n' Stirred* baffled his audience, notching barely a third of the sales of each of his previous records. The album's failure was magnified by the tour of North America that followed.

This began in June and totalled thirty-one arena dates. It was intended to be an elaborate spectacle, the centrepiece of which was a short Honeydrippers set, Plant and the band being framed by giant inflatable Cadillac cars. In the event it played out to three-quarters full houses or worse. It had been almost two decades since Plant had looked out on to rows of empty seats and it was a blow to his ego.

'Robert actually started to get ill,' says Woodroffe. 'We had to cancel one or two shows because he couldn't sing – he was getting sore throats and stuff. I think a lot of it was because he could see we weren't selling out.

'At the same time everything around us was becoming a much bigger deal. We started flying about in an executive jet, and we each had our own limousine waiting outside the hotel when we could have all got in to one car. It was all getting a bit too flash and it didn't feel as good as it had done in the past.

'Robert and I used to have talks about it, where we were going to go from there. I remember we were in Chicago four weeks into the tour, the two of us in a hotel room, and he asked

me what I thought we should do, carry on or go home. We did finish the tour, at least.'

'It could all have been avoided,' says LeFevre. 'The record was put back by six or seven weeks, but the tour was not. I pleaded for it to be postponed but it fell on deaf ears. I was told that the success of the Honeydrippers record would more than make up for the fact that Robert's new solo album hadn't gotten any exposure on the radio. This didn't come from Robert but it was very hubristic.

'It was oh-so disappointing. Even though I had such proximity to him personally, on tour I was the sound engineer and I travelled on the crew bus so our paths didn't cross as much on the road. It's very possible, though, that the failure of it all would have been mulled over again and again after each gig.'

Whatever professional agonies Plant was going through, the ailing tour doubtless influenced his next move. He had been asked to perform at the American Live Aid concert in Philadelphia, one of two to take place simultaneously on 13 July 1985, the other at London's Wembley Stadium. Live Aid was the brainchild of Bob Geldof, then singer with the Boomtown Rats, and intended to raise money for famine relief in the poverty-stricken African country of Ethiopia.

Geldof had assembled two stellar bills for the concerts. These might have reflected a new-found sense of altruism sweeping through the music business, although both shows were being broadcast worldwide and afforded all the participants unprecedented exposure. The London cast brought together Paul McCartney, David Bowie, the Who, Queen and U2. In Philadelphia, old-stagers like Mick Jagger, Eric Clapton, and Crosby, Stills, Nash and Young rubbed shoulders with more

up-to-the-moment pop stars such as Duran Duran and Madonna.

Plant had been approached with the offer of doing a Honeydrippers set. Agreeing, he corralled Page into this and somewhere along the line the plan was hatched for them to do Zeppelin songs instead. In a turn of events bordering on farce, John Paul Jones found out their intentions and asked himself along, the gig then becoming a fully-fledged Zeppelin reunion. The haphazard nature of its coming together was carried through to the day itself, the show taking place at JFK Stadium, one of the venues that Zeppelin were due to play at the climax of that awful tour of 1977 but had been forced to cancel.

Since Plant had already asked Paul Martinez to play bass and refused to climb down, Jones had to be accommodated on keyboards, tucked to one side of the stage and barely visible. There were two drummers, Chic's Tony Thompson and Phil Collins, who had first performed in London and then flown across the Atlantic on Concorde to join up with Zeppelin. The price of this gimmick was that Collins did not appear to have familiarised himself with Zeppelin's set, and he sat dumbfounded through most of it. Even still, he fared better than either Plant or Page.

Looking like an ageing Club Med dandy in a lurid purple shirt and white slacks, Plant strutted and preened, but his voice was strained, never quite hitting the notes. At a stroke, he had turned himself into the very thing he'd spent the past five years running to avoid becoming – a fading reminder of former glories. It was worse for Page. Eyes hooded, a cigarette dangling from his lips, he struggled to wrestle anything other than a tune-less squall from his guitar.

Fortunately for all concerned, there were just three songs for them to fumble through – 'Rock and Roll', 'Whole Lotta Love',

and 'Stairway to Heaven', which sounded so fraught it appeared as though they were playing it for the first time. They were not even the most embarrassed of the old guard. Confirmation of the Zeppelin revival had been so late in coming that they took the early evening slot initially allocated to the Honeydrippers, going on before Duran Duran and leaving Bob Dylan the honour of closing the show. Dylan had asked Keith Richards and Ronnie Wood of the Stones to join him without seeming to have told them what songs he intended on doing. Their brief set began as if by accident and soon degenerated into a hopeless shambles.

'Live Aid was a very odd thing to do,' Plant told Tom Hibbert of *Q* three years later. 'I found myself saying, "Great idea – let's have a rehearsal." And we virtually ruined the whole thing because we sounded so awful. I was hoarse and couldn't sing, and Page was out of tune and couldn't hear his guitar. Jonesy stood there as serene as hell and the two drummers proved that … well, you know, that's why Zeppelin didn't carry on.

'Yet through it all, the rush I got from that size audience, I'd forgotten what that was like. I'd forgotten how much I missed it. I'd be lying if I said I wasn't drunk on the whole event.'

Indeed, Zeppelin's performance might have been horrible, but the 95,000-strong crowd still roared in approval. Fifteen minutes after Zeppelin had left the stage thousands were still chanting for them.

'The whole thing was bonkers,' says LeFevre, Zeppelin's soundman at Live Aid. 'We were in the middle of Robert's tour, we breezed in, Jonesy wasn't invited. It was completely surreal. I can't even remember what songs they played, for fuck's sake.

'Back on Robert's tour, Jimmy came and got up with us at a show at the Meadowlands in New Jersey. He couldn't play a

note. It was like his brain was scrambled and his fingers weren't doing what he was thinking. It was terribly sad.'

For Plant, the return to his own tour after Live Aid was a sobering reality check. It limped on in America through to the end of July, coming to an abrupt conclusion in the UK the following September. There were just two British dates, in Birmingham and London. Plant had come to a crossroads and he was unsure which way to turn. Whichever direction he chose, however, he had made up his mind not to take anyone from his existing band with him.

'Being there at that time, I had too much information and too much technology,' he told me. 'I'd cut my hair and back-combed it, and I'd started wearing purple jodhpurs. Very funny, all that shit. Then I realised that David Crosby was right on that song of his, "Almost Cut My Hair" – he's not a sad old hippy.

'The whole deal is this, with people like Crosby and Neil Young and me, and this will make people dive for buckets to throw up into, but it's true: I bought the ticket,' he said, rubbing his hair, which had then grown long again, 'and I've still got it.'

'I'd just moved to Monmouth, near the Forest of Dean,' Woodroffe recalls. 'Robert had bought a place near there, too. He called me up one day and suggested we go for a drink. He came and picked me up, and we went to this little pub in the forest called the Foresters Arms.

'We had two pints of beer, both of them looking like pond water, and we sat there staring into them. He said to me, "What do you think we should do then?" I told him I didn't know. He said he'd have to think about it and give me a call. We didn't drink our beers. We both left and went home, and we never talked to each other again about it.'

Plant's purge didn't end with the musicians. It also took in Benji LeFevre, who had been working for him since 1973.

'By then, I'd bought a place near Jennings Farm,' says LeFevre. 'A little, run-down cottage that I'd picked up at auction. Robert came round one day and said, "I think that's it. Ta-ta, mate." No, it wasn't like that. After the tour ended, things had become frustrated. All he said to me was that he felt like he needed a change of blood.

'There you go. There was a bit of animosity about it between some of the band members and I voiced my opinion, and I don't think it necessarily sat particularly well with Robert. But I wasn't about to become a yes man after all that time with him. The proof of the pudding is that we're still mates and we still talk, though I felt a bit peeved about it at the time, as you can imagine. It was like, "Fourteen years and now what?"'

15

TALL COOL ONE

―――――

***Last night, I was wiggling around like
some ageing big girl's blouse.***

Four months after closing the door on *Shaken 'n' Stirred* and the
band he made it with, Plant again found himself chasing after a
new direction. He turned back to Led Zeppelin, agreeing to an
initial meeting with Page and Jones. It would not be the last time
he'd do so. Whatever else he has done, he has continued to be
linked as closely to the band as Page. Even closer is the bond
between him and Page. Indelible and unique to both of them, it
is as dependent on one as on the other. Through all the fluctua-
tions in their relationship, this much has been constant.

Also unchanging, nothing has seemed to separate Plant and
Page ever since Zeppelin ended as much as what their former
band has appeared to mean to them. The accepted view has
long been that Page still needs Zeppelin and Plant does not;
that Page has guarded his old band's legacy with a zealot's
fervour but also been trapped by it, never able to move on,
whereas Plant has shrugged off the past, forging ahead on his
own terms.

Certainly, the dynamic between the two men has changed. Plant established a career apart from Zeppelin and Page did not. Page has long wanted to re-form the band and Plant has often resisted him, shifting the power base between them. As much as Page has burnished Zeppelin's myth, Plant has been sardonic about it. Seen from this perspective, it is easy to believe that Page leapt at the chance to have Zeppelin do Live Aid and just as surprising that Plant submitted to it. The basic truth is that while Page has never escaped from being under Zeppelin's looming shadow, for the most part Plant has thrived outside of it. This, coupled with the fact that Plant is now the more dominant partner in their relationship, have been like thorns in Page's side.

Yet the fact is, no matter how ordered things have looked on the surface, tangled undercurrents govern Plant's feelings towards Zeppelin. He never forgot the control Page exerted over him at the beginning of the band. Although he avoided Zeppelin's songs when he first struck out on his own, not wanting to be seen to be using them as a crutch, it was never the band's music that he ran from. Rather, he was repelled by the world that had grown up around them and the terrible tragedies he saw as resulting from it. He left Zeppelin bearing an unspeakable sense of loss, and also a dreadful and unresolved guilt. There is no wondering that he wanted to get as far from the source of all this as fast as he could; and the further away he reached, the harder it became for him to return.

This is not to say that Zeppelin's accomplishments did not fill him with as much pride as they did Page; that he did not hold them up as high or would not fall back on them just as hard when he had to. Working on his own records, he continued to use Zeppelin as a reference point for his current collaborators and also to set a benchmark to measure them against – as often

as not an impossible one. The suggestion that he has never wanted or needed to go back to the band is also wrong. He did not consent to Live Aid from a position of strength, but against the backdrop of a failing album and an ailing tour.

'I once went to his house to shoot him and I was shocked,' says the photographer Ross Halfin. 'He'd converted a barn on the property into a kind of museum to Zeppelin. He had all these gold discs hung up and steamer trunks filled with copies of magazines that he was in. In the toilet, he'd framed the telegram from Peter Grant asking him to join the band. He was the last person I'd expected to see that from.

'I asked Jimmy why Robert was so dismissive of Zeppelin. He said, "I taught him how to sing, how to act and how to move – I told him how to do everything, and he resents that."'

Unlike Live Aid, this latest reunion took place away from the glare of publicity and in secret. In January 1986 Plant, Page and Jones met up in a village just outside Bath in England's West Country. Tony Thompson, who had drummed with them in Philadelphia, was flown in from the States. Their crew took over the village hall, filling it with equipment and using a couple of old parachutes to soundproof it.

To begin with, the signs were promising. They began messing around with ideas for new songs, Plant later suggesting that the results sounded like a cross between two of America's great alternative rock bands of the period, Talking Heads and Hüsker Dü. It was not long, though, before the same old problems came up.

'As much as we wanted to do it, it wasn't the right time for Pagey,' Plant told David Fricke of *Rolling Stone* in 1988. 'He had just finished the second Firm album and I think he was a bit confused about what he was doing. There was a little club that we'd go to in the town. Jonesy and I often chose to walk back

from it to the place we were staying in, at two in the morning. Pagey wouldn't come out, which is hardly the way to get everything back together again.

'The interesting thing is that after being without him and fending for myself, I'm a lot more forthright. When I reach a conclusion, I immediately react to it. Way back in the old days, this might have taken a week of mutual discussion.'

Things came to a head after just a week. The catalyst for this was Thompson being involved in a car crash, which put him out of action.

'Tony had become a local celebrity,' Plant informed Fricke. 'He was in a minicab with five other people one night. They took a corner too fast, went off the road and ended up in somebody's basement. I was called at five in the morning from Bath Royal Infirmary by a rather short-tempered matron saying, "We have your Mr Thompson here – he states you, Mr Plant, as his next of kin." I said, "But he's black." So that was the end of him.

'One of the roadies then played drums. He was quite good, too, but the whole thing dematerialised. Jimmy had to change the battery of his wah-wah pedal every one and a half songs,' he explained, perhaps using a euphemism. 'And I said, "I'm going home." Jonesy asked why. "Because I can't put up with this and I don't need the money." For it to succeed in Bath, I would need to have been far more patient than I have been for years. It wasn't to be.'

For all that, Plant would soon enough reach out to Page again. In the meantime he veered off once more. That autumn he started working with a songwriter named Robert Crash, who had produced the second album by the British electro-pop duo Eurythmics – 1983's *Sweet Dreams (Are Made of This)*. At the same time, his music publisher passed him a demo tape by a young

British band called The Rest Is History. One track on it caught his ear, 'Heaven Knows', a sleek pop-rock song.

Plant got in touch with the band's main songwriter, keyboard-ist Phil Johnstone, and they began batting ideas back and forth. The two of them hit it off, and since Johnstone was almost as forceful a personality as Plant, he brought in drummer Chris Blackwell, who had also played on the demo. In turn, Blackwell recommended guitarist Doug Boyle and bassist Phil Scragg to Plant, both of whom had been scratching out a living on the London club and session circuit.

'I first met Robert at a studio near Tower Bridge in London,' recalls Blackwell. 'He asked me if I wanted a cup of tea and a bun. Any nerves that I'd had just disappeared. He's a nice guy, very down to earth, though he has his moments.'

'The first impression I had of him was that he was very tall and also larger than life in every way,' says Boyle. 'There's a certain aura around him. He's unmistakably charismatic.'

Together with this fresh young group of cohorts, Plant worked up ten songs. He also took on a new manager, appointing Bill Curbishley, a formidable Londoner who had steered the Who for more than a decade and was also looking after the British heavy metal band Judas Priest. Although he still had not told his latest band that they would be doing an album with him he was ready to make another beginning.

Work began on the record at the start of 1987 and in two London studios, Marcus and Swanyard. Plant wanted to marry up the modern technology he had used on *Shaken 'n' Stirred* with more traditional song-craft. He appointed Phil Johnstone his unofficial musical director. It was Johnstone's job to manage the battery of electronic effects that Plant had ordered up –

drum machines, sequencers and samples – and also to translate Plant's more abstract instructions to the rest of the band. Since he was not a musician, Plant tended to communicate an idea by humming it or evoking a feeling, leaving Johnstone to turn such utterances into chords and notes.

Plant had retained Tim Palmer from the *Shaken 'n' Stirred* sessions and he remembers a certain amount of friction in the studio as Plant put his new charges through their paces. This was exacerbated by the fact that Plant was just then trying to quit smoking.

'I would sometimes argue for more guitars but that's not the right way to approach it with Robert because he doesn't want to be held back,' says Palmer. 'It was a little bit of a battle but we ended up finding a good compromise.

'Robert was his usual self with the band, prodding and poking, sometimes to good effect and many times not. I think Doug Boyle really struggled with Robert's constant harassing of him to play more and different styles, and to learn some of the roots of the stuff Robert was doing.'

'I remember Doug getting quite a hard time,' agrees Chris Blackwell. 'Absolutely, Robert can be a taskmaster and that's mainly aimed at the guitars and drums, for obvious reasons. Doug is very reserved. He could do the gig but to begin with it wasn't a good fit for him – he's really a jazz guitarist. He caught a lot off Robert, and much of it I felt was unnecessary and unwelcome.'

A talented musician, but a quiet, nervy man, Boyle now describes the experience of working with Plant as character-building but also emotionally draining. Like Robbie Blunt before him, the biggest problem he had was that he was not Jimmy Page.

'I felt a lot of pressure,' he admits. 'There were definitely fraught moments, some of which might have been nicotine related. There were some aspects of my playing that Robert didn't care for, some that he did. He was trying to eke out the parts he didn't like and introduce me to some more rootsy, rock 'n' roll type of stuff, which wasn't my natural domain.

'Maybe that tension also gave Robert the extra bit of grit he wanted to get on to that record. I definitely felt as if he was goading me to see how I'd respond. I think he must have noted that I played with a little more intention if I felt got at.'

Boyle's confidence was bruised and it took a further battering when he found out Plant had asked Page to guest on the record. Plant sent Page tapes of two songs, 'Heaven Knows' and 'Tall Cool One', the latter sounding like a reupholstered Gene Vincent track, and asked him to work out solos for each of them. Both were intended to be singles.

'The way Jimmy played was a bit like a cartoon caricature of himself,' recalls Palmer. 'He strapped on his guitar, had a cigarette and a beer, and he pulled those faces. I wasn't going to start telling Jimmy Page what to play, so we just gave him some open tracks and asked him to do what he felt was right. I picked through it afterwards and made up composite solos.

'If you were lucky in a studio you'd get an assistant to make the tea. The day that Jimmy arrived I suddenly had two assistants and a roomful of techs, all hoping to get just a glimpse of him and Robert together. There was a lot of laughter and joking around between the two of them. It felt very relaxed, no tension.'

Page got a shock when he heard the finished version of 'Tall Cool One'. The track ended with a burst of sampled Zeppelin riffs, snatches of 'The Wanton Song' and 'Custard Pie' among them. Plant claimed that he had been prompted to do this by the

Beastie Boys, the New York rappers having lifted the riff from 'The Ocean' for their 'She's Crafty' single of the previous year. He had not forewarned Page.

'As I recall, Jimmy's reaction was one of puzzlement,' says Doug Boyle. 'He gave Robert a very oblique look.'

'It was a bad thing to do, really,' Plant told me, chuckling. 'Yet at the time it seemed a bit of a hoot. Silly. They did sound fucking good as well, though.'

This same combination of the high-tech and the more organic defined the finished album, *Now and Zen*. It was a no less modern-sounding record than its immediate predecessor, the difference being that on this occasion the technology was used in support of the songs rather than the other way round. In this respect it was Plant's most accessible album to date.

'It was the record that kind of broke Robert back as a solo artist, in no small part because Jimmy was on "Heaven Knows",' says Blackwell. 'People rushed out to buy that. Jimmy later joined us onstage a couple of times, which again was brilliant, though it must have been very difficult from Doug's point of view. It was almost like trying to second-guess what was going on.'

Yet for all that he had pushed Boyle, it was bassist Phil Scragg whom Plant dispensed with as soon as the record was finished. He replaced him with Charlie Jones, a friend of Tim Palmer from Bath who had been playing in a local group called Violent Blue. Plant had decided to tour with this young band, but before that he had a further distraction to occupy him.

'Robert liked to take care of all the contracts himself and he had a reputation for being stingy,' explains Tim Palmer. 'There was some money that hadn't been paid out to Swanyard, and there were letters going back and forth between Robert and the lady that owned the studio, Margarita Hamilton. When Robert

finally cut the cheque, he sent it with a male stripper and a note informing Margarita that if she wanted the money she'd have to remove it from his underwear with her teeth.'

Not that Plant couldn't surprise with acts of generosity. That Christmas he had a large hamper sent round to Boyle's flat. He recalls, 'I opened it up and there was a card from Robert inside that said, "Thanks for all your work, you were brilliant." Robert had been so hard to please. It was the first time that I'd known what he'd felt about my contribution to the whole thing.'

That December of 1987, Plant and his band started tour rehearsals. Before breaking for Christmas, they also did two low-key warm-up gigs in the seaside town of Folkestone and a return for Plant to Stourbridge Town Hall. These served to unveil his new group but they were also the first shows at which Plant played Zeppelin songs as a solo artist. 'Misty Mountain Hop', 'Rock and Roll' and 'The Lemon Song' were all included in the set lists.

Chris Blackwell claims it was the band that coaxed Plant into this, recalling how he had walked in on them bashing through 'Immigrant Song' one afternoon and joined in. Yet it was more likely an entirely practical decision and one made at the instigation of his manager Bill Curbishley. An old hand, Curbishley knew even the whisper of Zeppelin songs was enough to shift tickets in America and it was there that Plant had most to gain.

During the first month of shows in the UK that spring he strutted like a peacock once more, closing in on 40 but starting over.

'Last night, I was wiggling around like some ageing big girl's blouse and I realise how stupid it all looks,' he admitted to Tom Hibbert of Q after one of these gigs. 'It was like self-parody, but

that's what I'm good at, that's what I know. What else am I going to do? Sleep with the board of directors at Coca-Cola and make an ad for them?

'I don't want to end up playing in the back room of some pub in Wolverhampton. It's a bit of a naff old game, life.'

Now and Zen had been released that February, charting in the Top 10 on both sides of the Atlantic. The North American tour, which began that summer and stretched to fifty dates, exploited this, with Zeppelin songs packing the sets and Plant in his pomp. It was among the biggest draws on the road in America that year, filling arena after arena, the audience responses echoing the frenzy Zeppelin had once induced, although some things in the background were very different.

'When we first hit the States a choreographer became involved, which was hilarious,' recalls Blackwell. 'He came out on the road with us for two weeks to show mainly Doug and Charlie how to move and what to do – when to run across the stage, when to spin round. I remember them not being at all happy about it.

'For 99 per cent of the time, Robert was lovely. Once a week, though, he'd have one of his weird days. I'd know we were getting one because on those occasions he'd always come down to the hotel reception in the same clothes, these baggy surfer pants tucked into cowboy boots. Whenever he dressed like that, he was a bit off and he'd give you the run around, becoming the taskmaster again. I don't know what it was, whether it was hormonal or something.'

'There was always a feeling that you were replaceable,' continues Boyle. 'If I wasn't delivering what he wanted, I knew that I could be gone in five minutes, though I didn't think that was a bad thing. It kept everyone on their toes.'

The sixth night of the tour, 14 May, was the Atlantic Records 40th Anniversary Concert at Madison Square Garden. Plant had been asked to perform a solo set. The label's chief, Ahmet Ertegun, had also begged for a Zeppelin reunion to close the show. Plant agreed to both. Coming onstage after performances by Crosby, Stills and Nash, the Bee Gees and Yes, his solo band's set was assured and well drilled, everything that Zeppelin's finale was not.

Plant had clashed with Page in the build-up to it. He wanted to have Blackwell on drums but Page held out for Jason Bonham. Plant was also unwilling to sing 'Stairway to Heaven', with Page again winning the day. It was a Pyrrhic victory. In the event Plant forgot the words to Zeppelin's best-loved song, most probably less by accident than design, although it was nothing if not in keeping with the general mayhem that unfolded around him.

If anything, Zeppelin's performance at this concert was an even worse mess than Live Aid had been three years earlier. It was like hearing four people playing independently of each other, Page looking troubled and going at a different speed to the others, Plant's voice sounding shot. By the time 'Stairway to Heaven' ground to a painful halt only Jones was left unruffled. Plant had the air of a man who had endured half an hour of root-canal work.

'That show was never mentioned again,' says Blackwell. 'Phil Johnstone used to have a dig at Robert about all sorts of things but that was never a topic of conversation. A reunion tour was never on the cards after that. Robert used to get all these offers and he'd be like, "Oh, fuck off!"'

'I had a strong feeling that the way the Atlantic thing went put a Zeppelin reunion on the back burner for him,' says Doug Boyle. 'Before it I thought there might have been something happening

a couple of years down the line. I don't know what went down but that gig was a very tense time between Robert and Jimmy.

'I think there was a part of Robert that missed Jimmy an awful lot. He'd often say to me, "Jimmy would have done this" or "Jimmy would have done that." It would always make me want to say, "Look, I'm not Jimmy. If you want him, go and get him." The two of them are like brothers. There's something very, very deep there.'

That summer Page had put out his first solo album, *Outrider*. It was heavy on bluesy guitar workouts but lacked memorable songs. Plant co-wrote and sang on one of them, a breezy rocker titled 'The Only One' that came and went and left little impression.

In the winter of 1988 Plant and his band went back out on the road in North America, doing a further thirty-seven sell-out shows. At the start of this run bassist Charlie Jones told Plant that he had begun dating his daughter Carmen. The couple would eventually marry and make Plant a grandfather. Right then, however, the effect on Plant of his daughter's presence on the tour was a source of great amusement to the rest of his band. Up to that point Plant had been enjoying life much as he had on Zeppelin's treks through America.

'Certainly from Robert's point of view, Carmen being on the road changed things,' says Blackwell. 'Everything after that had to be more above-board or swept under the carpet, and it was quite amusing to watch that happening. Not that Carmen wasn't cool and didn't know what was going on anyway.

'Especially in America, being on a tour of that size with some-one like Robert, it did kind of mean that you were given a ticket to do what you wanted. You could take it to whatever extreme you wished.'

* * *

Plant wanted to keep the momentum from the tour running. After a short Christmas break he summoned the band to his home in Wales to begin work on his next record. Deciding that *Now and Zen* had been too glossy, he intended to make a more straightforward rock album, guitars taking precedence over electronic effects.

Recording began at Olympic Studios in London, where two decades earlier Zeppelin had made their first album. At the end of the first day Plant pulled aside his new producer, Mark 'Spike' Stent. He told Stent he had already cost him more of his money than had been spent on the whole of Zeppelin's début.

'He's a tight old bastard,' Stent recalls, laughing. 'That's just part of his personality as well. He likes to give you a little dig now and then. He was an interesting chap. He's a very striking man. I remember him walking into the studio reception on that first day and thinking, "OK, that's a Rock God for you."

'Making the record, he was a bit of a tyrant. I'd use that word in more of a comical way. I mean, he runs the ship and he knows precisely what he wants. He was always cracking the whip but it was never personal – it was just out of pure frustration. At the same time he had a way of inspiring and getting great performances.'

Once again it was guitarist Doug Boyle who was at Plant's sharpest end. Still exhausted from the tour, Boyle found this record even more testing to make than its predecessor had been. He compares the way Plant approached it to that of Stanley Kubrick, the notoriously demanding film director.

'It was a very intense process,' he explains. 'Robert will go to extreme lengths to get what he wants and I drove myself to the edge of insanity. We had a couple of stand-up rows, squaring up to each other, although they were forgotten in a couple of days.

'Robert's biggest problem was with my reference points. He had this great fear that I'd been in a jazz-funk band, which is his biggest nightmare in music. He was always asking me if I'd been listening to Level 42.'

Although even the hint of jazz-funk on *Manic Nirvana* might have offered light relief. In essence it was a hard rock record and an unappealing one at that. Plant had not only let go of his old band's anchor to the blues but also their lighter touches, the pastoral shadings and folk roots. He seemed to have lost his way.

In November of that year he reunited again with Page and Jones, but this time only before a couple of hundred people in the West Midlands. The occasion was his daughter Carmen's 21st birthday party, which was held in the Hen & Chickens pub in the Black Country town of Oldbury. There, the three of them, backed again by Jason Bonham on drums, ran through a selection of Zeppelin tunes including 'Trampled Underfoot' and 'Rock and Roll'. Following the trials of the Atlantic Records concert this was like letting off steam.

'All of us who'd worked on the album got invited to that,' recalls 'Spike' Stent. 'That impromptu thing was an amazing moment.

'Robert, of course, also had this very interesting and convoluted web involving his ex-wife and her sister. I've got a feeling that at Carmen's party he may have also met someone else – some young girl. He was sat chatting with her at our table and I subsequently heard that they'd been seeing each other. That's Robert. He had the gift, for sure.'

Released in March 1990, *Manic Nirvana* did not repeat the success of *Now and Zen*. Later that year Neil Young, a grizzled touchstone of Plant's, released his *Ragged Glory* album, on which

he and his backing band Crazy Horse raged at the dying of the light. By contrast, Plant had not seemed so out of touch.

Again, he toured the album for most of a year. The shows were much better than the record had been, although some members of his band enjoyed this latest excursion more than others.

'There was a little bit more tension starting to come in,' says Boyle. 'At that point I think Robert was starting to think ahead and he was particularly looking at me. He couldn't move on with the same people around him. I thought the actual shows were magnificent but I had a strong sense it would be my last tour with him.'

'Travelling together, you really do see all sides of a person and there isn't a dark side to Robert at all,' says Blackwell. 'Sometimes there's a bit of bravado, when he puts the mask on, but you know it'll come off. I'd sit next to him on the plane and we'd be talking about wall colours or carpets. Those were my favourite times with him, when I got to see the real person.

'I met his dad a few times. He was a really down-to-earth Black Country bloke who wore a flat cap. I remember Logan being backstage on a skateboard, crashing into people. Both Shirley and Maureen were lovely, too. I guess we all thought that situation was odd but there were odder things happening. Nothing we were doing seemed to be very real, anyway.'

By the end of this period Plant's relationship with Shirley Wilson seems to have run its course. He never commented on this, nor on rumours linking him with the Canadian singer and former model Alannah Myles, one of his support acts on the tour. Then promoting their début album, the retro-rock band the Black Crowes also opened for Plant on these American dates. Their drummer, Steve Gorman, remembers Plant taking them to a blues club in Chicago.

'It was just him and us, and we drove down to the Checkerboard, this legendary hole-in-the-wall club on the South Side,' Gorman recounts. 'We went in and the house band was cooking. Then the MC got up on the mike, this old black dude. He goes, "There's a very special guest in the house tonight. He came from England and brought the blues back over here. Everyone needs to give him a round of applause. Ladies and gentlemen, Mr Led Zeppelin! Stand up, Led!"

'Robert was laughing so hard he could barely get up. He stood up and took a bow. For the rest of the tour we called him Led. He's very self-deprecating. He clearly loves and respects what Zeppelin did but he's the first guy to puncture the air around it.'

The tour wound down that December in the UK. Plant brought his band to Wolverhampton for a more intimate date at the town's Civic Hall. It was a fine show and he appeared in his element, basking in the audience's adulation. That night he sang a poignant version of Zeppelin's 'Going to California'. Though no one but he knew it, his next move would return him to the sounds of that song, and also of that time and place.

Around this time I found myself sitting next to him at a James Brown concert at Birmingham's NEC arena. He looked tanned and relaxed, and was accompanied by a young blonde in a short, figure-hugging dress. I related this encounter to Plant's old friend, LeFevre. 'Oh, her,' he responded, smirking. 'She was his niece.'

CROSSROADS

*My feeling of vulnerability is as
acute as my power is.*

The *Manic Nirvana* tour concluded in January 1991 and Plant
took off on the longest break he had had since leaving Led
Zeppelin. More than two years would pass between now and his
next record – and even longer before he toured again. He was
occupied with becoming a parent for the fourth time and also
in attempting to rediscover his musical place in the world.

That September he celebrated the birth of a son, Jesse Lee
Plant. The identity of the child's mother has been a source of
speculation ever since but Plant has never revealed it. However
complex their ties might be, Jesse Lee and Plant's two older
children, Carmen and Logan, established a close bond. Plant
adored them, being a doting if unconventional father.

Through the span of time he was out of public view the great
sea change in music came from America. R.E.M. broke open
the mainstream for alternative rock, the critical darlings from
Athens, Georgia, releasing two classic albums in the space of
eighteen months, *Out of Time* and *Automatic for the People*.

Grunge was born in the US Northwest. In September 1991 Nirvana, originally from the unremarkable logging town of Aberdeen in Washington State, put out their second album, *Nevermind*. Within four months it had knocked Michael Jackson's *Dangerous* off the top of the Billboard chart and sparked a short, sharp cultural tremor.

Nirvana kicked down the doors for other 'Seattle bands' like Pearl Jam, Soundgarden, Alice in Chains and Screaming Trees. Although these groups espoused a punk rock ethos, they were indebted as much to the bigger beasts of the '70s, such as Neil Young, Black Sabbath and also Led Zeppelin.

Plant also looked back for inspiration, honing in on this occasion on the records from the '60s that had captivated him, marking out the path he has followed from then to now. He dug out his old Buffalo Springfield albums and also re-absorbed the music that had swept out from San Francisco during that time, the psych-rock of Moby Grape, Jefferson Airplane, the Grateful Dead and Quicksilver Messenger Service.

In the summer of 1993 he collected his band together at his Monmouth home to begin writing his next record. Though the songs came, Plant was restless, dissatisfied, like a man with an itch he could not scratch.

The record was supposed to signal a fresh start. Plant had a new record label, having left Atlantic after more than twenty years with the company and signed to one of its rivals, Mercury Records. He had also brought in a new producer, Chris Hughes, a former drummer with Adam and the Ants who had made his name working with the pop group Tears for Fears.

What Plant did not have yet was a new band and his mood wasn't improved when recording began. The operation shifted between two studios, RAK in London and Sawmills, located in

an idyllic spot in Cornwall on the English south coast. The atmosphere was tense and soon reached breaking point.

'We started at RAK and I felt very comfortable until I began doing first takes,' recalls Blackwell. 'Then it all got a bit strange. Chris Hughes was telling me all this stuff that I knew was wrong, all these weird criticisms, but it felt as if it was coming from someone else. At the end of one session I was told not to go in the next day but I did. There was another drummer there, Pete Thompson, who I knew from way back. No one had said anything about it to me.

'We were residential at Sawmills, which kind of amplified the fact that something was brewing. I had to pop back to London for a couple of days, and again, when I returned it turned out there'd been another drummer in doing stuff. There was also another guitarist present, and I was told not to tell Doug Boyle about that.

'The break-up of that band was very messy and nothing was resolved. I was asked to take some time off from the sessions and Robert said he'd call, but never did. The next thing I knew, the album was finished. I went to listen to it and I was on one track. I wasn't called in for the tour and that was that.'

'Robert's head had completely changed and it was like we didn't know each other any more,' continues Boyle. 'I played on two tracks and went home. Eventually, Phil Johnstone phoned me and told me that Robert wanted to work with a different guitarist. To be honest it was something of a relief. I didn't have anything left to give.

'Robert was like a tank. He always needs to have new stimulation and territory to explore, and he won't do anything unless he's 100 per cent into it. I think it pains him to be like that. I've never known someone be so obsessed with music. It's bursting

out of him and he has to vent it, otherwise I'd imagine he'd end up running out of the house screaming. He pushed me as far as I could be taken. It was a joyous experience but at the same time I got broken by it.'

In the end Plant made his sixth solo album, *Fate of Nations*, with a sprawling cast of musicians. His most recent right-hand man, Phil Johnstone, like Doug Boyle and Chris Blackwell, co-wrote a number of the songs that appeared on the record but played on just a handful. Bassist Charlie Jones, now Plant's son-in-law, was kept on. Among those trooping in and out were the classical violinist Nigel Kennedy and a folk musician, Nigel Eaton, who specialised in a Medieval English stringed instrument, the hurdy gurdy. Four drummers were used and also six different guitarists.

'You have to praise the guy, because he's always questing to find new ideas and people to work with,' says the album's producer, Chris Hughes. 'He's not the sort of bloke to sit around waiting for things to happen, and in that sense he's not just a rock singer but a real artist.

'I don't think he's a born bandleader, though. There's two types: tyrants like Buddy Rich and James Brown, where you miss half a note and you get ridiculed or fired; and others that are much more concerned about getting the best out of the players and making sure everyone has a good time. He wasn't either of those. He kind of picked out guys and hoped that they would fit in with what he was doing. He lives his life liking and not liking, favouring and not favouring a huge number of people.'

As usual Plant paid particular to attention to the guitar parts on the record. Doug Boyle's time being over, he called in the great folk guitarist Richard Thompson, a former member of Fairport Convention, and a younger British whiz kid, Francis

Dunnery, whose prog-rock band It Bites had been a support act on his last UK tour.

'I never saw Doug Boyle light Robert up,' says Hughes. 'He wanted something different, something non-standard. Francis Dunnery, on the other hand, was a very visceral guitarist and I watched him fire Robert quite strongly with his playing.'

'Francis Dunnery was spectacular,' Plant enthused to me. 'A mad, crazy, tangential player. Do we really need prog-rock? Well, no, but if "Mad" Frank plays like that … He'd say to me, "What's this fucking 'playing the blues' thing, Planty?" I said, "Just listen to the Wolf,"' referring to Howlin' Wolf. I told him, "Play how he sings." But then, he was also like all the guitarists I've played with – a foil.'

The album itself was not quite what Plant had intended, however. His new record label was expectant of a more commercial-sounding album from him, not a great artistic leap forward. Where he had talked in advance of doing an organic-sounding record, Chris Hughes's forte was for bigger pop productions and he was as meticulous as Plant is impulsive.

Engineer Phill Brown, who had worked on 'Stairway to Heaven' with Zeppelin, was brought in at the end of the sessions to mix the tracks. He recalls the process being a fraught one.

'Chris is a great producer but I didn't like the way he did things,' says Brown. 'You might spend ten hours just moving a hi-hat around. Robert would often disappear, announcing that he was going for a walk. He'd be gone for an hour, and then come back and say sarcastically, "Are we ready yet?" I don't think he liked the direction he was being taken in. I did a week on the record and then left. It wasn't working for me.'

According to Hughes, 'The thing with Robert is quite a lot of the time he didn't really want to be told, he just wanted it to

be an open runway for him to be amazing. I've learnt over the years that certain artists seek your advice and others want your approval. Robert just wanted to get on with it. He's quite impatient.'

Fate of Nations gave some insight into Plant's private life. One of the more wistful tracks on the album, '29 Palms', was said to be about Alannah Myles, though as always he would not be drawn to admit to as much. On it, he sang of 'a fool in love, a crazy situation'. More affecting than this was 'I Believe', a lovely song that addressed the death of his first-born son Karac with heartbreaking candour. 'Big fire, on top of the hill, a worthless gesture and last farewell,' Plant intoned as if singing a lullaby. 'Tears from your mother, from the pits of her soul. Look at your father, see his blood run cold.' This was the most he had ever given away of himself.

'When you spend time with an artist you see things on a rawer level,' reflects Chris Hughes. 'You see it all – the bullishness, but also the fragilities and the frailness. He talked quite a bit about the Wilson sisters. Nothing I can remember specifically, just the fact that they were quite a force.

'The thing with Robert is he's very, very sociable and charismatic, but he doesn't operate in the way that most people do. In terms of what he wants to do and who he wants to spend time with, he really does just please himself. He can go wandering off down to the bus stop and meet a girl, and the next thing you know he'll have brought her back to the studio with him for a cup of tea. His interest in girls was ever-present, but that's OK.'

Although *Fate of Nations* was meant to court the mainstream, it came into a world where the blockbuster records were louder and more overly angst-ridden. These included Pearl Jam's second

album, *Vs*, *Siamese Dream* by Smashing Pumpkins and Nirvana's *In Utero*, this last record marking the ending of their – and grunge rock's – brief reign, and doing so with a howl from the abyss.

In the States in particular Plant was pushed out to the fringes, *Fate of Nations* barely scraping in to the Top 40 there. Even though he put a brave face on this, it was a body blow and one every bit as painful to him as the failure of *Shaken 'n' Stirred* had been eight years before.

Plant went back out on tour in April 1993. His stock had declined so sharply that he was opening for the American singer Lenny Kravitz on a run of European dates that summer. Kravitz had cribbed his entire act from Zeppelin, Jimi Hendrix and others, and was fifteen years Plant's junior.

The shame was that this touring band was as capable as any he had had as a solo performer. Guitarist Francis Dunnery joined him, alongside bassist Charlie Jones and a young British drummer, Michael Lee, who had grown up idolising John Bonham. The shows were strong and Plant in great voice, although he had a succinct enough explanation for this being the case.

'I sing better than I did because there's less powders going up me hooter,' he informed Deborah Frost of *Spin*. 'It's very difficult to give myself wholeheartedly,' he added, 'but when I do, as I have to this group of musicians, then I'm vulnerable. My feeling of vulnerability is as acute as my power is.'

Rubbing salt in his wounds was the fact that Jimmy Page had just then had an album in the US Top Ten. Harder still for him to take, *Coverdale·Page* paired the guitarist with ex-Deep Purple and Whitesnake singer David Coverdale, a kind of preening parody of Plant. Plant was scathing about it.

'Well, that record certainly trumped my samples,' he huffed to me, five years later. 'I burbled out all sorts of garbage about it but it seems rather cute looking back.'

Page, who like Plant was also now being managed by Bill Curbishley, was unapologetic, admitting he'd done the record instead of a Zeppelin reunion. Speaking to me at the time, he said: 'I was going through a totally frustrating and fruitless period so it was good just to be able to find a singer. I haven't spoken to Robert about it.

'You've got to take into account here that 1991 was a year off for all of us. Jonesy had a couple of arrangements to do but that wasn't going to take him a full year. I certainly didn't have anything on and Robert had nothing to do. So really, the whole path was open for the three of us to come together but Robert just didn't want to do it. After that I just thought, "This is just a total waste of time."'

Page's association with Coverdale was nonetheless short-lived. Plant's tour rolled on into the States that September, where he'd had to downscale from arenas to theatres. During the course of it, he was approached by MTV with the offer of doing one of its *MTV Unplugged* shows. The popular franchise, for which artists performed an exclusive acoustic set, had given a career boost to such long-in-the-tooth stars as Paul McCartney, Neil Young, Rod Stewart and Eric Clapton. It seemed to offer Plant just the shot in the arm he needed.

From the off he was of a mind to do something different within the format. When he had been in Paris earlier in the year he had asked the French producer Martin Meissonnier to work up some North African-sounding drones and loops for him, and he was keen to follow up on these. His manager Bill Curbishley, on the other hand, was more intent upon maximising the impact

of the proposed show. Sensing the perfect opportunity to bring two of his clients back together, he suggested to Plant that he bring Page on board for it.

The two men met up in Boston that November to discuss the idea, Page flying in to see Plant's show at the city's Orpheum Theatre. After the gig Plant handed Page the tapes he had received back from Meissonnier. The complexities of their relationship are such that every gesture is open to interpretation, not least by the two of them. In this instance Page read Plant's act as a test.

'He had these loops and it was, "Let's see if Jimmy can come up with anything. Or is he about to get in the limousine with David Coverdale?" No, I'm fine with a challenge,' Page told David Fricke of *Rolling Stone*. 'It was interesting getting together with Robert again. It's apparent that the third [Zeppelin] album, where you have the emphasis on acoustic, was more attractive to him as time went on, rather than the more hardcore elements. Whereas I'd jump off a roof into that – naked.'

Negotiations went on, weeks stretching into months. Plant rounded off the *Fate of Nations* tour in South America at the beginning of the following year. He came home and sunk into a depression, brooding on the state of his career and putting on weight, as he tended to do when at a low ebb. He seemed inert, unable to decide what to do next. He was still unsure about working again with Page, feeling the ghosts and the guilt stirring.

He went to see his old friend Benji LeFevre and asked his advice. LeFevre told him not to sign anything he could not walk away from.

'I also said I thought he owed it to himself, and to Maureen and to Karac as well, to see if he could resolve any issues within

him,' says LeFevre. 'Though I was surprised it was even an option. Having seen and heard Pagey playing at a couple of gigs with Robert, it had been terribly disappointing.

'Plus, the whole Zeppelin thing was a textbook on how to perpetuate the myth. They never did any press and then they didn't get back together again. That's fucking smart. Because it will never, ever be as good as it was.'

Finally, Plant made up his mind. Just as he had done after *Shaken 'n' Stirred* he fell back on his safest bet. In April 1994, six months on from their initial meeting, he and Page joined each other on stage again at a tribute concert for their old blues mentor, Alexis Korner, in the East Midlands spa town of Buxton.

'It was good to get back together being mates,' Page told me. 'A lot of water had gone under the bridge.'

Although if either he or Plant expected their passage from then on to be a smooth one they were to be disappointed.

17

GOOD TIMES, BAD TIMES

*It was like trying to give birth to
an elephant from a sheep.*

On 5 April 1994 Nirvana's singer–songwriter Kurt Cobain shot himself dead at his home in Seattle. In the note he left behind Cobain quoted a Neil Young lyric: 'It's better to burn out than to fade away.' Yet it was the line that preceded these words in Young's song 'My My, Hey Hey (Out of the Blue)' that best captured the essence of that year – 'Rock and roll is here to stay.'

Nothing reverberated through 1994 so much as the sounds and sense of the '60s and '70s, revived by their original creators or reclaimed by newer artists. The latest voice of a generation gone so shockingly, it was almost as though a balance had needed to be struck. The remaining Beatles regrouped to complete a track John Lennon had never finished recording with them, 'Free as a Bird'. The Rolling Stones, Pink Floyd and the Eagles all toured, the latter branding their comeback trek 'Hell Freezes Over', since they had once said it would be that long before they would play together again. The Fillmore re-opened in San

Francisco and someone even had the bright idea of staging a second Woodstock festival, corporate sponsors and all.

Britpop took hold in the UK, its roots embedded in the '60s, Oasis being cast as the Stones to Blur's Beatles, even though it was the former that sounded like the Fab Four and the latter better resembled the Kinks. On their *Second Coming* album, the Stone Roses from Manchester took their cues from Led Zeppelin, their guitarist John Squire very evidently in thrall to Page. Fittingly, two months before that record Page and Plant had released their first album together in more than fifteen years, although in their case this was not just a recycling of the past but a fresh spin on it.

After appearing at the Alexis Korner tribute gig that April, the two of them had begun working with each other on the loops that Plant had received from French producer Martin Meissonnier. Out of these they fashioned a new track, a seductive drone they called 'Yallah'. Far removed from the self-conscious sound of much of Plant's solo work to that point, it tapped back into the roving spirit of Zeppelin's most exotic moments. It also set the tone for what Plant intended for his and Page's *MTV Unplugged* performance, which was to take Zeppelin's music to foreign parts, using the folk music of North Africa as their vehicle.

'I'm certainly a lot different to the guy who sang on *In Through the Out Door* and it meant that we would be working together in a different form of partnership,' Plant later told Mat Snow of *Mojo*. 'The whole idea of being able to brandish the Arab link was so important to me and really crucial. If you don't modify it or present it in hushed tones, but mix it the way we are, a couple of questionable characters of ill repute, then you make a totally different form.'

It was not just with regard to the music that Plant was now taking the lead. Page had harboured hopes that John Paul Jones would be involved in the project but Plant dismissed them.

'If we hadn't started with the loops, then we'd have begun as a four-piece, which would have been a bit "roll of the barrel" for me,' he reasoned to Snow. 'Apart from the fact that it would virtually be Led Zeppelin and then the next person you start talking about is John Bonham, which is just so cheesy and ridiculous … Personally, I don't want to bring too much attention to the past, beyond the fact we're old fuckers who can still do it and have a history.'

Of course, in reuniting with Page and doing Zeppelin songs, in whatever guise, Plant was having his cake and eating it. Backed by his own most recent rhythm section, bassist Charlie Jones and drummer Michael Lee, Plant started rehearsing with Page for the broadcast. They took over the upstairs room of the King's Head, a pub in Fulham in West London. To assist them Plant first reached out to Ed Shearmur, a twenty-eight-year-old soundtrack composer and arranger who had been educated at Eton and had worked with Eric Clapton and Pink Floyd.

His next recruit was Hossam Ramzy, an Egyptian percussionist and composer. Ramzy had previously collaborated with Peter Gabriel on *Passion*, Gabriel's gripping soundtrack to the Martin Scorsese film *The Last Temptation of Christ*. That project was a template for the vision Plant now had for blending musical cultures, and he charged Shearmur and Ramzy with pulling off the same magic act for him and Page. Ramzy put together an ensemble of Egyptian musicians, drawing them from London's vibrant Arab club scene, with Shearmur acting as their arranger.

'You have to understand something about Egypt,' says Ramzy. 'Every empire that has taken place on Earth has invaded our

country. We Egyptians are mongrels of culture and the concept of world music has been with us since eternity.

'The first thing we tried out with Ed was "Kashmir". In attempting this big marriage between the two cultures and not watering one down with the other, to begin with it was like trying to give birth to an elephant from a sheep. Then I thought of going back to the pure Egyptian blues music, something called Baladi, which comes from the backstreets of Cairo, and putting it right next to the blues that Robert and Jimmy came from. That was the Eureka moment.'

This new version of 'Kashmir' came together over several days, with Plant and Page both adding their input. Plant, however, was the more vocal of the pair, and among the other musicians it was he who was seen as having the casting vote.

'Robert knew a great deal about Egyptian and Arab music in general,' says Ramzy. 'He asked me a lot about the Arab world. He wanted to make sure he understood it correctly. He'd come and practise his Arabic with me, because he had learnt how to speak it.

'Robert is one of the sweetest people you could meet, but when it comes to making music there are no friends for him. He is very demanding and every note counts.'

The code cracked with 'Kashmir', work then continued apace, a balancing act being struck between Zeppelin's hard blues and English folk influences, and the still more ancient North African musical traditions. The resulting sound was loose and pliable, full of heady swoops and dramatic plunges, spice on its breath and dirt beneath its fingernails.

Plant pushed on. He brought in Porl Thompson, the Cure's original guitarist, and recalled Nigel Eaton from his *Fate of Nations* album sessions, adding the dense, droning sound of his

hurdy gurdy to the rich mix. To help re-create 'The Battle of Evermore' he tracked down an English-born Indian singer, Najma Akhtar, to be his counterpoint on the track, relocating it from misty mountains to scorched terrain.

'Robert was like a dark presence in that room at the King's Head, enormous and vastly looming,' recalls Nigel Eaton. 'He's very aware of the power he's got. Yet I found him more passionate than demanding. He was very enthusiastic, jumping about the place. I think he wants you to be good, so that he can look good as well.'

'Robert was very much in control of the whole enterprise and what he said went,' adds Najma Akhtar. 'He'd originally sent me three songs to listen to and I remember Jimmy suggesting to him that I should sing on all of them. Robert said no, just "The Battle of Evermore". Jimmy tried to ask why not, but I only did the one.

'Generally, I think Robert is the key-holder in their relationship. Both of them are extremely intelligent and knowledgeable about different kinds of music, but they're otherwise very different people. Robert interacted with me more. He was the taskmaster. Jimmy seemed shy and very reserved. There was a lot of tension between them, both artistically and also personally.'

Filming began in the second week of August in Marrakech, Plant and Page performing with the local Gnaoua master musicians. Scenes were shot in the courtyard of a house in the old city and also in Marrakech's great public square, the Djemaa El-Fna, as dusk fell and smoke from the outdoor food stalls swirled around them. Plant appeared enraptured and lost in the moment.

'With the Gnaoua, it's about pure music and expression on their part,' he told the writer Alvaro Costa. 'It has nothing to do

with commercial inferences. They don't relate to that concept whatsoever. It's a one-off thing. They expect nothing but they give a lot, and if they like you they give even more.'

The following week the operation moved on to Dolgoch in Snowdonia, filming taking place in the Corris slate quarry near Plant's Welsh farm. The main *Unplugged* show was recorded over three consecutive nights at the end of that month at the London TV studios before a small, invited audience. It was a bold and exciting performance, Plant, Page and their core band embellished by the Egyptian ensemble and also the London Metropolitan Orchestra, the outpouring of sound having a thrilling abandon to it.

Three months later Plant's label released a live recording of the show. Titled *No Quarter* and credited to Jimmy Page and Robert Plant, it was an artistic and commercial success, boosting both men. This time there would be nothing fleeting about their reunion.

Plant and Page agreed to take the *No Quarter* concept on the road for a world tour that would last more than a year. The first confirmed shows were in the US, a total of forty-seven arena dates that ran from February to May 1995. The month before these began the two of them flew to New York to attend a ceremony inducting Led Zeppelin into the Rock and Roll Hall of Fame. It was an awkward occasion, since Jones was also present. During their acceptance speech, he expressed relief that his former colleagues had found his phone number.

Not that he was asked to join them in summoning up Zeppelin's spirit on the ensuing tour, which started in Pensacola, Florida, on 6 February. This undertaking was a logistical nightmare, union rules requiring them to use an orchestra local to

each city to augment their seven-piece band and the Egyptian musicians. In order to rehearse the different orchestras Ed Shearmur had to travel to every venue a day in advance of the rest of the party.

It meant that everything was always on the verge of falling apart, but they pulled it off. Had they not, it is likely that none of those that flocked to see them would have been unduly bothered. The shows were powerful and emotionally charged, but one sell-out crowd after the next appeared ecstatic enough at just being witness to Plant and Page doing Led Zeppelin songs together again, even though 'Stairway to Heaven' was never among them, Plant having put his foot down on that score.

Plant otherwise seemed to be enjoying himself, on stage and off. He played practical jokes on the backing musicians, once ordering up an ageing prostitute who came into their dressing room and offered to service each of them. On days off he occupied himself playing tennis or with sightseeing trips. He had also started up a relationship with Najma Akhtar, who joined up with the tour for selected dates.

'The two of them had seemed very close at the King's Head pub,' recalls Nigel Eaton, 'but we hadn't a clue they were dating, even after the TV recording. Robert's very charming, though, and there were always lots of lovely ladies hanging around.'

'I once asked Robert how he went about choosing a girl when he was in Led Zeppelin,' adds Hossam Ramzy. 'He told me, "It was very simple. There would be a thousand of them and I'd just go, 'You, you and you – fuck off. The rest, come with me.'"'

For all Plant's effusiveness, Page remained as elusive as ever. He tended to remain secluded in his hotel room, venturing out for the show and retreating to it again afterwards.

'It's very hard to describe Jimmy,' says Nigel Eaton. 'He's a bit like me, one of those loner types at school that never went out. I don't think he remembers what it's like to be broke quite as clearly as Robert does.

'I could more or less ring Robert up in his hotel room and tell him we were all heading off, and often as not he'd come along. I remember that he came horse riding with us all in Arizona. I never felt able to do that with Jimmy. He was always very nice to me, but he was much more intense and I was warier of him.'

The longer the tour went on the more his and Page's differences niggled Plant. He called up friends, bemoaning the fact that while he was now off playing tennis Page still wanted to stay up all night. There were also darker mutterings emanating from Plant's camp that Page's drinking was inhibiting his performances.

'I found that tour really unpleasant,' says the photographer Ross Halfin, who accompanied Page on it. 'It was sort of Jimmy's camp, which was his guitar tech and me, and then Robert and everyone else. You were made to feel as if you shouldn't be there. Admittedly, Jimmy was drinking a lot by the end of it so he was hard work.

'The two of them did seem to get on for the most part, though. Robert used to call Jimmy "Jimbob" all the time to try and annoy him but Jimmy would just ignore it. Jimmy had also wanted John Paul Jones to be there but Robert wouldn't have it. Jimmy was as much to blame for that situation because he gave in to it.'

From the States the tour wound on through Europe. Plant and Page headlined the Glastonbury Festival in the UK that summer, and also two nights at London's Wembley Arena. Peter

Grant came to the second of these London shows. It was the first time Plant had seen his old manager since parting company with him back in 1982. Grant had lost weight and seemed at peace with himself. Four months later he was dead, a heart attack taking him on 21 November 1995.

Grant was buried at Hellingly Cemetery near his home in East Sussex the following month, Plant, Page and Jones all attending the service. By then Plant's mood had already blackened. He was beginning to feel the same strain as he had been under during Zeppelin's last days. He and Page had then completed a second American tour, and their current manager Bill Curbishley was pushing hard for them to carry on through the following year. Plant refused to commit, taking off instead for a short holiday, Najma Akhtar going with him to the Caribbean.

'Robert was always under this negative pressure,' she says. 'He felt as though he was responsible for the incomes of all the people that toured with him and he carried that weight on his shoulders. When we were in the Caribbean, the stress of that manifested itself in a severe breathing problem.

'He continuously said to me, "Oh my God, I have to stop but Bill wants me to carry on." It was his most repeated phrase and a constant dilemma for him. I think he was just fed up of having to keep doing the Led Zeppelin thing. He was driven to tears by it.'

Dates had previously been booked in South America, Japan and Australia for the start of 1996, and Plant honoured these. He held firm about not doing more, however, and the tour came to an end in Melbourne on 1 March.

'The general feeling was that we'd all had enough by then,' says Nigel Eaton. 'The next time I saw Robert was twelve years

later. He came round to my house in London to have a guitar painted by my wife. We drank tea and ate pie.'

Plant took most of the rest of the year off, putting himself back together at home in the Midlands. He had his friend 'Big' Dave Hodgetts to run things for him there, to keep the house in order and to soak it up when he needed to blow off steam. Hodgetts made the arrangements when he decided to pack up and go to China to travel the Silk Road to the Great Wall. Even at home Plant was never still.

'Every second is precious to Robert,' says Akhtar, who spent a lot of time with him during this period. 'He didn't want to waste life lying in bed, sleeping, or relaxing or watching TV. He's always up and doing stuff. He loves to drive and to visit his place in Wales. I remember going up there with him to plant a tree.

'He's very spontaneous and passionate. The simplest, most unexpected things make him laugh. I think his love of life is his biggest strength – that and also his ambition, although that can be his weakness, too. Being that ambitious, sometimes you trample on people, unwittingly or not.'

Plant settled Akhtar into the regular beat of his village life. They went to the local pub and round to the neighbours for dinner. He took her with him to see his football team, Wolverhampton Wanderers, and to watch a local Zeppelin covers band named Fred Zeppelin.

'He's very patriotic about his little village,' she says. 'He likes to visit people and to be in the pub, the Queen's Head. No one thinks of him as a superstar there, he's just lost in friendly faces. To see that side of him was nice. He hated having to go to London, which he referred to as "going to work". He became a different person at home. When he was away he'd always buy

gifts for friends and loved ones back home. He's not wasteful or extravagant, but nor is he spendthrift.

'In some respect, he's meticulous. He makes endless lists, every day started with one. "Do this, do that and call so-and-so," with him ticking them off as he went. His garden is one of his passions. It becomes a mission for him. And once he's on a mission he won't deviate or stop until it's been done properly. First of all he wanted a pond and later on he got a big lake made. He's very lucky, too, because he has all these worker bees that buzz around, organising and getting stuff done for him.'

The reverie was broken by the death of Plant's mother Annie. Losing another one of his anchors hit him hard.

'Even though he was surrounded by a loving family and friends it was a very sad and dark time for him,' says Akhtar. 'His mum was adorable, and so full of energy and beans. After losing her he made an immense amount of time for his father. Maybe out of guilt that he hadn't done so before. Robert's persona is that of a strong he-man, but inside he's as soft as a marshmallow.

'I remember there being a lot of big family get-togethers. I met Robert's uncle and his sister, his children, and also Maureen and Shirley and their extended family. Both of them were lovely and very welcoming. They're of Indian origin, but much more Anglicised than I am, Christian whereas I'm a Muslim. I'd never been around Asians like that. Robert would often say to me: "Maureen and Shirley can do this, why can't you? They're like this, why aren't you?" As people he and I were very different.'

Plant's relationship with Akhtar came to an end at the same time as his period of grace at home. She says they both became too busy and wrapped up in their own lives. When his thoughts

turned to work and the road ahead he threw himself into it, not looking back.

He and Page had decided to make their first album of new material since Zeppelin's *In Through the Out Door* in 1979. They began rehearsals for it in November 1996. Plant had come full circle from when they had first got back together, shedding the extra musicians, stripping things back to a basic four-piece band completed by Charlie Jones and Michael Lee. The songs they began knocking into shape were also more straightforward and shorn of extrinsic flourishes. Most of all they made one think of Zeppelin, albeit in an older, more careworn incarnation.

They approached a thirty-four-year-old American, Steve Albini, to record them. An iconoclast, Albini was a musician himself, fronting such confrontational groups as Big Black, Rapeman and Shellac. He had engineered records for hundreds of punk, hardcore and alt-rock bands, working fast and with no frills. He had made a rare excursion into the mainstream in 1993 when working on Nirvana's *In Utero* album, alarming their record company with the harshness of its sound.

Towards the end of 1997 Albini joined Plant and Page at London's famous Abbey Road Studios, scene of the Beatles' greatest artistic flights, the record being completed in just thirty-five days. Plant and Page had not done an album this fast since Zeppelin's début.

'You can't go waffling on about the whys and wherefores,' Plant told me soon after. 'We just had a good time. Not too glossy, more of a live situation. We were all in the same room at the same time and it turned out nice. Much better than the last one we did together, *In Through the Out Door*.'

'I don't remember much of that one, to be honest,' Page interjected dolefully.

'But the thing is,' Plant continued, brain rushing on, 'who the bloody hell are we playing to now? The generation we first started playing for have all but gone, because the intensity and lust for music disappears. So we're playing to and for ourselves.

'Truth to tell, it would be nice to be up there with the big boys of today. I don't think it's within the psyche of youth culture to consider us extreme any more, though, no matter what. And yet I've a strange feeling that we might be – in a clandestine fashion.'

Released in the spring of 1998, the record was titled *Walking into Clarksdale*, a reference to the great Mississippi blues town to which Plant had made a number of pilgrimages. Like the best blues it was spare-sounding and unadorned. There was a new warmth to Plant's voice, especially so on more reflective songs such as 'Blue Train', a further poignant hymn to his late son Karac, and 'Please Read the Letter', one of several songs in which he pored over the ruins of broken relationships. Page, too, sometimes played beautifully, his solo on 'Upon a Golden Horse' like drops of rain after a storm.

I met up with the two of them in London shortly before it came out. Dressed in black, Page was quiet and diffident, perfectly pleasant but never seeming to be entirely there, keeping something held back. Plant was much more demonstrative, a 49-year-old man still resplendent in leather trousers and a satin bomber jacket, although he was hard to pin down. All in the same sentence he could be friendly and charming, then prickly and detached. It had the effect of keeping one's attention on him.

He was least aroused whenever the conversation turned to Led Zeppelin, whereas Page at such times seemed childlike in his enthusiasm. Plant came to life in the present, enthusing about the music of the British techno band the Prodigy and in

particular that of Jeff Buckley, the son of American folk singer Tim Buckley. Like his father, the younger Buckley's flowering was brilliant but tragically brief, 1994's wonderful *Grace* being the only album he completed before his death in 1997 aged thirty. Most of all that day Plant railed against the notion that he might belong to a rock aristocracy alongside such peers of his as McCartney, Jagger and Clapton.

'The testiest work of most people of our age is long gone,' he told me, gimlet-eyed. 'Without bragging, I think we're quite capable of doing something extraordinary one minute and maybe something tedious the next, but at least we'll push. There's no better bloke to work with on an imaginative guitar level than Jimmy. But if we'd gone back and done it the other way, re-forming Zeppelin, doing the stadiums and all that shit, we'd be friends with the Royals by now.

'The rock aristocracy? That's for people who haven't got anything else to do, people who have found a successful formula and clung on to it. Look at Sting. He was in a serious punk band. Now ... I don't know what's happened there. I will not be kissing Albanian women onstage at the Royal Albert Hall. Though I would do in a doorway somewhere in Soho if it were dark.'

Yet try as he might this was a circle he could not square with Page. For as long as they were together, people would come along wanting and expecting to see and hear a version of Led Zeppelin. He would soon feel the weight of this pushing down upon him again.

Prior to the release of *Walking into Clarksdale* he and Page did a handful of shows in Eastern Europe in the spring of 1998, just them and Jones and Lee. They played in Croatia, Hungary, the

Czech Republic, Poland, Romania and Bulgaria. To make things more interesting for themselves Plant and Page hired a car and drove from show to show, breaking off from the main touring party. Less than a decade earlier Zeppelin's records had been banned by the former Communist regime in Bulgaria.

'People would club together to buy one album between them on the black market, facing imprisonment if they were caught,' explains Anton Brookes, Plant and Page's publicist on the tour. 'All these guys in their mid-forties came to the show in Sofia with their original records. They were telling Jimmy and Robert the stories of how they'd hidden and preserved them. Both of them were overcome by that and it ended up being the wildest show I've ever seen.'

I caught up with the tour in the Turkish city of Istanbul. The show was taking place in a circus tent in the Asian half of the city. Since Plant and Page were staying in Istanbul's European sector across the River Bosphorus they elected to catch a public ferry to get to it. They sat side by side on the boat's upper deck, curious onlookers staring at them, Plant with a black hat pulled down over his long hair but still unmistakable. 'This,' he said, smiling, 'is very weird indeed.'

The gig was electrifying but it was a Zeppelin one in all but name and absent friends. Their old band's songs filled the set and they performed them straight, 'What Is and What Should Never Be' and 'Babe I'm Gonna Leave You' bringing the house down. Plant prowled the lip of the stage tossing his mane of hair to the mighty crunch of Page's guitar, the years rolling back.

Finishing with a rollicking 'Rock and Roll' they fled the venue before the last notes had died away, Plant climbing into a waiting saloon car, Page and everyone else boarding a minibus.

Even then the Zeppelin echoes persisted. As Plant was sped away the bus was left idling, the driver having nipped off to smoke a cigarette. He was fast spotted sauntering back through the crowd that had begun to throng around the vehicle.

'Oi! Get in here and fucking drive,' Plant and Page's manager Bill Curbishley snarled through an open window, eyes blazing. When we did set off it was haltingly, since the streets around the venue were now swarming with people. Jabbing a finger at the hapless driver, Curbishley turned to tour manager Rex King and said, 'Fire this cunt.'

On the drive back to the hotel Page looked to have been drained by the gig but he was chattier than he had been in London. He told me that he was intending to take a short holiday in Egypt before he and Plant toured North America, and that he wanted to see the tombs of the pharaohs. When we got back to the hotel he said he fancied a nightcap and made for the bar. Plant was nowhere to be seen.

'I always got the impression with Robert and Jimmy that it was like little brother and big brother,' says Anton Brookes. 'When they're together Robert's kind of in Jimmy's shadow a bit, and he's prone to being a bit disruptive because of that and the fact that he's not in control. That element was always there when I was with them. But then Robert was also very protective towards Jimmy. If Jimmy ever appeared uncomfortable in an interview or unsure of what to say Robert would take the lead. He'd always look out for him.

'Jimmy keeps to himself and Robert's very flamboyant, though I think that's partly a defence mechanism. He seems very open but Robert doesn't actually give anything away. He's engaging and very much a people person but he's quite guarded, too. His face lights up when he's talking about music or football, things

he's passionate about. But if you tried to talk to him about Zeppelin or himself he'd blank you.'

As ever the tour of North America was a bigger deal. The album had sold steadily but not remarkably there, but Plant and Page's reputations – and the promise of Zeppelin – still filled arenas and left audiences baying for more. It was the same story for fifty shows and Plant began to tire of the routine, the endless act of dipping back into his past. By the time of the final dates in Europe at the end of that year he was spent.

Page wanted to carry on, to make another record and try again to talk Plant around to having Jones on it, but Plant would hear none of it.

'I needed to go off and do something that was the very anti-thesis of playing huge buildings in places like Mannheim in Germany,' he later told me, 'to people who wanted Led Zeppelin and the two of us were the nearest thing they could get to it.'

Plant bailing on him did not stop Page from keeping the Zeppelin flag flying. The following year he joined the Black Crowes for a series of well-received shows in the US, playing mostly Zeppelin songs, carbon copies of the originals. After that tour had finished, the Black Crowes' drummer, Steve Gorman, ran into Plant whilst both of them were on holiday on Nevis Island in the Caribbean.

'My wife and I were having lunch at the hotel bar one day and Robert was sat right across the way from us, drinking a daiquiri,' he recalls. 'He came over and he couldn't have been sweeter. He told me he'd heard what we'd done with Jimmy and thought it was great. He said, "Yeah, he plays better with you guys than he's done with me for the last few years." I told him there was no pressure on us, and he just laughed and said something about how nice that must be.'

DOWN FROM THE
MOUNTAIN

*Robert described it to me as like hearing
a voice from another planet.*

As 1999 stretched into a new millennium Plant was playing in pubs around the English Midlands with a covers band. The beginnings of this dated back to 1997, during the time he took off between projects with Page. Back then he had agreed to perform at his local tennis club's annual charity bash.

Scrabbling around for musicians to help him out Plant roped in Kevyn Gammond, his next-door neighbour and former guitarist with his old group the Band of Joy, and a drummer, Andy Edwards, who was running a music course with Gammond at a nearby college. Playing at Bewdley Tennis Club, this make-shift band did a cover set that included Donovan's 'Season of the Witch' and the folk-rock standard 'Morning Dew', Plant's village doctor among the couple of hundred people in attendance that night.

By the middle of 1999 Plant had told Page that he would not be making another record with him. He had suggested to Gammond that they revive their covers band, calling it Priory of

Brion, the name inspired by Plant's love of both Arthurian legend and also the Monty Python film *Life of Brian*. Andy Edwards also returned and brought with him two friends with whom he had been playing in a jazz trio, bassist Paul Wetton and a keyboard player, Paul 'Tim' Timothy. They began rehearsing in the large garage of Plant's house, the walls of which were decorated with the gold and platinum discs he had been presented with. The songs they worked up were drawn from his record collection.

'I never think about the journey that I'm having, I just do things,' Plant later told me by way of explanation for this latest diversion. 'There are very few things that I need to go back to. I couldn't do Priory of Brion again, for instance, but to form a band and vow never to play east of Offa's Dyke was a fantastic moment. I should have it tattooed in Welsh on my arm.'

'Paul, "Tim" and I were getting a musical education,' says Andy Edwards. 'Robert would pull out all these records to play to us, everything from '60s garage bands to '80s techno. We heard a lot of Moby Grape and Buffalo Springfield, Arthur Lee and Stephen Stills. Robert listens to absolutely everything. He's got a room at the house with a beautiful old stereo and his choice records in it. I'm sure he's got a vast amount of vinyl stored elsewhere. He once told me he had a million records.

'Most of our rehearsals, he had a guitar round his neck. He's a good, solid guitarist. He loves musicians jamming and improvising, and he really responds to that. He is a control freak, though. He oversees every aspect of what's going on, down to the snare drum I was using and what it sounded like. If I had a criticism of him, it's that on occasion he would try and pull everything apart. Working with him is a pressure situation and I found it difficult at times.'

Edwards was using an old Ludwig drum kit that Plant had set up in his garage. Plant eventually gave it to him, although it would be months before Edwards discovered its significance.

'After we'd done a couple of gigs, I asked Robert if he'd got any cases for the drums,' he recalls. 'He took me into this room just off from the garage and began pulling stuff down from the shelves. The first case he brought down had "John Bonham – Led Zeppelin" written across it. That Ludwig kit was the first one John had been given when he'd joined Zeppelin.

'That's when I realised what I was stepping into. You're dealing with something that's monumental. In my life that band will always be the thing that defines me, even though for Robert it was just one little thing that he did.'

The first gig the Priory of Brion played was on 23 July 1999 at the Three Tuns Inn in Bishop's Castle, a small town in Shropshire on the English–Welsh border. They performed improvised versions of the Beatles' 'Something' and Love's 'Bummer in the Summer', Elvis songs and old blues numbers such as 'Baby, Please Don't Go'.

'It was a pub that was local to us and we'd expected to get a hundred or so people there,' says Edwards. 'I remember Robert saying, "We can't use my name at all – there'll be helicopters landing in the car park if they know it's me." That's why it became the Priory, because we had to keep its identity a secret. Everybody still knew. Chinese whispers were enough to have 300 people turn up.

'Robert had a Dictaphone with a tennis training tape on it. In between songs he held it up to his microphone. The audience were hearing stuff like, "To play the overhead stroke …" It was so stressful for the rest of us because we just wanted to get it right.'

Further shows followed at pubs, clubs, school halls and local folk festivals. The music he was performing in Priory of Brion cemented Plant's connection to his roots but the process went deeper than that. It seemed to be a reminder to him of the man he had once been or the one he was when not being Robert Plant, the Rock God. He sat on a stool for these gigs, his hair pulled back, scanning sheets of lyrics that he had placed on a music stand, reading glasses perched on the end of his nose. There was no act, no artifice. It was as though he were stood naked before each small audience.

Like the Honeydrippers all over again, Plant revelled in being in a band that played music for the pleasure of doing so. And just as he had done back then, he called up local promoter Roy Williams to ask him to book gigs for the band and run the sound desk for them.

'My manager Bill Curbishley fled in horror,' Plant told me. 'He said it was like watching a thoroughbred racehorse pulling a milk float. Bill asked me, "Why are you doing this? The whole thing is so fucking awful I don't even want any commission." I told him that was good because there were no earnings.'

Towards the end of the year Priory of Brion did a couple of shows at venues significant to Plant during his formative years: Stourbridge Town Hall, where as a teenager brimming with self-confidence he had opened up for the likes of Gene Vincent and the Walker Brothers, and Queen Mary's Ballroom on the site of Dudley Zoo, which he had played with the first incarnation of the Band of Joy and had also been the scene of his wedding reception in the far-off winter of 1968.

'That Ballroom's not a bad gig, it's got a nice low ceiling,' he told me. 'I also saw Spooky Tooth and Joe Cocker there in the '60s. The thing is with music now, it's opened up into this huge

deal where, if someone like Oasis re-formed, it would be for a tour of fucking stadiums around the world. Wow! I think I'd rather be at Dudley Zoo. Though that might also be the only choice I have left.'

'At that show, the crowd were all shouting out for "Whole Lotta Love" so Kevyn Gammond jokingly played the intro to it,' says journalist John Ogden, who was covering the night for the Midlands newspaper the *Express & Star*. 'Robert wouldn't do it, though. I heard that Kevyn got a real bollocking from Robert afterwards.'

Plant began to range further with Priory of Brion. The following spring the band left the UK for the first time, playing at a blues festival in Bergen, Norway. For now the sense remained that such jaunts were like boys' clubs outings and of the pressure being off Plant. He particularly enjoyed a short tour of Ireland they did that June, opening up for the irascible Irish singer Van Morrison. Plant had been afflicted with a bad back since his car crash on Rhodes in 1975 but he delighted in cramming into a small Transit van with the others.

'That Irish tour was like being on holiday and seeing the sights,' recalls Andy Edwards. 'The guy we had driving us on the first leg was giving us the history of Ireland as we went, all about the potato famine and where St Patrick had done what. Robert ended up handing him more money and telling him he was staying with us.

'I can remember us doing one gig in a big tent. There was a 25-foot walk from it to the dressing rooms. Van Morrison got picked up in a limousine and driven to the back of the stage. That was the closest I got to him. Back then Robert seemed to be rebelling against that whole kind of thing.'

Soon, however, the fun began to seep out of the band. Plant could not keep a lid on things – did not want to – and the shows started to get bigger, raising his and the audiences' expectations. That summer Priory of Brion had slots at both Glastonbury and the Cambridge Folk Festival, steps up from the local events they had done the previous year. There were more dates on the continent, too, where Plant was now being billed under his own name, the crowds numbering thousands rather than hundreds.

Plant was also getting itchy feet. Pressed by Roy Williams into listening to Emmylou Harris's 1995 album *Wrecking Ball*, he'd become evangelical about it. The great American country singer and her producer Daniel Lanois had fashioned an atmospheric new sound on this record, one as evocative as a moonlit prairie, allowing her to haunt and shape-shift songs by Bob Dylan, Neil Young and others. Plant had begun to think of doing something similar, although he doubted it would be possible with his current group of musicians. He took them into Rockfield Studios in Wales to demo three tracks, the feeling that they were being tested not escaping the others.

'I imagined those tracks were to go and play to his management,' says Edwards. 'There was a growing pressure on us and you started to see the cracks. Robert seemed to be slowly getting disenchanted. I felt there were a lot of people around him asking why he was wasting his time with the band.

'Robert argued our case, but there was pressure on him, too. Bill Curbishley came to see the gigs but he didn't talk to the rest of the band. He seemed to be grumpy with us.'

That November Plant took Roy Williams with him to see Emmylou Harris perform in Dublin. Backstage he got chatting to Harris's guitarist, Buddy Miller, filing his name away for future

reference. On the flight over to Ireland he had also quizzed Williams about the size of venues that Priory of Brion was now being booked into, 2,000-seat theatres like La Cigale in Paris and with more of a production.

'I told him I thought it was getting too big,' says Williams. 'I said, "We'll go and watch Emmylou, and put it into your head that you're going into the same venue the next night with what you've currently got." He came out of the show and said that he didn't want to have any more gigs booked for them.'

Priory of Brion played their final shows in November and December 2000, four in Greece and three in the UK. The last was at the Wulfrun Hall in Wolverhampton, four days before Christmas.

'We'd had a row with Robert in Greece, nothing terrible but everyone was starting to get on each other's nerves,' explains Edwards. 'After Christmas he rang me and said he didn't want to work with Paul and Tim again. He was very vague about what he was going to do with me. Nothing was cut and dried.

'It was a difficult time. Paul, Tim and I had all had to give up our day jobs, so we were earning a living with the band. I had no other work. I ended up joining an Oasis tribute band and then a prog-rock group. I built myself back up but I came out of the Priory being quite insecure about my playing because of all the outside stuff that had gone on.'

'If you're those guys, you've got to enjoy the moment,' insists Roy Williams. 'That's the reality of it. It's not a bad thing to have on your CV. Take that and move on.'

In any event Plant had disappeared around his next corner, gone to them, although there is no doubting that he had been changed by the Priory of Brion experience and that it had also

allowed him to sketch out a blueprint for the future. From now on Plant would no longer peacock about in leather trousers or scream like a banshee. Likewise it had fired his interest in interpreting other people's music and doing so through the process of improvisation.

Piecing together a new band, one that could be flexible and adaptable, he went back to his son-in-law Charlie Jones and also guitarist Porl Thompson, who had toured with him and Page. At Roy Williams's recommendation he brought in drummer Clive Deamer, who had been working with the Bristol trip-hop collective Portishead, and another musician from that scene, keyboardist John Baggott. For lead guitar he turned to Justin Adams, who had a track record playing with North African musicians and had been a member of ex-PiL man Jah Wobble's band.

Plant called this band Strange Sensation and they began gigging in the spring of 2001, taking on shows that had originally been pencilled in for Priory of Brion. That summer he took them into RAK Studios in London to make an album, bringing in an old acquaintance to record them, Phill Brown, who had worked briefly on his *Fate of Nations* album and had engineered a session for Led Zeppelin.

In great part *Dreamland* was a covers album, some of the songs surviving from Priory of Brion's live sets, such as the American folk singer Jesse Colin Young's brooding 'Darkness, Darkness' and also 'Morning Dew'. As he had done for his first solo album, Plant was funding the sessions himself, having left Mercury Records.

'Robert could do what he wanted and he was certainly no longer looking at it in terms of making a hit record. Most of the songs were way too long for that,' says Brown. 'That didn't inter-

est him at all. His approach was very much to capture a great blues track.

'He's completely in control of things in the studio and he doesn't accept half measures, but when you bring in musicians of that calibre you don't need to give them constant direction. There's always an edge to him and he doesn't suffer fools, but he was enjoying himself and good humoured. He had a house round the corner from the studio in Primrose Hill and of an evening we'd all go down his local pub. Robert was always joking that he had to be careful about how much he drank because he has high blood pressure.'

Brown also recalls being in the studio on the anniversary of Plant's son Karac's death on 26 July.

'He and I talked at great length on that day, about his kids and that business of there being a supposed curse on Zeppelin,' recalls Brown. 'He just dismissed it, said it was one of those terrible, tragic things. He's quite forthcoming if you get him in the right environment, otherwise he didn't dwell in the past. There was the odd remark about Jimmy Page, either positive or not, depending on the discussion, but he very much looks to the present and to the future.

'While we were doing the album, he got an offer to re-form Zeppelin with Jason Bonham on drums, something like $70 million for a world tour. Bill Curbishley brought it up and I know that Page was totally up for it, but Robert wasn't interested. He and Jimmy have a total love–hate relationship. They'll get together and do things, but then something always screws it up and they don't talk to each other for a while. They disagreed a lot about the way things should be.'

Like Page, another constant in Plant's life was his interest in women, his relationships with them often being just as

complicated and messy as the one he had with his former band mate. Brown remembers him bringing a new girlfriend to the studio one day.

'He was fifty-two, fifty-three at the time and she was twenty-seven,' Brown says, laughing. 'His daughter Carmen popped in later and, in front of everyone, said, "Next time you bring someone home, Robert, can you make sure that they're older than I am?"

'Robert moans a lot about all the alimony he has to pay out but he keeps screwing around. That girl caught him with someone else and left immediately. He's never going to learn. My wife knows Robert from way back and she's always had this slightly uneasy feeling about him, because of his flirting. He flirts a lot.'

Listening to *Dreamland* is to hear many of the sounds that had filled Plant up these last forty years come pouring out. He had been singing the powerhouse blues of 'Hey Joe' and 'Skip's Song' by Moby Grape for almost that long.

Plant and Strange Sensation toured the album through to the end of 2002, five months of dates in Europe and three around the States, playing theatres and ballrooms. The shows amplified the mood of the record, the band mixing different and more exotic flavours into Zeppelin songs and whisking an older song of Plant's such as 'Tall Cool One' off down a Moroccan souk.

As he had been making *Dreamland* Plant had also heard something else that had stopped him dead and suggested yet another path for him to follow. The folk music of black America, the blues, he had known for years, but just now he had started to explore its white counterpart, bluegrass. Its roots going back to the music of the peoples who had migrated to and settled in America – jigs and ballads from England, Scotland and Ireland, gospel and blues spirituals sailed over from Africa on the slave

ships – bluegrass had first fermented in the Appalachians and the country's rural backwoods. Played on traditional instruments such as banjo, guitar, Dobro and fiddle, it was music that was danced and sung along to at large social gatherings.

The advent of the radio age at the dawn of the 20th century enabled bluegrass to be broadcast across the country and by the time of the Second World War it had its first stars – Jimmie Rodgers and the Carter Family, and also the Monroe Brothers. It was fiddler Bill Monroe who gave bluegrass its name, splitting with his sibling Charlie in 1938 and forming a new band called the Blue Grass Boys. Bluegrass festivals popped up around the States through the '60s but the music was introduced to an even wider audience in 2000. That year saw the release of the Coen Brothers' film *O Brother, Where Art Thou?*, which was set in rural Mississippi during the Great Depression of the 1930s. The film's soundtrack featured contemporary bluegrass and country artists performing traditional songs and sold more than eight million copies in the US alone.

Such was the success of the record that the cast of musicians assembled for it reunited for a sell-out tour of the US in the summer of 2002. They had also gathered two years earlier for a show at the Ryman Auditorium in Nashville that had been shot for a documentary film called *Down from the Mountain*. Among the artists seen performing and being interviewed in the film were Emmylou Harris and such established bluegrass acts as the Fairfield Four and Ralph Stanley, as well as two of American country's brightest stars, Gillian Welch and a singer and fiddle prodigy from Decatur, Illinois, named Alison Krauss. Plant was in the middle of making *Dreamland* when the film was screened in London in the summer of 2001. He took off to see it, bringing his band and producer Phill Brown along with him.

'One day Robert said, "Right, I'm taking you guys out,"' Brown recalls. 'He's an interesting guy. He can be incredibly generous but also very tight. It's a weird thing. He took us all down to Soho. We went to a restaurant and then to the cinema to see *Down from the Mountain*.

'The rest of us were all sitting along from Robert on the same row wondering what all this was about and then on comes this most amazing movie. The two people that most impressed us in it were Alison Krauss and Gillian Welch. Afterwards, Robert couldn't stop going on about Alison Krauss's voice.'

Plant's friend, the DJ Bob Harris, had just then turned him on to Krauss. Harris had got to know Krauss and her records had become a fixture on his country-music show for BBC Radio 2.

'In the summer of 2001 Robert was driving back from a gig and he was listening to my show in his car, Saturday night turning to Sunday morning,' relates Harris. 'I played an Alison Krauss track and it was the first time he'd heard her.

'Robert told me that he pulled the car over. He was in the middle of the countryside on a beautiful summer's night. He said he turned up the radio, got out of the car and stood there under the stars listening to Alison sing. Robert described it to me as like hearing a voice from another planet.'

REBIRTH

*I'm north of the Arctic Circle on a boat,
playing gigs for the Inuit fishermen.*

Robert Plant was set on his own great adventure. This took him further from the spotlight and deeper into his own musical roots, following his nose and trusting to his instincts. It fed the music that he was making. The further he roamed and the more baggage he shed the freer it became. It was as though in finding a new purpose he had also found himself.

He began 2003 journeying with Strange Sensation guitarist Justin Adams to the world's most isolated music festival. The Festival au Desert takes place each January in the West African country of Mali, far into the Sahara Desert, staging a celebration of the continent's musical riches. Plant and Adams flew into the ancient Malian city of Timbuktu from southern Morocco, hitching a ride on a prop plane chartered by the BBC for a TV crew from the children's programme *Blue Peter*. To reach the festival site from there requires a 60 km drive by jeep across the desert as there are no roads. If anything was symbolic of Plant's flight from rock stardom this was it.

'We had Charlie Patton and some shrieking Berber music on the stereo,' he enthused to me. 'The whole idea of paying your own way to the Sahara to sing … it's insane. But isn't that great? If you want to play for the Tuareg you've got to get there. You've got to do it in order to have the experience.'

Here, in the cradle of the blues, Plant performed radical rein-terpretations of his own and Zeppelin's songs, backed by Adams and percussionist Matthieu Rousseau from the French band Lo'Jo, whose own music is steeped in North African traditions. Their backdrop was sand dunes and a dark Saharan sky, spread out around them a makeshift village of Berber tents. Also on the bill were Tinariwen, a band of Tuareg tribesmen who play hypnotic desert blues. Soon after, Plant was instrumental in getting them a record deal in the UK, Adams producing their excellent third album, 2007's *Water Is Life*. At night they slept under the stars. I once remarked to Plant how he was able to have experiences like this and yet still the thing he was most asked about was re-forming Led Zeppelin.

'Yeah, it's almost as if people can't see it,' he responded. 'It's like, a woman with white high heels and a pencil skirt will attract my eyes but most people will miss it completely. Media, journal-ism, popular culture – all of it is just so monosyllabic. The wonder to me is that everybody isn't doing these things.'

That summer he took Strange Sensation to north-east Europe to do shows in Latvia, Belarus and Ukraine, and they did some recording in Tallinn in Estonia. He and the band also drove north, heading to the outer reaches of Scandinavia.

'Robert wanted to know what the furthest place up was you could play in Norway,' recalls Roy Williams, Strange Sensation's sound engineer. 'There was a place called the North Cape, the last spot on the map. We didn't know if anybody had ever been

to play there or even if you could, but we went anyway and did four gigs in the Arctic Circle. The best thing I've ever done.

'We used boats to travel up country and along the fjords. One place we did, it was a village hall that held 500 people. They'd never had a band on there. There were a few times where we were the first band of any stature to go to a place.'

When he broke off from this roving Plant went back home to the Midlands or Wales, trading one sense of glorious isolation for another. At home his mind turned to more basic matters.

'Robert phoned me up out of the blue around this time,' recalls his friend Dave Pegg, bassist with Fairport Convention. 'He said, "Peggy, do you know any women?" I thought he was taking the piss. He said the problem was that he didn't want to meet people who knew who he was. He asked me if I knew of anyone nice, those were his words.

'Actually, I did, a neighbour across the road from us in Banbury. Robert said, "Can you ask her if she fancies coming out to lunch?" Turned out she knew of him but not much about him. He drove up here and we went with them to a local Thai restaurant. It was a very pleasant lunch and they got on really well. Thing is, though, I'd lent her that book about Zeppelin, *Hammer of the Gods*, and she didn't think she could cope with all of that.'

In any case, a more significant union was on Plant's horizon. Continuing to dig down to the roots of bluegrass music he had picked up the Smithsonian Folkways recordings of the earliest Appalachian artists, and travelled through Kentucky and Tennessee in a rental car. Plant had also got to know Bill Flanagan, an executive at the music TV channel VH1 in New York.

In 2001 Flanagan had been tasked with coming up with a

concept for a signature performance show for VH1's new acquisition, CMT, the country-music channel. He had hit upon the idea of pairing rock singers with country stars for a series of one-off collaborations, calling it *CMT Crossroads*. Having previously done a show for VH1 with Plant, he thought him ideal for this alongside one of CMT's most popular artists, Alison Krauss.

Born in 1971, Krauss had been Illinois state fiddle champion at the age of 12 and won a Grammy before she was 20 for her third album, 1990's *I've Got That Old Feeling*. She had gone on to release a further five albums with her band Union Station, becoming the most successful performer in modern bluegrass. Flanagan began the process of bringing her and Plant together. It ended up taking him more than four years.

'The funny thing about Alison is that she loves a lot of hard rock, things like Aerosmith and Def Leppard,' Flanagan says. 'I called her then manager, Denise Stiff, and asked how Alison would feel about doing a show with Robert Plant if I could get him. Alison was sat beside her and she just screamed. Then I had to start work on delivering Plant.

'With Robert, it's like meeting a 19th-century big-game hunter. He's been around the world, bagged all the elephants, escaped from a boiling stew-pot and being eaten alive, and come back to the pub to throw darts with the boys. Robert really knew of Alison's stuff, but he was off roaming the world and she always has fifty projects on the go. It was like trying to get a thread through the eye of a needle.

'In attempting to recruit him for the show, I'd leave messages with his office and eventually he'd call back. He'd say things like, "I'm north of the Arctic Circle on a boat, playing gigs for the Inuit fishermen. They call me," and he then said some unpro-

nounceable, twelve-syllable word. When I asked him what it meant he told me, "Man who looks like an old woman".'

So much of what unfolded in 2004 was ruinous or wretched, or both. The Middle East was wrenched by conflict, in Lebanon, Israel and the Gaza Strip, and also in Iraq. In December, a tsunami swept across the Indian Ocean, devastating whole countries and killing hundreds of thousands of people.

Robert Plant endured his own darkness that year, losing his father. He otherwise carried on his odyssey. In January 2004 he again performed at his local tennis club's annual charity bash in the Midlands, getting up to sing Elvis and Jerry Lee Lewis songs with a local band, and then drawing the raffle. The following September he donated money for a statue of the 15th-century Welsh king Owain Glyndŵr to be erected in Pennal, a village near his home in Snowdonia. He attended its unveiling at the small village church, asking the organisers that his presence not be publicised in advance. The patrons of this bronze figurine were recorded on a circular plaque set in stone beneath it. On this he was listed simply as 'Plant'.

He also went back to writing songs, the first time he had done so to any concerted degree in more than six years, working with his Strange Sensation band mates at his home in Wales. From there they moved to studios in London and England's West Country, piecing together a new album, *Mighty ReArranger*. It was to be his strongest solo record to date, the songs potent and powerful if never outstanding.

A musical stew, it mixed hefty blues with North African drones, '90s trip-hop with the sound of America's West Coast in the '60s. There was something proud and defiant to it, a refusal on Plant's part to rest on his laurels or go quietly to older age.

He said as much on 'Tin Pan Alley', the song soothing to begin with, then raging, Plant singing: 'My peers may flirt with cabaret, some fake the "rebel yell"/Me, I'm moving up to higher ground, I must escape their hell.'

'What he wanted to do with that record was simple enough,' says Roy Williams. 'It was to send out message: "Don't forget about me."'

In the middle of stirring this potent brew Plant finally got around to making contact with Alison Krauss. Bill Flanagan at VH1 had passed on her phone number to him and he called her one night at home. Their first conversation, however, was short and inconclusive.

'Alison wasn't really saying anything and I thought, "Fucking hell, she's got those Quaaludes I've been looking for!,"' Plant later told Q magazine. 'I've been married before so I know what it's like to have a woman mumbling at me.'

'At the time I was putting my three-year-old son to bed,' said Krauss. 'I was laying down next to him so I had to be real quiet. When Robert suggested I took down his number, I said to him, "I'm sorry, I don't have a pen and I can't get up right now."'

Plant persisted, and the more he spoke to Krauss, the more set he became on doing something other than just a TV show. He had a notion that they should do a record of some sort together.

'Being the mercenary television executive that I am, I said that was a fantastic idea,' recalls Flanagan. 'I said that we could put out a record of the show, like Eric Clapton's *Unplugged*. He told me he didn't mean that. What he wanted to do was go into a studio first and cut stuff with Alison.'

That November Plant and Krauss sang together for the first time in Cleveland, Ohio. This was at a Leadbelly tribute concert staged at the city's Symphony Hall and they performed 'Black

Girl', a song the venerable bluesman had written in 1944. Krauss did not feel the song had suited them but was swayed by Plant telling her backstage how he had driven through the Appalachians listening to the bluegrass singer Ralph Stanley. For his part Plant's mind was made up.

'It was an amazing night,' he recalled, speaking on the BBC documentary *By Myself.* 'I'm stood next to a beautiful woman who can sing like an angel and knows exactly what she wants. I thought, "That's got to come back again."'

Mighty ReArranger was released in April 2005, attracting glowing reviews, a couple of Grammy nominations and an enthusiastic audience, without bringing Plant in from the margins. He and Strange Sensation set off on tour again. The dates extended to the end of that year and on through the next two summers, taking in Europe, the States and North Africa. They played shows at the Ice Palace in St Petersburg and beneath the illuminated minaret of a mosque in Tunis, with the last of them being at a festival in the Welsh mountains in August 2007.

For all this, it was a few days that Plant spent in Nashville in October 2006 that would resonate the most. It was then that he went into the studio with Alison Krauss. At 58 he was about to make not just the best record of his solo career but one of his best of all.

The build-up to it was protracted both by the difficulties of matching up their respective diaries and also the different vision each of them had for the project. Krauss wanted to make a country record. Plant was more inclined to do something with a funkier flavour and using musicians from New Orleans.

In the end Plant relented. He agreed to test the water in country music's capital city and with Krauss's choice of producer,

T-Bone Burnett, the two of them having first worked together on the *O Brother, Where Art Thou?* soundtrack. An accomplished musician himself, Burnett put together a crack studio band that included Tom Waits's regular guitarist Marc Ribot and a stellar Nashville rhythm section of bassist Dennis Crouch and drummer Jay Bellerose.

'T-Bone, who is the smartest guy in any room, also brought in all these songs that had a spookiness and mystery to them,' says Bill Flanagan, invited down to the session by Plant. 'I think Robert suddenly realised that Elvis had two DNA strands combining in him, and that the hillbilly strand led to a fascinating place.'

'The same darkness that you find in bluegrass and murder ballads, it is a darkness that is absolutely in Robert, in his voice and life,' Burnett told David Fricke of *Rolling Stone*. 'Alison understands that, and Robert worked hard to get it.'

Encouraged by Burnett, Plant and Krauss had also picked out songs. The three of them amassed over fifty selections, ranging from 1950s country standards and an old Everly Brothers tune to a track Plant had previously recorded with Page, 'Please Read the Letter'. Whittling these down to thirteen, they worked fast at recording them, as much out of necessity as anything else, spending five days at Sound Emporium Studios in Nashville and as long again at three studios in Los Angeles at a later date.

The chemistry between them was instant, Plant and Krauss nailing three master tracks on the first day in Nashville. For Plant, who had rarely sung harmony vocals before, the experience was a new and testing one.

'The thing I remember most from that session was that Robert was confounded and then delighted with what Alison was teaching him about harmony singing,' recalls Flanagan. 'As he said, in

Zeppelin and his previous solo work harmonies were things that'd be addressed if there were a couple of hours spare at the end of the session. He'd never been in a group like the Beatles or the Band, where they were such an important component.

'Alison really showed him a lot of ways to go. As a great singer, that excited his ear. That's got to be interesting to one of the great vocalists, doing something with his voice that he hadn't done before.'

'Before I met Alison I'd never known how beautifully eerie and evocative white American mountain music is,' Plant told me. 'I don't mean country music or bluegrass but the things from which a lot of that contemporary stuff has developed. Stuff that guys like Clarence Ashley were churning around at the start of the last century. Guys that worked in the lumber mills and made this spectacular music.'

The record, its title *Raising Sand* plucked from a lyric on *Mighty ReArranger*, was Plant and Krauss's very own *Wrecking Ball*. In common with that Emmylou Harris album it had a unique and timeless atmosphere to it, hushed and whispering. The sound of it was spare and spacious, the texture dry and with the snap of old bones. The sense of darkness that T-Bone Burnett spoke of was there, too, like shadows at the edges of a sepia-tinted photograph or a chill breeze blowing in the dead of night.

The cast of songwriters pulled together on it was just as fasci-nating. Among them were the maverick Tom Waits and Gene Clark, who was behind some of The Byrds' most elevated moments, a tortured soul dead of a heart attack at 46. And also the late Townes Van Zandt, the great lost son of country music. Like Clark, Van Zandt was an alcoholic and a drug addict as well, Dylan, Willie Nelson and Merle Haggard among the many to have covered his aching songs.

Theirs and other compositions on *Raising Sand* were ballads, slow dances and hoedowns, each one as pared as the next, a skeletal framework for the two lead voices, both of them gentle and intimate like lovers on a first date. Krauss otherworldly, Plant not just emoting the words now, but crawling down inside each song and inhabiting it. He sang exquisitely, perhaps better than he had ever done – as convincing on the playful Everly Brothers track 'Gone, Gone, Gone' as he was on Van Zandt's desolate 'Nothin'' or his own 'Please Read the Letter', reworked here as the softest incantation.

It would be another year before *Raising Sand* came out, and then it was amid all the fanfare of another Led Zeppelin reunion, although it would not get lost. Plant had written a line in the album credits that read: 'Gratitude to T-Bone and the Blue Glow who steered an old dog to new tricks'.

'How much Mr Burnett was able to say, "No, sing it like this," I don't know,' says Benji LeFevre, Plant's old friend and sound engineer, laughing at the thought. 'I'm sure that he did but I'd loved to have been a fly on the wall at those sessions. Either way, it was the first thing Robert had done since Zeppelin that really blew my socks off.

'It was like he'd found something at last. He'd had the courage to sing songs that were in the range of his voice now, because he can't do that wail any more, and he sounded fantastic.'

'Making that record was incredibly nerve-racking,' Plant told me. 'Because the challenge of it was just that, can an old dog ever really learn new tricks? Hey presto! I was born again.'

20

GONE, GONE, GONE

What better way to sign off? Twenty million applications for tickets.

In 2007 pop culture's Richter scale got nudged hard and often. By the unveiling of Apple's iPhone and the 400th episode of TV's *The Simpsons*. Or by Spanish actor Javier Bardem's Oscar-winning portrayal of sadistic killer Anton Chigurh in the Coen Brothers' film *No Country for Old Men*. From music there was the rise of Amy Winehouse and a spate of reunions by British groups – the Police, the Spice Girls, Pink Floyd at London's Live Earth concert, and also Led Zeppelin.

Of them all, Zeppelin's comeback had the most seismic impact. The band's return for a single concert at London's O2 Arena at the end of the year sparked an almighty scrum for tickets, many millions around the world entering an online ballot for the 18,000 available. The gig itself was a worldwide news event. Zeppelin's myth had inflated exponentially in the two decades since Live Aid and the Atlantic Records concert, the memories of those rotten performances all but forgotten. Having once been reviled by

critics, they were feted now as one of the greatest rock bands of all time, if not the greatest.

In that intervening period nothing had served to burnish the band's aura more than Plant's repeated refusals to regroup with them. The more he put it off and the longer Zeppelin remained silent, the more substantial they seemed in hindsight. Of course, bringing a version of Zeppelin back to life was one thing, living up to a legend quite another.

The challenge of doing so was the furthest thing from Plant's mind as 2006 slipped into 2007. Having completed work on *Raising Sand* with Alison Krauss he went home to the Midlands and resurrected another of his former bands, although the Honeydrippers came back without fanfare for a couple of concerts in the Black Country. The first of these, at Kidderminster Town Hall in December 2006, Plant had organised to raise money for one of his neighbours to have life-saving treatment for a brain tumour. Two months later the band played JB's club in the town of Dudley to mark the 60th birthday of Plant's long-serving sound engineer Roy Williams.

Plant had called up his former guitarist Robbie Blunt as well as Andy Silvester for these gigs, both of them members of the original Honeydrippers whom he had toured with in 1981. The line-up was completed by keyboardist Mark Stanway, a friend of Plant's who played in a local rock band, Magnum, and a rhythm section made up of two part-time musicians whom he knew from his village pub. There was a familiar ring to how Plant prepared this group. Rehearsals took place in the barn adjoining his house, the set of vintage rock 'n' roll and R&B tunes they worked up pulled from his record collection.

At the Dudley gig Jeff Beck turned up to do an unannounced opening slot. Just like the previous date in Kidderminster, the

venue was heaving that night and the vibe intended to be knock-about, although Plant's idea of such things extended only so far.

'Robert wasn't all that chuffed after the JB's show,' reveals local journalist John Ogden. 'He didn't think it had been good enough musically and he was a bit grouchy about the band not hitting the standard he'd expected.'

'The size of the audience doesn't matter to him but it's got to be of a certain quality,' agrees Mark Stanway. 'Robert's got too much of a reputation to protect. He's a perfectionist and he'll let you know if it's not what he wants – straight away. Robbie, Andy and I are long in the tooth now, so he was never on our case, but bear in mind that the bassist and the drummer weren't pros.'

Plant remained sequestered in his Midlands sanctuary as winter turned to spring. He cajoled Stanway, Blunt and also Roy Williams into joining him in another of his local endeavours, the team he entered for his village pub's weekly quiz night.

'There was us, a table of regular guys from the pub, and a team of women that won the quiz every week,' Stanway recalls. 'If the question was on football or music, Robert was the man. He's got such a wealth of knowledge of pre-'65 music. He can name all the players in each band and every B-side. Although oddly, he can't remember a single word of any song he has to sing. Everything has to be written down for him. He's got a hell of a library stashed out at his house, too, all the original classic sides. It must be worth a fortune.

'One week, I remember there was this question: "If you add up the numbers on a roulette table, what do they come to?" The answer is 666. I just happened to know that and wrote it down straight away. Robert went, "Really? I've got to tell the Dark Lord!" Next thing, he's got his mobile out and he's on the phone to Jimmy Page.'

Plant and Page were already in touch about another matter, that of Led Zeppelin's return. Ahmet Ertegun, their champion at Atlantic Records from 1968, had died the previous December following a fall backstage at a Rolling Stones concert in New York. The eighty-three-year-old's widow, Mica, intended staging a tribute show in her late husband's honour and asked that Zeppelin headline it. Even in death Ertegun's influence was enough to persuade Plant to do things others could not.

To begin with the band's principals envisaged doing something as terse as their previous comeback sets had been, a handful of songs and off. They got together in London that June for a first rehearsal, Jason Bonham again joining them on drums. Plant, Page and Jones had rust to shake off, but the younger Bonham had an encyclopaedic knowledge of Zeppelin's and his father's work.

'I've known Jason since he was 18 months old, when his dad and mum were living in a caravan,' Plant later told Phil Alexander of *Mojo*. 'We go back a long way. He came to the rehearsals without any of the trappings, except for the fact that he's historically obsessive, which to me is such a yawn. I mean, who cares what the fuck the difference is between night one somewhere and night two somewhere else? You just play it and then go away.'

Plant fled such irritations later that month, taking off with his Strange Sensation band for shows around Europe and North Africa. After these were done he called time on that particular group. He might then also have reflected on how he had never been able to do the same with Led Zeppelin.

* * *

The O2 show was announced on 12 September 2007 and originally scheduled for the end of November. The following month *Raising Sand* was released. Expectations for it were slight, a measure of Plant's standing at the time being the fact that it was almost cursorily, though positively, reviewed in *Rolling Stone*. The magazine afforded it the same amount of space as records by the Senegalese singer Youssou N'Dour and an American indie rock band, Les Savy Fav, focusing much more on the Eagles' first new album in twenty-eight years and on Radiohead's *In Rainbows*.

Raising Sand eclipsed both of those records. It entered the US and UK charts at Number Two and by the end of the year had sold over two million copies, driven as much as anything by the old-fashioned phenomenon of word of mouth. Plant had not enjoyed a success like this for more than twenty years and he was as surprised by it as anyone. Zeppelin's rehearsals for the O2 show had been ongoing and the idea had expanded to it being a full-blown set. There had also been discussions about a tour.

Yet if Plant had been hedging his bets to begin with he was soon enough resolved as to what to do – and not just by the acclaim being heaped upon *Raising Sand*. Within the Zeppelin camp old tensions had resurfaced. He and Page were bickering over the proposed set list, and the prospect of there being greater riches to follow had lent the whole enterprise an unsavoury edge.

'The early days were very hush-hush. Other than the band and the crew there was no one else about,' says Roy Williams, running the sound at rehearsals and later the O2 gig itself. 'When they decided to do a full show that all changed. Not among the group, but the various managers started coming in and vying for position. Part of that was that Bill Curbishley had once managed Robert and Jimmy, but Jimmy had now moved to another company, Q-Prime, with Peter Mensch.

'I remember driving past Wembley Stadium with the crew one morning and one of the guys said, "This time next year we'll be in there." I was thinking, "I don't know about that." With Robert the nature of the beast is to be inquisitive.

'Alison Krauss once said she got scared whenever he went into a record shop because she didn't know what he was going to come out with or be thinking. That's what he's all about – he pursues music a little bit further. Like when he and Jimmy worked with the Moroccan musicians, that was more at Robert's instigation.'

'Robert really, really didn't want to do that reunion,' says Benji LeFevre. 'He called me up about it several times. Reading between the lines and through the conversations that we had I could tell he was apprehensive about it before they even got together. Then there were things that happened in the run-up to the gig that were just so predictable. But what better way to sign off? Twenty million applications for tickets.'

As the O2 date loomed and rehearsals for it became more intense, Plant had to go off and promote *Raising Sand*. The success of the album had placed more demands on his time and this added to the tension surrounding the Zeppelin reunion.

One man, at least, was happy. More than four years since he had first approached Plant about it, TV executive Bill Flanagan got to make his *Crossroads* show for the country music channel CMT. Plant and Krauss filmed this in Nashville in the run-up to the record's release, although it wouldn't be screened until early the next year. For the taping the two of them and T-Bone Burnett assembled the full *Raising Sand* band, adding a third guitarist to it, Buddy Miller. The subsequent performance was striking, musicians at the top of their game combining with two outstanding singers whose voices entwined as if made for each other.

It peaked with two Zeppelin songs, 'Black Dog' and 'When the Levee Breaks', both of which were stilled and made into gothic country blues. Krauss sang the latter as a mournful lament, Plant retreating to the shadows and plucking at a guitar. 'Black Dog', with the two of them singing together, was entirely remade, the stripping away of its musical bombast locating something desperate and menacing at the heart of the song. It was now about unrequited lust and pitched like a murder ballad. In a way he was not able to do working with Page on either *No Quarter* or *Walking into Clarksdale*, Plant could dip back here into his past and unshackle himself from it.

'It was a great show, and we had an interesting opportunity to see the Nashville audience's reaction and their kind of awe,' recalls Flanagan. 'Though at the beginning of the taping there might have been too much awe, since people were sitting there like they were in a cathedral on Christmas Eve.

'Thing is, Nashville is a whole town devoted to music, and if you're 25, 35 or 45 years old and a music fan, you've listened to Led Zeppelin and Robert Plant. When Robert walks in the room, it's like Jesse James going into the saloon in Tombstone. Just going out to dinner with him in Nashville, people were falling over themselves.'

'Robert's voice had changed drastically,' adds Plant's friend and neighbour Kevyn Gammond. 'That wailing for the Devil had quietened down. When he was working with Alison Krauss, people down our local pub would say to him, "Oh, we like this song and that song, Robert." They all probably hated Zeppelin.'

Within a month, however, Plant was expected to be wailing for the Devil again, handcuffed once more to Zeppelin and all that he had been almost forty years ago. For him, Page and Jones

to be able to re-create that image of themselves seemed an impossible conjuring trick, one they had twice before failed to pull off when they were two decades younger.

The suspicion that each of Zeppelin's three originals was finding the task onerous was strengthened at the start of November, when the O2 show was postponed for a month. The reason given for this was that Page had fractured a finger. Perhaps all too conveniently, this bought them more time. And as if Plant's emotions were not mixed enough with all that was going on, he had also learned that his friend and assistant 'Big' Dave Hodgetts had been diagnosed with terminal cancer and given just weeks to live.

The vacuum before the gig was filled by Atlantic's release of a Zeppelin compilation album, *Mothership*, which sold well. In the week leading up to the show Zeppelin staged a full dress rehearsal at the O2. This calmed nerves. Plant's voice had warmed to the job. He had also been judicious in fighting his corner over the set list, refusing to do songs like 'Immigrant Song' or 'Achilles Last Stand', the highest registers of which he fought to reach. The band had gelled, too, the extra weeks having been put to good use.

'The other three weren't happy initially that I'd missed those rehearsals,' Plant told Q magazine later, 'but it was actually a good thing. It gave them the chance to get used to playing together. So from everybody's point of view things worked out perfectly.'

When the day of the gig finally dawned, 10 December, it did so grey and chill. Plant had invited Alison Krauss to London for the show but she had declined, instead giving the ticket to her elder brother Viktor. Plant had also arranged for the ailing Dave Hodgetts to be flown down to London and be sat at the mixing

desk in the O2. It was otherwise a night on which Plant wanted to at last put ghosts to rest.

There were several other acts on the bill for the concert, former Rolling Stone Bill Wyman, ex-Free and Bad Company singer Paul Rodgers and the Who's Pete Townshend among them. Few, if any, of the 18,000-strong audience were there because of them and not even a trace memory of their performances lingered. For those picked out from the online lottery and paying £125 each for a ticket the show was only ever about Led Zeppelin and the measure to which reality stacked up to myth.

In the immediate build-up to the band's set the backstage area was cleared of people, the warren of corridors, catering rooms and production offices silenced. In their respective rooms Plant, Page, Jones and Jason Bonham were left alone with their thoughts. His mind made up that this would be the last full show he would ever do with Led Zeppelin, Plant paced and fretted. Good would not do it. He had to not just meet expectations but to transcend them.

Minutes before going on the four of them gathered in the corridor leading to the stage. They shared a brief, awkward embrace. Out front the audience was being shown a short film that compiled moments from Zeppelin's heyday, flickering images of them as they once were. Building up from a low rumble to a sustained roar, rolling from the back to the front of the arena, the charged atmosphere was lit by this and then exploded as the stage lights went up.

During the next two hours, through a sixteen-song set and willed on by the crowd, Led Zeppelin flew again. There was something almost heroic about it, watching as this battle against the ravages of time was fought and won. They started cautiously,

edging their way into 'Good Times Bad Times' and 'Ramble On', the three principals all dressed in black. Lift-off came with 'In My Time of Dying', Page's bottleneck guitar still vicious, Plant gone off to some other place, his voice rising up from the depths of the song. A furious 'Trampled Underfoot' came next. Then a brutish 'Nobody's Fault But Mine', followed by 'No Quarter' and 'Since I've Been Loving You', each as imposing as the other.

Only 'Stairway to Heaven' seemed shrunken. It came just over half way through the set, Page not quite nailing the intro and Plant still unable to give his all to it. In any case, it was 'Kashmir' that defined them now. Greeted with the loudest roar of the night, it sounded ageless. 'Whole Lotta Love' was next and then the closing 'Rock and Roll', the admirable Jason Bonham hurling the band into it, the crowd left drained but exultant.

Standing outside the arena after the gig, Dave Grohl ran up to me and put me in a bear hug. I had met him just once before, not long after he had started Foo Fighters, and we had spoken briefly then, but he barely knew me. It was that sort of night. Grohl had flown in from his home in Los Angeles that morning to see the show and was returning the next day. He was effusive, though, suggesting this had been one of the great nights of his life.

'It was one of the best concerts I'd seen Zeppelin do,' insists the DJ Bob Harris, who had first seen them in 1971. 'They were so clear and focused. I know that weeks of work had gone into it, and that Robert had been completely insistent about that being the case.

'Watching him come back on for the encore and seeing all hell was breaking loose in the audience, I thought, "Whose head would not be turned by this moment?" I caught up with Robert a few days later and said to him that surely now he'd do a reun-

ion tour. He said no and asked why would he, because to him it had been all about revisiting something that had passed and not a new experience.'

Not that everyone had been convinced. Benji LeFevre, twenty-seven years after he had last managed Zeppelin's sound, found himself at the O2 marvelling at the audience's reaction but not the show itself.

'I didn't think it was particularly terrible or brilliant,' he says now. 'It was too loud and there was too much feedback during the first half. The physical reality is that Robert can't hit the high notes any more, so it wasn't even a facsimile of what it used to be.

'I'd be very, very surprised if they ever did it again. The honesty with which Robert opened his arms at the end of "Stairway to Heaven" and said, "We've done it for you, Ahmet" – I think that was probably a great personal moment for him. It might have been the point at which for him it was all neatly tied up and filed away.'

For all the big musical gestures it was smaller moments like this that spoke loudest that night. Such as the smiles and eye contact that passed between Plant, Page and Jones, caught on the stage screens and communicating joy, relief and the knowledge of all they had shared but also endured. Or being sat at the side of the stage and watching as Page was led down the steps from it at the end. Soaked in sweat, his shoulders hunched, he had nothing left to give. This was to witness the curtain pulled back, revealing what just one performance had taken out of the sixty-three-year-old.

At the climax of the show, Plant's first thought had been for his friend Dave Hodgetts. As the last notes of 'Rock and Roll' were still fading he peered into the darkness and asked, 'How was it, Dave?'

'That was a special moment,' recalls Roy Williams, who was standing beside Hodgetts on the mixing desk. 'When he said that, I saw Dave's two thumbs going up. That probably says more about the man than anything else. The fact that with all that was going on around him, in that few seconds he'd thought of his mate. It was a week later that Dave passed away.'

Soon the backstage corridors filled with friends and revellers. Plant slipped through this throng, got in a car and drove off to a kebab shop in North London, leaving it all behind.

In the immediate aftermath of the O2 gig there was the sense of something special having happened, and then mounting speculation that the band would announce further shows in a short time. This never came to pass, although Page, Jones and Bonham were convinced at first that Zeppelin was going on. At one stage plans had been laid for a thirty-date world tour, gigs pencilled in for London, Paris, New York and Los Angeles, as well as Australia, New Zealand, India and China.

'Some of us thought that there would be more concerts in the none-too-distant future,' Page told David Fricke of *Rolling Stone*. 'I know that Jason, who had been playing with Foreigner, resigned from that band. But Robert was busy.'

For a time Page, Jones and Bonham continued to work together, attempting to write new material. They considered finding a new singer, going so far as holding auditions, Steven Tyler of Aerosmith being one of those who was tried out. Common sense won out, however, and the plan was abandoned. Plant was long gone by then, off with Alison Krauss and down the road ahead.

'The O2 was great for Bonzo's mum and for Jason, and for the rest us to put our shoulders back once more,' he told me. 'It was

good but that was because we didn't have to look at it twice. It didn't come around every summer, or end up as background music for picking out the balls on the National Lottery and all of that old bollocks.'

The dust from Zeppelin's comeback having settled, Plant and Krauss began a tour together in Louisville, Kentucky, in April 2008. In all they played forty-four shows in North America. These gigs followed the pattern of their *Crossroads* performance, picking out the highlights of the *Raising Sand* album and other country standards, recasting Zeppelin songs such as 'The Battle of Evermore' to fit the same mould. The tour crossed to Europe that May for a handful of dates, among them a sell-out at Wembley Arena in London, before returning to the States for more shows in the autumn, the last of these being in Saratoga, California, on 5 October.

On the tour Plant formed a close bond with guitarist Buddy Miller. Born in Fairborn, Ohio, in 1952, Miller had been playing in bluegrass and country bands since high school. A musician's musician, he had toured with Emmylou Harris, Steve Earle and Linda Ronstadt, releasing several decent solo albums and also producing records for soul man Solomon Burke and the country singer Jimmie Dale Gilmore. Plant seemed at ease with the world. He enjoyed being able to share the spotlight with Krauss and sang beautifully.

'Robert came to do a show in New Jersey where I'm now living,' recalls Dennis Sheehan, Plant's assistant during the late '70s. 'It was one of the best shows I've ever seen and he appeared to me to get so much joy out of it. He didn't look as if he was under any pressure.

'We met up beforehand. Robert's a tall guy but he was stooping. I told him he looked like an old man. He said he'd gotten a

bad back from being sat on a tour bus. I did wonder what the hell he was doing on a bus when he could fly. He told me that country folk still tour on buses and he didn't want to feel like he was doing something different. He said, "It'd be like I was showing off all my money."

'That's one great thing about Robert, he knows the reality of being very wealthy but he's remained down to earth. At heart he always will be the proverbial hippy.'

'Alison's a lovely lady but also an absolute hoot,' says Roy Williams, sound engineer for the tour. 'The one thing us guys on the crew all said was that we wished she'd project that side of her personality a little bit more at the gigs, rather than being demure.

'She used to do an a cappella thing during a song called "Down to the River to Pray", with her, Robert and the band all stood around one microphone. I remember the first open-air show they did, the New Orleans Jazz Festival, hearing silence sweep across a crowd of 60,000 or 70,000 people. That was something quite special.'

Plant had invited another of his old friends, Bob Harris, out to see him and Krauss perform in New Orleans in the spring of 2008. Harris and his wife were then celebrating their wedding anniversary, and Plant insisted on taking them out on the town afterwards. On the drive back into the city from the festival site, the early evening air hot and sticky, Plant spotted an old road-house bar, the Mother-in-Law Lounge. It had belonged to the late R&B singer Ernie K-Doe and was named after his Number One hit of 1961.

'Robert wanted to go in but the place was locked up,' remembers Harris. 'We all of us hammered on the door for a couple of minutes. Eventually, this tiny little black woman in her 70s

opened the door, Ernie K-Doe's widow. She'd got a wig on that was lopsided and seemed entirely nonplussed by our arrival.

'She put the lights on and went behind the bar, stood with her back to us fixing drinks. Robert started telling her how amazing it was to be there, because he used to practise singing to her husband's records, doing the classic hairbrush in front of the mirror pose. He said it was through her husband's music that he'd started to sing. Finally, she turned round and said, "Well that's real nice, honey. Do you still sing?" Robert said, "Yeah, every now and again."'

JOY

———

***I think it's all down to the way
the coke was cut in the '70s.***

Robert Plant had never paused much to celebrate, wanting to be on the move and doing. Yet he made an exception for such things during the summer of 2008 and also into the next year. That August he turned 60 and marked the event with a party. The nature of this said much about him. It was no glittering occasion but rather an informal get-together for family and friends held at his village pub, the Queen's Head.

Plant arranged for a marquee to be erected in the pub's beer garden, in which caterers served a buffet of Indian food. His three children were there and also his ex-wife, Maureen. Among friends present were the DJ Bob Harris, his former Band of Joy guitarist Kevyn Gammond, and also Perry Foster, who had taken the teenage Plant on as singer with his Delta Blues Band as far back as 1964. The American blues musician Seasick Steve turned up and so did Lenny Kravitz, his band's large tour bus getting stuck in the narrow country lanes leading to the pub.

This being British summertime it poured with rain, but Plant had hired a couple of stand-up comics for the occasion and they kept spirits high. Frank Carson, the late Irish comedian, based his routine on Plant's perceived tightness with money. Plant, he said, had paid for him to stay at a three-star hotel. 'Sure enough, as I was lying in bed last night,' he concluded, 'I could count three stars through the hole in the roof.' Plant laughed louder than anyone else.

'These days, Robert has mellowed entirely,' reflects Perry Foster. 'He's still got a bad back and he walks with a bit of a stoop. His face looks a bit lived in, too. At the party I told him, "I know just the thing for you, Bob – why don't you go off and get a facelift?" He jokingly told me that he'd just had one.'

The weekend before his 60th bash Plant accepted an invitation to become an honorary Vice President of Wolverhampton Wanderers, the football team he had supported for fifty-five years. His fellow Vice President, Steve Bull, a former Wolves player and England international, recalls Plant turning up to the first game in his new role.

'The job is to be an ambassador for the club, to meet and talk to people in the executive boxes at the ground on match days,' explains Bull. 'We're supposed to come to the home games in a suit but Robert rolled up in his jeans, his hair tied back and with an old satchel slung over his shoulder. He said, "That's me, I'm not going to change." He's a scruffy git but underneath that a top man.

'He tends to let me do most of the talking. He's quite a self-contained person, keeps himself to himself. He's very opinionated about football, though. He calls me at home to talk about every game. I can get through a full bowl of spaghetti while he's ranting on; I just put the phone to one side on the table and let him get on with it.'

The following July Plant was made a Commander of the British Empire for his services to music, attending a ceremony at Buckingham Palace in the presence of Prince Charles. At this time I was Editor of the British music magazine, Q. Later that year I asked him to accept an Outstanding Contribution to Music honour at the magazine's annual awards in London. He told me that such garlands made him uncomfortable since they suggested he had died, but he agreed nonetheless. On the day itself, a frigid October's afternoon, he was the centre of attention and it clearly fitted him well.

Turned out in a maroon suit for the event, which took place at the Grosvenor Hotel on London's Park Lane, Plant held court. In the hotel's ornate ballroom, younger acts such as Arctic Monkeys and Muse flocked to his table, sponsors and fellow guests queued up to shake his hand and have their picture taken with him. He obliged them all, eyes twinkling and always ready with a joke at his own expense. Bob Harris and members of the Tuareg band Tinariwen presented him with his award, the prelude to which was a film of Plant through the ages, as rock god, pop star and now the singer of haunting country songs.

'In 1963,' he began his acceptance speech, 'most bands passing through my town worked off the same sheet – Chicago R&B and early Motown identikit – packed with mail-order arrogance and a taste for our local girls. No social commentary, just cash and penicillin.

'One day, the singer in a school beat group got sick and I stepped in. Singing the songs was OK – what do you do with yourself during the guitar solos? Stare at your shoes and think of Elvis, or preen? What a blast. I was in heaven and ignored with a vengeance.

'Well, time passes, creating shapes whilst styles and fashions come and go, nothing too self-conscious, blissfully slogging on through the blacked-out worlds of Mods, Rockers, beatniks, the ludicrous elite and the hazardously psychedelic. Then one day all the walls, the doors and the floor dissolved. The Pan Am airliner taxied to a halt. The door flew back to reveal a subculture of wild, vulnerable, joyous, pained messengers, shamen, antichrists and hustlers, genius and trash. All ministered by a support system of bogus medics, seers, cheap perfume and sweat: vivid, glorious and now all but gone.

'The world is smaller now and a new world of music continues to confirm its beauty. Africa, for example, now telegraphs its distress, its anger and its corruption to a universal audience, as did the far-off prophets Lenny Bruce, Dylan, J. B. Lenoir and Billy Bragg.

'Down the years, as much or as little of this whirlwind has been mine to connect with. I have drawn a beautiful wild card that enriches my days and allows access to all the worlds of music and people and energy. A card for naïvety, a card for learning and a card for saying thank you.'

With that, and to a hushed room, he thanked those he said had helped him along the ride. They included Page, Jones and John Bonham, Elvis Presley, Howlin' Wolf and Arthur Lee. He mentioned Ahmet Ertegun, Peter Grant and Zeppelin's former tour manager Richard Cole, Sandy Denny and Alison Krauss, too. He also referenced the old Welsh rebel king Owain Glyndŵr, Stourbridge Town Hall and the Chicago Plastercasters. Last of all he thanked the Dansette Conquest Auto, his first record player, bought for him by his parents in the far-off mists of 1960.

* * *

Plant was not given to reflection, however, nor was he idle for long. Earlier in 2009 *Raising Sand* had won a Grammy for Album of the Year, beating off Coldplay and Radiohead among others. Plant, Alison Krauss and the record's producer, T-Bone Burnett, attended the Grammy Awards ceremony at the Staples Center in Los Angeles that February. By then they had begun having discussions about making a follow-up album but these had not progressed far.

'T-Bone hosted a dinner after the Grammys and was nice enough to invite me,' recalls VH1 executive Bill Flanagan, who had first put Plant in touch with Krauss. 'The three of them were hanging out and talking about the fact that they were supposed to have started a second record. It felt as though each of them thought it, but no one wanted to actually say that they'd captured lightning in a bottle, and did they really want to try to do that again. Earlier that day, T-Bone had said to me it might be better if he just produced a record with Alison, one that didn't have that weight of expectation on it.

'I also think that each of them felt that he or she had bent a little to accommodate the others on *Raising Sand*. With the next one, each of them wanted to do it more their own way. You get three people thinking that, then it's going to be so much harder to pull together.'

Burnett was leaning more to repeating the *Raising Sand* formula, and he was Krauss's preferred producer, although she was set on a less antiquated sound. Plant was angling for change, too, suggesting a broader range of material and also working with a different producer, Daniel Lanois.

'Alison and I were thinking of contemporising our thing really quite radically,' Plant told me. 'I said we had to find some-one that was crazier than us and really nuts for music, and Daniel

Lanois was that guy. Alison went to see him separately. I wanted to do my own thing.

'I knew that Dan was so driven. He'd just then done an album with Neil Young, *Le Noise*, and everyone was telling me that I wasn't going to believe it when I heard it. They said he'd really put Neil through it. But then, Neil needed to get on the fucking programme. We all do, otherwise we'd end up at the Playhouse in Nottingham.'

It was Krauss who eventually pulled the plug on the project, stating there was nothing wrong with killing the goose that laid the golden egg. Plant agreed and they parted amicably. She went back to her band, Union Station. With them she released a new album in 2011, *Paper Airplane*, a critical and commercial success, although T-Bone Burnett was not its producer.

Plant had been spending more time with Buddy Miller, guitarist in the *Raising Sand* touring band, at his home in Nashville, where he lived with his wife, the singer-songwriter Julie Miller. An avuncular man, Miller shared with Plant a dry, sardonic sense of humour and also a boundless curiosity about music. The two of them had started sifting through songs, looking for different things to interpret. These days Plant showed little inclination for writing new material.

'I gave up writing,' he later told Stephen Rodrick of *Rolling Stone*. 'The last time I lifted a pen was when Tony Blair became a Roman Catholic. Soon I'm going to need help crossing the street.'

Plant asked Miller to help him put a band together, the two of them recruiting from the cream of Nashville's session players bassist Byron House, multi-instrumentalist Darrell Scott and drummer Marco Giovino. Looking for a vocal foil to replace Alison Krauss, and at Miller's suggestion, Plant called up Patty Griffin. A

fine singer-songwriter, and also an accomplished pianist and guitarist, the forty-five-year-old Griffin had started out performing in coffee houses in Boston as a teenager. She had released her first album, the acoustic *Living with Ghosts*, in 1996. Four more records followed, each corralling together her country, folk and gospel influences, and establishing her as a formidable talent.

Towards the end of 2009 this group began rehearsing in Nashville. Plant had put together three CDs of material that he and Miller had picked out, asking the others to learn the songs in advance.

'It's all really in the seeing what happens,' Plant told me when I asked how he went about starting each new adventure. 'I'm a singer. I don't have any of the problems that musicians do – I can try things with people and if they don't work out it's not too bad. I don't walk in a room with the sort of huge historical reference that Clapton had, when it was "Eric Is God". Imagine having an off night with that.

'I just stay close to kindness and really good people. You can afford to be naïve and out of place, because everybody comes to meld in. That's what happened with this group. There was so much apprehension in the room but within four hours everybody's shoulders were as low as they could possibly go and we were playing in a very special way. It's a great band and it's all Buddy's doing.'

'At that time Robert wasn't thinking of doing anything definitively,' explains Marco Giovino. 'He just wanted to go into a room and see what happened. He'd picked out a bunch of songs, old folk and mountain tunes. We ran through them, deconstructing them and adding alternative instruments, giving them legs. After a week he turned to us and said, "Well, fellas, I guess we're making a record."

'Buddy was absolutely his musical director. A lot of their musical paths crossed. The two of them have a deep love of the stuff that happened in San Francisco in the '60s and psychedelic music in general, bands like 13th Floor Elevators. Robert definitely has an idea of where he wants something to go, though, and how it should sound. And if he can't physically play that on guitar he will sing it to you.'

To make the album the band hired the singer Gillian Welch and her partner David Rawlings's studio in Nashville, the two of them charging Plant a negligible fee. It was a big room, wide and with 25-foot-high ceilings. In keeping with the spirit of the songs, Plant shunned digital technology, recording instead the old-school way direct to 16-inch tape. He referenced his own past, too, giving this new group and also their record the same name, 'Band of Joy'.

It proved to be Plant's second great album in a row, although it didn't have the surprise factor of *Raising Sand* or that record's extra dusting of magic. Like it, *Band of Joy* conjured a singular mood, this one melancholic but tinged with hope, the atmosphere it suggested being that of a Deep South town in the dead of a hot summer's night, the crackle of neon and the buzz of fireflies.

The songs ranged from such archaic pieces as the traditional song 'Satan, Your Kingdom Must Come Down' and an Appalachian folk ballad 'Cindy, I'll Marry You Someday', to more contemporary selections such as 'Angel Dance' by the LA-based Tex-Mex band Los Lobos, and a brace of brooding tracks by Minnesota drone rockers Low, 'Silver Rider' and 'Monkey'. Plant sang with restraint and assurance, his voice slipping in to each song as if it were a favoured old suit.

'On a practical and absolutely workmanlike level I've learned more in the last five years about what to do and not to do than

at any point,' he told me at the time. 'People say I can't sing "Immigrant Song" any more. That's bollocks, I can, but it'll take me a couple of weeks to get my register open like that again. The point is that singing is about all aspects of the weather, all of the gift. Both these women, Alison and Patty, have taught me that.'

The ebb and flow of music being cyclical, *Band of Joy* fell in with one of the strongest currents of the time, a shift towards more rustic and traditional sounds. Bands such as Fleet Foxes, the Black Keys, Band of Horses and Midlake had risen to prominence in America, each of these groups delving back to the roots of rock, blues and folk to fashion their own thing. In Britain the band Mumford & Sons and a teenage singer-songwriter, Laura Marling, were fronting a new folk movement. Longer-in-the-tooth songwriters such as Tom Petty, John Mellencamp and Elton John, in partnership with Leon Russell, had also made records that looked to an earlier era for inspiration, acting their age and sounding all the better for it.

Plant was on a creative roll and he found himself back in step with the times as well. Released in September 2010, *Band of Joy* was a Top 5 record in the US and the UK. It was preceded by a series of low-key theatre dates in the States and a one-off show at a 2,000-capacity venue in North London, the Forum. This last show was among the very best Plant had done in years, singing with relish as his band painted a vivid, changing musical landscape peppered with rock, blues, folk, country and gospel landmarks.

Plant also handed the group songs from his solo career, such as 'In the Mood', and Zeppelin standards like 'Tangerine' and 'Houses of the Holy', to have them recast. They felt like new again, but sounded as aged as whisky matured in an oak cask. This act of transformation served another purpose, of making

Plant's own musical history seem amorphous and constantly evolving.

'We filmed that gig and, man, you should see it,' he enthused to me weeks later. 'It's one of the best shows I've ever seen. Like the Band's *The Last Waltz* but without anyone famous. I was so proud of it.'

Plant and his latest Band of Joy began a full tour in Europe that October, returning to the UK at the end of the year and then heading to North America for a six-month run from the start of 2011. I ran into him in London before the tour began, when Band of Joy were filming a performance for the BBC TV show *Later … with Jools Holland*. I had gone there to interview Adele, who debuted a new song called 'Someone Like You' on the same show. She sung it unaccompanied but for a piano, sucking the air from the studio.

After the filming Adele was standing in her dressing room, surrounded by people from her management and record companies, drinking wine from a plastic cup. Plant swept in unannounced and strode straight up to her, wrapping his arms around her and then kissing her on the cheek. 'You know, you make me very proud to be British,' he told her, beaming, and then he was gone again.

Playing with the Band of Joy he became captivated by Patty Griffin. Even before it became known that the two of them had fallen in love, it was obvious that their working relationship was different to the one he had had with Alison Krauss, less formal and much more flirtatious.

'Patty Griffin is a fantastic entity,' he told me. 'She's delicate and charming. She's a great songwriter and sings like Mavis Staples's kid sister. And she has this great Irish laugh.

'On stage, whenever I go into character and become that guy from way back,' he said, miming brandishing a microphone stand, tossing his hair back and pouting, 'she laughs so much that I have to be him all the more. So then I sidle up to her like Rod Stewart, even more of a caricature.'

'Robert always travelled on the bus with the rest of us,' says Giovino of the tour. 'The post-gig drives in America would be the most rowdy, with pretty much everyone in the front lounge of the bus, someone DJ-ing on their iPod and the wine flowing. He seemed to really enjoy it, trading jokes, ball-busting and talking about obscure bands. Though none of us would ever have to ask when his football team had lost.'

The band began the final leg of the tour in Rome in July 2011. On the morning of their show in the city Plant was enjoying a sightseeing trip to the Coliseum with Buddy Miller and Patty Griffin when he took a call from his friend Bob Harris. Having been successfully treated for cancer in 2007, Harris had just then learned that he would require further surgery.

'Robert was deeply sympathetic but he didn't overreact,' recalls Harris. 'Later, through the course of the treatment I was having, one of the doctors mentioned Robert's name. I didn't know it but he puts a lot of money into cancer research. When I went back to him about it, he just said, "I've got all this money sloshing about for Christ's sake, I may as well do something constructive with it."

'Throughout that period he phoned me two or three times a day, when he was getting on and off planes, checking that I was all right. He was determined to keep my spirits up and it was phenomenal what he did. When I got the all-clear, the second I told him he said, "Brilliant, you don't need me ringing you every day now." And that was it, he stopped.'

The Band of Joy played their last show at the Hardly Strictly Bluegrass festival in San Francisco on 30 September 2011. I had met up with Plant in London some time before this and then he had been bright eyed and full of bravado. He had come straight from one of the regular Led Zeppelin business meetings. 'Five hours with Pagey,' he said, an inscrutable smile on his face. I asked him where he saw himself heading next and he shrugged, suggesting anything was possible.

'With my career, I think it's all down to the way the coke was cut in the '70s,' he added, laughing, before becoming more serious. 'Some people think you get to my age and it's an easy option. Well it isn't, because I'm learning all the time and sometimes I fuck up really badly. But at least everybody smiles. It's not the end of the world.'

22

CODA

*It's a very different life that
he's living now.*

In February 2013 Plant gave an interview to the Australian TV news show *60 Minutes*. During this the host Tina Brown asked him about being the 'bad guy' for not agreeing to tour with Led Zeppelin following their 2007 reunion concert in London. 'The other two guys are Capricorns and they keep schtum,' he responded. 'But they're quite contained in their own worlds and they just leave it to me to do this. I'm not the bad guy. You need to speak to the Capricorns because I've got nothing to do in 2014.'

Within hours of Plant's words being broadcast, media outlets around the world were reporting the possibility of Zeppelin re-forming the following year. Yet there was no mention of a second interview he gave to Australian TV the next month, this time to the *Today Tonight* show in Adelaide. Asked if he was genuinely considering rejoining the band, Plant replied, 'Well, no. I just said I wasn't doing anything then. I would definitely rule that out. I'm up for anything that's new. Just give me a hint of something that's good fun.'

Not that it ever dulls, but interest in Zeppelin had been stirred towards the end of 2012 by the release of *Celebration Day*, the belated film of their show at the O2 Arena. The film itself was a disappointment, being nothing more than a straight document of the gig. It put neither the event nor Zeppelin into any kind of context, failing to capture the sub-plots and little intimacies that surrounded both.

Yet it was enough to reunite Plant with Page and Jones, the three of them promoting the film at screenings in New York, London, Berlin and Tokyo that October. A couple of months later they were together again. This time it was in formal evening attire to receive the Kennedy Center Honors in Washington, DC, from President Barack Obama in recognition of their contribution to American culture and the arts. In his introductory speech Obama thanked the three of them for behaving themselves, noting their history of 'hotel rooms being trashed and mayhem all around them'.

That night's tribute concert to Zeppelin featured performances from Foo Fighters, Kid Rock and Lenny Kravitz, with Plant, Page and Jones looking on. The highlight of this was an extraordinary version of 'Stairway to Heaven' by Ann and Nancy Wilson of the band Heart. Backed by Jason Bonham on drums and, as the song unfolded, also by a gospel choir and a string section, the Wilson sisters reclaimed Zeppelin's most familiar tune as a grand epic. At its end Plant was caught on camera, apparently wiping a tear from his eye.

During the London press conference to announce *Celebration Day* Plant had been testy but in all other aspects he appeared at ease with this popping back to his past. Latterly, he had seemed more reconciled with it, happy enough to revisit that time so

long as he was not expected to stay there. And happier still to be able to keep people guessing.

'The great thing is Robert can do anything now,' says Bill Flanagan from VH1, who had got to know Plant well. 'What will he do next? It could be that he's going to wet his finger, put it up in the air and say, "You know, there's a nice breeze blowing in from Africa, I guess I'll head off that way." Or then, he might think it'd be kind of fun to get up and sing "Black Dog" again.'

'I did a shoot with the three of them in New York on the afternoon of the *Celebration Day* première,' recalls photographer Ross Halfin. 'The weirdest thing was when they were walking out of the hotel at the end of that, Robert turned to Jimmy and said, "We really should do something together." Jimmy sort of dismissed it afterwards, saying he didn't mean it. But you never know with them.'

It has been more than thirty years since Zeppelin broke up but an awful lot of people still cling to the hope that they will return, most never having got to see them the first time around. But then, of course they do. In all that grainy concert footage, on the records and through the acres of print devoted to telling the glorious and gory details of their story, Zeppelin seem immeasurably bigger and better than the countless groups that have since taken their place. No matter that they are that much older now, or that one of their number is missing – even the suggestion of what Zeppelin once was would do.

This much has been – and very likely will be – unchanging. So too, however, Plant's resolve not to give himself up to it again, hardened through the years by the successes he has had on his own. The older he gets the more this appears to be the one thing about which he is intransigent. In all other aspects of his career

Plant seems forever open to change and having different experiences. To press on, as if standing still might be the death of him, forward motion being his benediction.

Towards the end of 2013 Plant parted company with his long-serving manager Bill Curbishley, replacing him with his personal assistant Nicola Powell. Although he did not give a reason, it was suggested to me by people who know both men that Plant felt that Curbishley had been too willing to push him back towards Zeppelin. Indeed, Curbishley had instigated his reunion with Page in the 1990s and he appears to have been more enthusiastic than Plant about the group coming back together to promote the *Celebration Day* film.

Plant's friend, the folk singer Roy Harper, refers to him as 'Robust Planet'. 'Robert was very wise not to carry on into a dusty, web-strewn grave,' Harper insists. 'It's not something he can recapture and all those things are not as emblematic to him as they would have been in his youth. It's a very different life that he's living now.'

In the summer of 2012 Plant formed another new band, calling it the Sensational Shape Shifters. The core of this was the same as that of his previous group, Strange Sensation. Drummer Clive Deamer having joined Radiohead in the interim, Plant brought in Dave Smith, who had been playing North and West African music for years, and added the Gambian musician Juldeh Camara to the line-up.

He debuted the band at shows in the UK and the US that July and August, his partner Patty Griffin joining them for some dates. They toured Central and South America in the autumn, Singapore, Australia and New Zealand through the spring of 2013, and the US again the following summer. This particular

collective is like a hybrid of all the music Plant has fixated on, repurposing Zeppelin songs and old blues and folk standards, mixing in the Americana influences of his most recent records and also the very differing sounds of North Africa and '60s psychedelic rock.

Although there were no original songs in their sets their feel was fresh and unpredictable, the heat of reinvention warming them. Plant delighted most of all in overhauling the Zeppelin canon. In these hands 'Black Dog' became a desert blues, 'Heartbreaker' like a '90s techno track and 'Gallows Pole' music for a whirling dervish.

For the first time in nearly a decade Plant has also been writing songs, and with different people again. During the last couple of years he has worked up a bunch of material with guitarist Buddy Miller and another of his last Band of Joy musicians, drummer Marco Giovino.

'I'm in touch with Robert a lot, and six months after the Band of Joy tour ended we began trading ideas back and forth,' says Giovino. 'Not long ago we met up at Buddy's house here in Nashville. I'd sent Robert some drum loops that I'd made up at home and he'd been jotting down ideas to go with them.

'It's definitely different to the Band of Joy record, rockier and with more of an edge to it. I was witness to a lot of what Robert's writing about while we were on the road because he's talked about his relationship with Patty on a couple of the songs.'

Added to this Plant and Patty Griffin have been writing together. One of the tracks resulting from this, 'Highway Song', appeared on Griffin's excellent *American Kid* album of May 2013 and Plant sang on another, 'Ohio'. Both songs are bare, gentle and graceful, with Plant's voice whispering through them like the wind. 'We each have similar places we come from as singers,'

Griffin told *Billboard* at the time of its release. 'He inspires me. He goes far and deep.'

Plant has taken the Sensational Shape Shifters into the studio, too. He intends releasing a new album in 2014. The measure both of how far it is that he ranges and how freely he roams is that he could make this record with this band, or with the Band of Joy or Patty Griffin, or with someone or something else. Likewise, there are no boundaries to its musical remit; it could just as easily head for the Appalachians or the Sahara again as another place entirely.

Fifty years since he first started singing and performing in bands Plant still so obviously gets off on music, and he continues to cast around for different ways of experiencing it. These other ongoing projects aside, in the last year or so he has also sung with the Texas-based folk singer Amy Cook on a track titled 'It's Gonna Rain' on her *Summer Skin* album, and on the British rock band Primal Scream's most recent record, *More Light*.

'This is what knocks me out. There are a just a handful of people that have had the experience and accomplishment that Robert Plant has had,' says Flanagan. 'There's thirty, forty, at tops fifty of them in the world in that pantheon. First of all, most of them are smart because you don't survive if you're not. The dumb ones have either died or gone bankrupt. But usually, the passionate love of music that got them there in the first place has cooled.

'Success sidetracks people in a lot of different ways, not all of them bad. It's not just that they get greedy and have to support their six mansions and their private planes, running off with groupies and getting divorced. People also get pulled from music by doing charity work, making movies, writing books and collecting art. You very, very rarely meet someone like Plant,

who is still just as fanatical about music after forty years at the top. That's almost unprecedented.'

Robert Plant turned 65 in August 2013. In his home country he is now eligible for a bus pass and a state pension. In many respects he seems both settled and content. He and Patty Griffin divide their time between his homes in England and Wales and Austin, Texas, where Plant rents what he described in an interview with the *Independent*'s Tim Cumming as an 'an old crack house'.

In Texas Plant and Griffin are regular faces at Austin's many fine blues and country-music venues. Back in the Midlands the two of them are just as likely to be seen together in Plant's village pub or of a morning in the local coffee shop. Plant's friend and neighbour there, Kevyn Gammond, recalls spending Christmas 2013 with the pair of them. He and Plant bought each other the same gift, a box set of 1950s films featuring the British comic actor Leslie Phillips.

'Phillips is one of Robert's great heroes,' Gammond reveals. 'At one time he used to check into hotels under Phillips's name, and Robert had got him to sign my collection for me. We were sat there, exchanging these presents and enthusing about Leslie Phillips, and Robert looked at me and said, "So, it's come to this."'

And yet, however grounded Plant has appeared to remain, however everyday his foibles, his is not a normal life, at least not in the sense the rest of us would define normal. He has been a rock star since he was nineteen years old, fêted and fawned over for all of his adult years. As recently as May 2013 he was forced to take out a restraining order against a female fan, Alysson Billings, who he said was obsessive and allegedly believed she was having a relationship with him. The website TMZ.com reported that in court papers, Plant had alleged that Billings had

bombarded him for three years with gifts and messages, her entreaties taking on a darker turn when he began dating Patty Griffin. 'Your betrayal with another woman still stabs my mind,' she is said to have written him. 'She's got you so pussy-whipped and henpecked, it makes me want to puke.'

Then again, he has seen and tasted more than most people ever do, although none of this has inured him from the dreadful pain of loss. That ache and those memories are anchored to the very depths of his soul. Perhaps it has been this that has kept him going on, heading for the light of the new and in doing so keeping out of the shadows.

He admitted as much when speaking to Mat Snow of *Mojo* magazine in 1994. 'I've lost too many people around me to even see any empty spaces,' he said. 'I know there's emptiness in my heart but I fill up the places.'

The journey he has followed through music has been remarkable, and not just for the heights he has gone to with Zeppelin or the fact of him standing tall on his own. It is more that he is still curious, still questing, still wanting to be challenged and surprised. This, at a time when almost all of his peers have accepted their lot, stopped asking or reaching for more, nothing left to do but wait for their dotage.

Looking for parallels one could point to Johnny Cash, who managed such a great late run in the company of producer Rick Rubin, or Bob Dylan, even now able to touch greatness, or Leonard Cohen and Neil Young, this despite their best work being long gone. Each of them now keeps to their own furrow, however, and in this respect Plant is unique. For him there have been no self-imposed barriers.

Not everything he has done has worked. Since Zeppelin there has perhaps been just a small percentage of it that would qualify

as great. But most often he has been good and better, and one could not once have called his next move with any degree of certainty.

'I'm just so excited about what I do,' he told me a couple of years ago. 'I look after it like a baby child, as Robert Johnson would say. I'm a very lucky guy. For the contacts I have – a thousand pen pals, some of who speak Tamasheq and live south of the Sahara.

'My whole deal is that I can't do anything alone. I can't consider doing a thing without going out and press-ganging bright souls and spirits. That's what I look for, some kind of radiance and an innocent kindness. I know that sounds fucking hippy, but there's not a thing I can go near that doesn't have that equation.

'I can't say that I'm fortunate in that respect, because I put a lot into it, but my rewards aren't the gongs, the lifetime achievements and all that … stuff. It's more that, with the insatiable love of music and the weaponry I have, the repertoire I can go in to now is phenomenal.'

He paused then to consider how fast time passes, his mind shooting off at another tangent as it tends to do. He recalled a former girlfriend, five years past, and how she had urged him to commit to a certain future. 'She wanted to hear the sound of a pushchair, I think,' he said. 'So I promised her a trip to the seaside instead.'

Plant said he took this unfortunate girl to Cleethorpes, a windswept town on the English east coast, and then on a chill afternoon to see a football match. 'We went to a good fish and chip shop, too,' he protested. 'Then we split up. Well, I ran off with Miss Lapland. I'm seeing her again next week, actually. Lovely girl.'

In the telling of this there was a wicked glint in his pale blue eyes, those eyes that have seen so much. Later I wrote to him asking how he would feel about looking back over the full span of his life and giving it his own perspective.

His reply ran to a single line. He said: 'Thank you for asking, but I think it's too early in my career for me to be doing that – there's so much more to come.'

ACKNOWLEDGEMENTS

This book would not have been possible without the help and guidance of many good souls. I am well aware that most sane folk consider a long list of names to be as enticing as root-canal work but it would be very much remiss of me not to recognise their significant contributions.

I must first thank Robert Plant for past interviews and, although he did not authorise it, for allowing me to go where I did during the months of researching this book.

A big tip of the hat to my incomparable agent Matthew Hamilton at Aitken Alexander Associates for services above and beyond the call of duty. Thanks, too, to my man in New York, Matthew Elbonk at DeFiore and Company. I owe much to Natalie Jerome at HarperCollins in London on account of her wise urgings and promptings, and for the same to Denise Oswald at HarperCollins in New York. Thanks, too, to Simon Gerratt and Mark Bolland, my editor par excellence, and to all those at HarperCollins who have worked on this project.

My wife Denise Jeffrey did a sterling research job. I am also indebted to the following: Nicola Powell, Barbara 'BC' Cherone, Bernard MacMahon, Steve Morris, Neil Storey, Trudie Myerscough-Harris, Frances McMahon, Paul Brannigan, Mark

Blake, Max Lousada, Dave Ling, Simon Raymonde, William Rice, Sue Sillitoe, John Woodhouse, Paul Berry at Wolverhampton Wanderers FC, Julie Wilde at King Edward VI College in Stourbridge, Dave Brolan, and to Paul Toms for IT salvation.

I would have been lost without all of those who were gracious enough to allow me to interview them for this book – and not just for their time and insights, but often as not for many other kindnesses, too. Thank you: Jim Lea, Dave Hill, Ross Halfin, Kim Fowley, Anton Brookes, Richard Cole, Bill Flanagan, Glenn Hughes, Bill Bonham, Nigel Eaton, Doug Boyle, Andrew Hewkin, Marco Giovino, Hossam Ramzy, Steve Gorman, Mike Kellie, Steve Bull, Mark Stanway, Christopher Selby, John Crutchley, Bob Harris, Jody Craddock, Michael Des Barres, Carole Williams, Dave Pegg, Roy Harper, Laurie Hornsby, Tony Billingham, Phill Brown, Mike Davies, Andy Edwards, Bev Pegg, Perry Foster, Dennis Sheehan, Chris Hughes, Michael Richards, Tim Palmer, Benji LeFevre, Roy Williams, Colin Roberts, Mark 'Spike' Stent, Trevor Burton, Jezz Woodroffe, John Ogden, Najma Akhtar, Chris Blackwell, Kevyn Gammond, Gary Tolley, John Dudley, Stan Webb, David 'Rowdy' Yeats and Dave Lewis.

I have also been fortunate enough to interview Jimmy Page on two previous occasions and thank him for that now.

I am likewise grateful to all the writers, journalists and photographers whose work has informed and illustrated this work.

Whatever is good in this book is thanks to all of the above. Any faults or inaccuracies are mine.

I was first inspired to write by the encouragement and patience of good teachers – Mrs Godby, Mr Bowler, Mrs Jeavons, Mrs Hinton, Mrs Wymer and Geoff Sutton. And most of all by my mum and dad, who have never not supported me and who have always pointed me in the right direction.

Thanks and much love also to Mark and 'Tashi Rees-Martinez, to 'Uncle' Michael Rees for his great generosity and invaluable help, and to all the members of the Rees and Jeffrey clans.

I consider myself hugely lucky to have been able to earn my living writing – and pontificating – about music for two-decades-and-counting now. I would not have been able to do so had I not come into contact with Steve Morris, Phil Alexander, Dave Henderson or Malcolm Dome. I am profoundly grateful to each of them. I also gained nothing but good from working alongside Marcus Rich, Jason Arnopp, Caroline Fish, Scarlet Borg, Dave Everley, Lucy Williams, Jo Kendall, Stuart Williams, Gareth Grundy, Matt Mason, Simon McEwen, Steve Peck, Russ O'Connell, Ian Stevens, Matt Yates, Ashlea Mackin, Mark Taylor, Warren Jackson and all the other fine folk who inspired and tolerated me through many very happy years at *Kerrang!* and *Q* magazines.

This book was written to the music of Led Zeppelin, Robert Plant, the Grateful Dead, Buffalo Springfield, Moby Grape, Jefferson Airplane, Fairport Convention, Van Morrison, the Band, the Byrds, Love, Alison Krauss, Patty Griffin and Gillian Welch. The pleasure was all mine.

SOURCES

BOOKS

Alan Clayson, *The Origin of the Species: Led Zeppelin – How, Why and Where It All Began*, Chrome Dreams

Charles R. Cross, *Led Zeppelin: Shadows Taller than Our Souls*, Aurum

Neil Daniels, *Robert Plant: Led Zeppelin, Jimmy Page & the Solo Years*, Independent Music Press

Stephen Davis, *Hammer of the Gods*, William Morrow & Company

Stephen Davis, *LZ-'75: The Lost Chronicles of Led Zeppelin's 1975 American Tour*, Fourth Estate

Pamela Des Barres, *I'm with the Band: Confessions of a Groupie*, Helter Skelter Publishing

Peter Guralnick, *Careless Love*, Abacus

Barney Hoskyns, *Led Zeppelin: The Oral History of the World's Greatest Rock Band*, Wiley

Barney Hoskyns, *Waiting for the Sun: Strange Days, Weird Scenes and the Sound of Los Angeles*, Bloomsbury

Nick Kent, *Apathy for the Devil*, Faber & Faber

Andy Neill and Matt Kent, *Anyway, Anyhow, Anywhere: A Complete Chronicle of The Who 1958–1978*, Sterling Publishing

Andrew Loog Oldham, *Stoned*, Vintage

Paul Oliver, *Blues Fell This Morning*, Collier Books

Richard Cole with Richard Trubo, *Stairway to Heaven: Led Zeppelin Uncensored*, HarperCollins

Brad Tolinski, *Light & Shade: Conversations with Jimmy Page*, Virgin Books

Mick Wall, *When Giants Walked the Earth: A Biography of Led Zeppelin*, Orion Books

Ned Williams, *A Century of the Black Country*, The History Press Ltd

Rob Young, *Electric Eden: Unearthing Britain's Visionary Music*, Faber & Faber

ARTICLES

Phil Alexander, Led Zeppelin feature, *Mojo*, December 2012

Jacoba Atlas, Robert Plant interview, *Circus*, March 1970

Mark Blake, 'Led Zeppelin: Let There Be Rock', *Q*, March 2005

Chris Charlesworth, Robert Plant interview, *Melody Maker*, 8 February 1975

Chris Charlesworth, 'Robert Plant: Plantations', *Creem*, May 1976

Alvaro Costa, Unpublished Page and Plant interview, 1995

Cameron Crowe, 'The Durable Led Zeppelin', *Rolling Stone*, 13 March 1975

Tim Cumming, Robert Plant interview, *Independent*, July 2012

Stephen Dalton, Robert Plant interview, *The National*, April 2009

Anthony DeCurtis, 'Refuelled and Reborn', *Rolling Stone*, 23 February 1995

Dave DiMartino, 'Hot Dog to Big Log', *Creem*, October 1983

SOURCES

Chuck Eddy, 'Robert Plant: Technobilly', *Creem*, June 1988

David Fricke, Robert Plant interview, *Rolling Stone*, 24 March 1988

David Fricke, 'The Return of Led Zeppelin', *Rolling Stone*, 13 December 2007

David Fricke, 'Beauty and the Beast', *Rolling Stone*, 26 June 2008

Deborah Frost, 'Robert Plant: Last of the Red-Hot Rock Stars', *Spin*, 1993

Andy Gill, Robert Plant interview, *Independent*, 16 November 2010

Tom Hibbert, 'Robert Plant: Guilty!', Q, March 1988

Barney Hoskyns, Robert Plant interview, *Rock's Backpages*, 2003

Barney Hoskyns, Robert Plant interview, *Tracks*, 2003

John Hutchinson, Robert Plant interview, *Record Magazine*, September 1983

Cliff Jones, Robert Plant interview, *Rock CD*, April 1993

James McNair, Robert Plant interview, *Mojo*, July 2002

Charles Shaar Murray, 'Robert Plant – and That Below-the-Belt Surge', *NME*, 23 June 1973

Mark Petracca, Robert Plant interview, *Creem*, September 1993

Stephen Rodrick, Robert Plant interview, *Rolling Stone*, 20 January 2011

Steven Rosen, Robert Plant interview, *Guitar World*, July 1986

Robert Sandall, 'Led Who?', Q, May 2008

Austin Scaggs, Robert Plant interview, *Rolling Stone*, 28 October 2010

Sylvie Simmons, Page and Plant interview, *Rolling Stone*, 1998

Mat Snow, 'Percy Pulls It Off', *NME*, 8 June 1985

Mat Snow, Robert Plant interview, Q, May 1990

Mat Snow, Page and Plant interview, *Mojo*, December 1994

Mat Snow, Page and Plant interview, *Mojo*, May 1998

Phil Sutcliffe, 'Not the Led Zep Reunion', Q, December 1994

Frank Tortorici, Page and Plant interview, *Addicted to Noise*, 24 March 1998

Steve Turner, 'Zeppelin Man Takes the High Road to Nirvana', *The Times*, June 1990

Mark Williams, Robert Plant interview, *International Times*, April 1969

Richard Williams, 'Robert Plant: Down to the Roots', *Melody Maker*, September 1970

MISCELLANEOUS

The Black Country Society

Down from the Mountain, Momentum Pictures DVD

The International Bluegrass Museum, Kentucky

Led Zeppelin: How the West Was Won, Warner Music Vision DVD

No Quarter: Jimmy Page and Robert Plant UnLedded, Warner Music Vision DVD

Robert Plant: By Myself, BBC TV

TMZ.com

Wolverhampton City Archives

INDEX

341

Canned Heat 24
Cannon Hill Arts Centre, Birmingham 75
Cannon, Freddy 189
Captain Beefheart 66–7
Cardiff City stadium 171–2
'Carouselambra' 194
Carson, Frank 311
Carson, Phil 208–9, 211
Carter Family 283
Cash, Johnny 329
Causey Farm Road, Birmingham 14, 17, 31, 202
CBS records 61, 63–4, 65, 74, 89
Cedar Club, Birmingham 55, 67
'Celebration Day' 111
Celebration Day (film) 323, 324, 325
Chamberlain, Neville 12
Chambers, Richard ('The Beak') 20, 30, 32, 41, 47
Chantry School of Holy Trinity, Stourbridge 19
Charles, Prince 312
Charles, Ray 92, 222
Charlesworth, Chris 160–1
Chateau Marmont Hotel, LA 93
Cherry Tree, the (pub), Welwyn Garden City 99
Chic 222
Chicago Plaster Casters 98, 313
Chicago R&B 37, 312
Chicago Stadium 153
Chicken Shack 39, 134
Chigurh, Anton 295
Chislehurst Caves 148
Christian, Dick 163
Christian, Neil 84
'Cindy, I'll Marry You Someday' 317
Clapton, Eric 27, 36, 60, 77, 86, 225, 253, 258, 290
Clark, Gene 293
Clash, the 172
Clearwell Castle, Forest of Dean 187
Clent Hills 14–15, 102
Cliff, Jimmy 72
Clifton, Peter 145
Clockwork Orange, A (film) 153
Clouds 108

Club A' GoGo, Newcastle 59, 73
Club Lafayette, Wolverhampton 99
CMT (music channel) 288, 300
Cobain, Kurt 256
cocaine 105, 138, 154, 155, 157, 170, 178, 321
Cochran, Eddie 16–17, 21–2, 27
Cocker, Joe 276
Coen Brothers, the 283, 295
Cofton Club, Birmingham 68
Cohen, Leonard 118, 329
Coldplay 314
Cole, Richard
 American tours: 1968–9 93, 96–7; 1970 113; 1972 129, 130; 1973 138, 139; 1975 154–5; 1977 174–5, 179–80
 and Bonham 141, 142, 146
 character 130, 140, 141, 155, 178
 and drugs 138, 154, 171, 174–5, 192, 196
 Harris on 158
 at Headley Grange 110
 in India/Far East 125
 and Jersey 163
 and Karac's death 182, 183
 Kellie on 130
 on Led Zeppelin 106–7, 192
 on Page/Plant 120
 on Plant 96–7
 Plant thanks 313
 and Rhodes accident 161, 162
 Sheehan on 155
Colin, Jesse 280
Collins, Phil 207, 209, 211, 214, 226
Colston Hall, Bristol 215
'Communication Breakdown' 90, 105, 159
Concert for Kampuchea 195
Connaught Hotel, Wolverhampton 76
Conservative Club, Stourbridge 38
Continental Hyatt House, Sunset Strip 85, 105
Cooder, Ry 67
Cook, Amy 327
Cool, Ricky 202
Cooper, Alice 94
Cordell, Denny 74
Corris slate quarry 261

INDEX